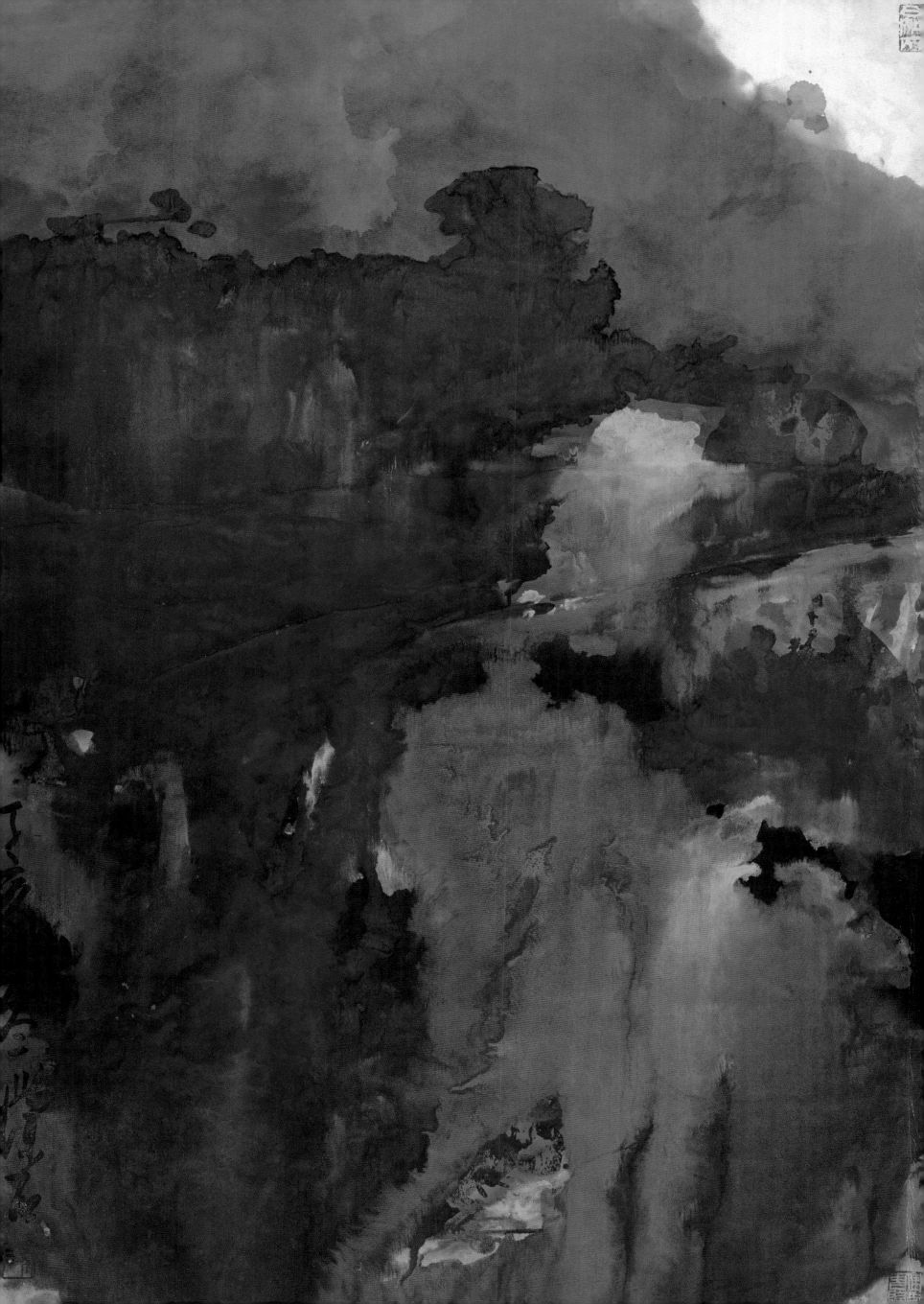

THE COLLECTION OF PU SHI'S PAINTING

溥佐画集

天津人民美术出版社（全国优秀出版社）

TIANJIN PEOPLES FINE ARTS PUBLISHING HOUSE
(STATE OUTSTANDING PUBLISHING HOUSE)

麒麟书院藏画

简　历

秦树明，画名璞石。
1948年生人。
1955年上小学。
1960年小学毕业。
1961年跟着董先生学习西河大鼓，而后至1973年在河间县文化馆从事曲艺工作。
1974年在本村企业当业务员。
1978年改革开放，开始经商。
1985年成立河间县新华电缆厂。
1995年被评为全国劳动模范、河北省人大代表。
1997年自学书法、国画。
2000年创办麒麟书院。
今任新华线缆集团董事长。

Brief Introduction

Qin Shuming was born in the Year 1948, and received his primary education from 1955 to 1960. After that he quitted from school and started to learn Xihe Opera for 14 years. In 1973, he started to work in the county's cultural center, it was not long before he quitted again and do some business affairs for his village until he started to be in real business in the year 1978. In 1985, he established Hejian Xinhua Cable Factory, ten years later, the factory turned to be Xinhua Cable Group, and he himself became its president, he also gained the title of the country's labor exemplar, and was elected to be a member of the People's Congress of the Hebei Province. Since 1997, he started to learn Chinese calligraphy and painting all by himself, and three years later, he established Qi Lin Calligraphy Gallery.

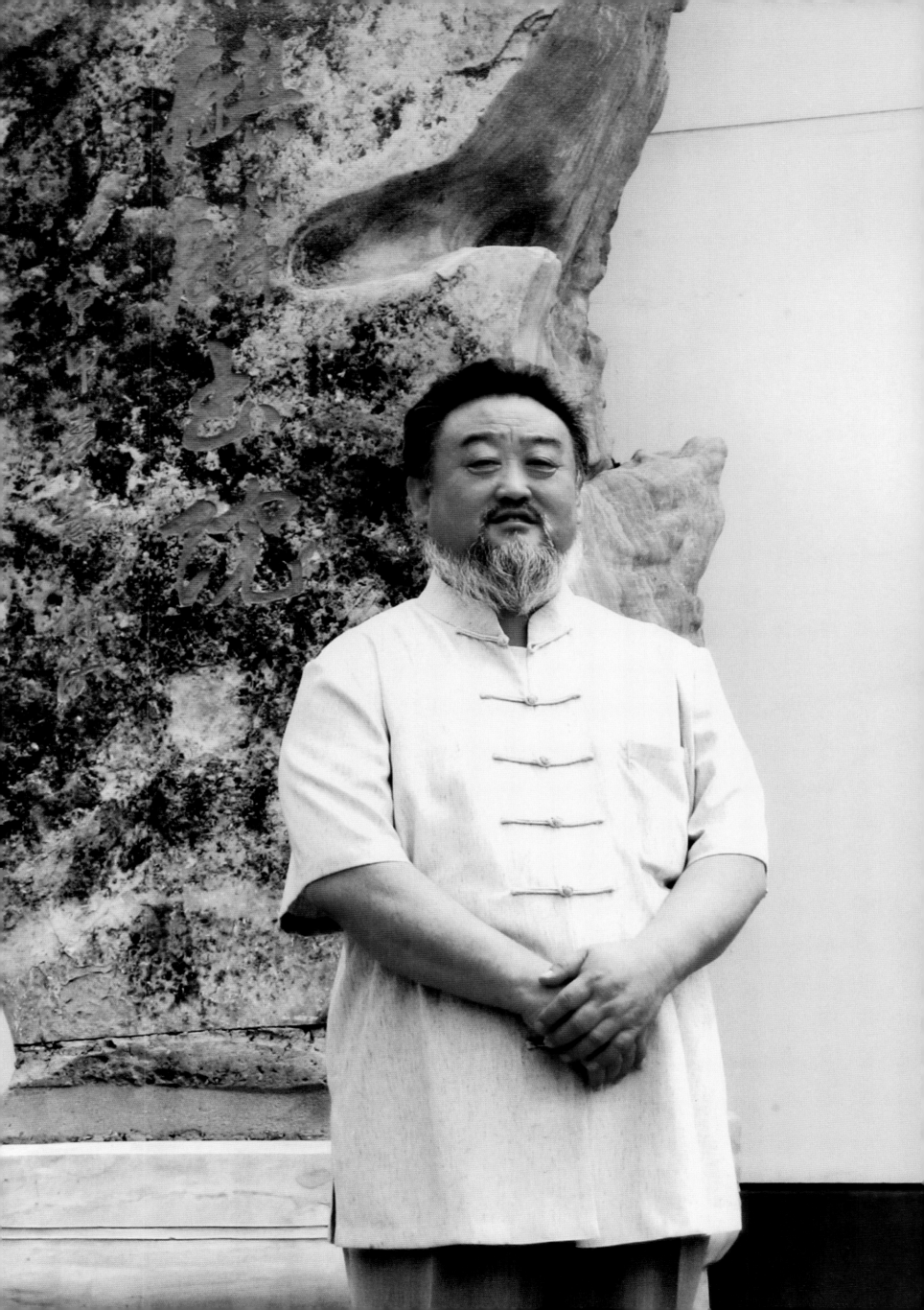

自做盘古自开天

——璞石画集序　　　　　　　　老庄

道可道，非常道，
老庄对着璞石笑，
不受刀斧不成器，
风化千年成灵璧，
生命化玉玉成人，
血肉为躯玉为魂，
真魂不腐玉之坚，
真质不杂玉之纯，
自做盘古自开天，
自做佛祖自开山，
大笔一抡写大象，
班门不出此大匠……

以上摘取的是《璞石问道图》的题诗。由璞石先生泼彩作灵璧，我在其空间指画而成《璞石问道图》，上首穿红衣者是璞石先生，团面长须、挺胸扬臂，表现出桀骜不驯张扬自得的神态。下首坐的是老庄，白发黄袍。老庄比璞石岁大一轮，同属鼠，璞石白须飘拂，逼得老庄也只好长出胡须来，与其对应。朋友说应写成"论道图"，璞石先生以他少有的谦虚说："不，是璞石向老庄问道。"我以少有的不谦虚，对璞石的问道以诗的形式做以回答。

我把璞石的作画方法列为禅宗，他抛弃了"即雕即琢"的过程，对传统的态度是"承意不彼"，用不着吃力地打进去，再费劲地爬回来。这种蝉虫的教学法，璞石不取。他下笔即我法，立地成佛。其巨幅《大象图》可谓登峰造极，前不见古人，后人也很难跟踪蹈迹，艺术之可贵、可珍，是不可模仿性，凡可摹可拟甚至可以乱真和超真者，绝不是一流艺术品。凡自我重复自我克隆，一辈子按照自己的脚印走的艺术家，只表明他江郎才尽，失去了创造力。真正的艺术家是在变中体现自己的艺术风格，而不是制造一个固定的模式，来框定和限制自己的，把创造变成自己的桎梏。

璞石的大象系列，是他动物画中的代表作，余者如牛、犬、猫头鹰、黑天鹅等皆自具家法。他的动物造型不是按照生理结构来使笔用墨，更不是西方机械的结构和重组，他是混沌其形，直取其意，笔笔老到，洇迹鲜明。恍惚的意象定格于纸上，使人瞠目称奇，他淘汰了写生模拟的中间环节，下笔直逮"九方皋相马"的审美境界，不管牝牡黄骊，超然直取其精神。

璞石先生是成功的企业家，他又是中国书画艺术的鉴赏家和收藏家。其藏品之精之丰使人惊叹，看出他比一般企业家具有超常的战略眼光。他又是奇石收藏家，在河间故乡有他庞大的奇石馆。他像愚公移山一样，把巨大的灵璧奇石从遥远的南方产地源源不断地运回北方，走进北京的麒麟书院，门侧边有巨石耸立，给人以庄严肃穆之感。在颇为宽敞的四合院中，四周奇石陈列，鬼斧神工、千姿百态，如罗汉变相，打坐参禅，进入冥想的世界。米芾拜石，视奇石如神灵，然自于石外。而先生自命璞石，将自己的生命和灵璧同化，已跻身于奇石之中了。

院中竖立着一块块巨大的木化石，其肌体纹理皆已玉化，细腻光洁坚硬而滋润，使人油然而生爱抚之意，它们经历过了亿万年的地质变动，沦没浩劫，而今重见天光，它已不再属于生生灭灭，倏忽变形的自然现象了。它已进入了不朽的大道，不死不生，已超越了轮回，这不正是佛家所追求的涅槃之境么。

在这里我们看到了璞石先生对人类精神最深层次的追求。

人生有不死之道，精神不朽莫过于思想的迹化了，这就是绘画的产生，它是人类灵魂的体现，把造型艺术变成精神的化石，它奇美，幻化流变生姿，各具形态，蕴藏天地之理和人类追求真善美的最宝贵的灵思。在混沌中开出光明，其中有物、有真、有信，微妙通玄，连着人类的灵犀。

璞石先生正是从画石中开始了他的山水创作的。他把万里江山，也当作一块石头的整体来画，他作的是大块文章、浑朴、大气、磅礴、豪迈、混沌、原始稚拙而又天真。完全独出心裁，完全是自家的招数，有些莽撞，有些妄为，有些凿空乱道，有些唐突先贤，然又歪打正着，反

成合道。使人瞠目结舌之余顿然开悟，无法之法乃为大法，作法自困为法自缚，斤斤于凿枘，循规蹈矩者，岂敢有这样的气魄，这样的胆识，这样的作为，开创这样的境界？相比之下，我们司空见惯，滥目成俗的东西，就显得过于抠唆、局促、择发数米，太小家子气了。为彻底冲破传统笔墨的图圄，璞石又开始了泼彩的试验，画家应是最个人最独立最自由的行为，艺术和科学思想没有禁区，对物质和精神世界的追求却更要经过许多失败。经验的积累如沙里淘金，真正的书画珍品，都是在废纸千张中产生的。艺术家最可贵的就是首创精神。

道家"无为"的秘意就是在"无处"而为，"无人迹处有奇观"，发前人所未发，得前人所未见，有独思独创独见才有独得，增自然之所无，补造物之不足，艺术始于原创然后有传承有发展有突破流派纷呈，百花齐放。

同时也鱼龙混杂，泥沙俱下，浊清合流，多样混同的文化现象，它丰富了人们的精神生活，给人以喜悦，也给人徘徊和迷惑。然而现象的浮沤，是生生灭灭的，而原创精神却是不朽的，它是人类文化精神的脊柱，这正是璞石创作的可贵之处。我与璞石先生相识很晚，目击而道存，还是因在无为之处不谋而合，他的创作，是禅宗顿悟体现自性的。而我的创作是道家的、流变的、宗自然的。

"即雕即琢复归璞，
无天无地无今古，
方便自开万重门，
自玩鬼斧自通神，
胸若天府得灵源，
大道一通无事难……"

在这里我的创作思想和璞石先生歧路同归，道通为一了。

何谓道？道是万法之源。道是老子对易思想独一多元，无方无极变于不变，发散思维的总概括。易是象征的，以阴阳为道，老子是求实的，以有无为道；庄子是超然的，以齐是非为道。三玄为一，天理人心统一，构成"天人合一"的道家哲学。它是人类精神的太阳，其大德的光辉，是普照万物的。

道是宇宙的本体，道是宇宙观、世界观、人生观和方法论。哲学的真正本质是普适万有，属于全人类的。它根于人性，即人之所本。所谓历史，皆人心的历史。所谓经济规律，实人心错摩交流之规律。所谓社会学即人心学，民意是决定一切的，它具有神性的尊严，是不可违逆、不可亵渎、不可玩弄和践踏的。人类生活的最高境界是精神的追求，故画要有格调有品位有境界体现中华民族的人文精神。

人是需要物质和金钱的，无物质无法生存，金钱少了也办不成大事，然对于金钱与物质的追求，究非人生之目的。备物以养形，保形以养神，神是目的，人有精神乃活，失去精神就成了死尸。连猪崽都知不吃死母之乳，西方哲学把物质放在第一位，失去了人本，人就变成了物资的奴隶，人已被物物化得不像人了，从孩子教育起把人类驱向物欲争夺，弱肉强食的丛林，把人类社会变成了斗兽场。

道家哲学是拯救人类精神的，它摒弃思想专制和暴力、强取豪夺积心盘剥、强势集团对弱势的压榨，它以大慈出发，以俭行为德，以不争为平等精神，维护人类共同的尊严，互爱互助互为成就，以容万不同为大同，以合众是为大功，这才有真正和谐社会的诞生。

璞石先生由一个企业家向艺术家精神世界的攀登，我想起蔡元培以"美育救国"的思想，打破古今中外一切精神的枷锁，从皇权专制和西方强权话语的语境中，冲决出来，从历史的陈腐积淤中冲决出来，一个国家使人民有了自主独立的思想人格和创造精神，这个国家的国格才是充实的、让人尊崇的，才真正体现它的国格，而立于世界的民族之林。

在当代出现璞石这样的艺术家是让人庆幸的。

庄子论道，颜成子修道有九种境界，第一是野，也就是冲破藩篱和驯畜式的教育，使人类的天性得到自由的发展和解放。

对璞石的原创精神我寄予厚望，这是我乐于为其作序的原因。

Master of A Completely New Style of Art

——Preface to the Collection of Pushi's Paintings Old Zhuang

To guide what can be guided is not constant guiding.
I examined the uncut jade with pleasure.
Thanks to his attitude towards hardship,
His firm and pure nature,
He became the master of his own style of art.
Look at the elephants he painted, so living and strong,
Who believe he used to be my student?

This is a part of the poem on the painting "Pushi Asking for Guide". Pushi painted the Lingbi Stone, and I drew, with my finger, the two characters. On the left side sits Mr. Pushi, bearing a round face and long beard, he is wearing a red long gown, his chest thrown forwards, and his arms raise, showing an obstinate, unruly and self-satisfied manner. On the right side sits Old Zhuang, that is me. I am wearing a yellow gown, also bearing white hair and beard. In fact, my chin is always clean shaved, but since Pushi is 12 years younger than me, and now that he appears on the painting to be an old man, I have to add white beard on my chin. Some friends suggested the painting be called: "The Discussion on Guide". "No," Pushi said, in a rare modest attitude, "This is Pushi asking for guide from Old Zhuang." So I composed this poem, in a rare immodest attitude, to give his question an answer.

I sorted Pushi's style of painting as Zen, he doesn't paint every thing in an ornate style, his attitude towards tradition being just absorb the spirit, in stead of learning everything in detail. You could see my way of painting from the first stroke of his brush. His "Elephants" has reached the peak of perfection. His painting is not an imitation of the ancient painters, and the later painters could not imitate him. The real value of a masterpiece is its spirit, which is not imitable. A painting that could be imitated is not a real piece of art work. A painter always imitating himself and move carefully in his own footprint could only show that he is lack of creativity. A real artist shows his style of art in a way of constant change, in stead of building an unchanged style and turns creativity into a shackle.

Pushi's painting of elephants is the representative paintings of his paintings of animals. You could also recognize his own way of painting from his paintings of cattle, dogs, parrots and black swans. He doesn't shape his animals according to their physiological structures, the animals he painted share a blurry shape, you could read, from his tactful stroke of brush, their artistic conception. He jumped over the medium step of sketch and imitate, and express directly the spirit of various kinds of animals.

Mr. Pushi is a successful entrepreneur, meanwhile, he is an appreciator and collector of Chinese painter and calligraphies. The excellency and rich of his collection is astonishing. He is also a collector of rare stones, he built a gallery of rare stones in his hometown, the Hejian Country, he ceaselessly transported huge Lingbi Stones from the Southern part of China, their place of origin, to his hometown. Entering the Qilin Study in Beijing, you could see huge rare stones beside the gate, and in the big yard of the study, you could see rare stones in various shapes, like arhats sit in meditation in different appearances, leading you into a world of deep thought. Mi-fu worshiped stone, regarded stone like gods, he was still in a world outside stone. Mr. Pushi regards himself as an uncut stone, he is among the stones.

Many huge tree fossils stand in the yard, their quality and venation had turned to be much like that of jade. One could hardly help touching the fine, smooth and moist surface of the tree fossil. Having experienced geological changes over billions of years, those ancient trees are no longer what they used to be, they had become something eternal, something beyond life and death. This is just the destination Buddha pointed for us all.

Here, we read, from the character of the tree fossil, the route of Pushi's pursuing towards human spirit.

The best example of the immortality of human spirit is the expressing and recording of human thoughts. This is just how the art of painting come into being. Painting is the portrait of man's soul, those art of shaping turned to be the fossil of human mind. The extreme beauty of paintings come from the eternal changing of shapes, reflecting nature of the world, and recording the most precious part of human thought in their pursuing of reality, kindness and beauty.

Pushi's first step towards the landscape painting is his painting of stones. In his landscape paintings, he regards the landscape as an extremely huge piece of stone. What he composed being something under a great topic, simple, vigorous, heavy and boundless, though a bit turbid and childish. His paintings show extreme originality, he paints in nothing but his own way, which is somehow crude, reckless and could be regarded to be rebellious against tradition, but wait, it hits the center of the target anyway. After gazing at his paintings dumbfounded, one might gain immediate comprehend: the rule of no rule is the real rule. How could those who bind themselves with a certain rule of art have such a great courage as to paint in Pushi's way? Comparing with Pushi's paintings, those we see

everyday everywhere seem to be too constraint, trifle and narrow—minded. Pushi is now trying to paint with the skill of splashing of colors, this is a further challenge of the traditional ways of painting. The composing of a painting should be the most personal, independent and free act of art, there is no forbidden area in the field of art and science. It is true that great creations often come after many times of failure, many a good piece of painting could only come into being after the wasting of many pieces of paper. The most precious spirit of a painter is his ability to create.

In my point of view, the theory of "no conduct" advocated by Taoism means to conduct in a place that no previous conduct had been conducted. "You could always find marvelous spectacle in a place with no human footmarks". Starting from a place where no predecessor have worked upon, you are likely to gain what they have not gained. Think in your own way and then you are likely to have your own point of view. In the field of art, everything started from original creation, then, art could be succeeded and developed by later generations, and various schools of art could then come into being.

While art enriches people's spiritual life, and bring us into a state of happiness, it also take us into a state of hesitation and confusion. While the appearances of art change constantly, the spirit of original creation remains eternal. It is the support of the cultural spirit of human being. Original creation is the most precious part of Pushi's composition of paintings. It had been a short period of time since I get to know with Mr. Pushi, it was from the theory of "no conduct", that we found something in common. The ideas of his painting come from Zen's sudden awareness, portraits the domestic side of human self; while those of my paintings come from my understanding of Taoist theories, and advocates the spirit of nature.

Out of an ornate style, and back to simple.
Forget the differences between places and times.
Exploring his own path toward the principle.
And nothing is really difficult.

It is in this point where my way of painting and that of Mr. Pushi reach the same goal by different routes.

What is the principle of origin? It is the origin of all the methods. It is Li Er's general summarize to "The Book of Changes". "The Book of Changes" advocated symbol and regarded 'yin' and 'yang' as the principle of origin. Li Er advocated reality, and regarded 'exist' and "non—exist" as the principle of origin. Zhuang Zhou's point of view seemed to be much aloof, he regarded "right" and "wrong" as the principle of origin. All the three theories added up to the foundation of Taoism. The principle turned to be the combination of the spirit of gods together with that of human. This is the sun of human spirit.

The principle of origin is the noumenon of the universe, it's the basis of human philosophy and methodology. The real nature of philosophy is that it could be used in all circumstances, and it belongs to all peoples. The foundation of the principle of origin is human nature, so history is nothing but the history of human thought, and economic rule is nothing but a rule of human communication, and sociology is noting but a science of human thought. Human thought determines everything, it should never been violated and tampered. The final extent of human activity is their advocating of spirit, so a piece of art work should be touchable, testable, and reach such extent as to reflect the spirit of humanism.

Materials and money are important, one could not survive without necessary materials, and in order to fulfill a hope, you do need enough money. But desire towards materials and money should not be regarded as the goal of life. Get necessary materials ready in order to live, and keep ourselves alive in order to reach a higher spiritual extent. A man is a man when he got spiritual life, and he is equal to a dead body when he only got material and money. Even a baby pig knows that he should not suckle milk from the dead body of his mother. The Western philosophy put material to the leading place, and so human being become slaves of material. In the Western countries, children are educated to get stronger so as to win in battles for materials. Human society becomes a fighting place of animals. Darwinism is a principle for animals rather than for human being.

Human spirit could be survived with the philosophy of Taoism, get rid of autocracy and violence, the weaks are no longer the prey of the strongs. Taoism advocated charity and thrifty, it encouraged people love each other, help each other and respect each other's dignity. A harmonious society is possible only with the philosophy of Taoism.

From Mr. Pushi's path from an entrepreneur to an artist, I remember Mr. Cai Yuanpei's theory that the education of art could help to save the nation. A nation is respectable only when its people got independent thought and ability of creation.

It is a matter of rejoicing to have an artist like Mr. Pushi here in our society. I do hope Mr. Pushi could keep his steps forward in his path of creation, this is why I am glad to write this preface here.

自 序

我现在听到最多的谈论是学历、文凭、大师，人人都说自己是大师，如果说学历、文凭、大师能够使一个人从精神上得到满足的话，也算是一剂良药。本人没有资格加以评论，小学水平，没有文凭，只谈现象。也有人说我是社会大学毕业，是在苦水里面泡出来的。学上得不多，书读得不少，不敢说无书不读。过去有一段曲艺生涯，说西河大鼓14年，白天看书晚上说书，形成了职业爱好。并且还收藏书，历史上最有名的《四库全书》，本人有幸也收藏一部。

我过去的经历用两句话来概括比较合适：从推小车到坐小车，从我说书到书说我。这是一个跨时代的转变，说到这还要说我这一生有三件大事没有想到，一件就是改革开放；二件就是事业上遭到了挫折；三件就是六十岁的人走向了艺术学习了书法和国画。

过去也有过辉煌，我创办的企业从1993年至1998年在河北省全省纳税第一。1995年我被评为全国劳模，1999年还参加了河北省组织的光彩演讲团到各市演讲，所到之处一片喝彩。可到了2001年事业上受挫后，过去的车水马龙、门庭若市不见了。在这期间我学会了自己与自己交流，在书画上找到了乐趣。起初画牛，农民出身的我对牛非常熟悉，也把牛看成是真正的君子，我想我画，我画我心。最喜欢的就是山水，人在山水之间有心旷神怡的感觉，有人说你应拜一个名师，我说大自然与万物就是最好的老师。不求有多高的技术，也不求学院里面传授的艺术理论，说实话也不懂。我自己也有一点论点：厚重，达到自然；要有气势，体现博大胸怀，不失传统笔墨。从古至今，在我的作品中找不到任何人的痕迹，完全自我。画得好与不好不重要，重要的是自己走出一条路："自由画派"。

璞 石
2007年中秋于麒麟书院

Autobiographic Preface

Educational backgrounds, diplomas, and great masters are the most frequently used terms nowadays, everybody call himself a great master, if having educational backgrounds, diplomas, and titles of great master could really make one feel spiritual satisfy, so much the better. I, with no diploma, and received no more than primary school education, am not in the position to give any comments on this matter. Some of my friends said that I had graduated from the university of life, it is true that I was raised from a poor family, had very little school experience, and red a great amount of books. For more than 14 years, I engaged myself to Xihe Opera, everyday, I acted on the stage at daytime, and red books at nights. I also collect books, among my collection, you could even find the famous Encyclopedia of Four Aspects.

My story is about how a man pulling a barrow become one sitting in a car; and how a man telling stories from a book become one whose story could be found in a book. Changes are obvious, besides, there are three things that I could not dreamed to see, but effectively, I have seen them all. One is China's reform and opening to the world, one is the setback in my career, and what's more, a sixty year old man's first step towards Chinese painting and calligraphy.

I had experienced some good times in the past, I used to be the number one taxpayer in the province from 1993-1998, I was granted the title of the country's labor exemplar in the year 1995, in 1999, I was chosen as a member of the "glorious lecturers" arranged by the Hebei Province, giving speeches everywhere. Our trip was accompanied by acclamations. The glory faded completely after 2001, when I had a setback in my career. Visitors that used to be a crowd in front of my gate disappeared. During this period, I learned to communicate with myself, and started to enjoy myself with Chinese paintings and calligraphies. At the beginning, I painted cattle, for being raised up in a farmer's family, I am quite familiar with cattle, and in my eyes, cattle is a real gentleman. What comes to my mind, I paint, and my painting is just a mirror of my mind. Landscape painting is my favorite. One is likely to feel relaxed and happy in a beautiful landscape. Friends suggested that I should find a good teacher, but I think I could not find a teacher better than the works of god. I do not want to learn painting skills and artistic theories taught in the campus, they are things beyond my understanding. My theory is my painting should be heavy in order to be near from the nature, and vigorous, in order to portrait the width of my thought. No other painters' trace could be found in my paintings, they are mine. It is not important whether or not my paintings are good, what is important is that I must go my own way: the School of Freedom.

Pu Shi
Mid-auturm Festival, 2007
Qi Ling Calligraphy Gallery

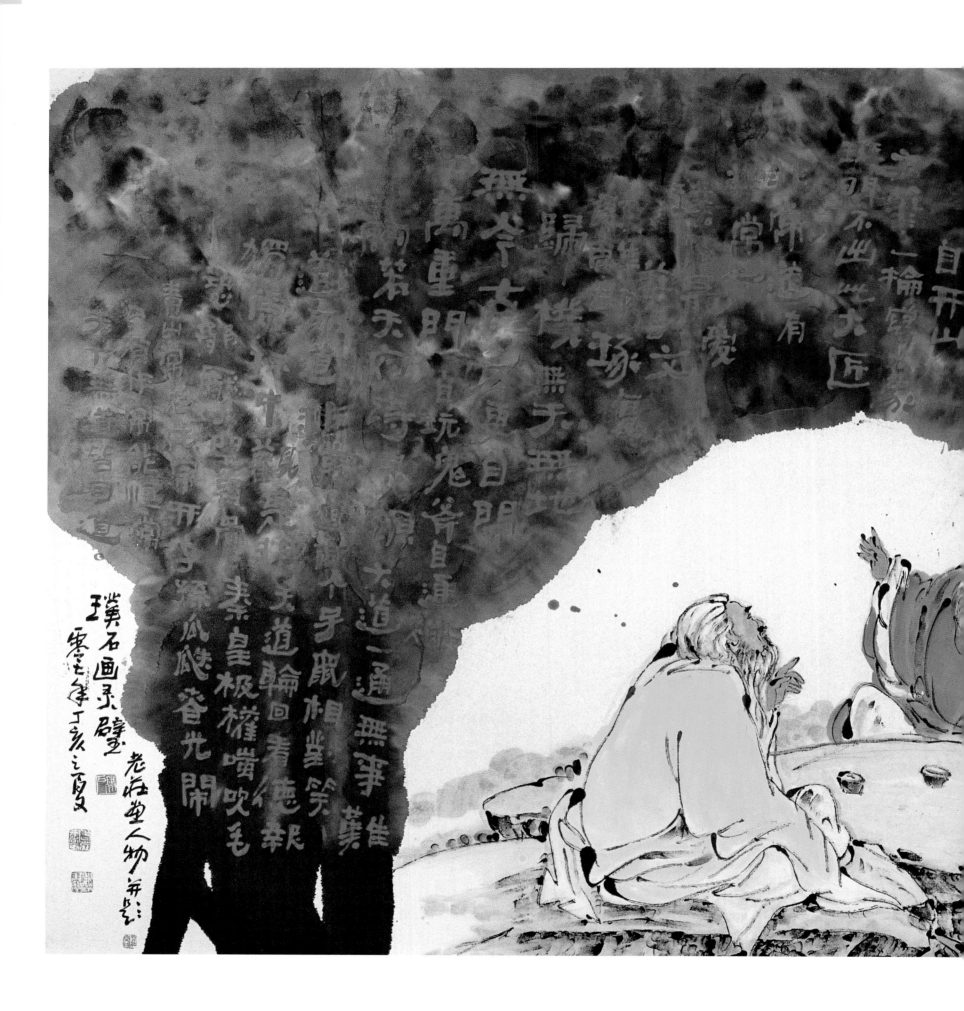

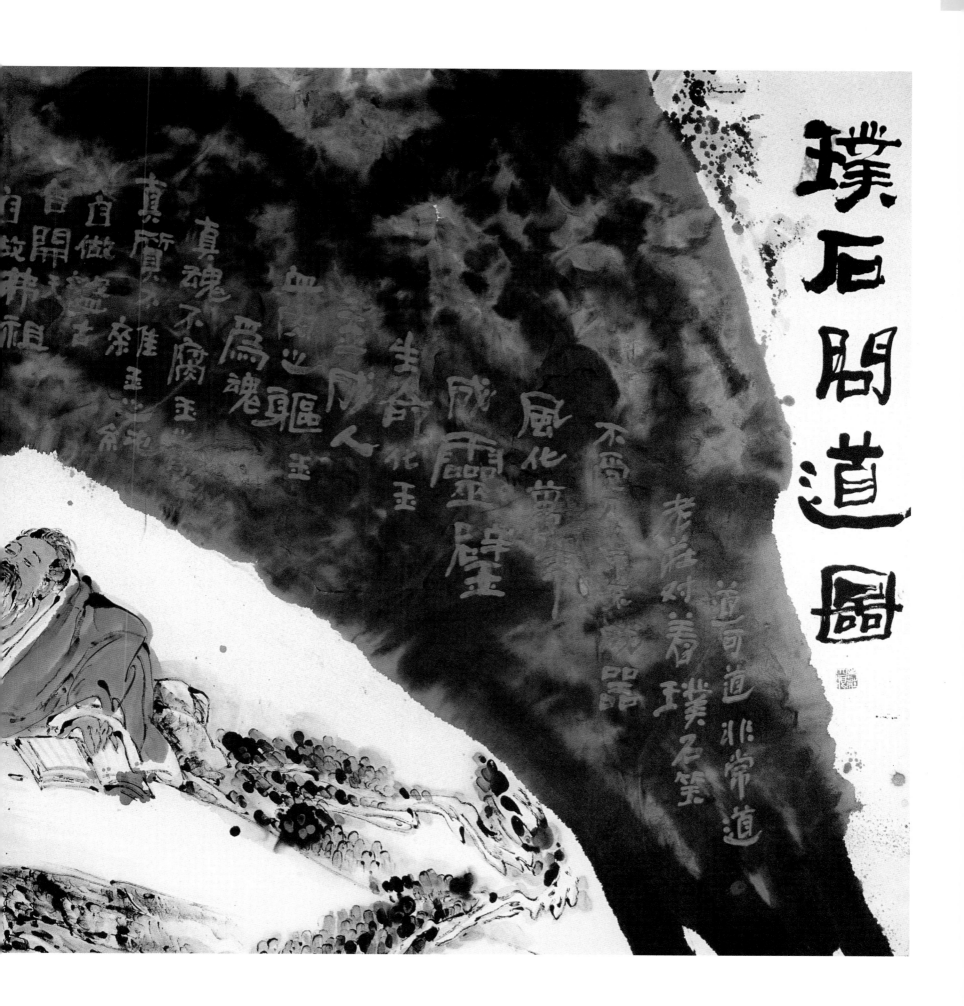

璞石問道圖

真魂不腐玉為魂

生命化玉

成壁璧

風化萬年

不廢古今

道可道非常道

老莊對着璞石笑

山水　　LANDSCAPE

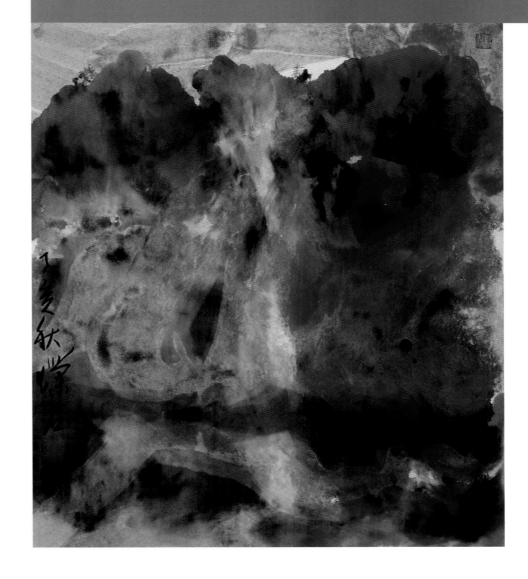

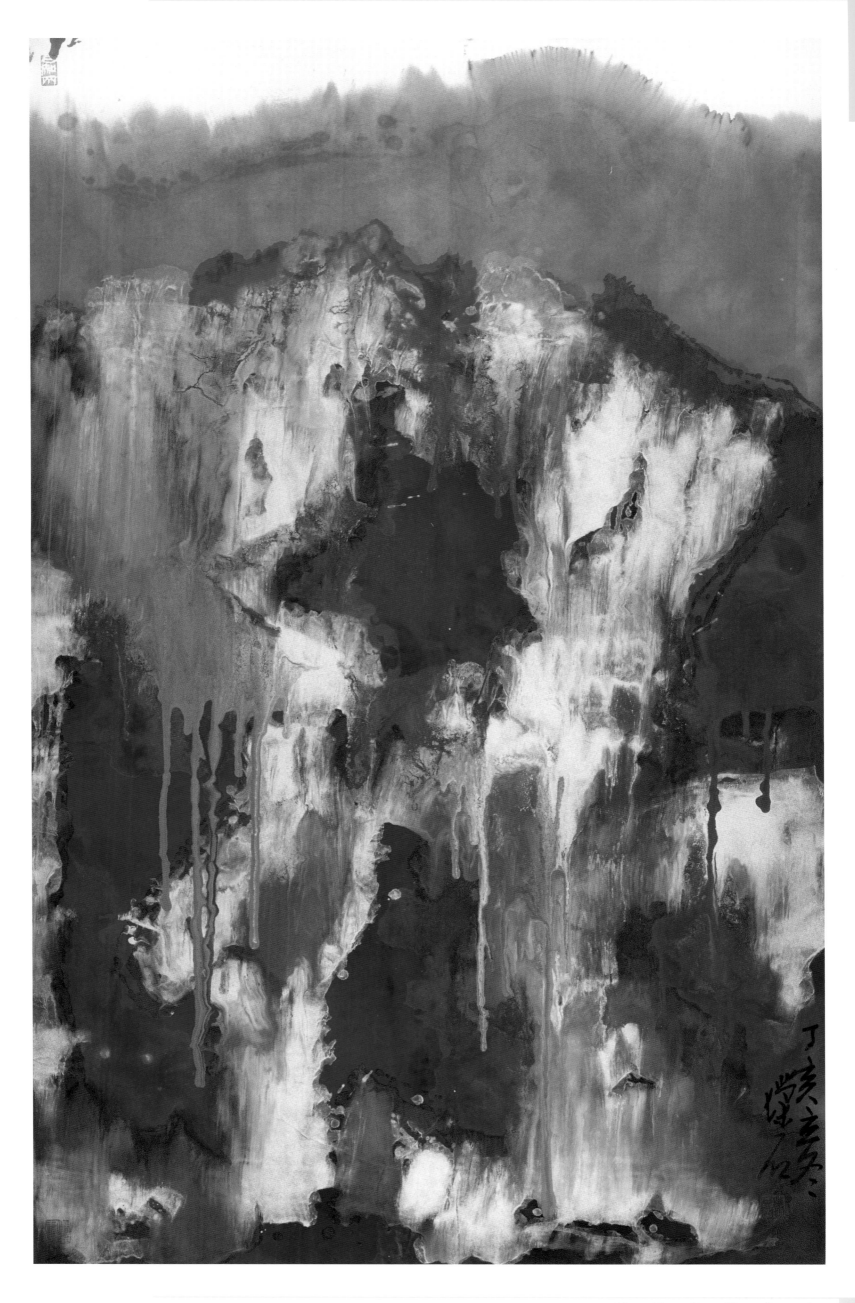

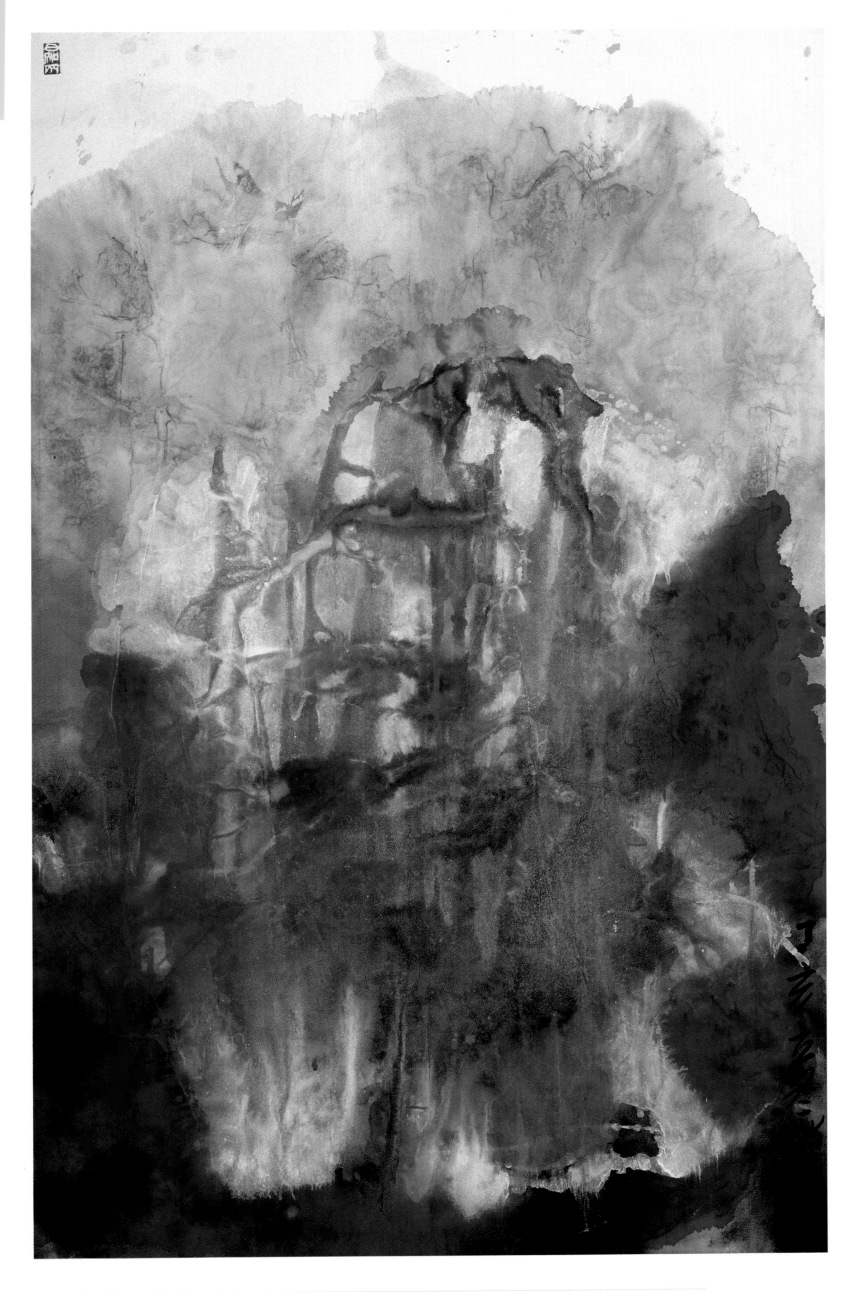

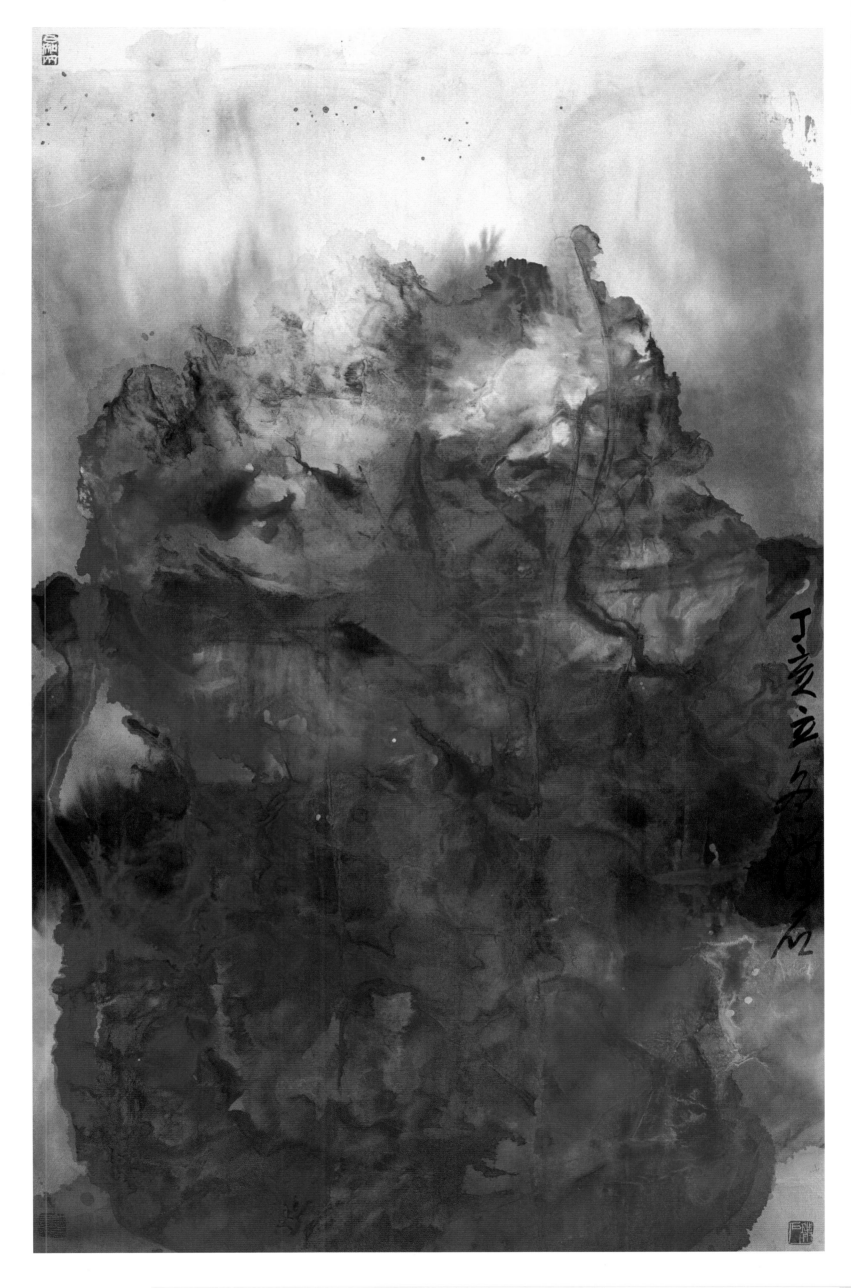

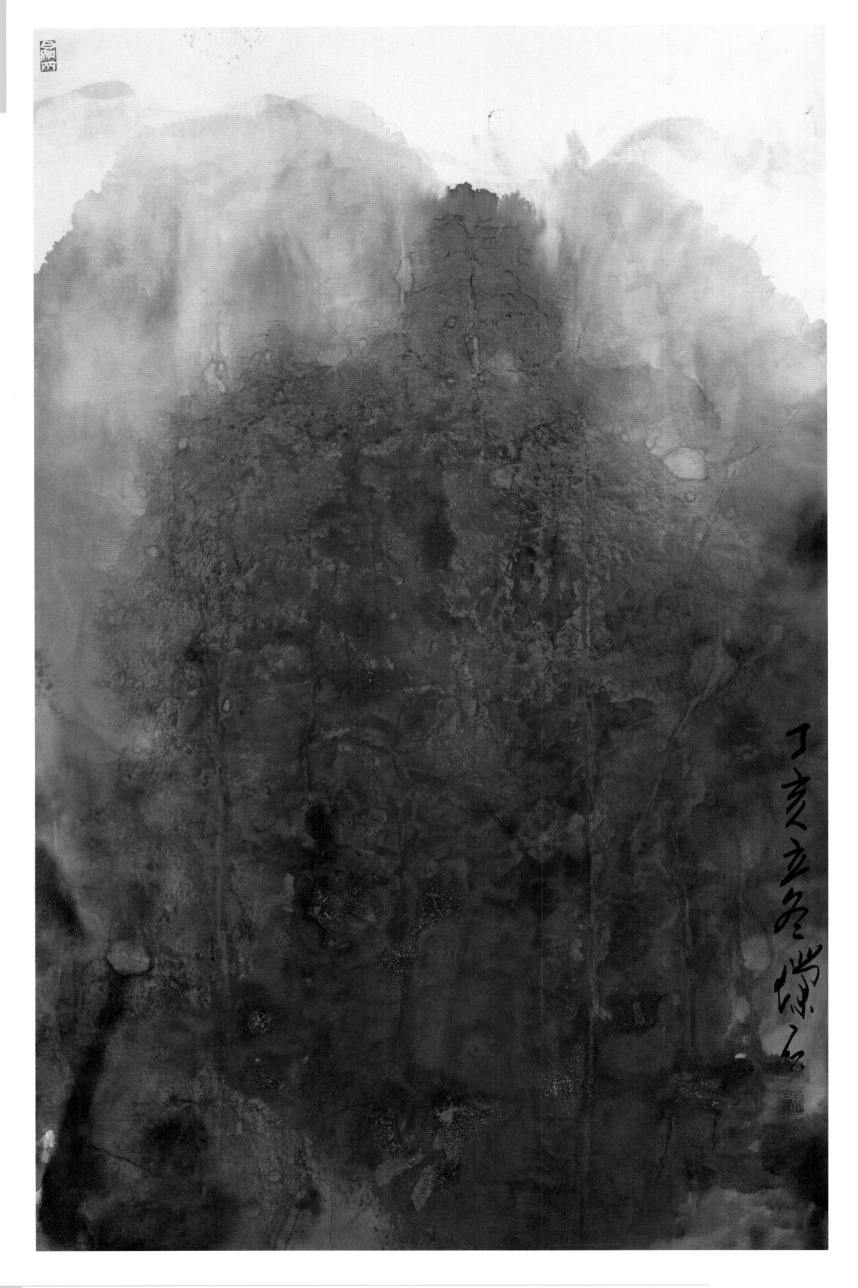

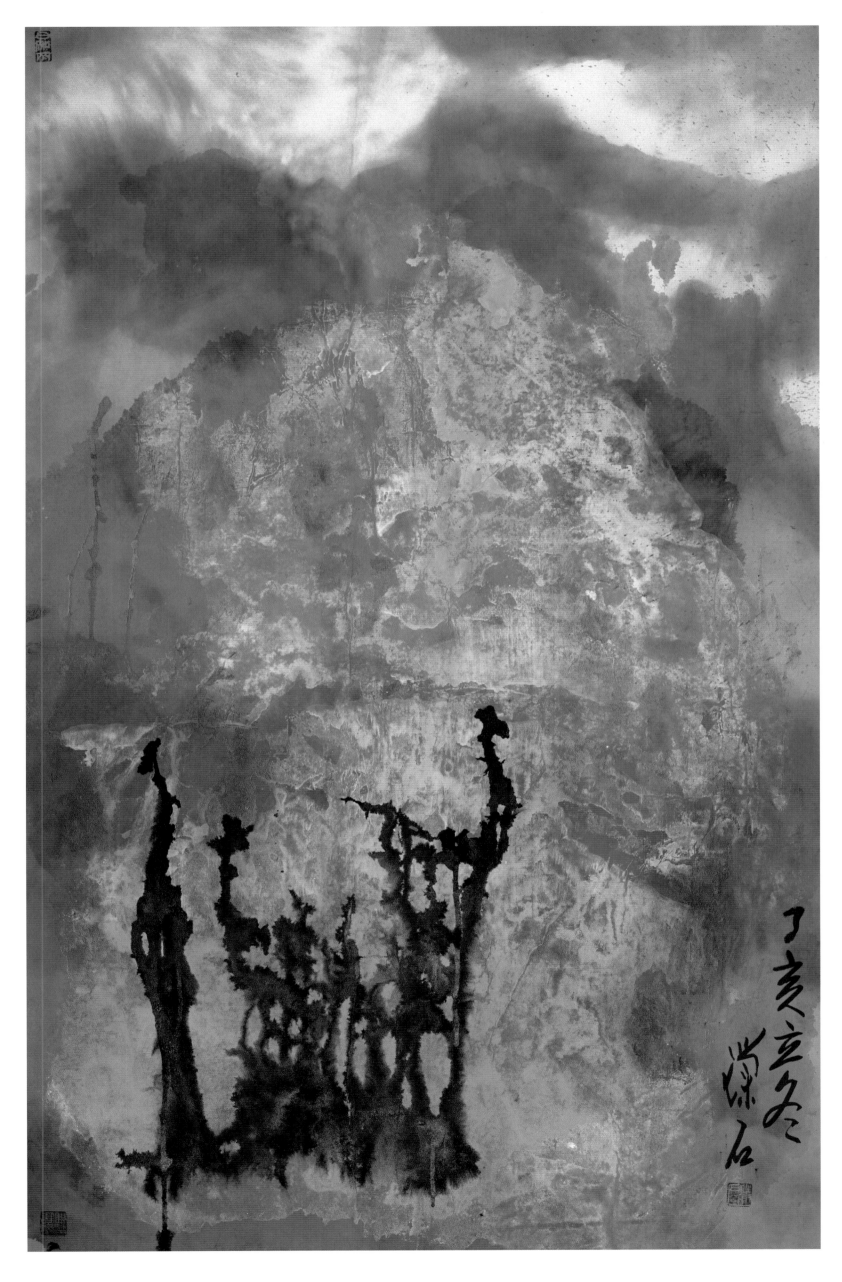

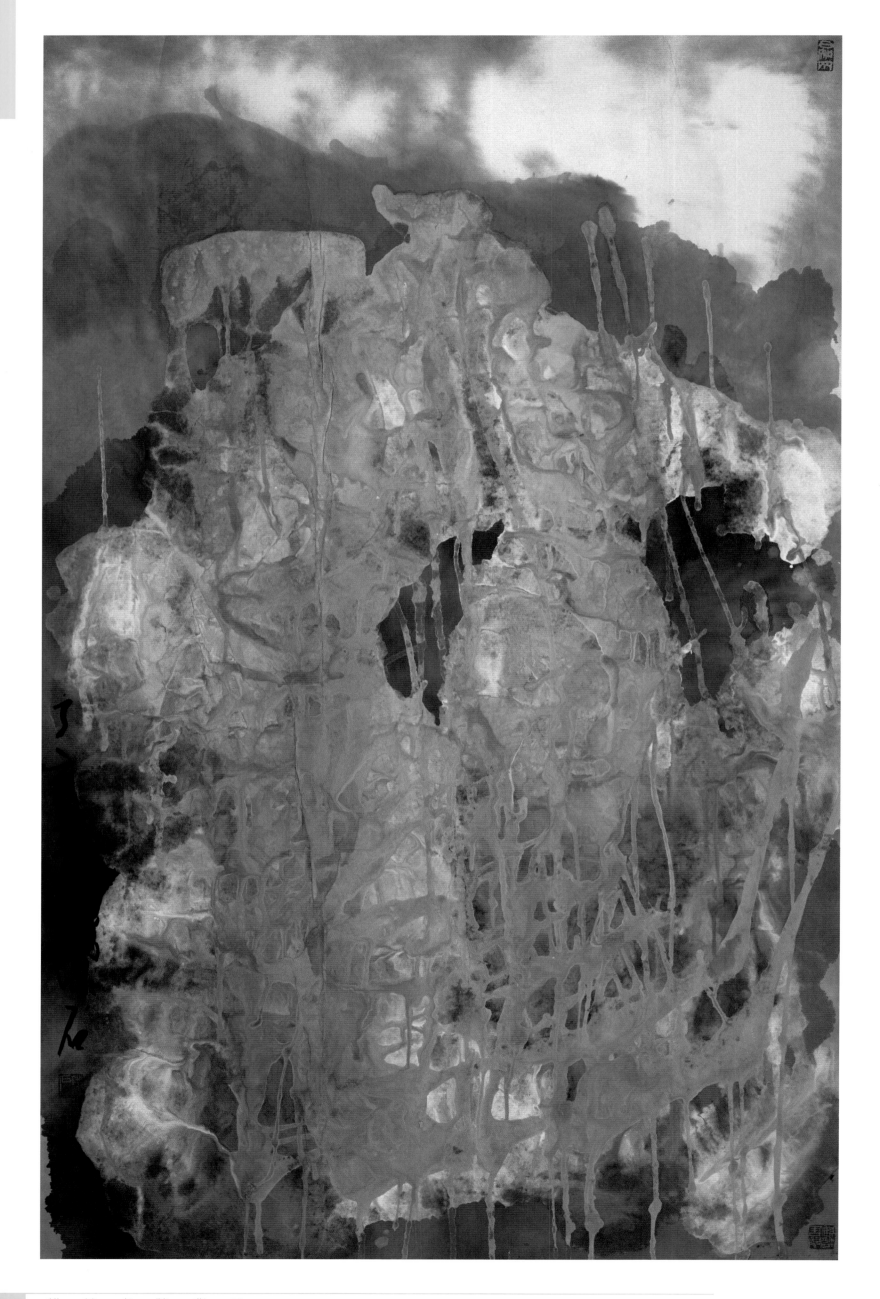

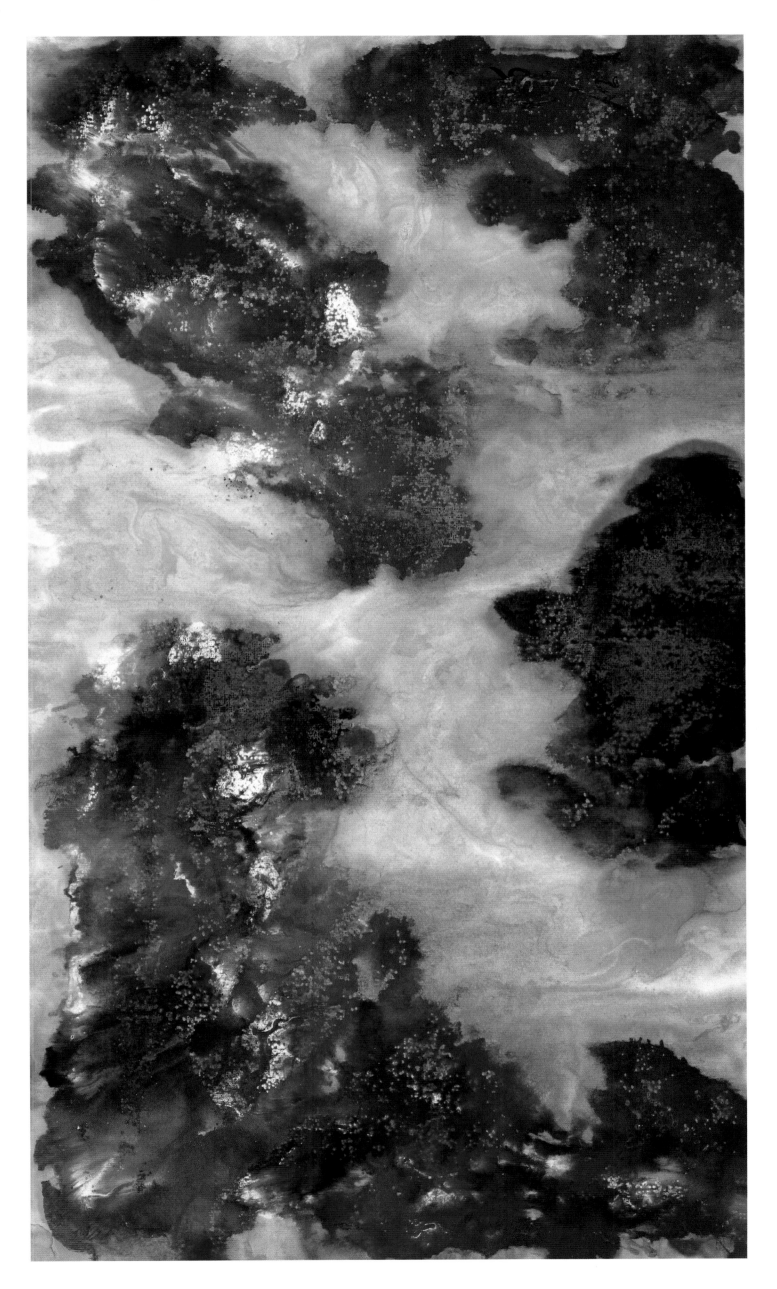

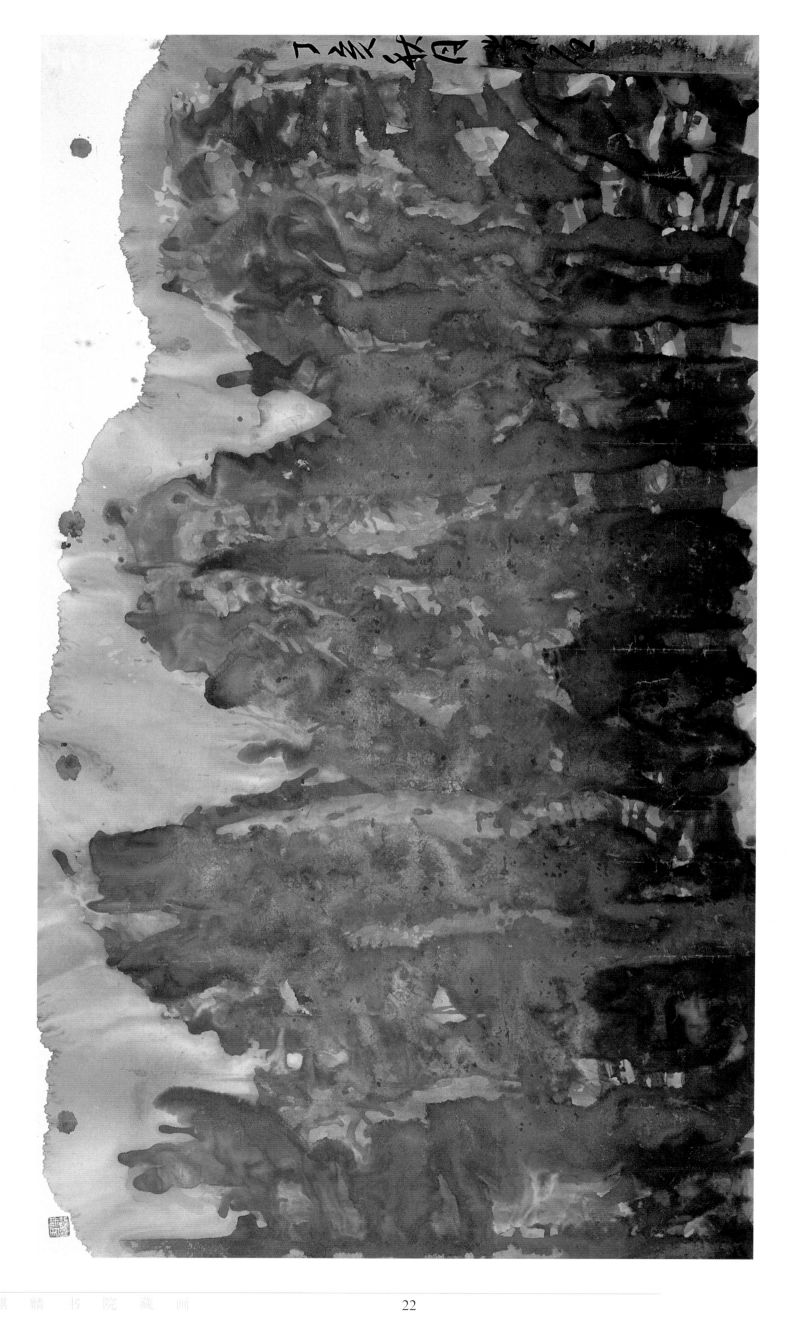

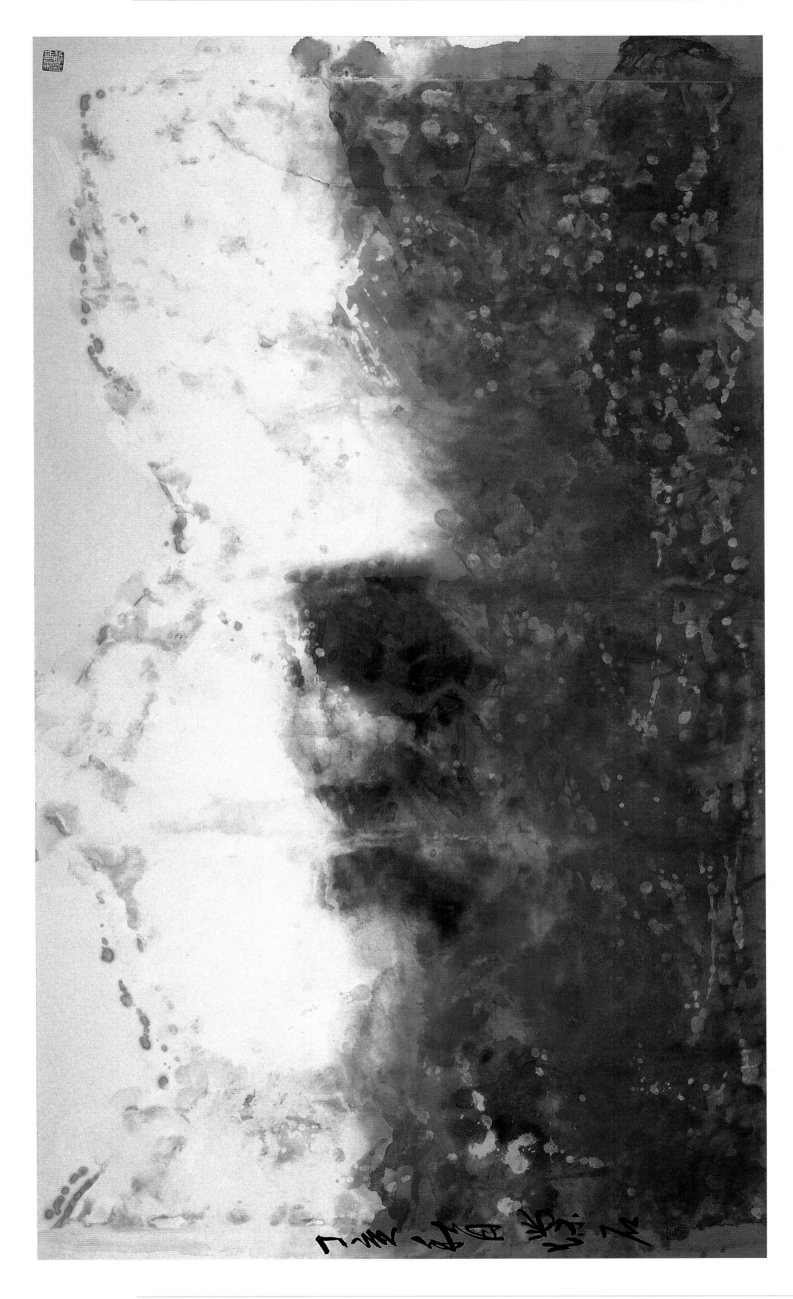

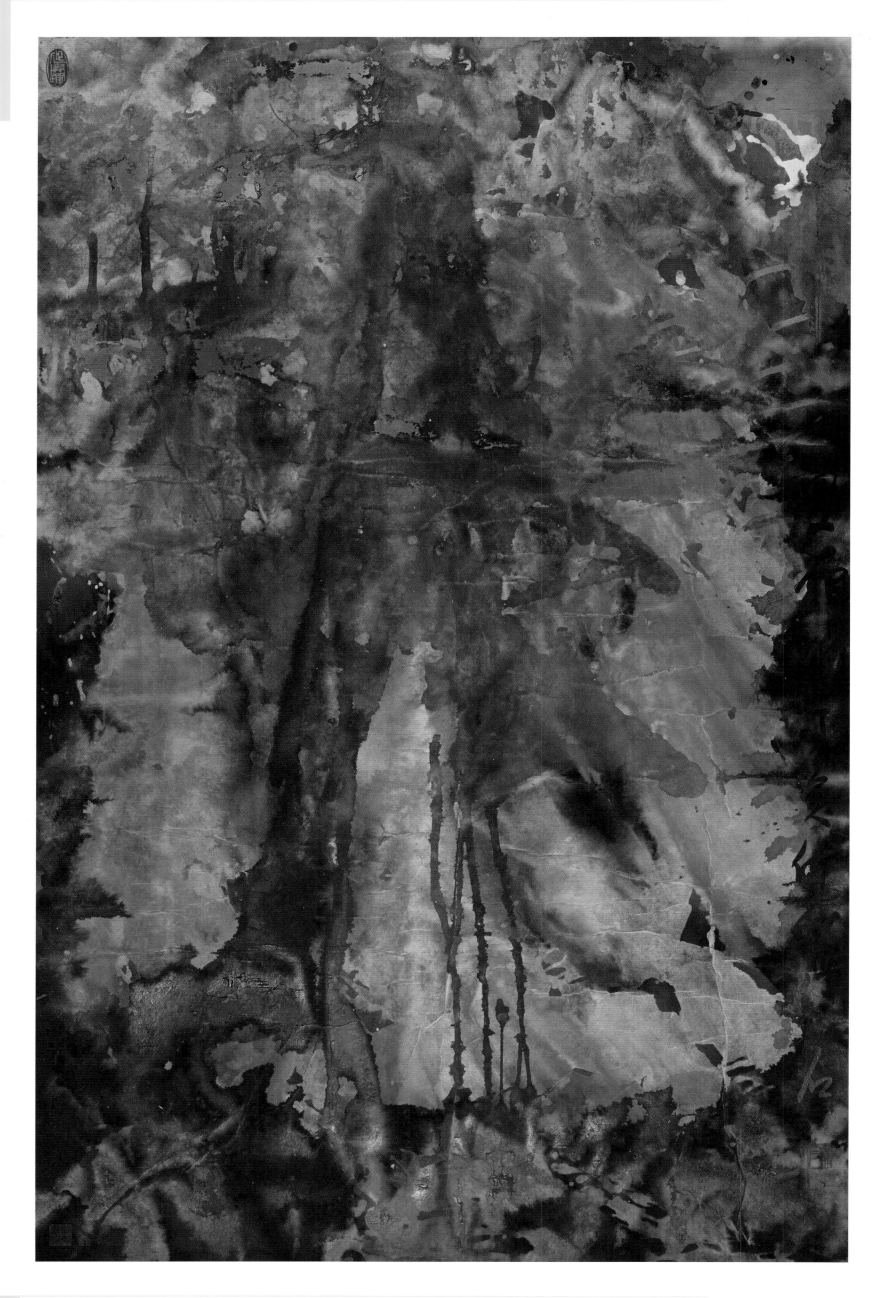

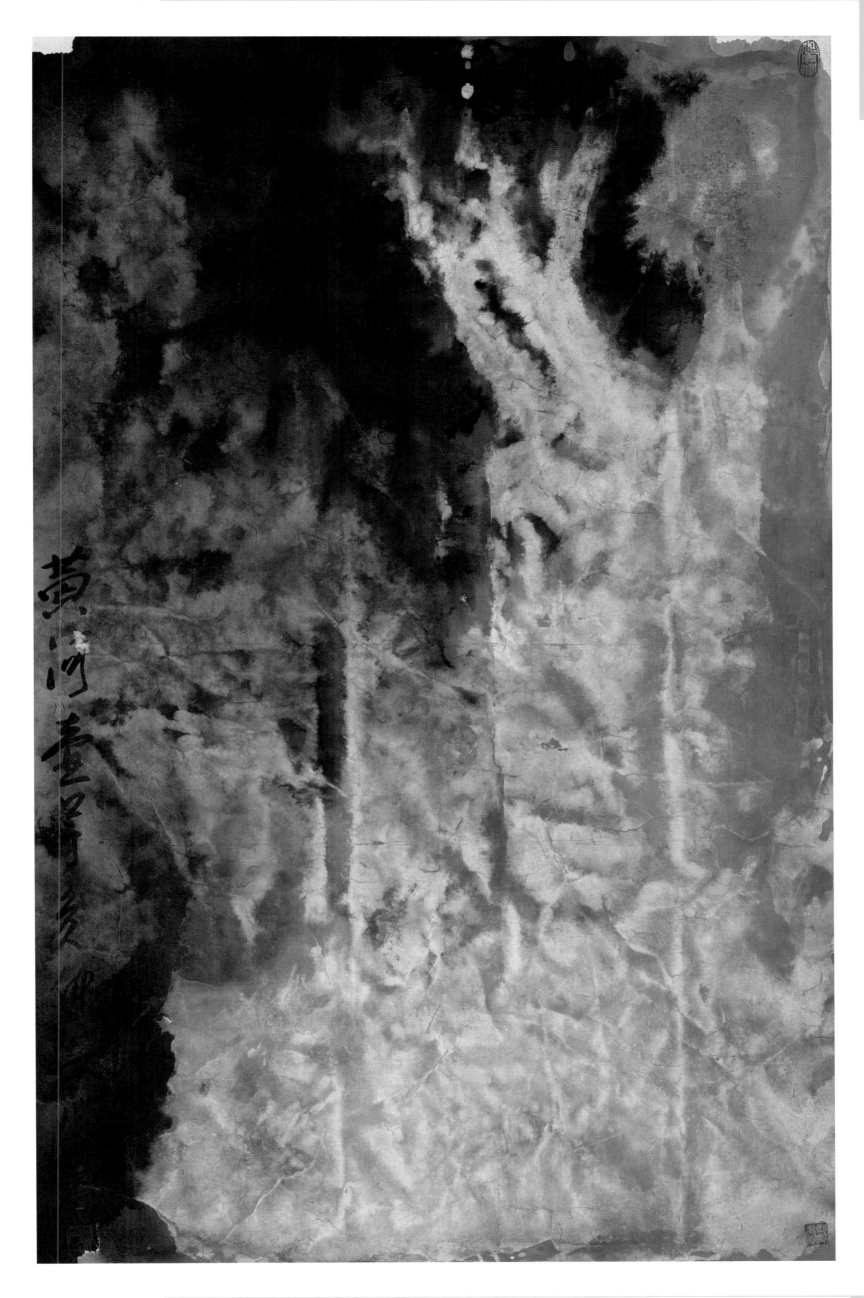

黄河壶口晚景

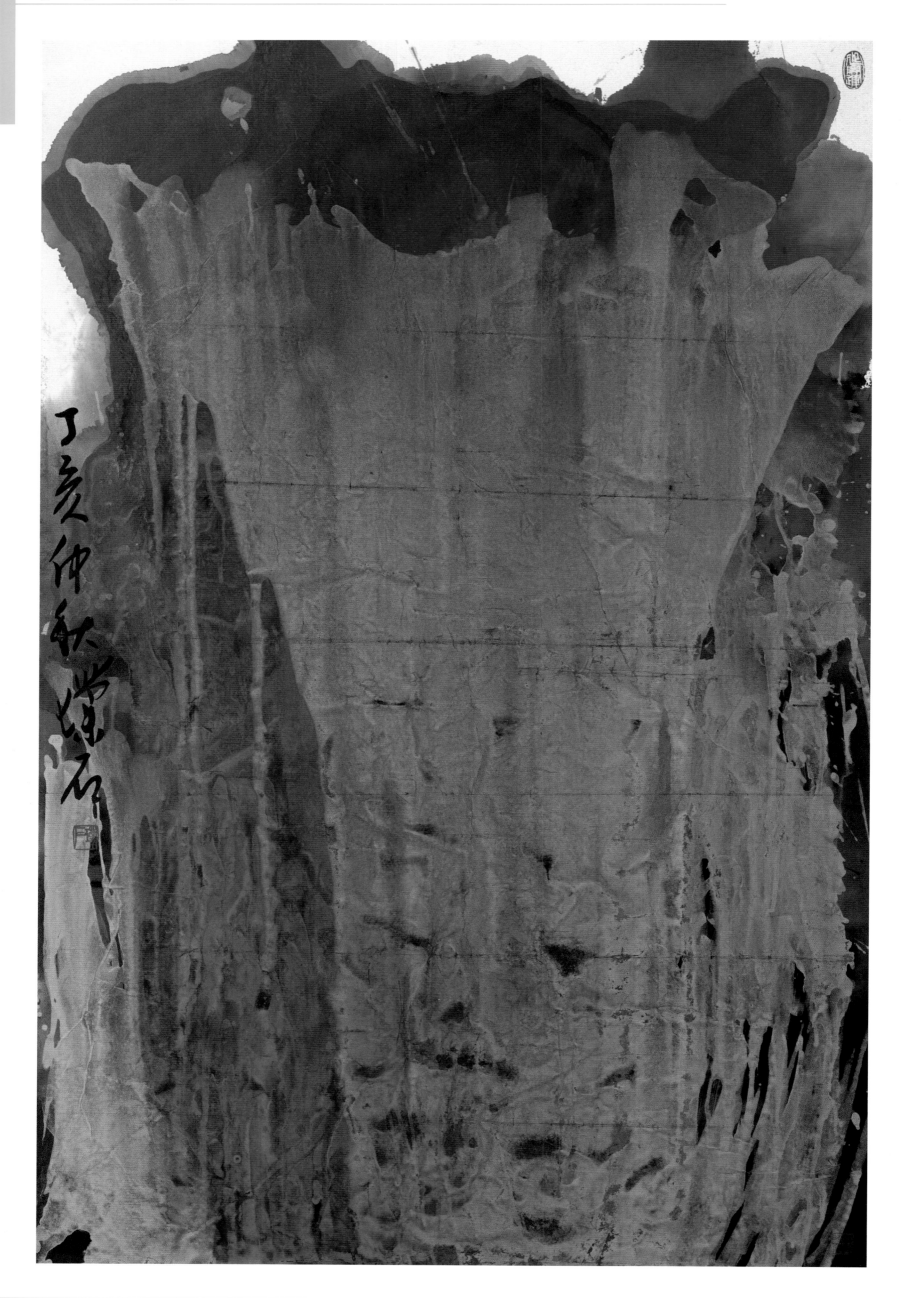

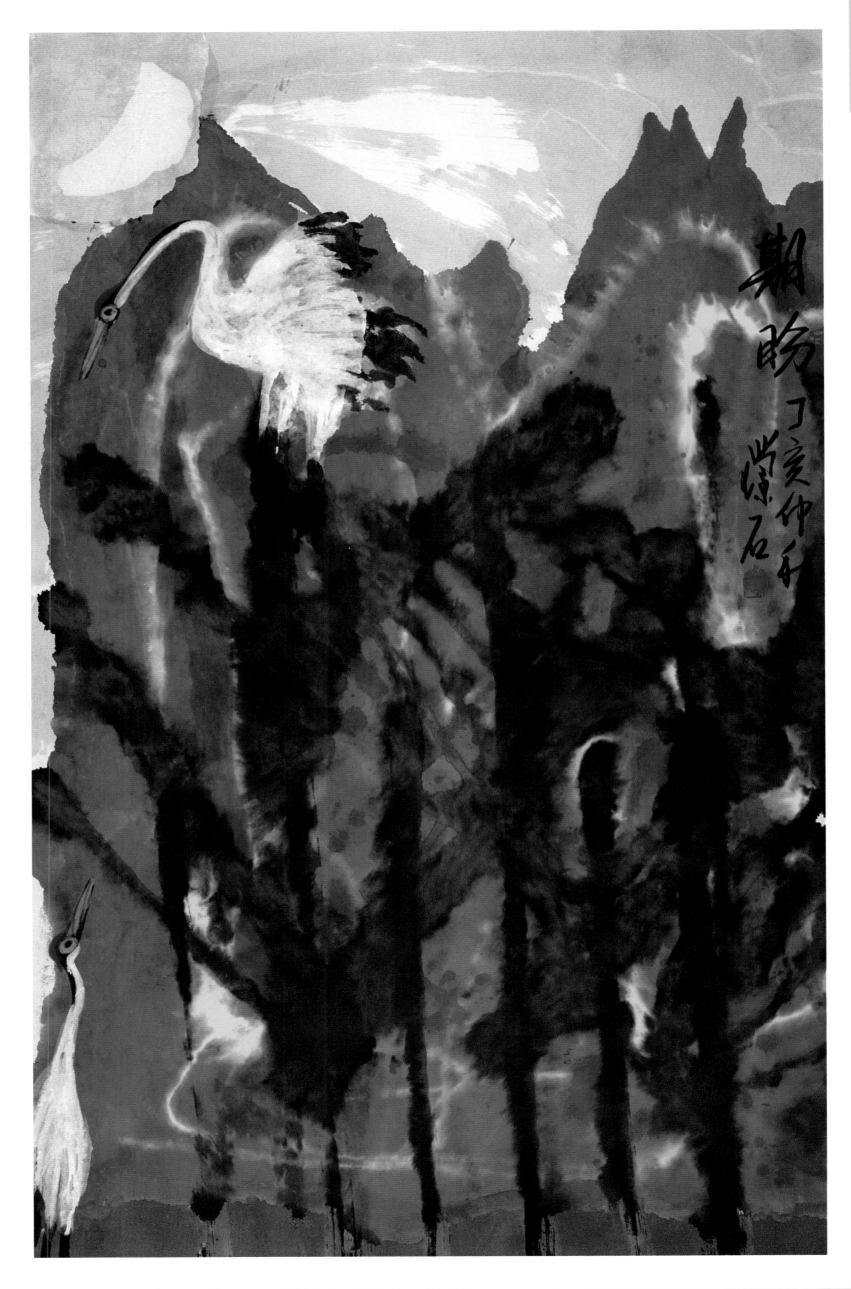

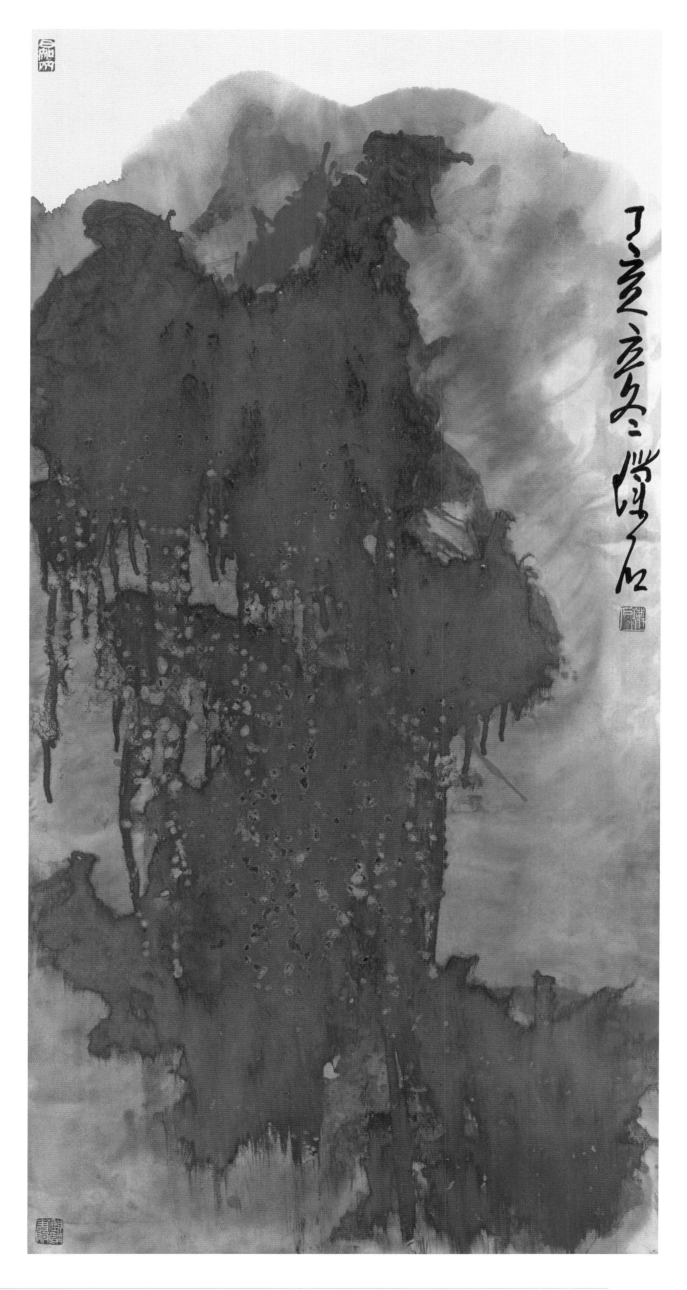

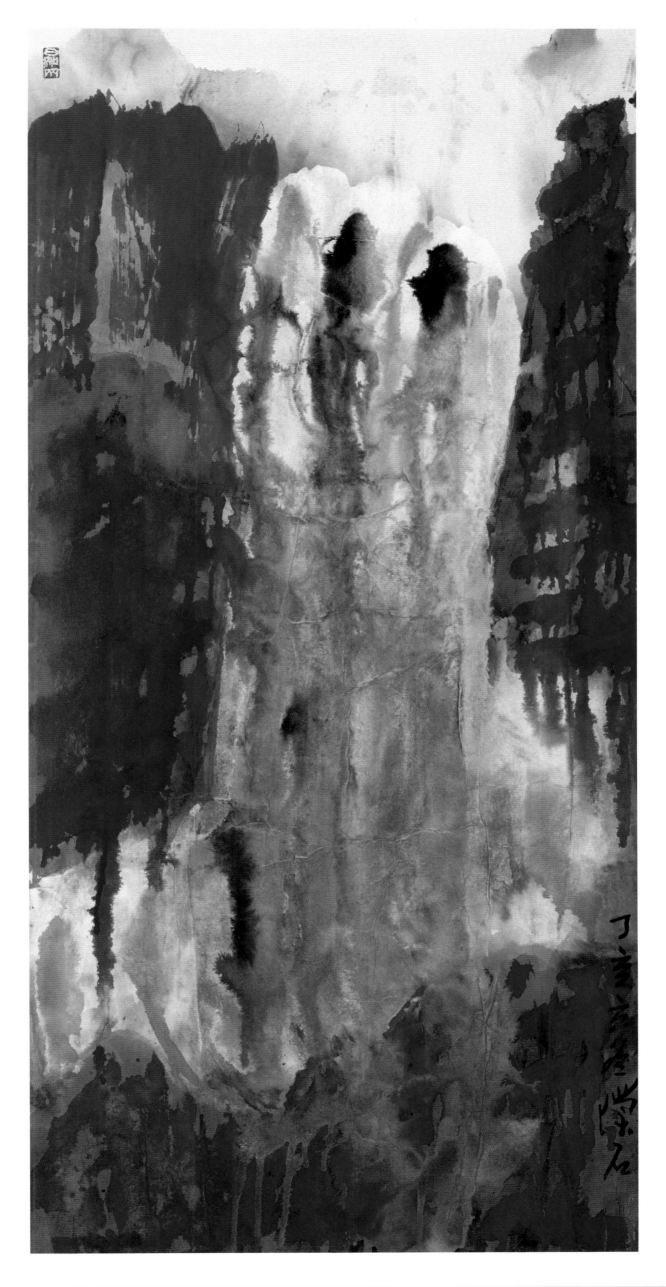

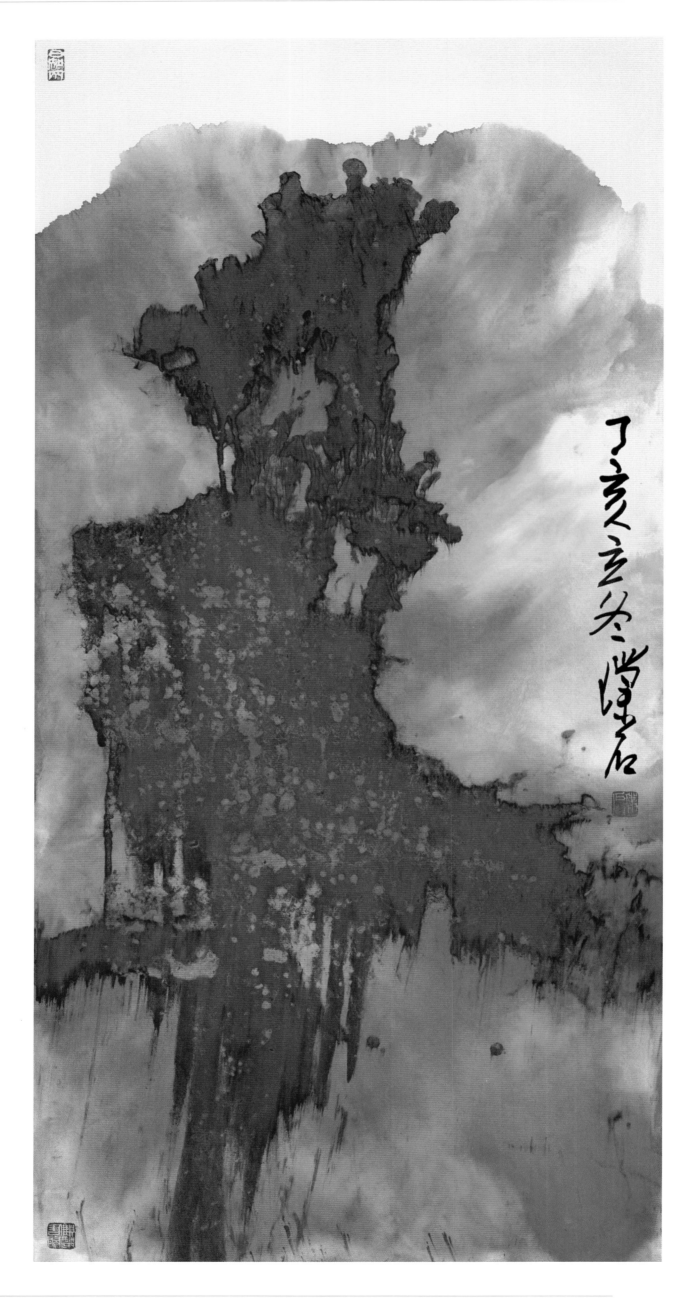

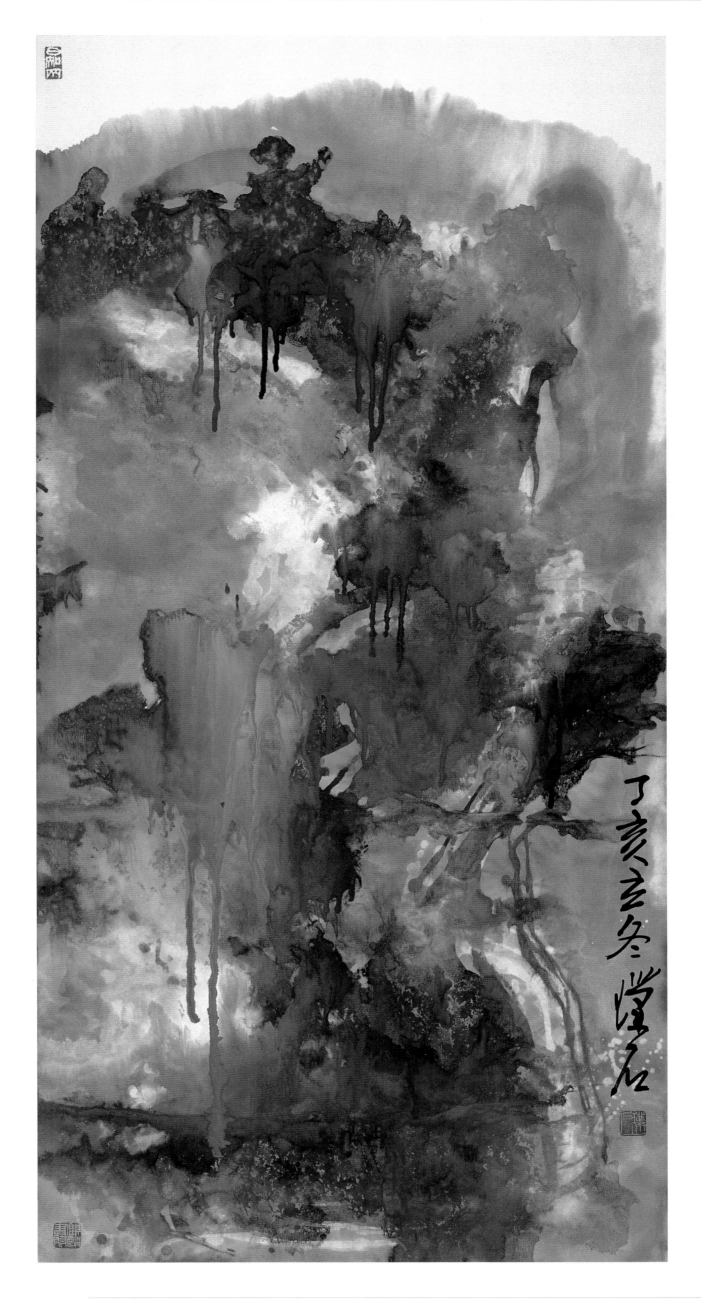

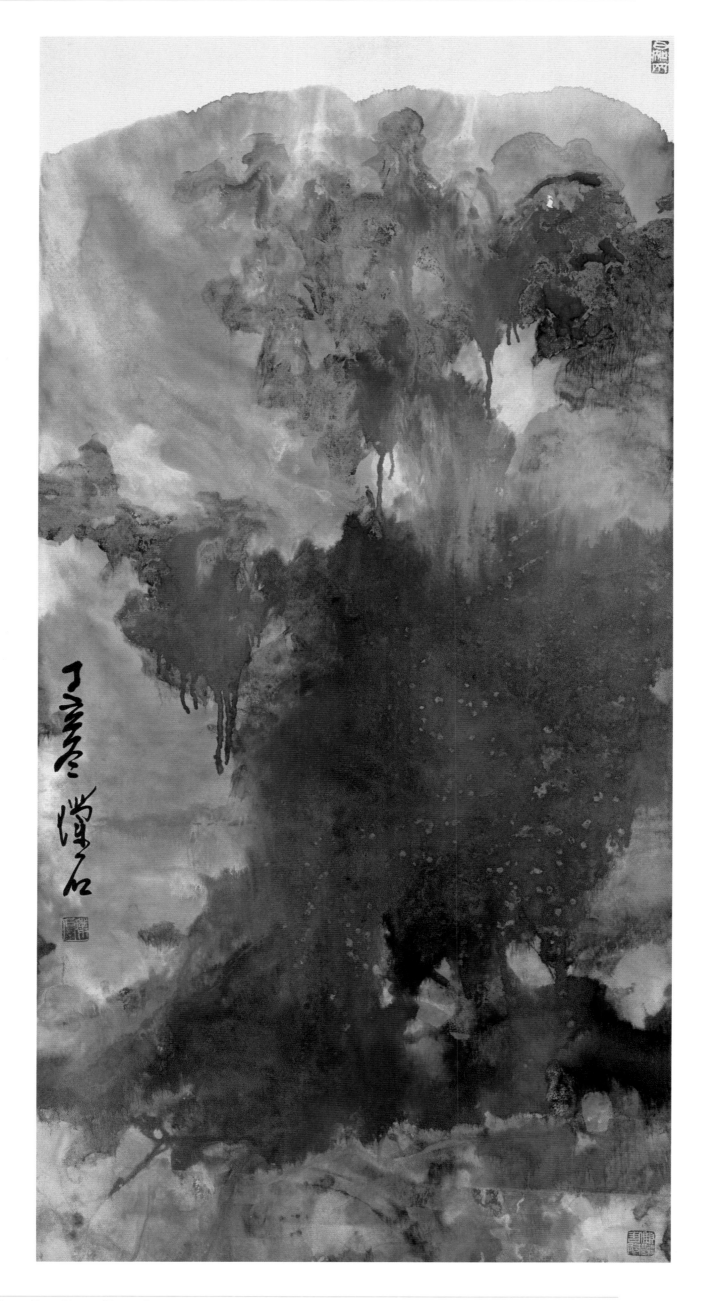

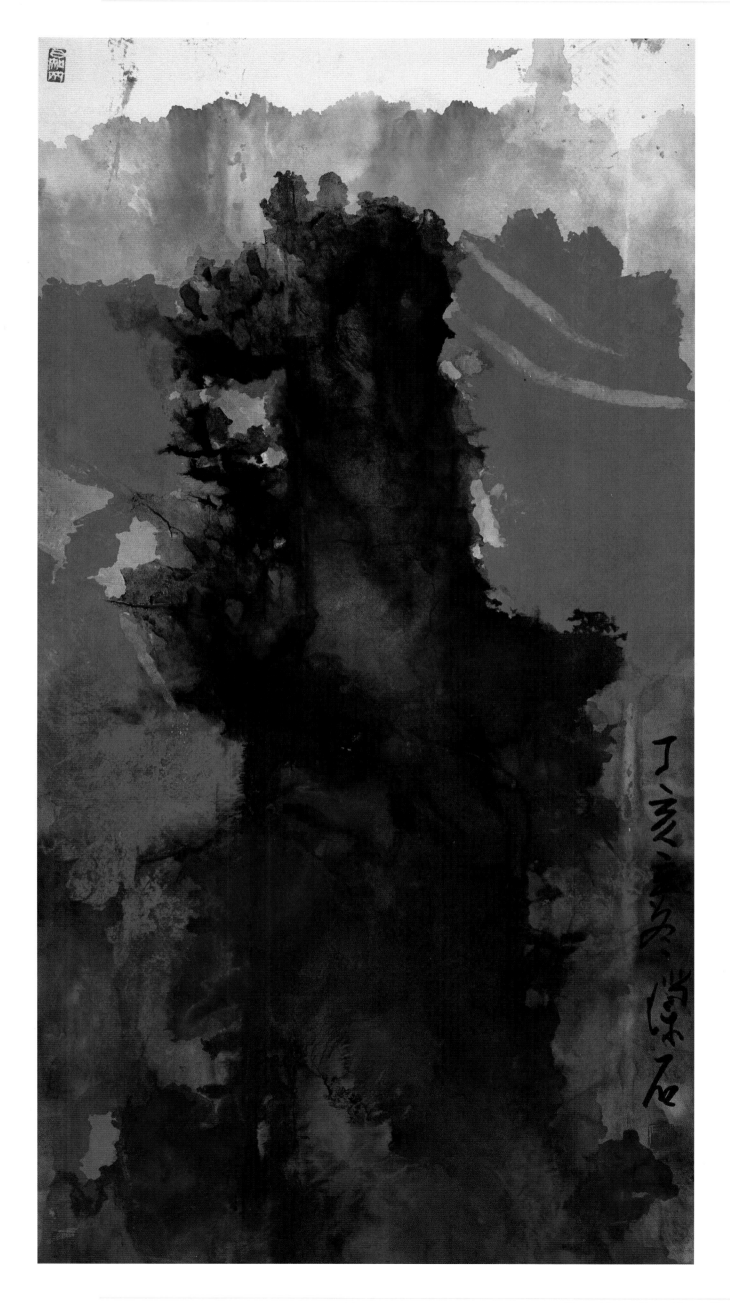

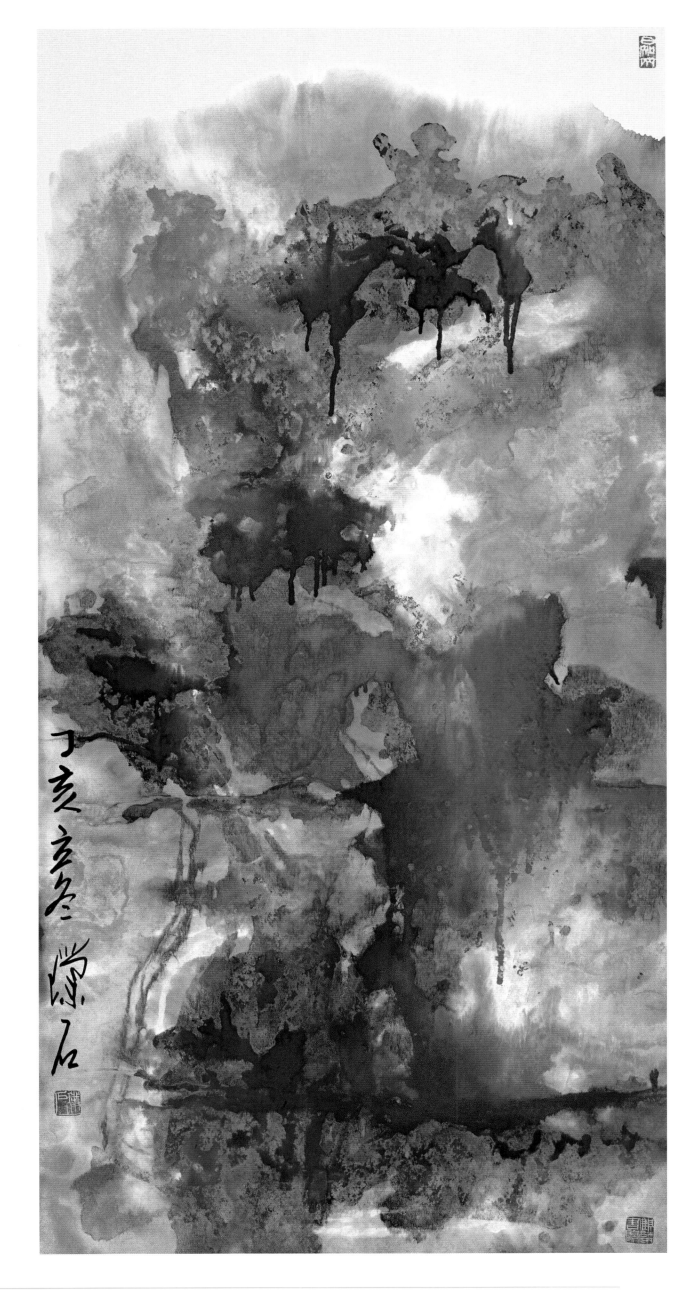

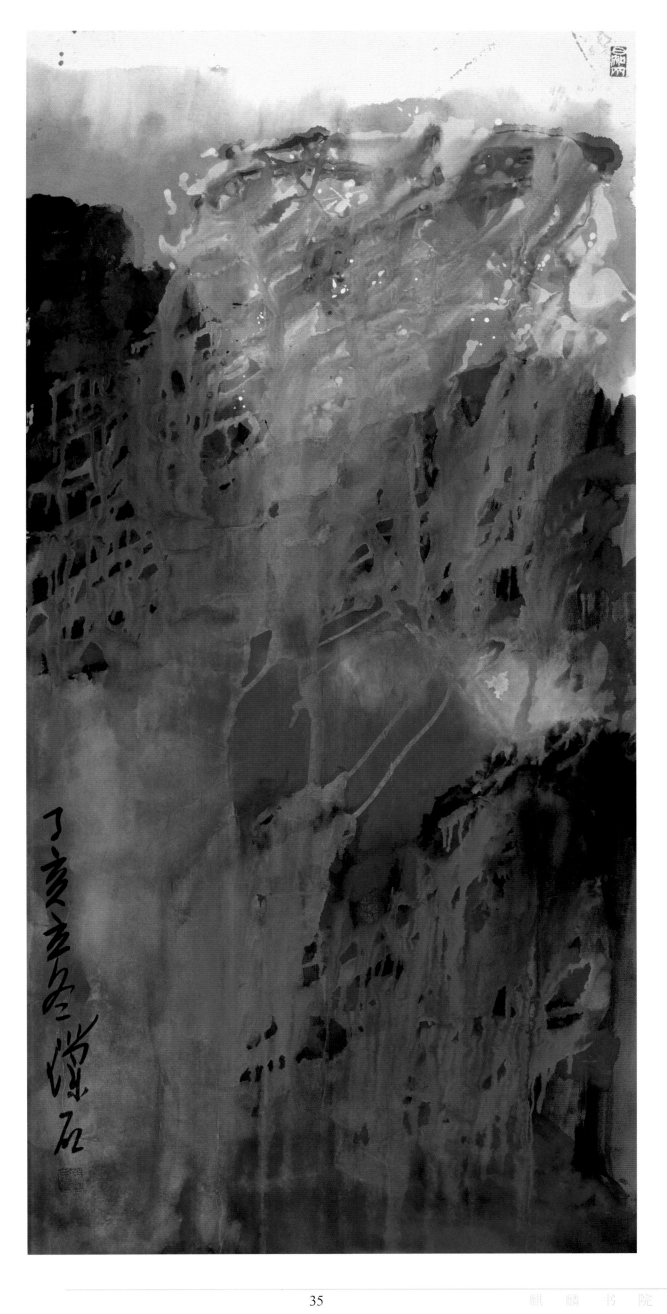

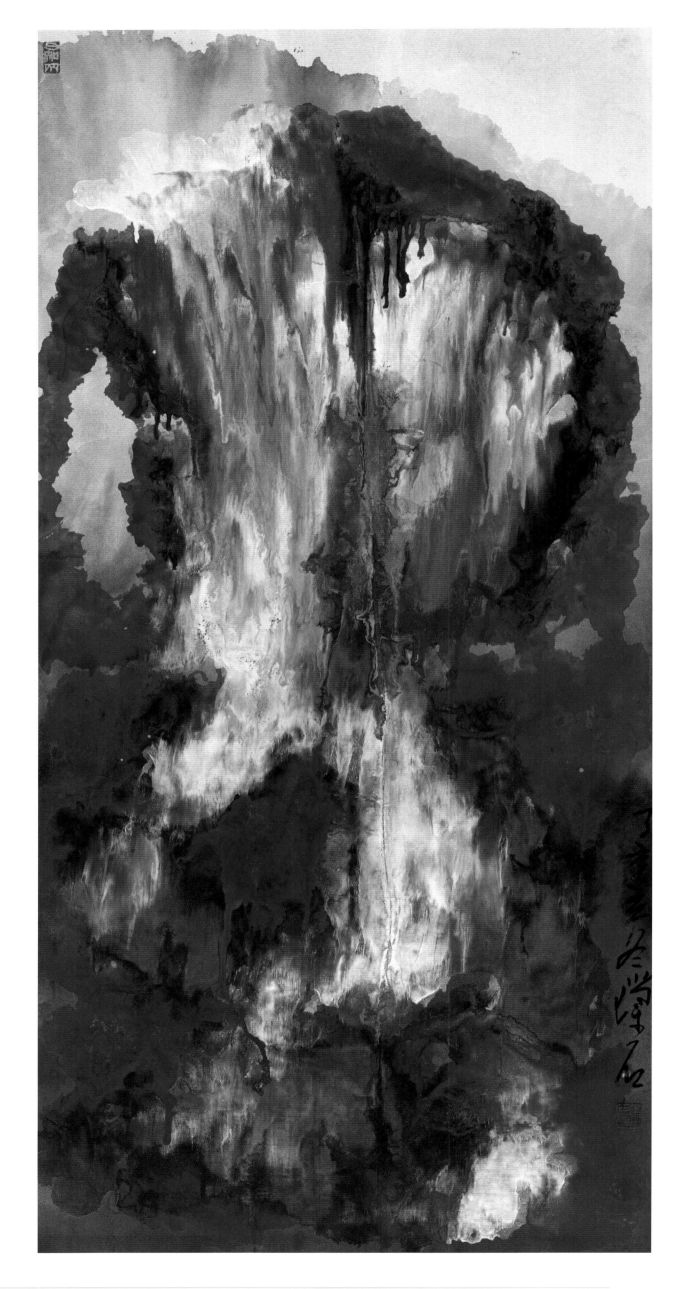

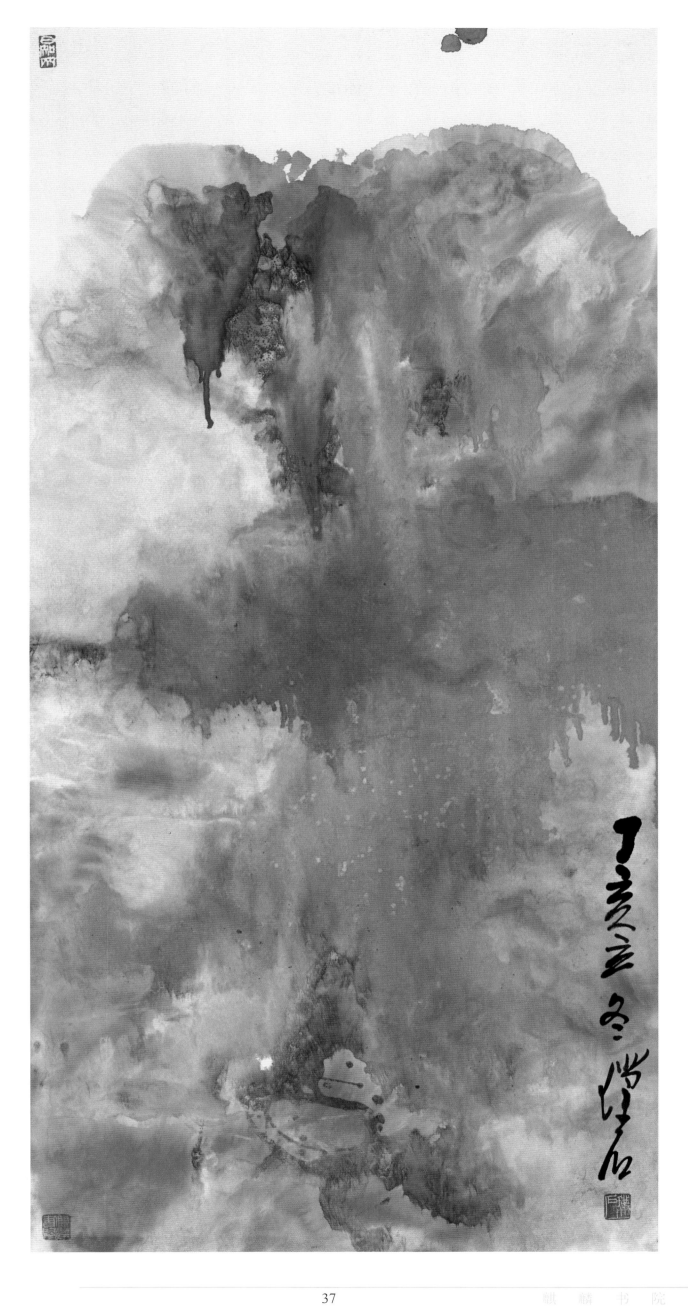

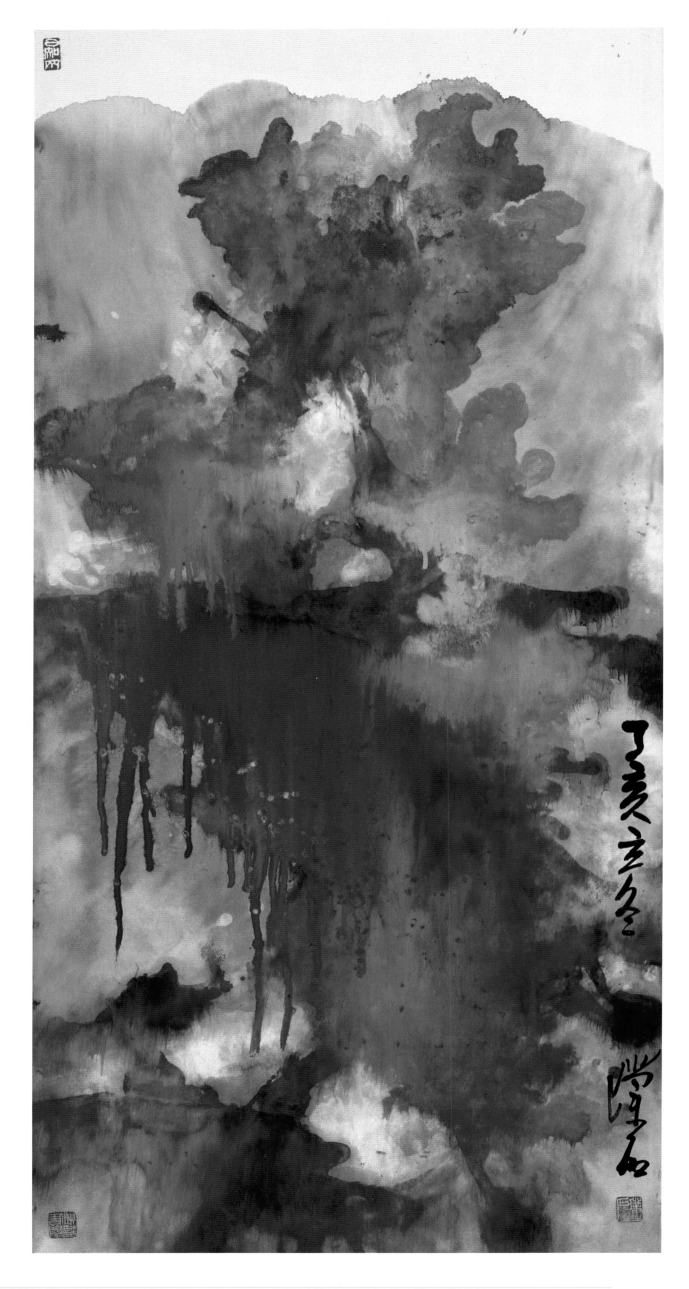

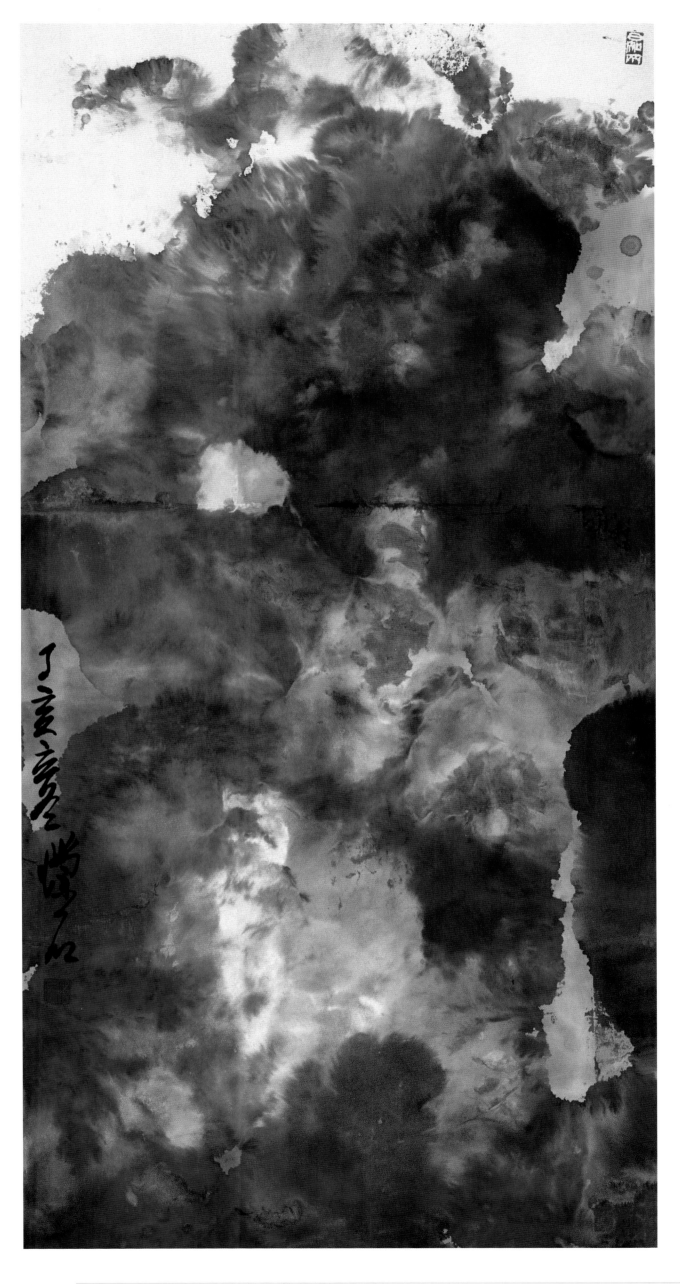

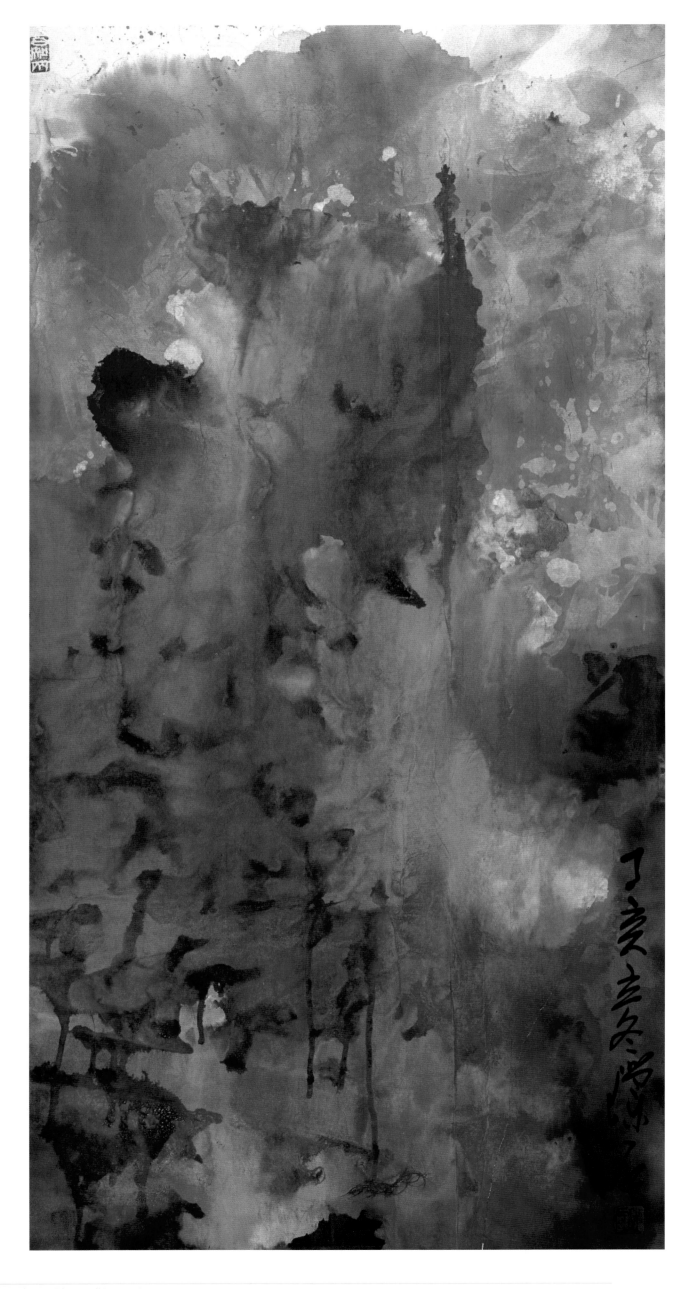

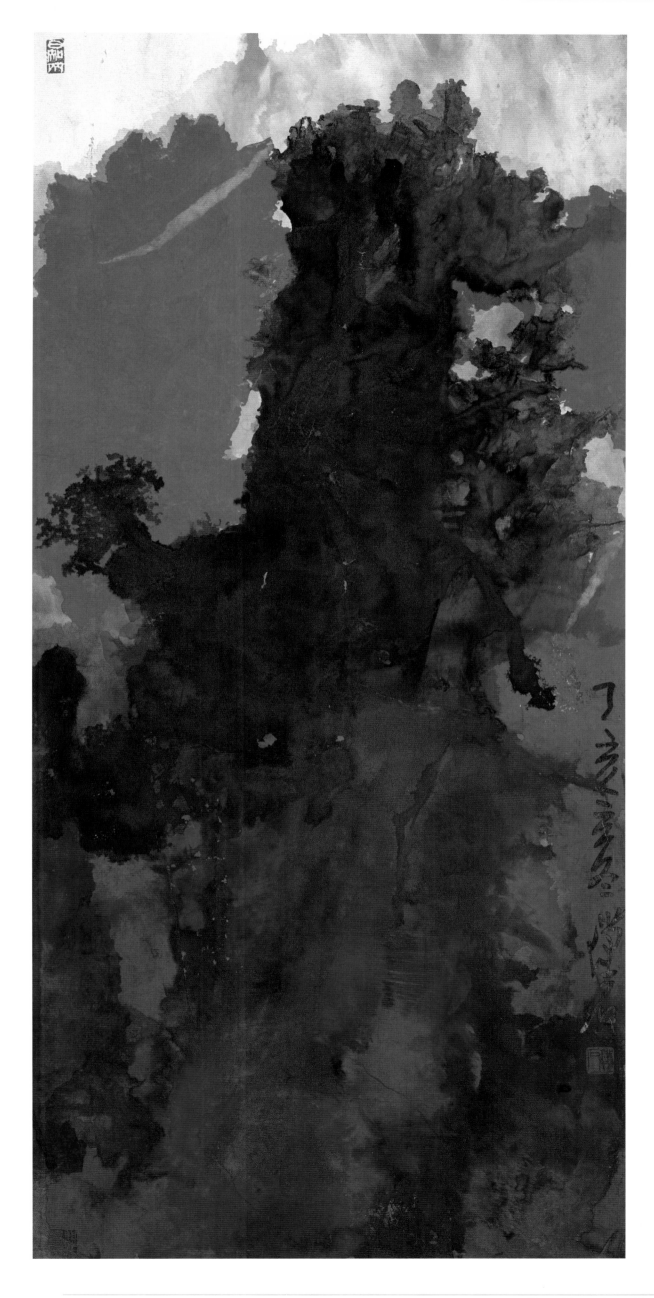

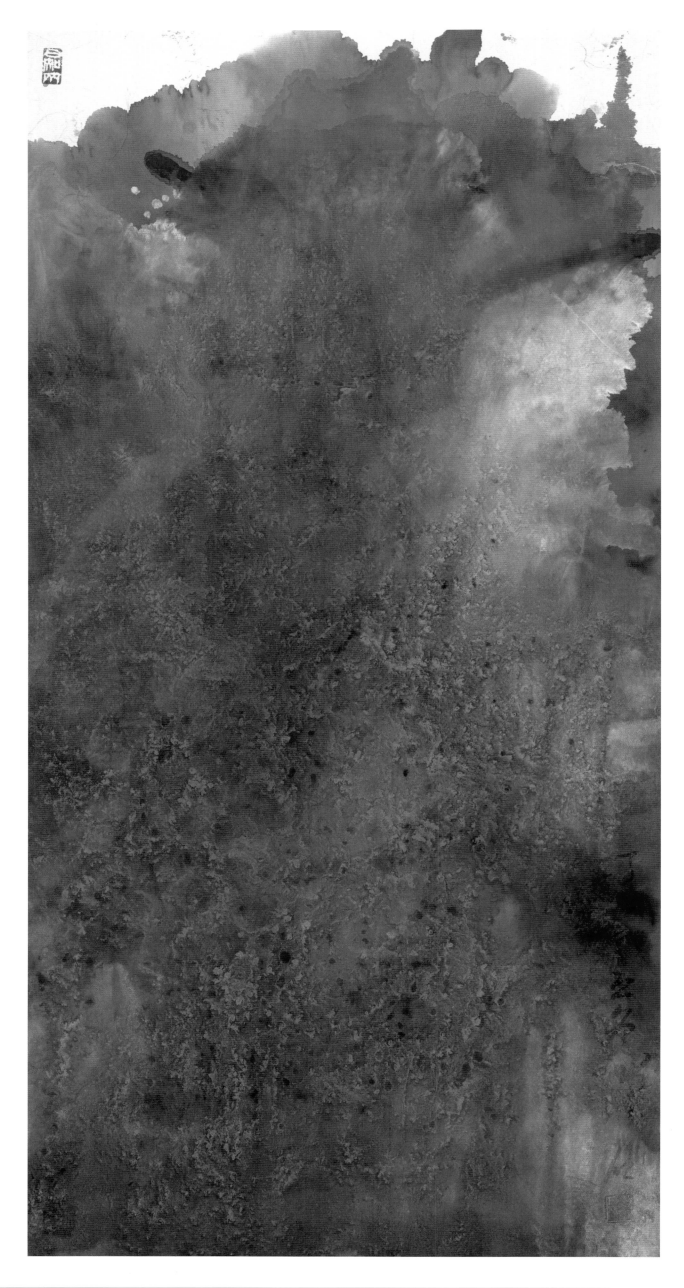

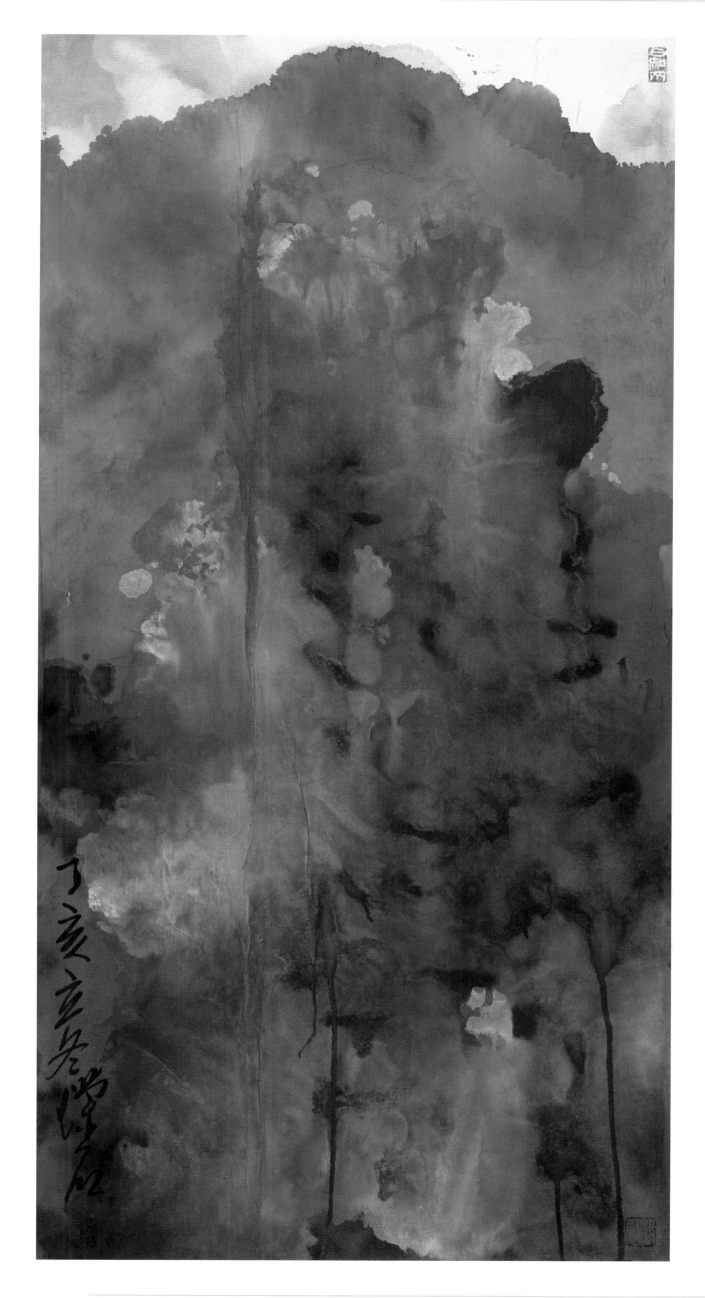

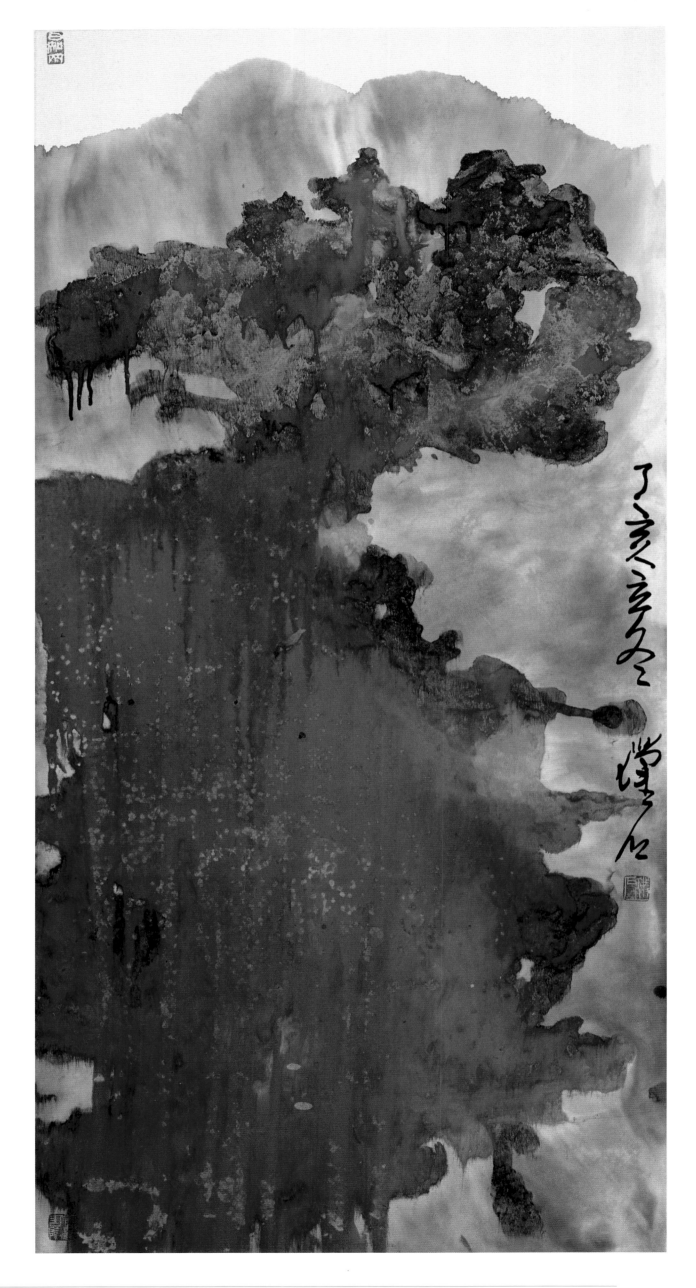

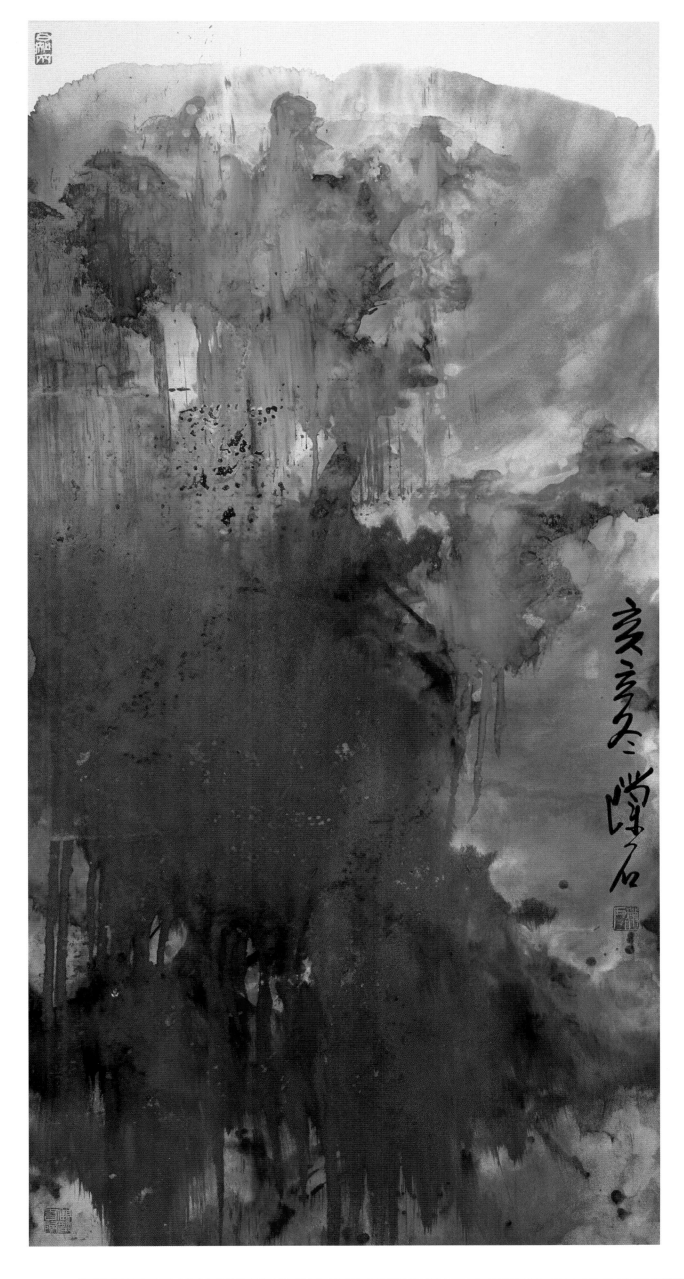

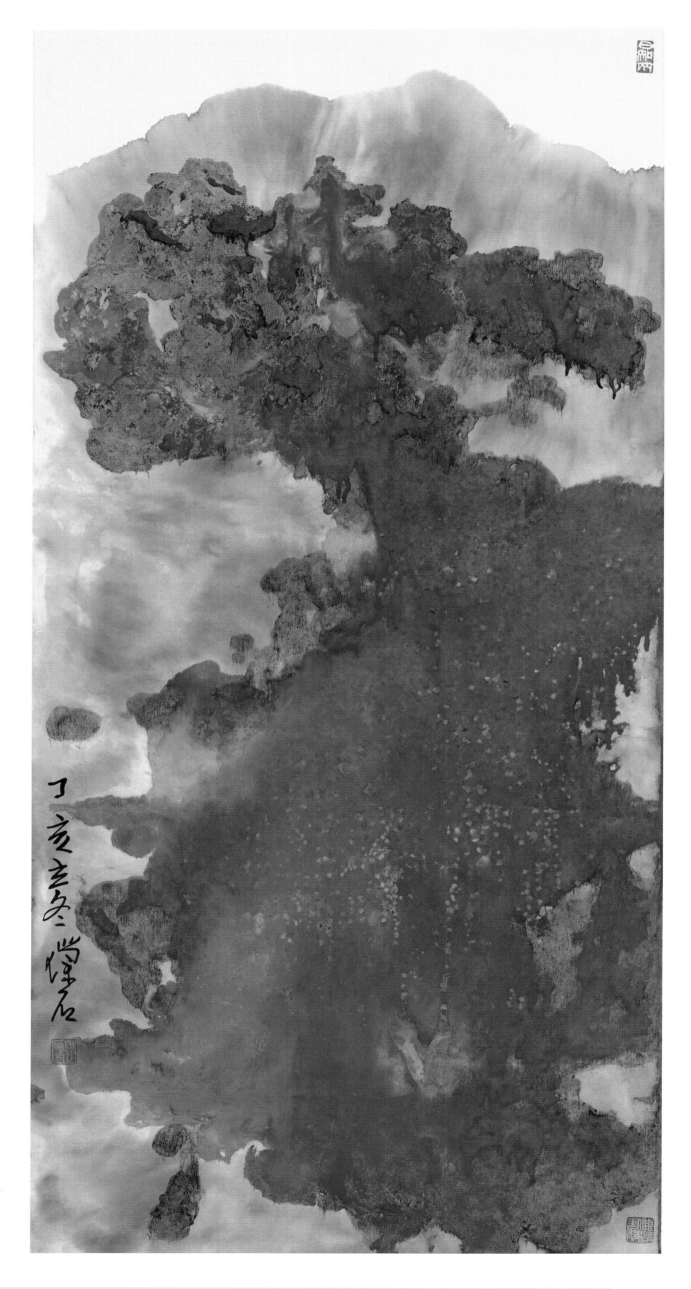

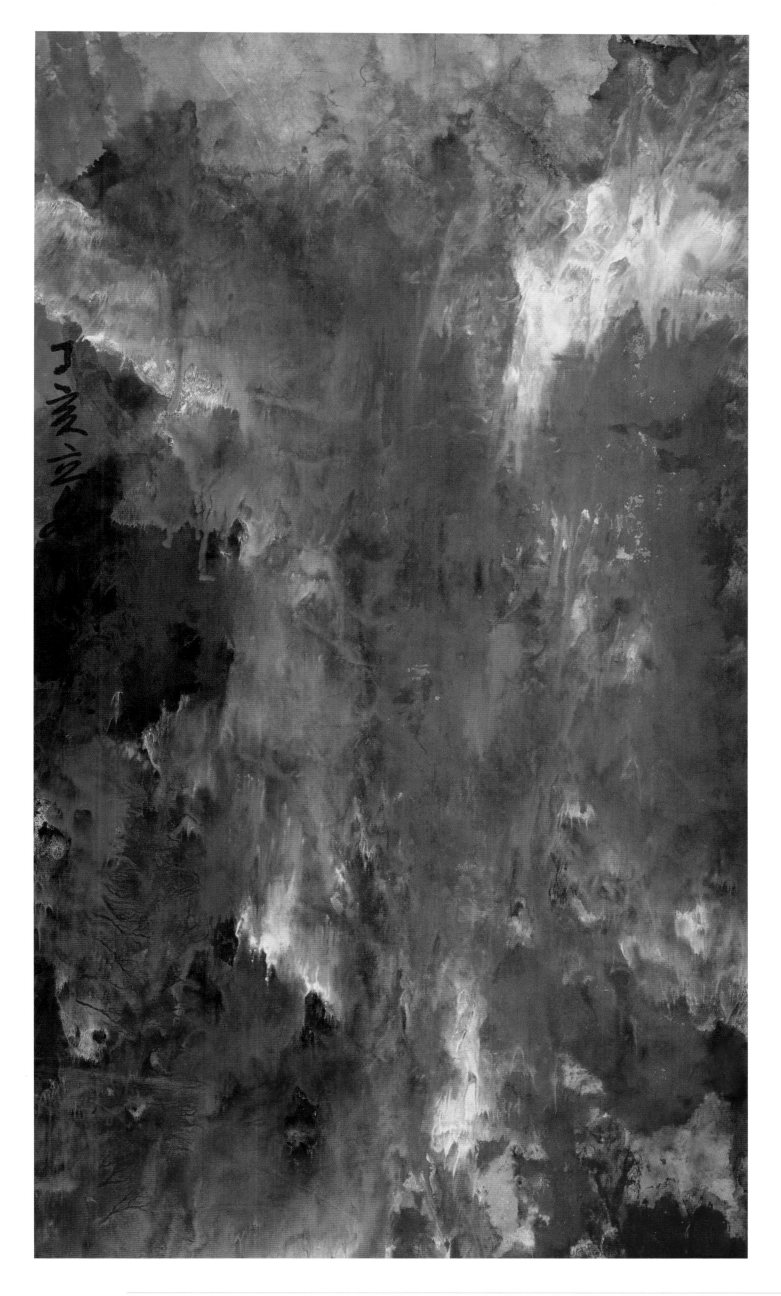

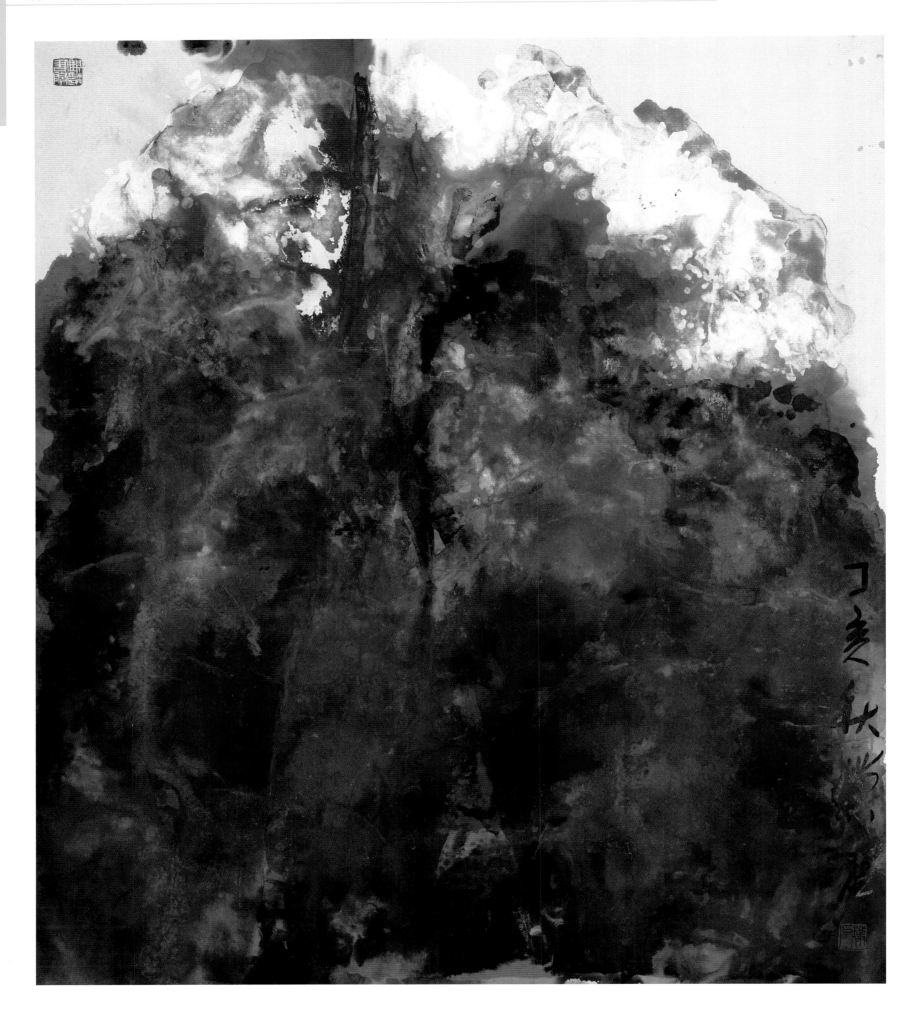

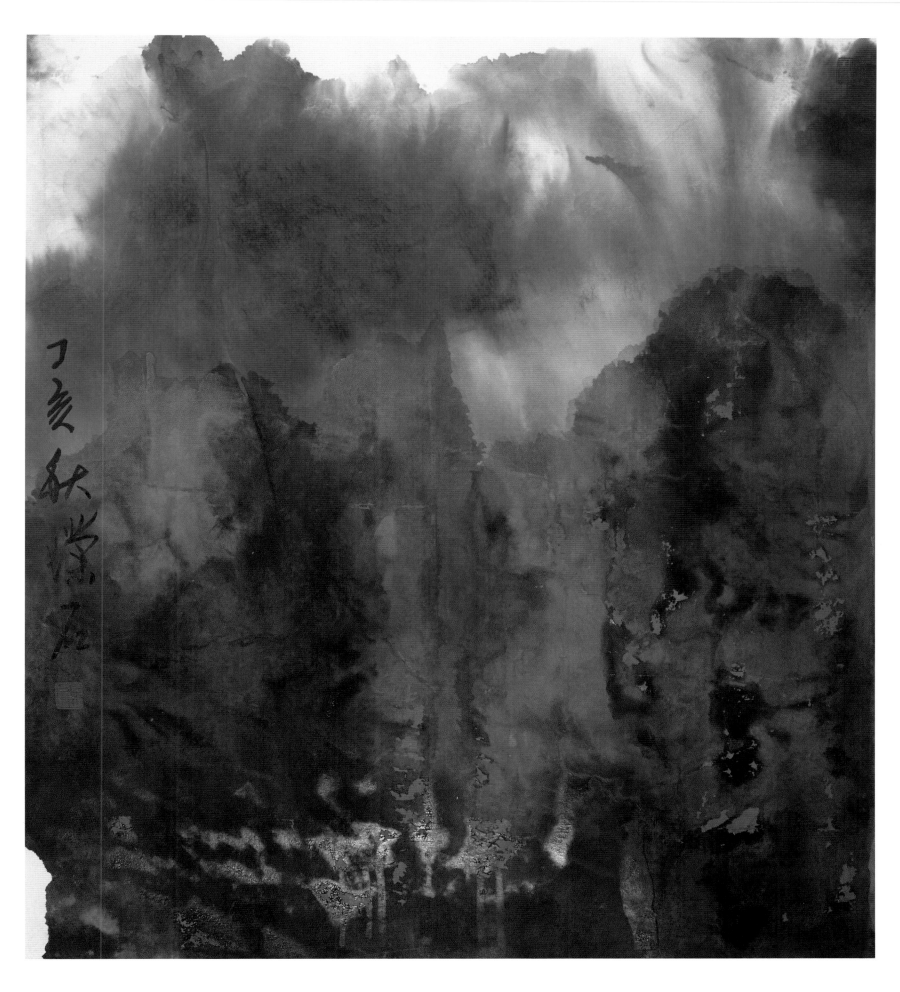

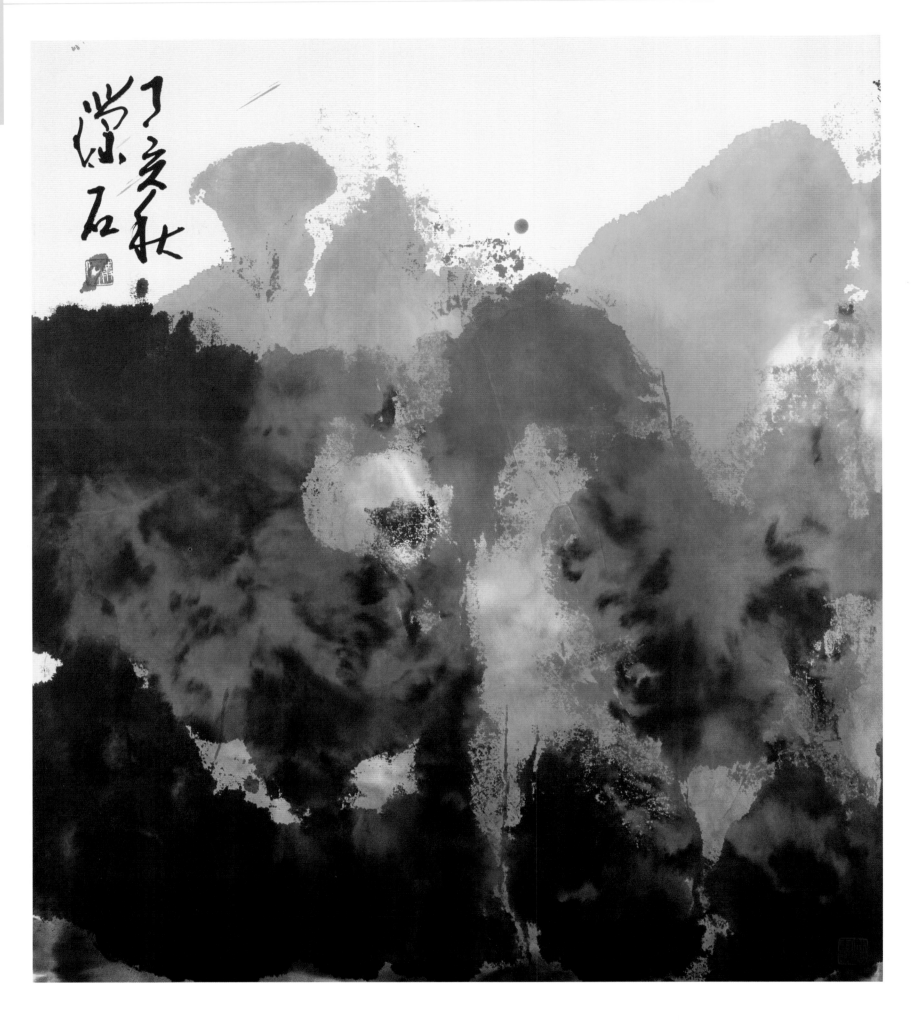

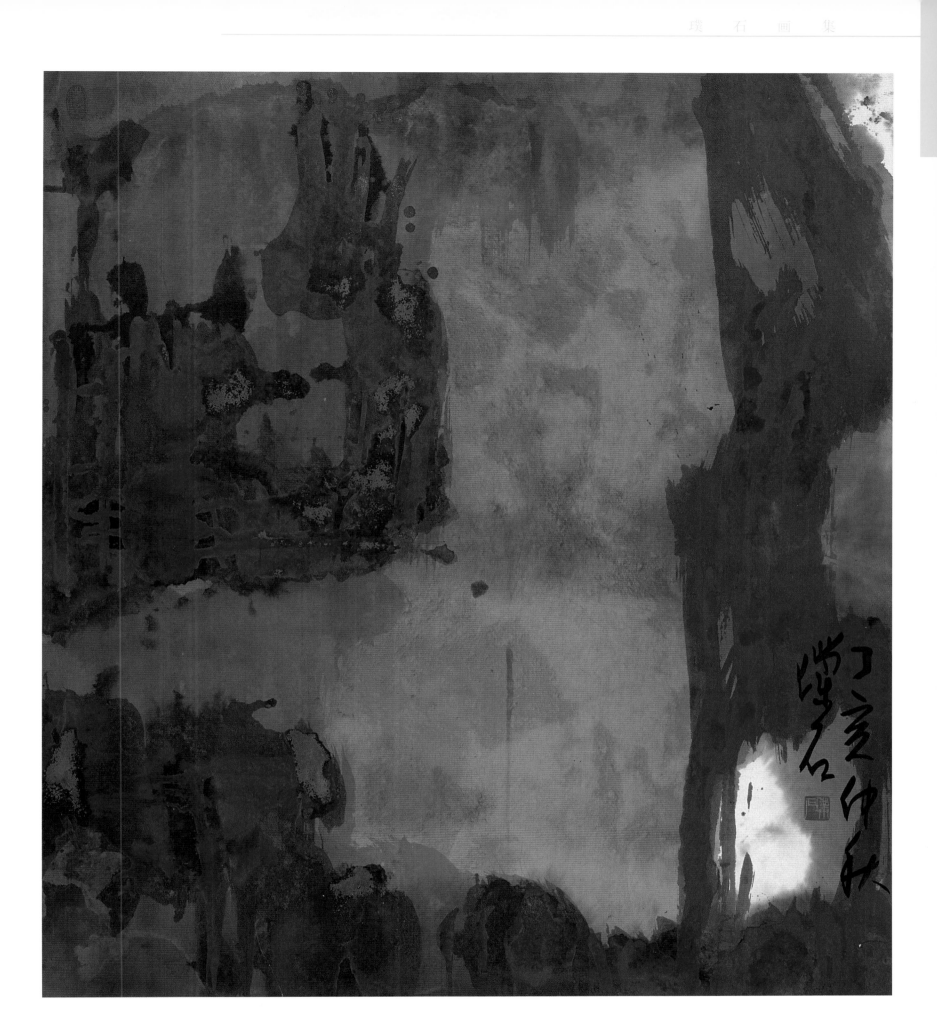

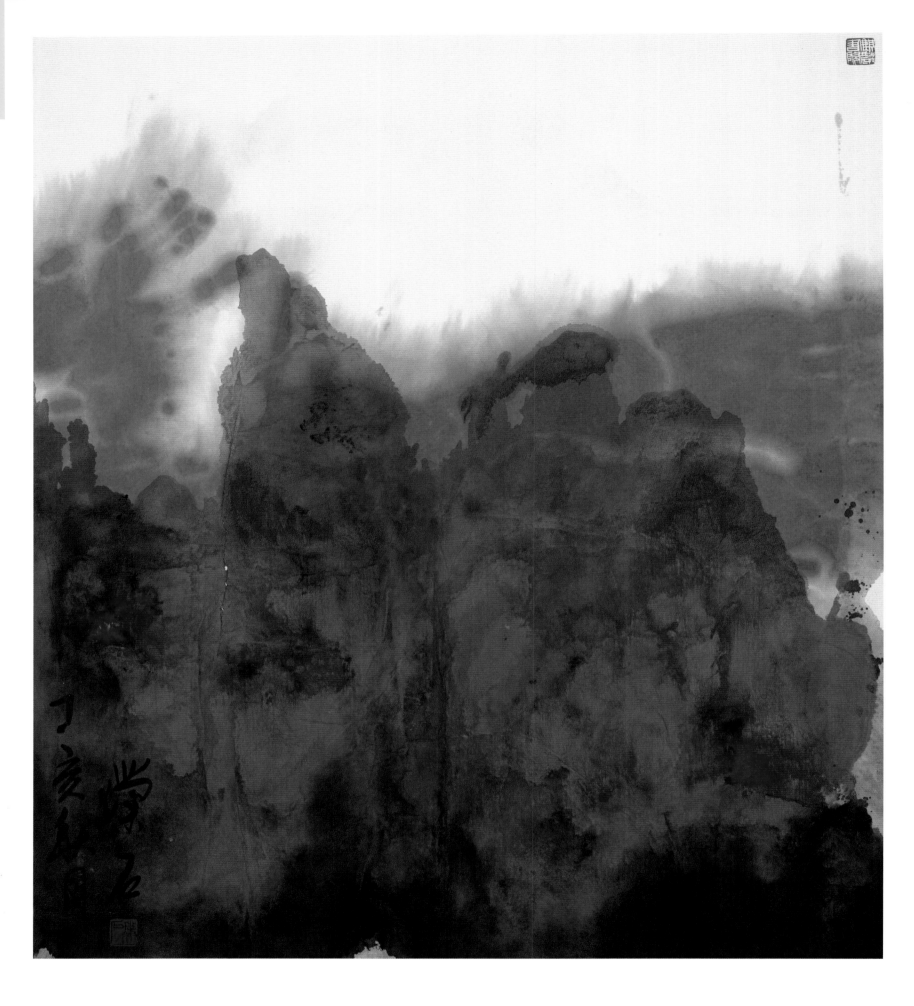

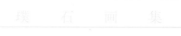

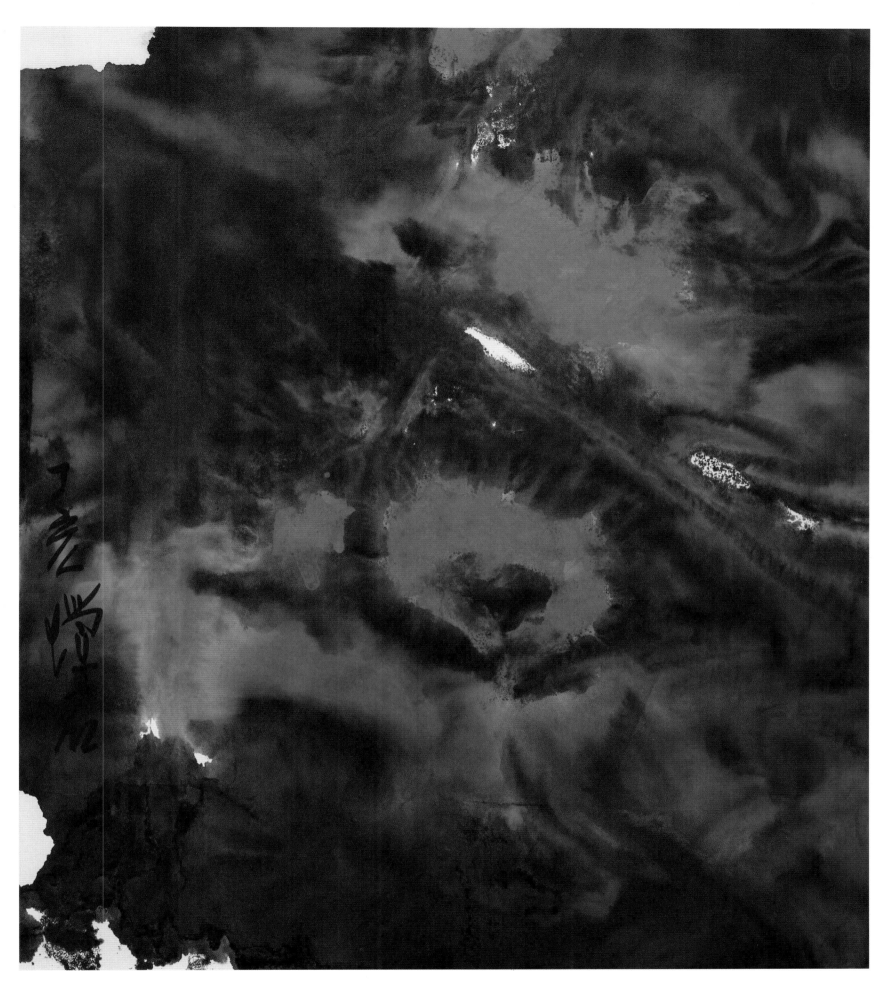

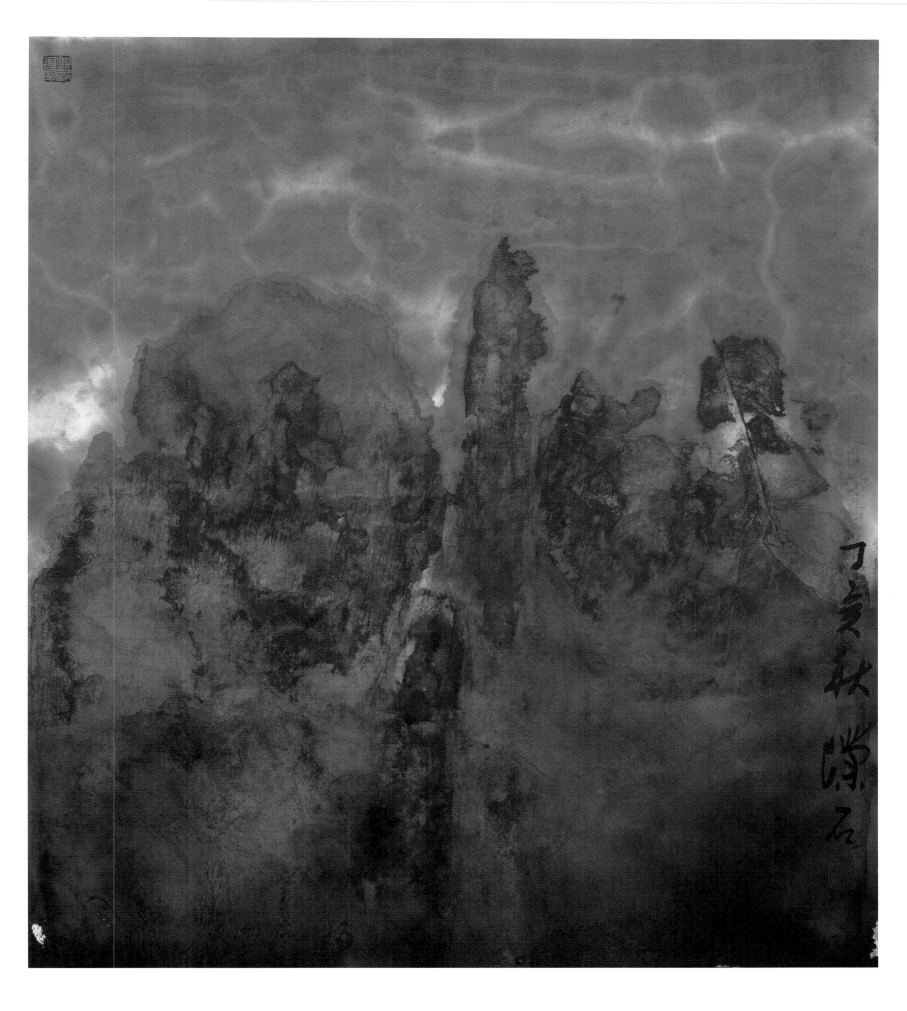

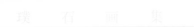

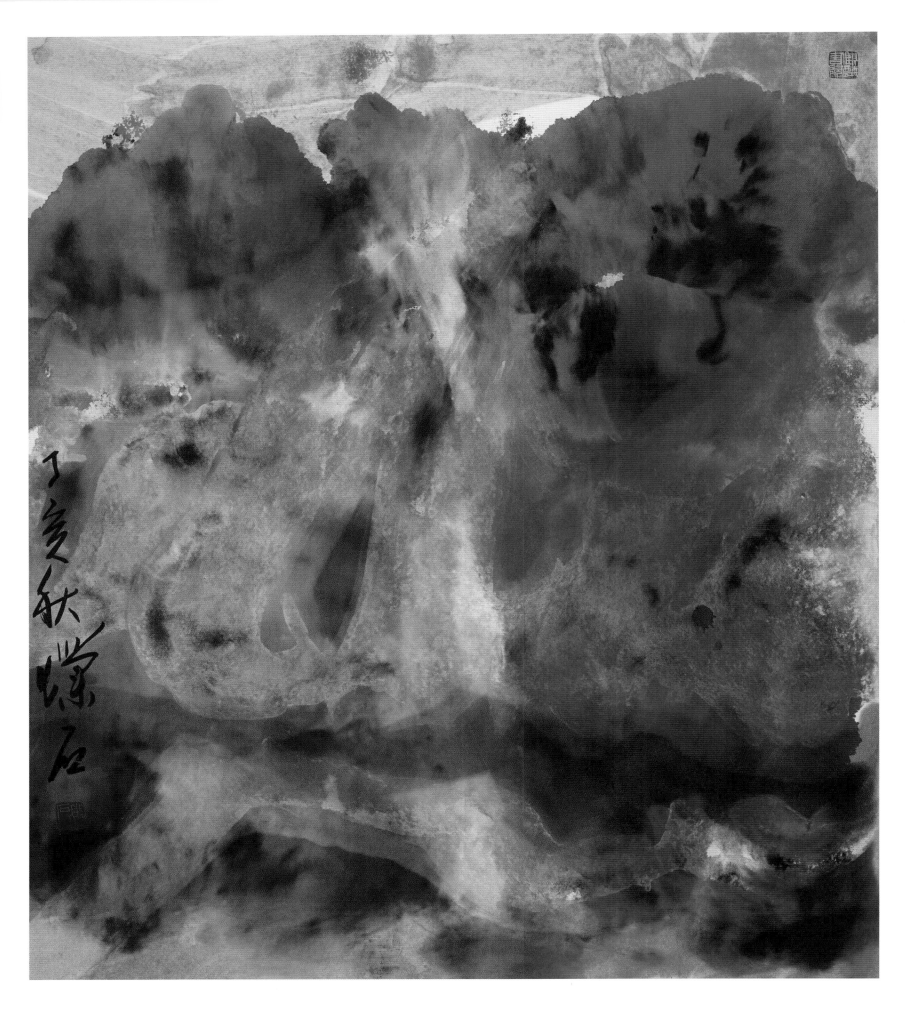

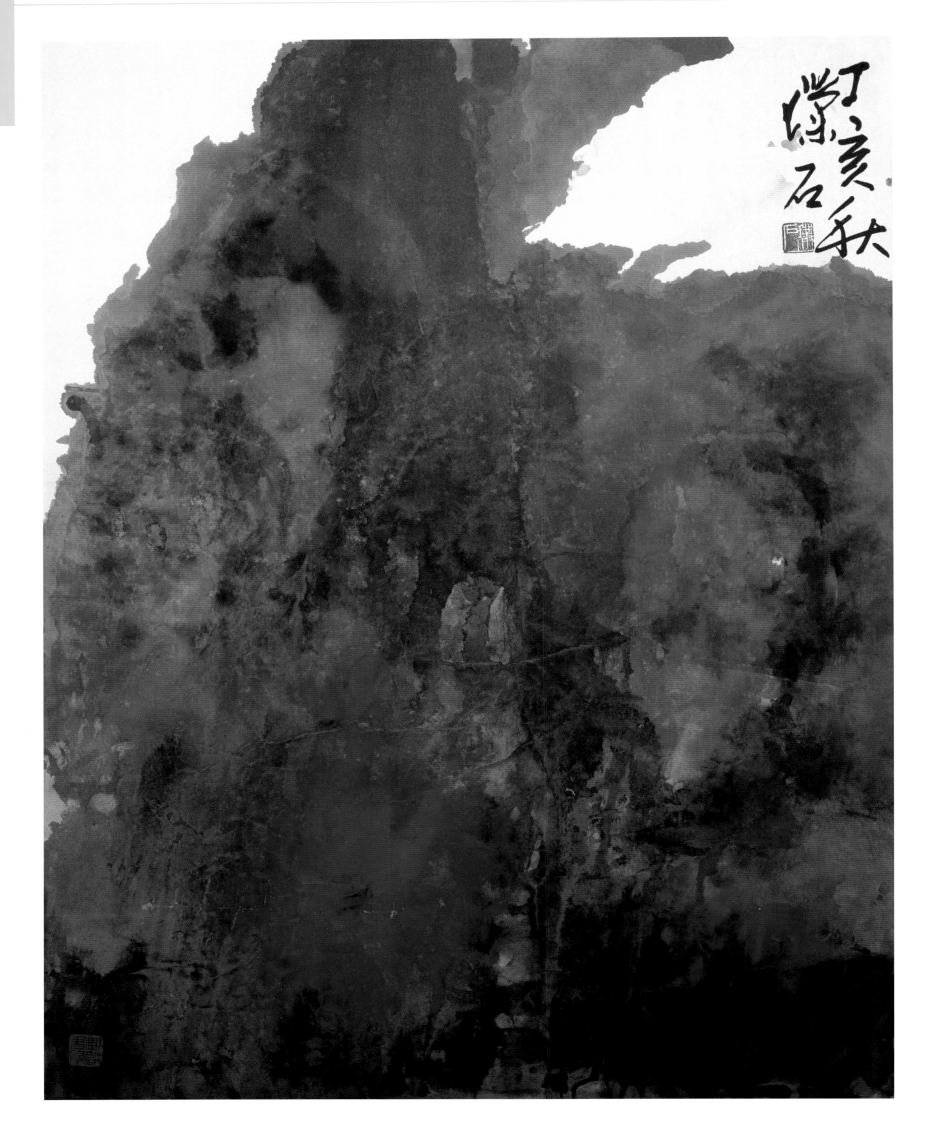

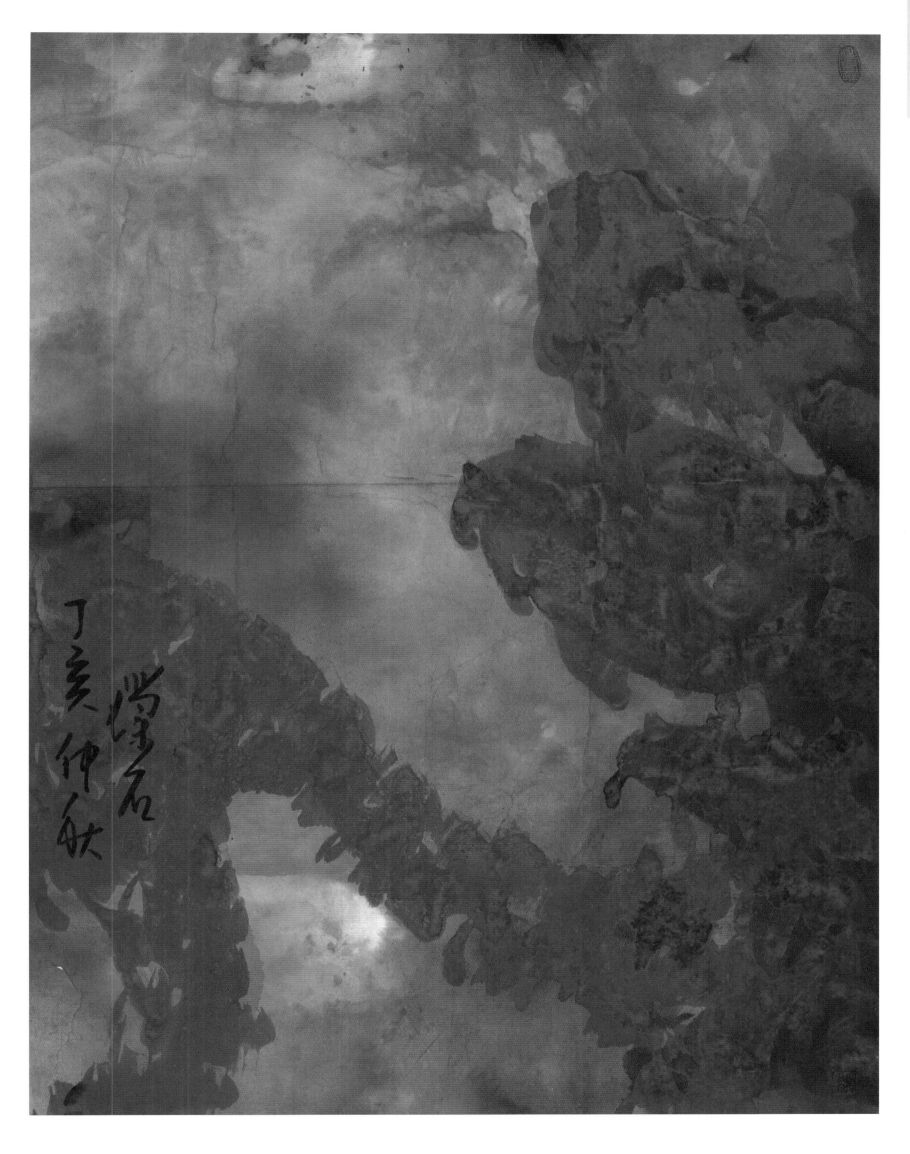

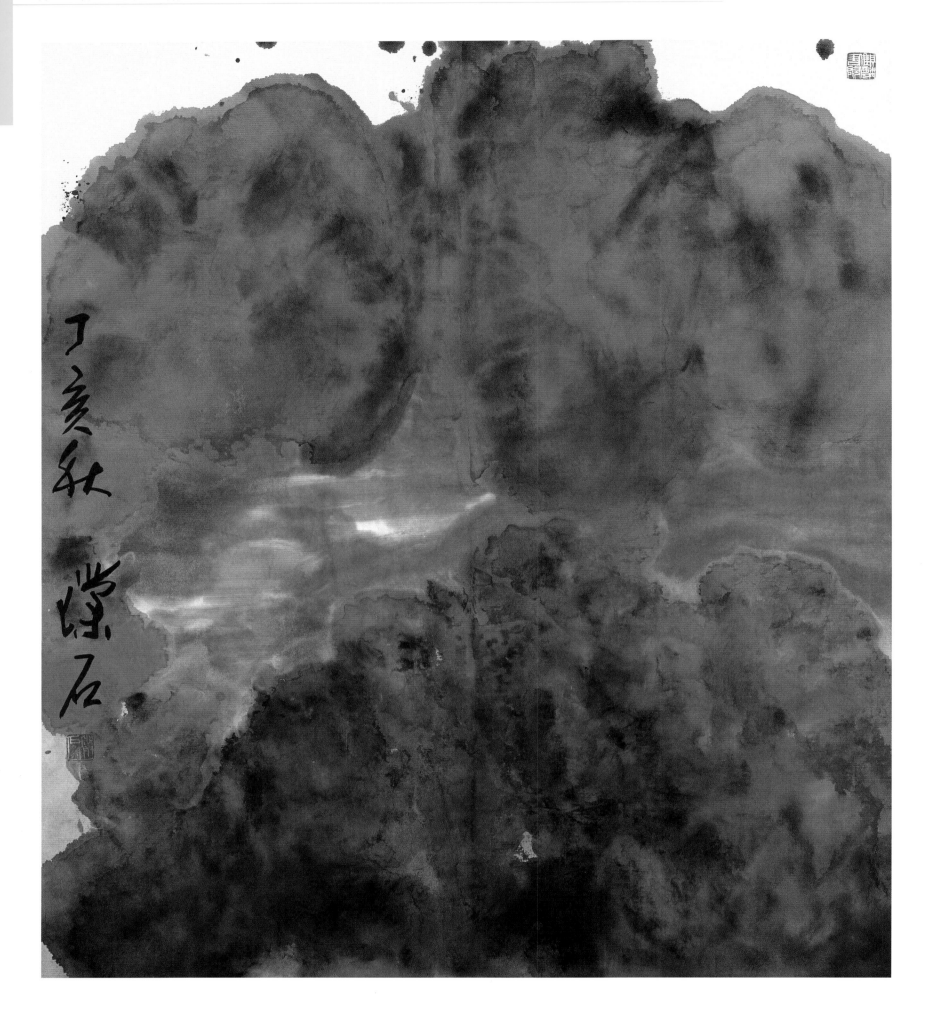

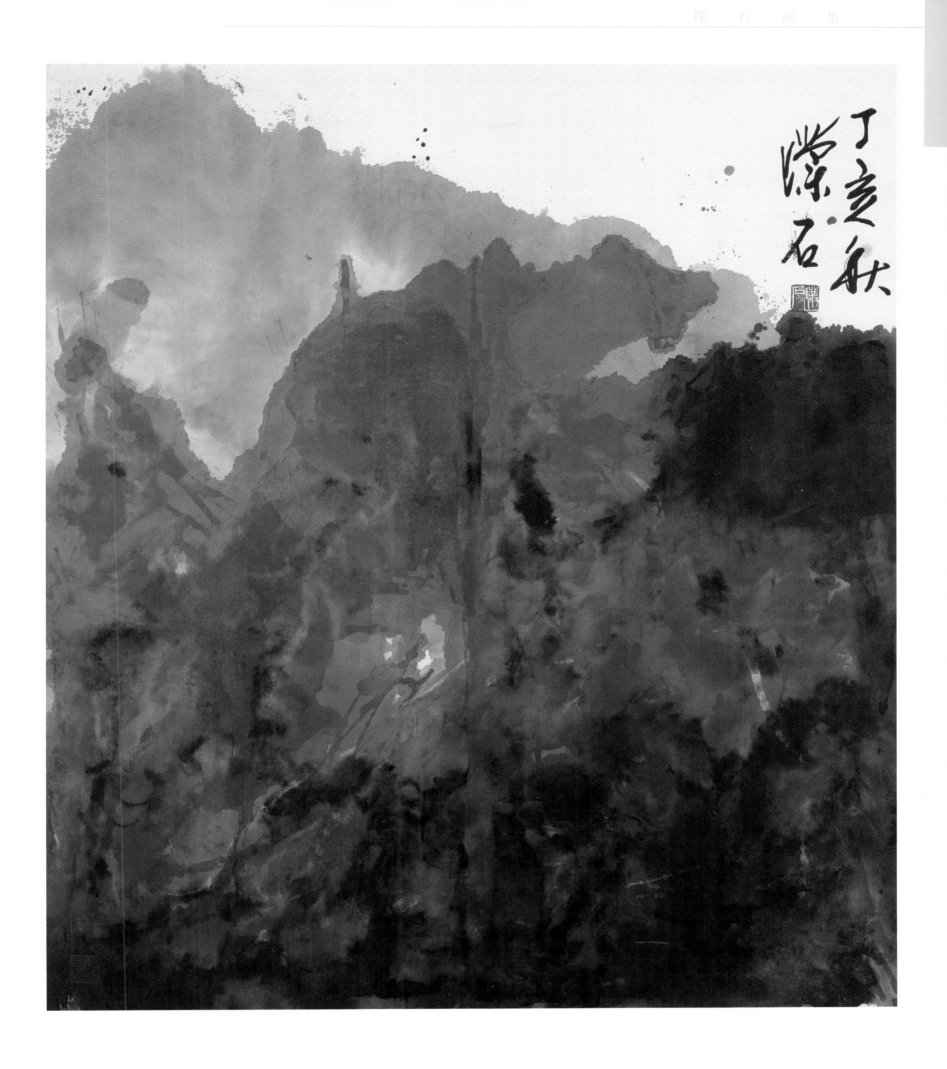

丁亥秋 漆石

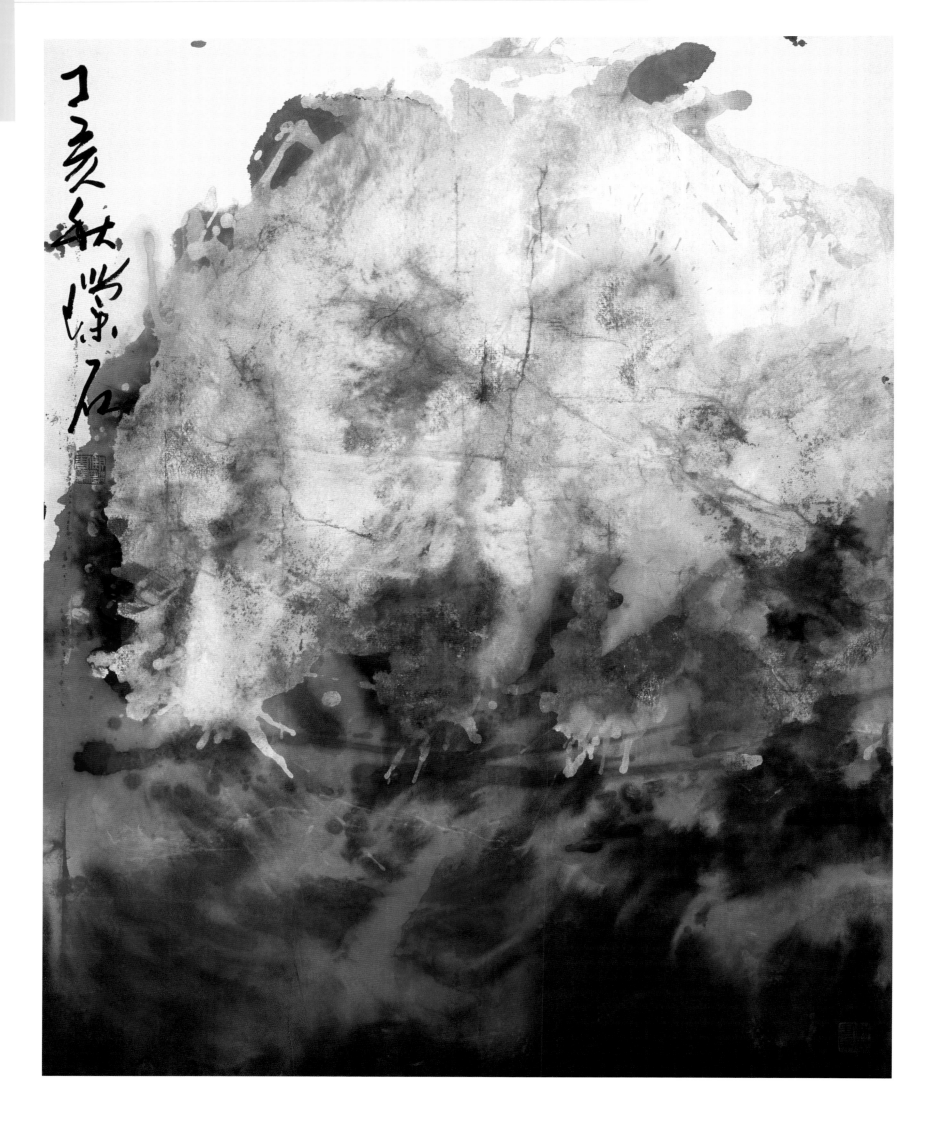

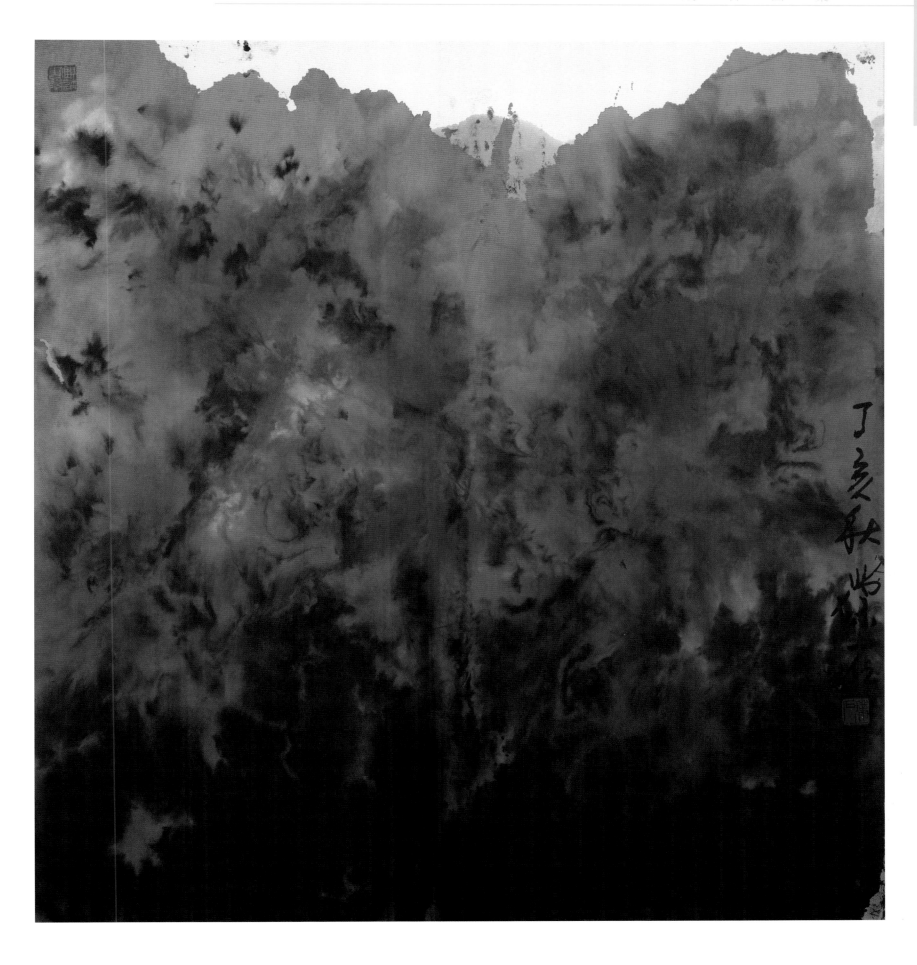

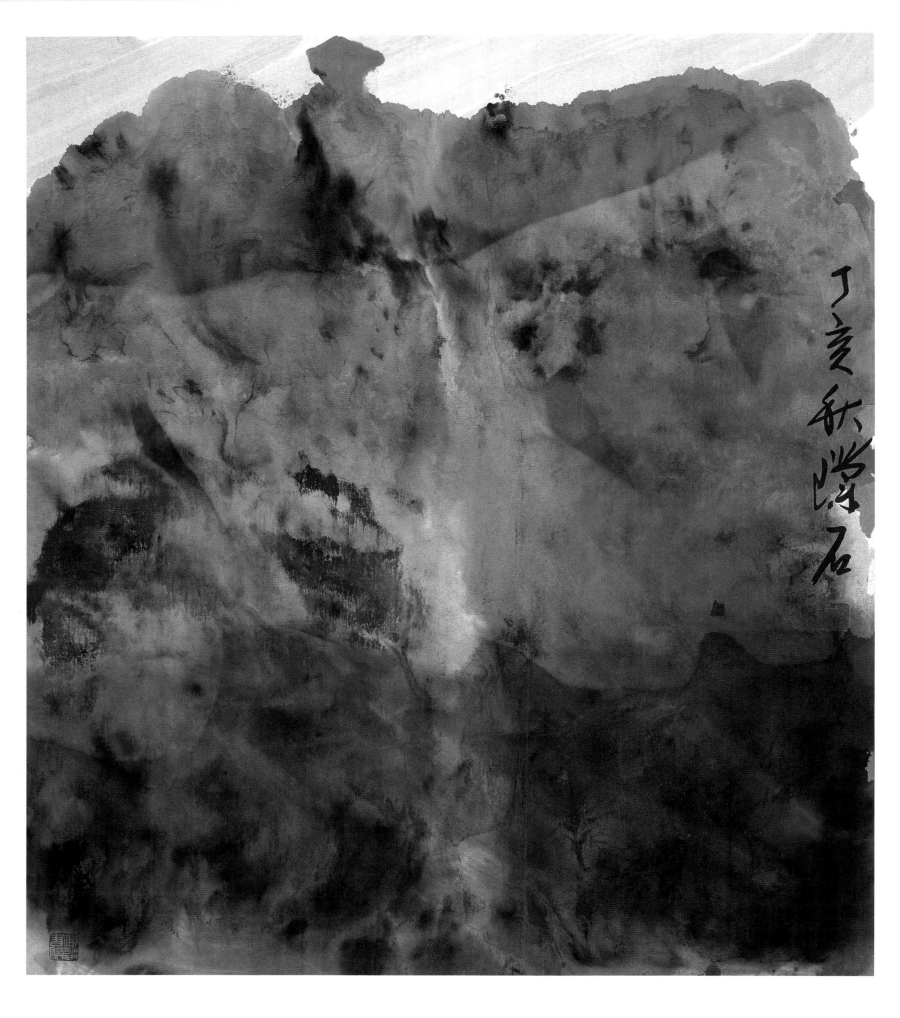

丁亥秋瑛石

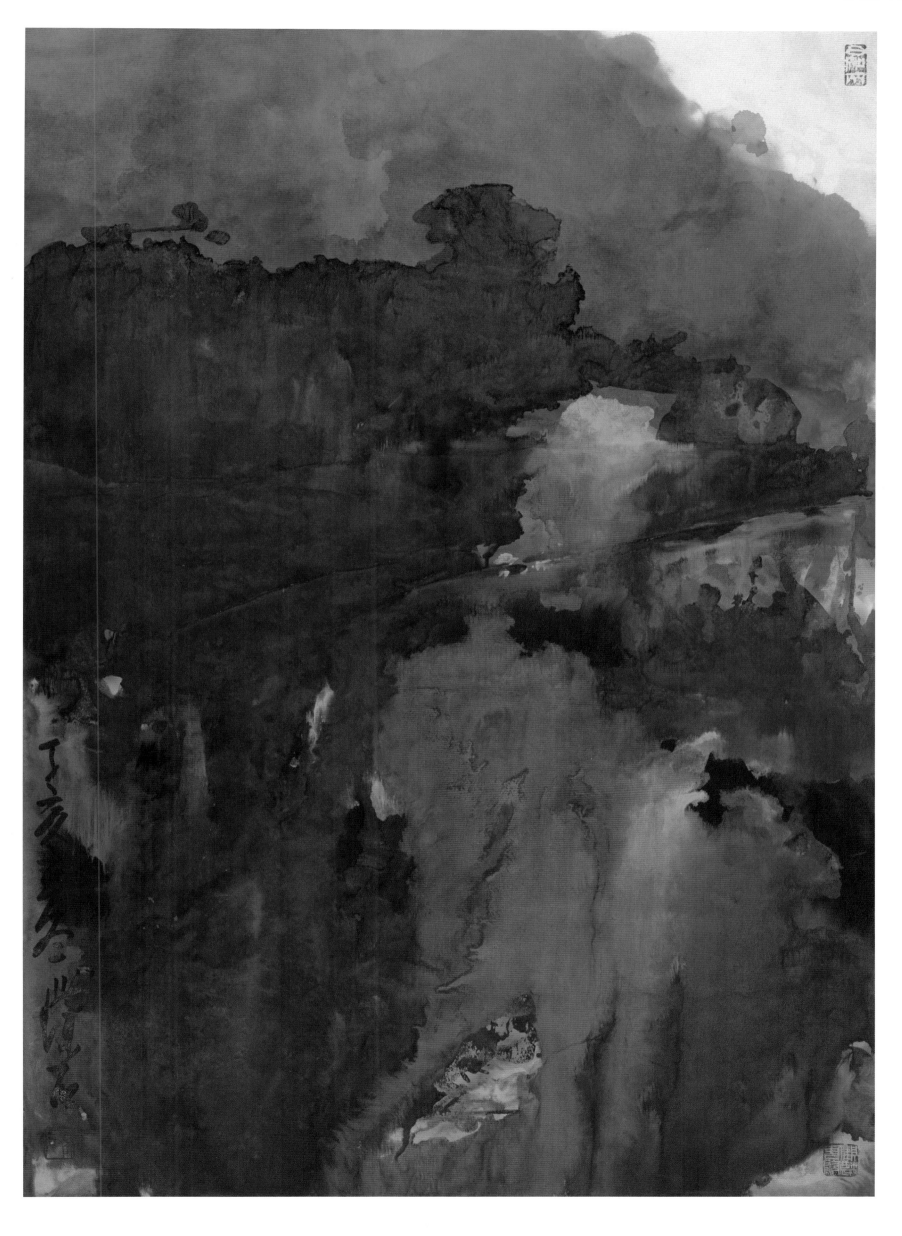

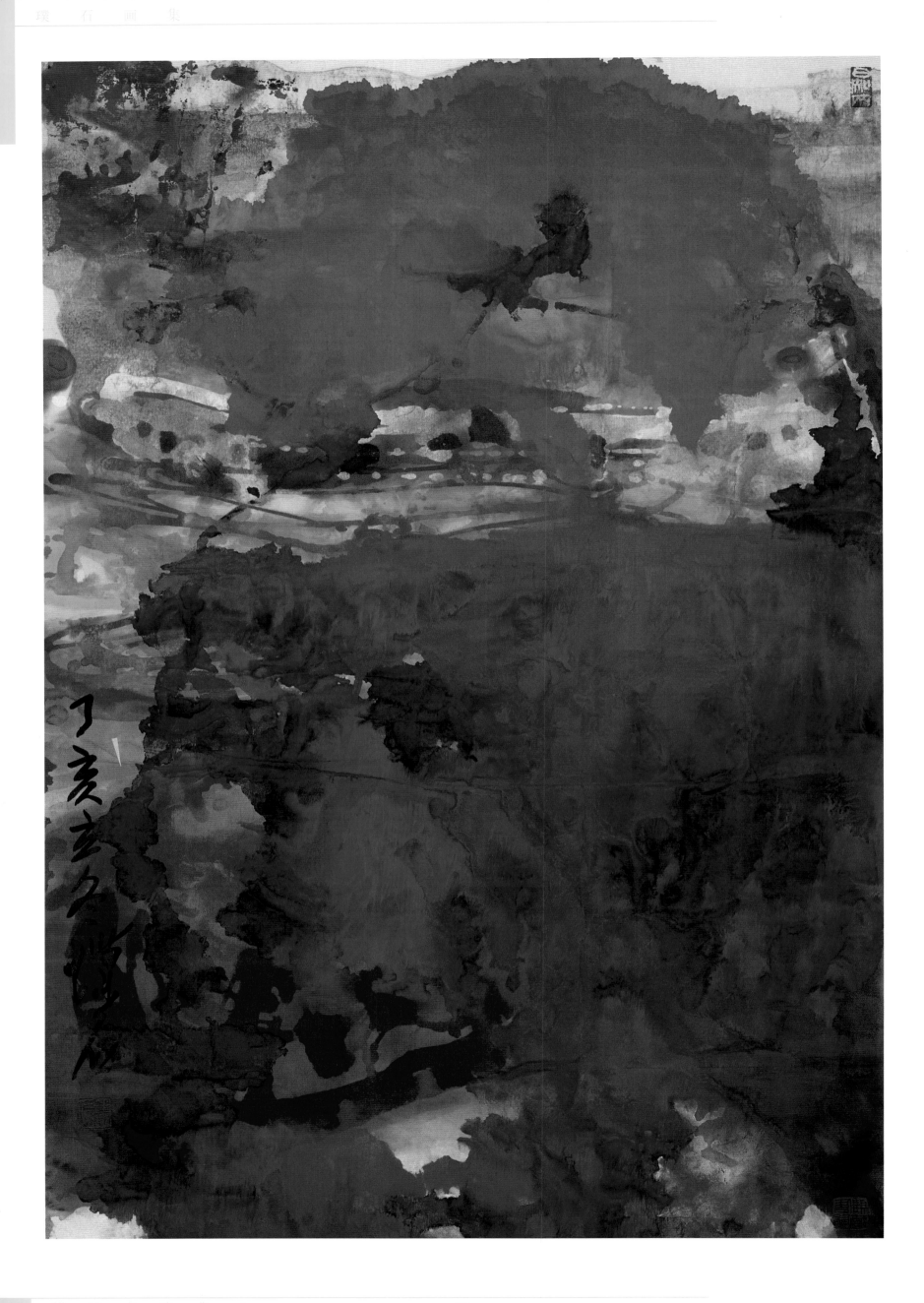

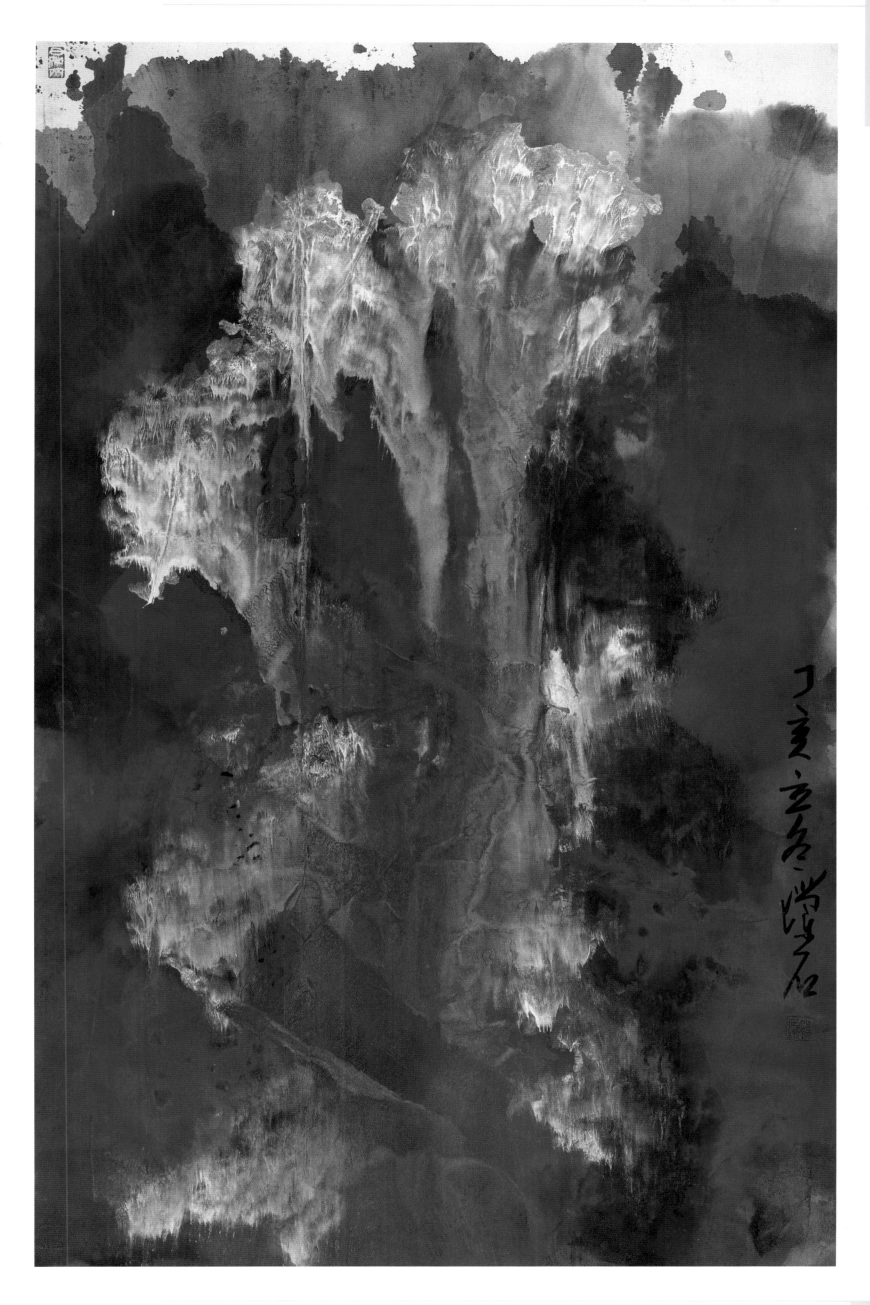

丁亥立冬之际璞石

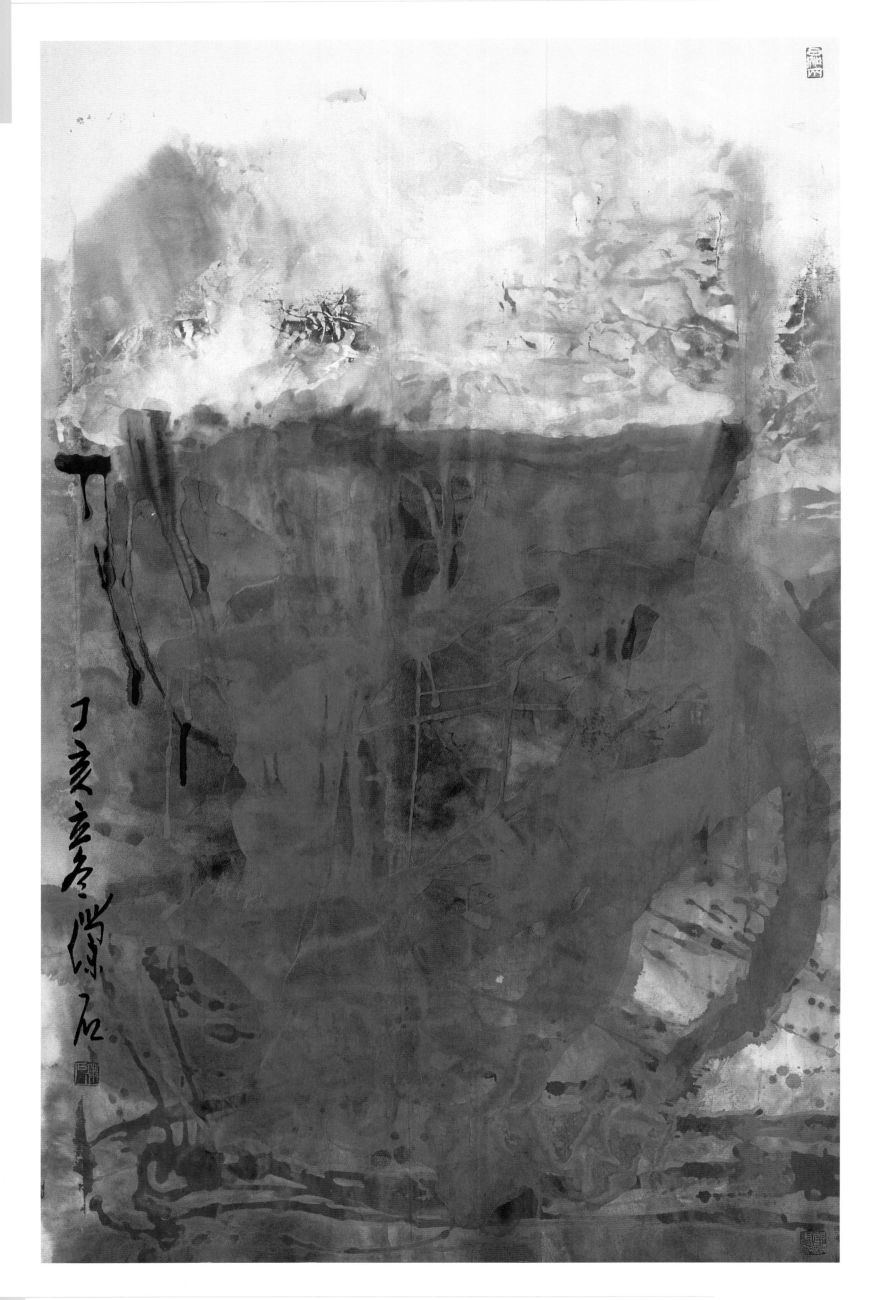

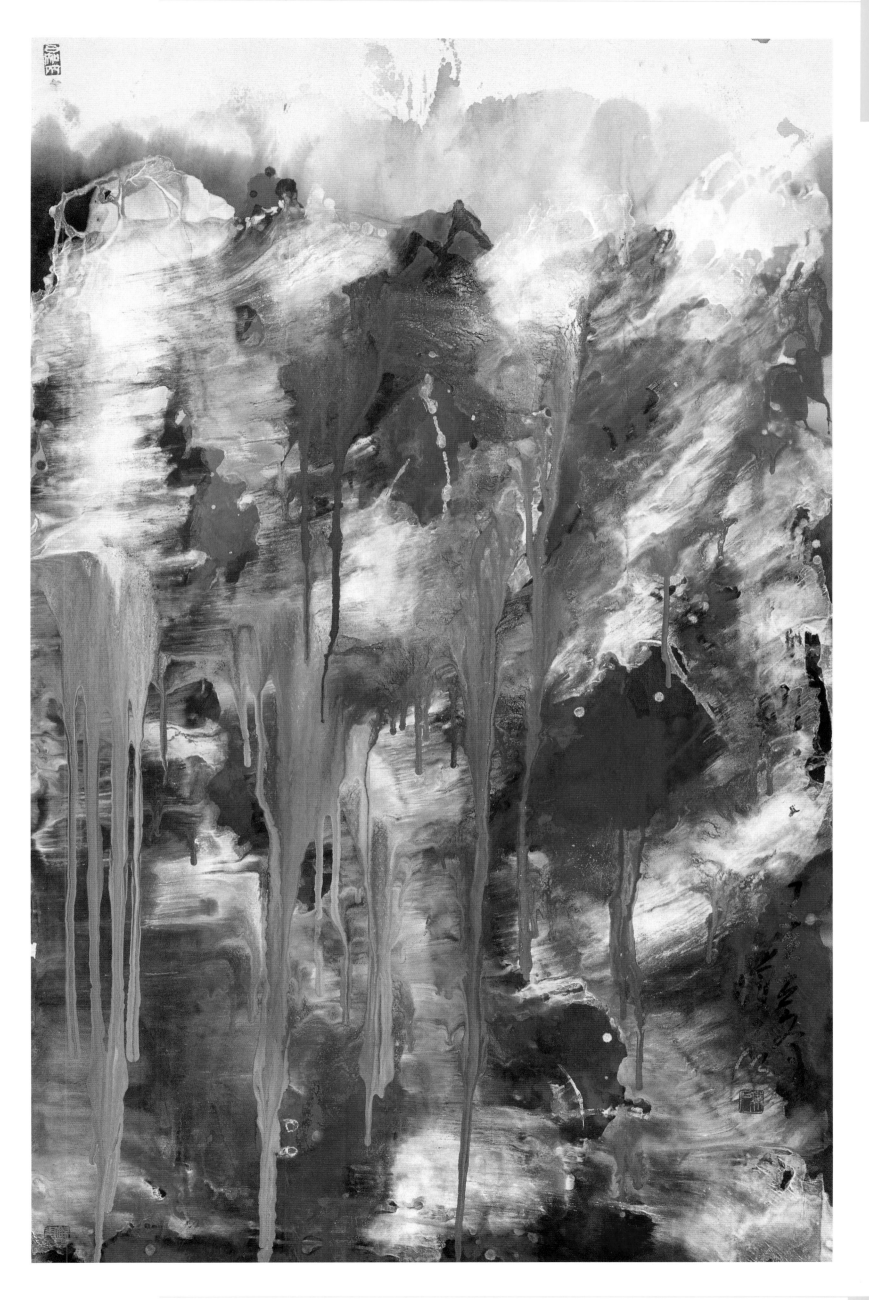

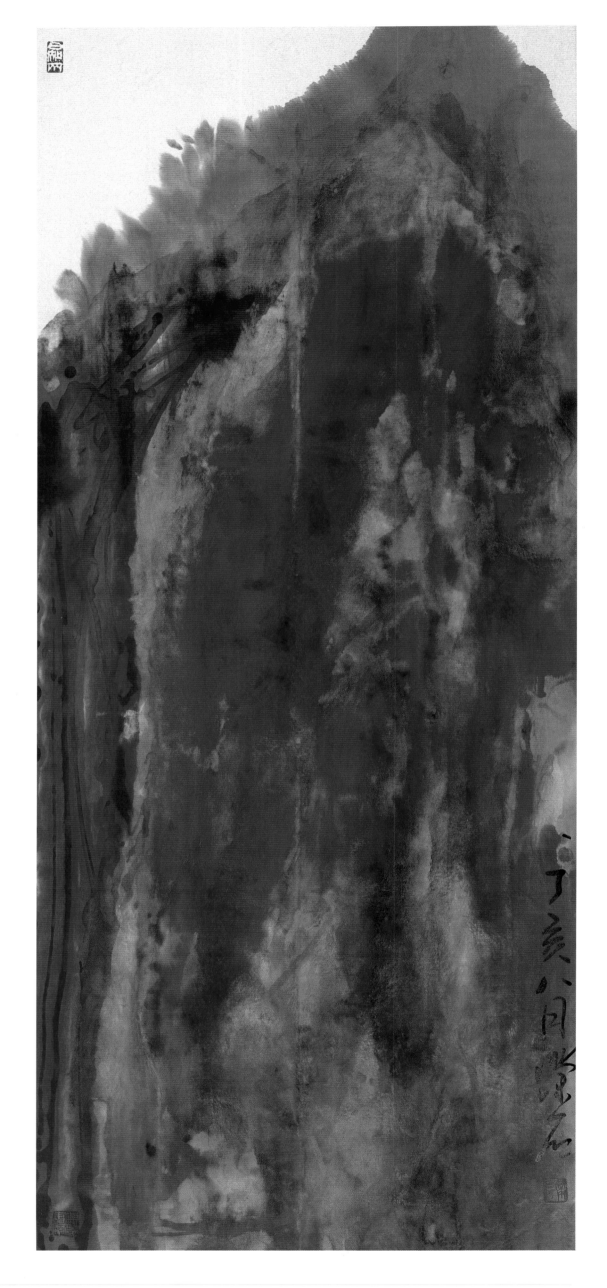

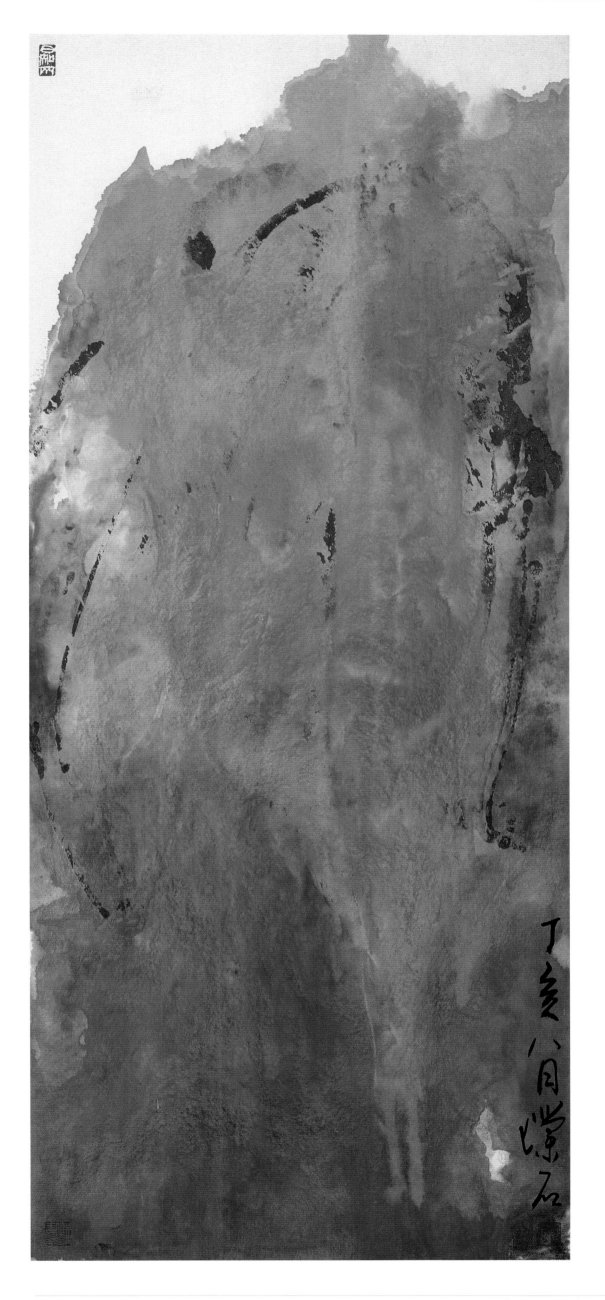

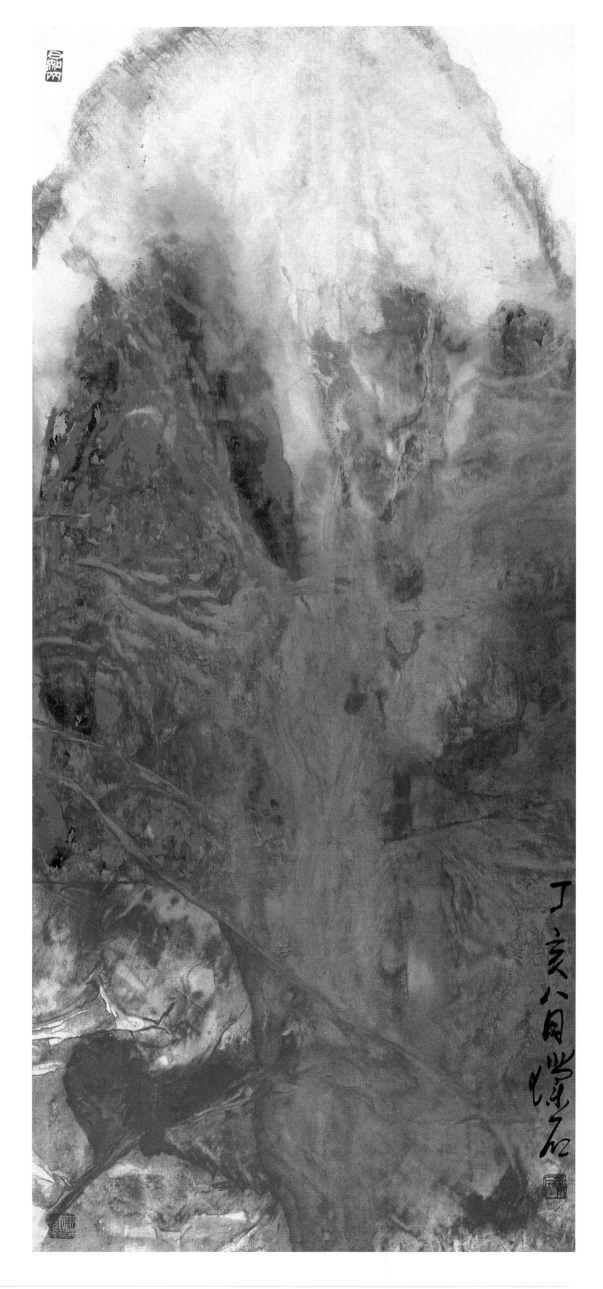

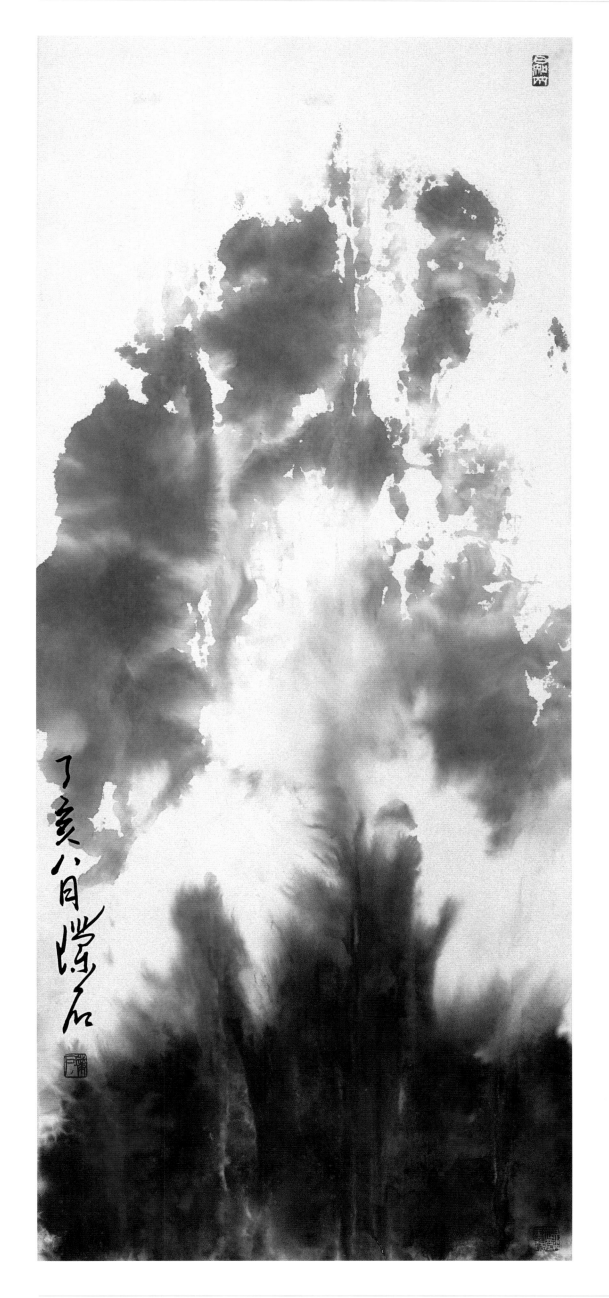

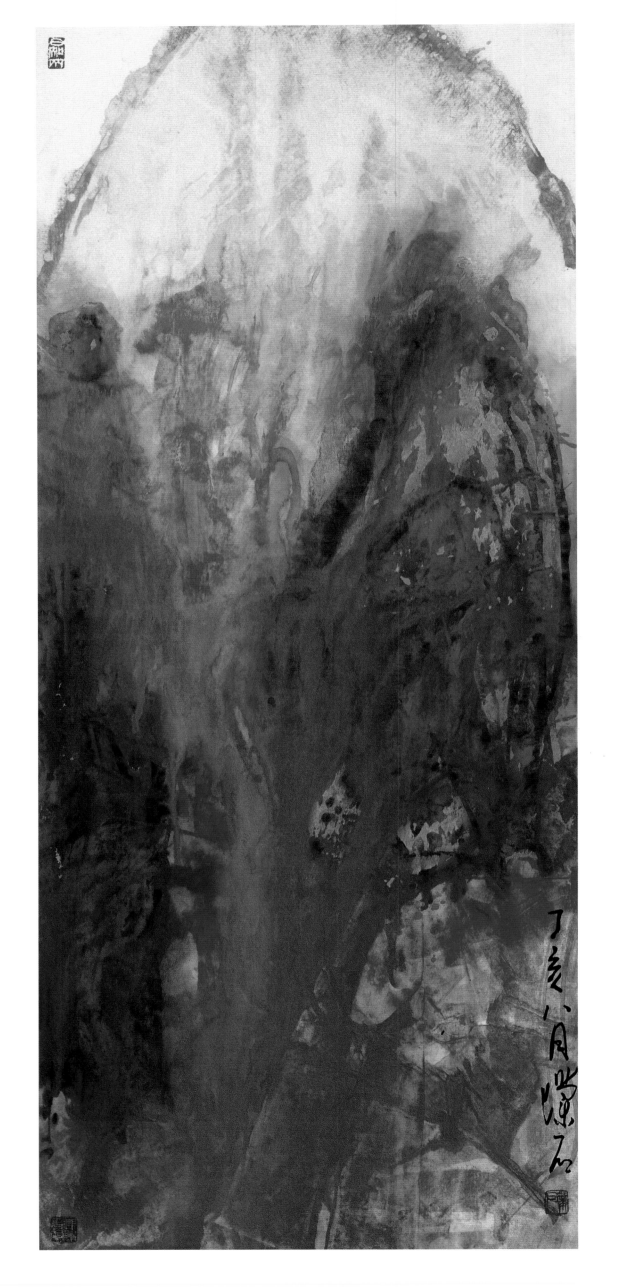

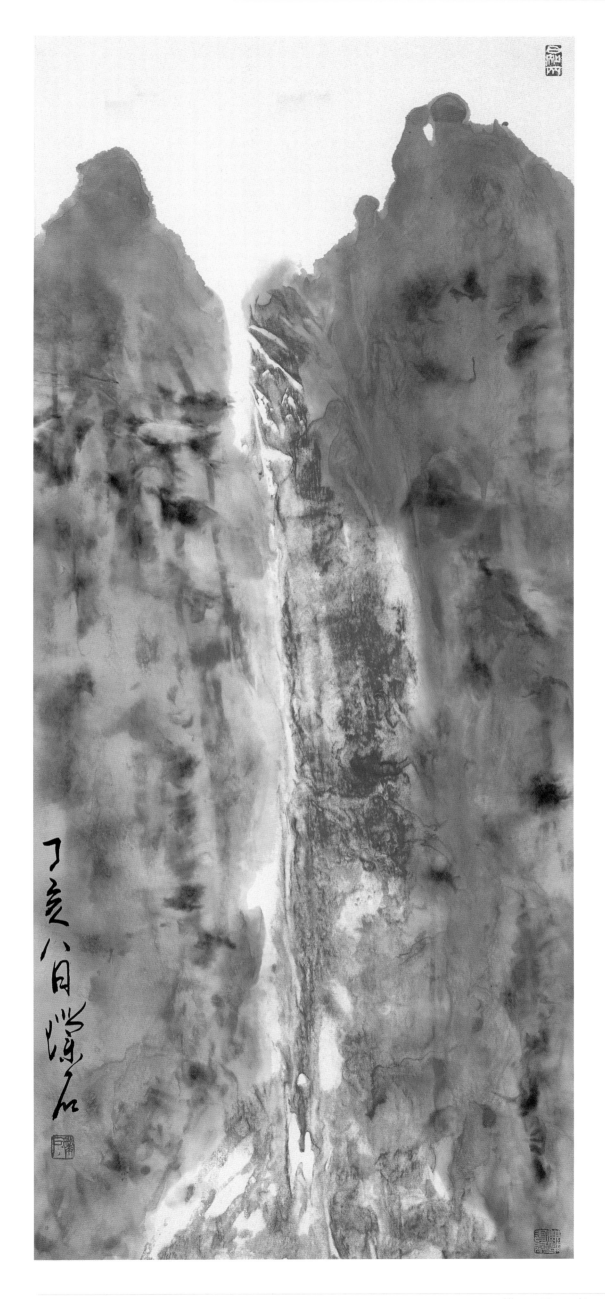

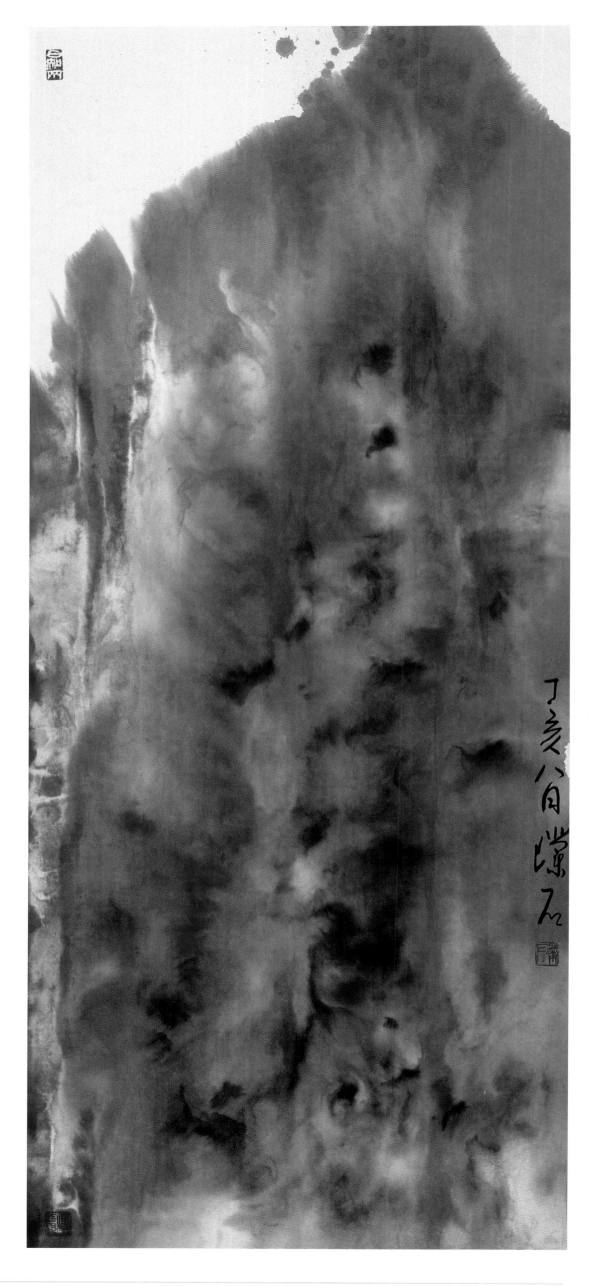

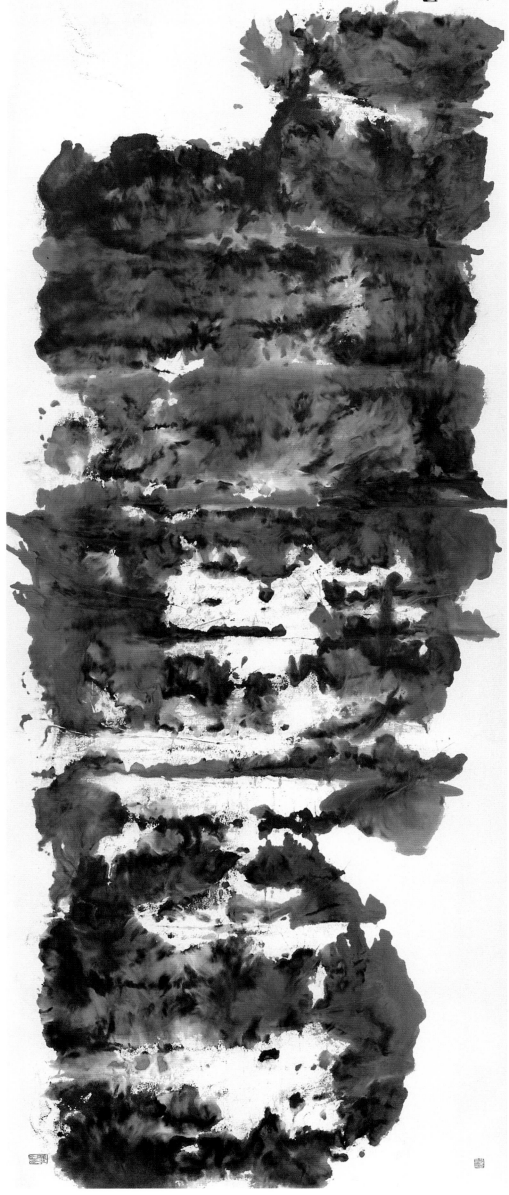

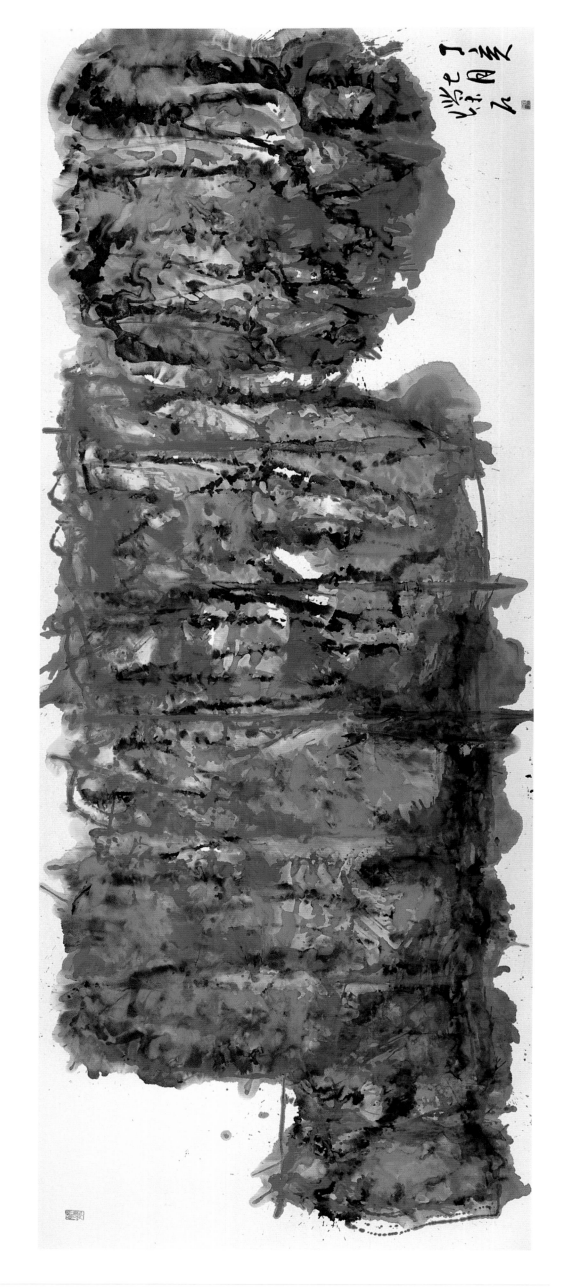

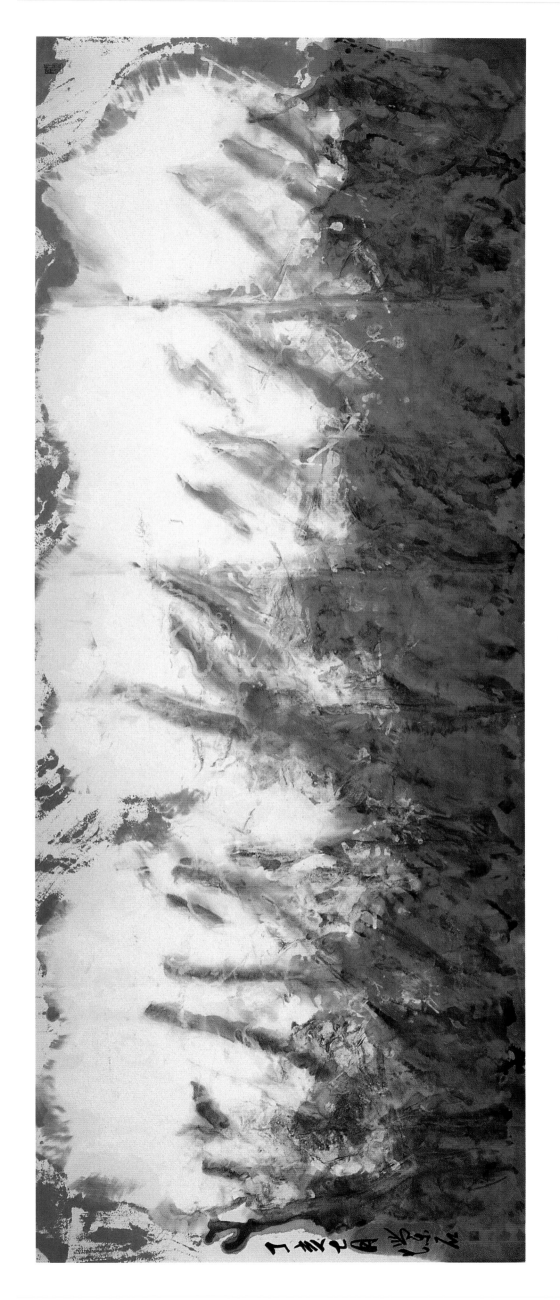

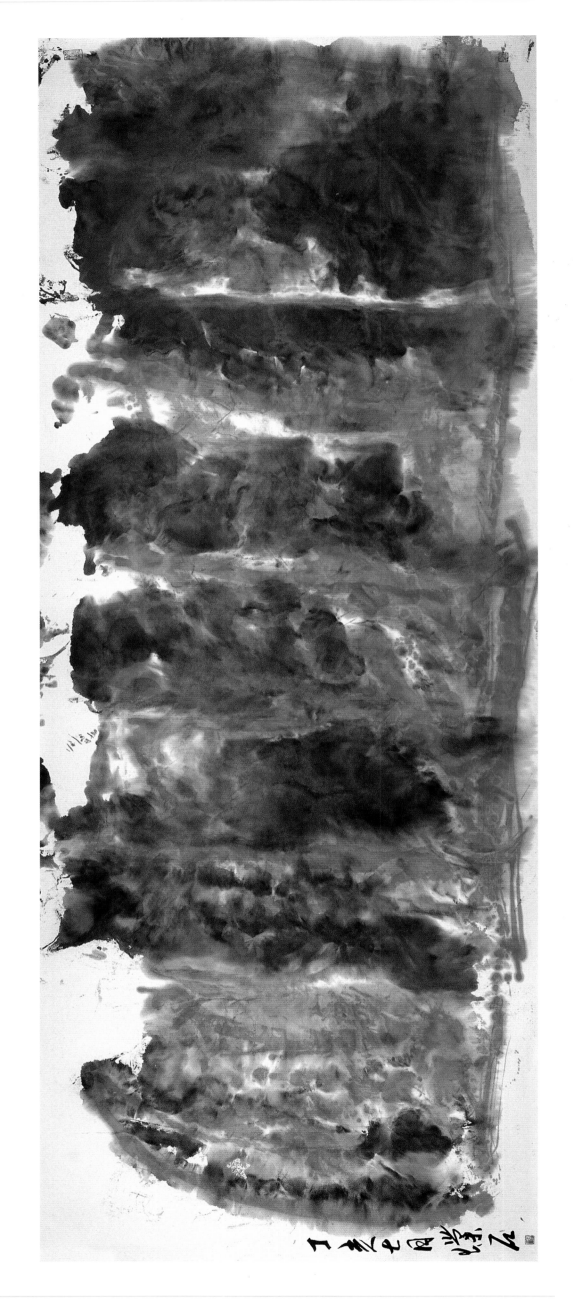

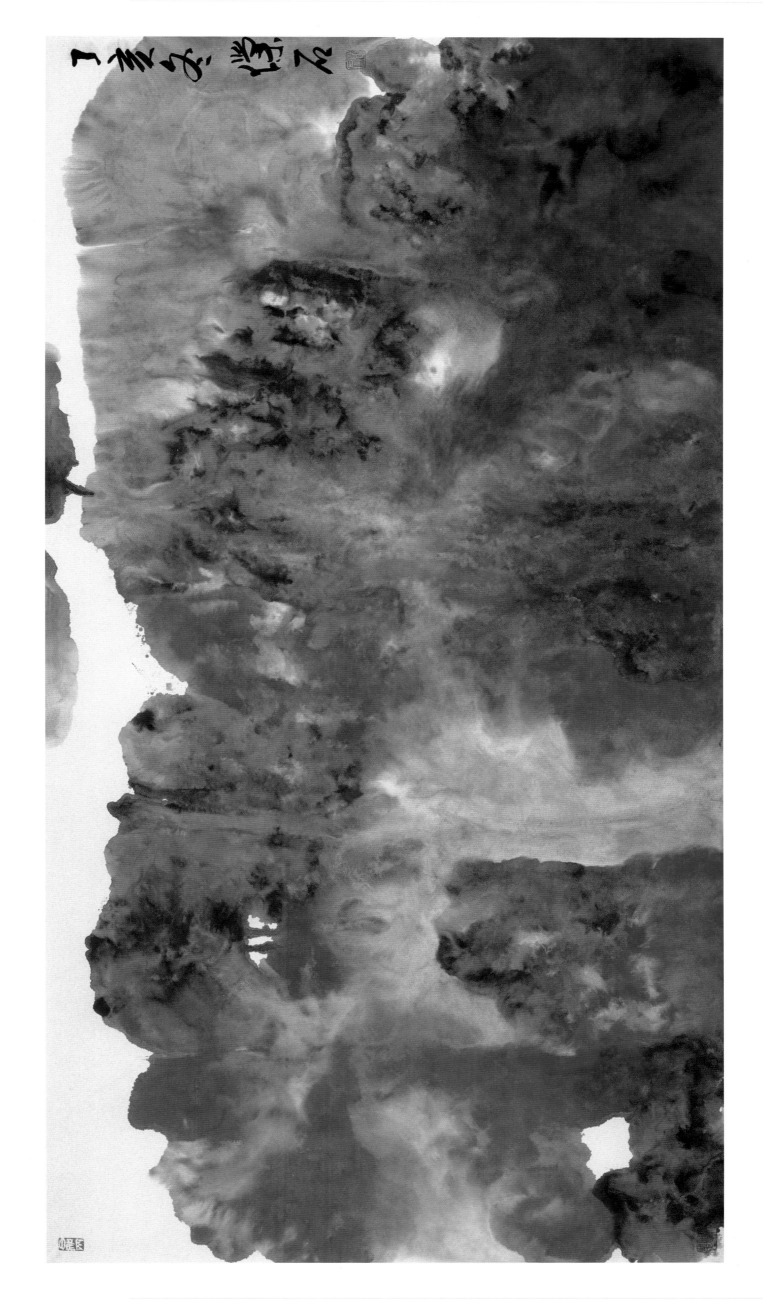

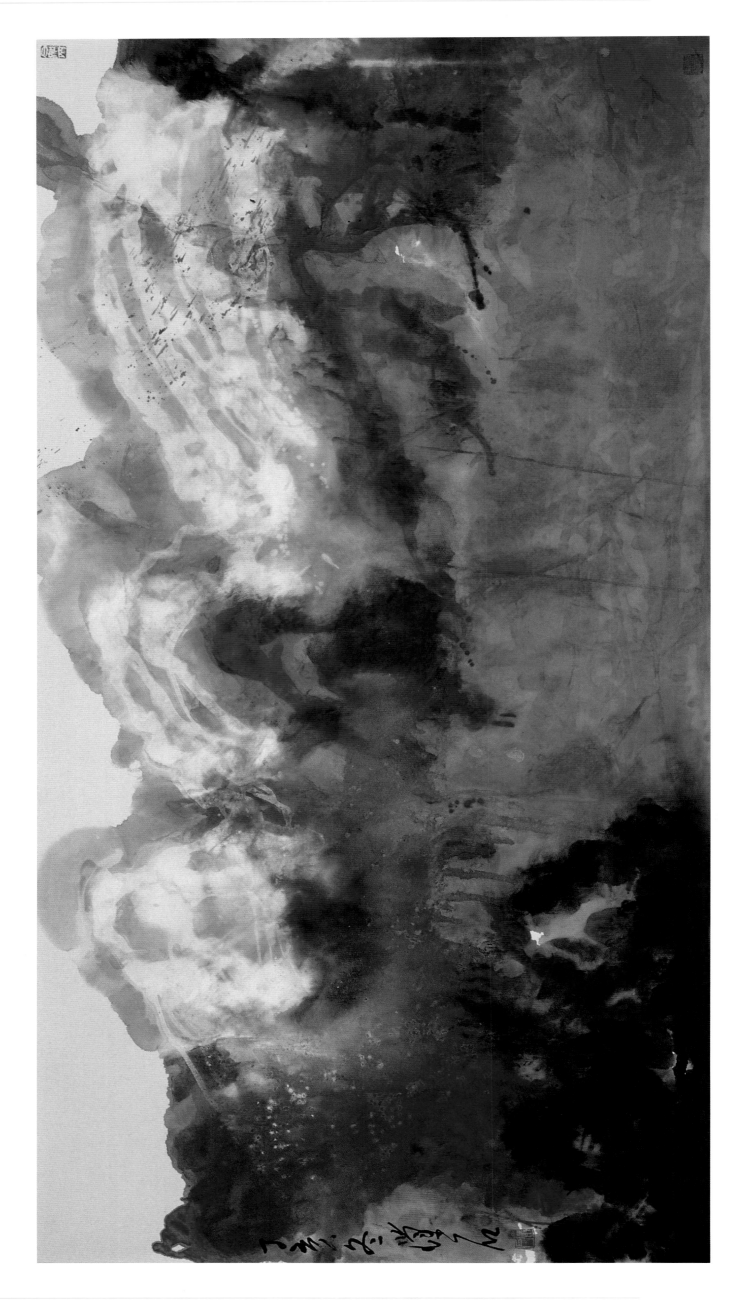

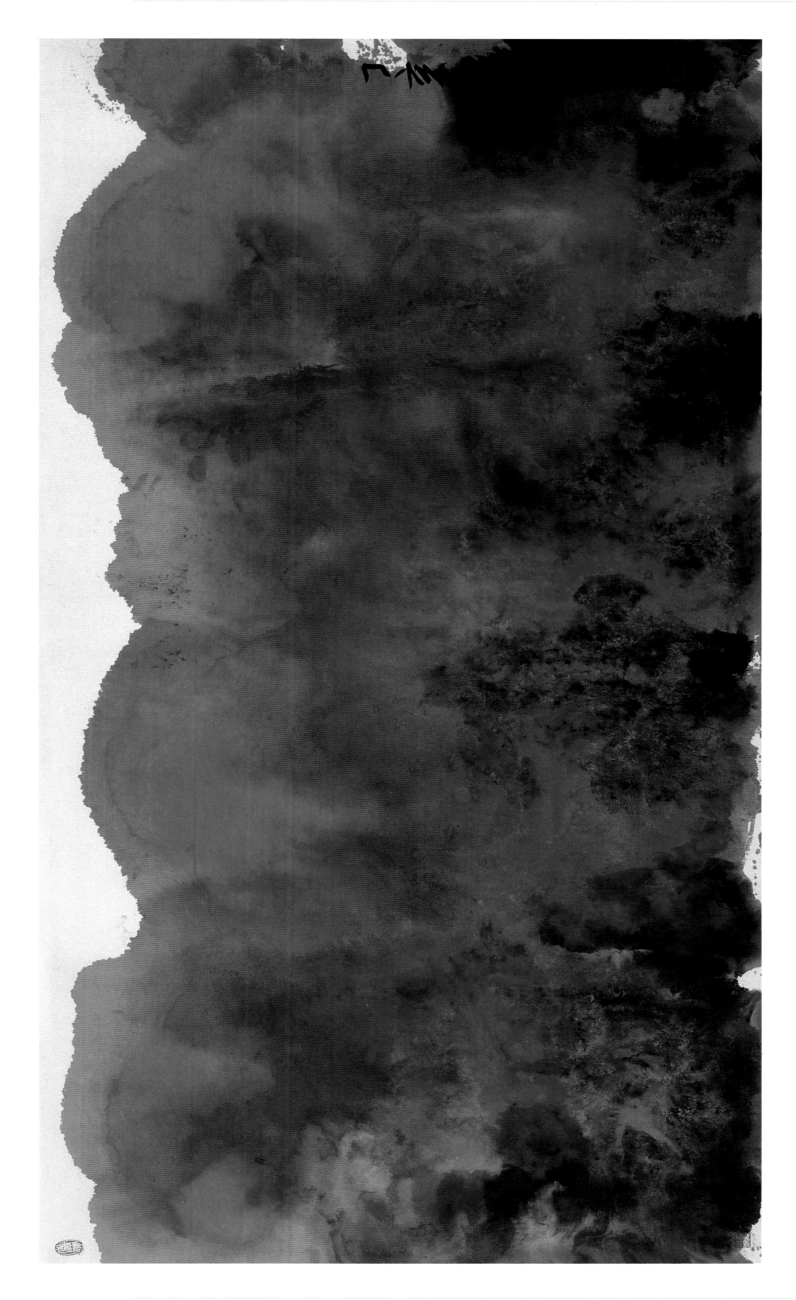

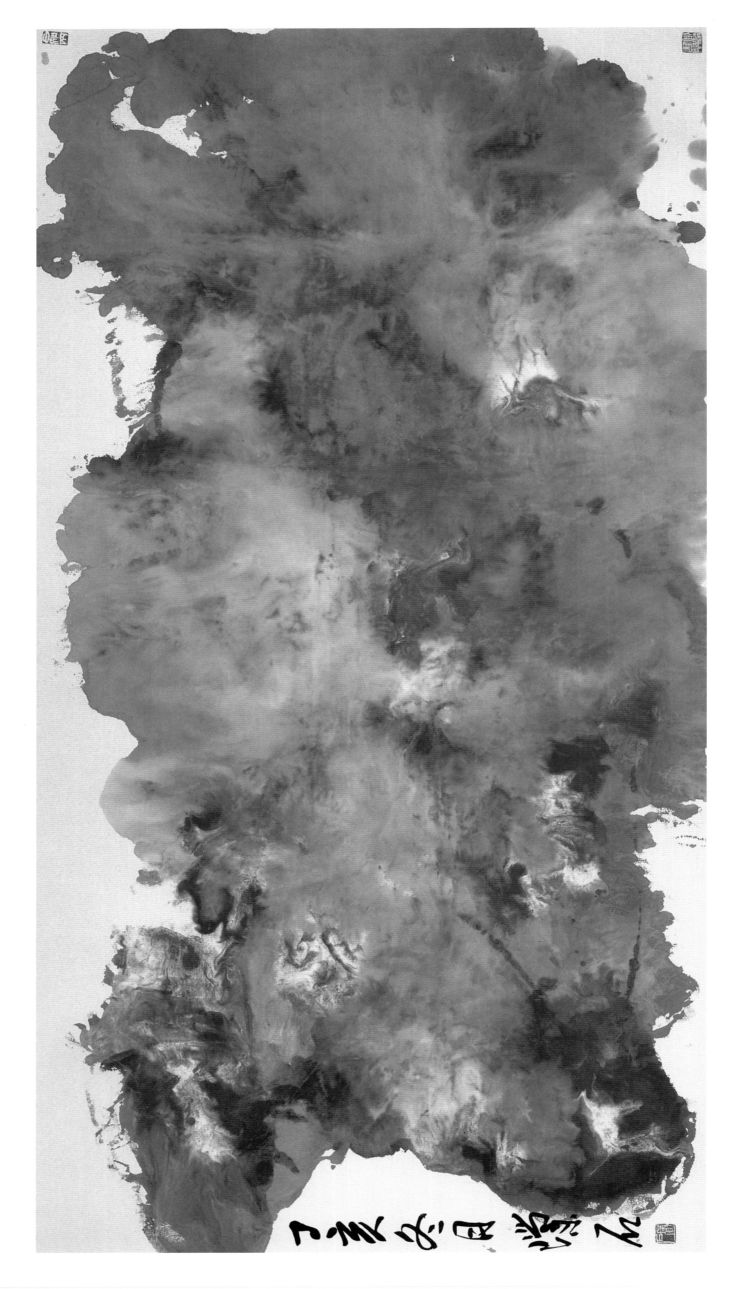

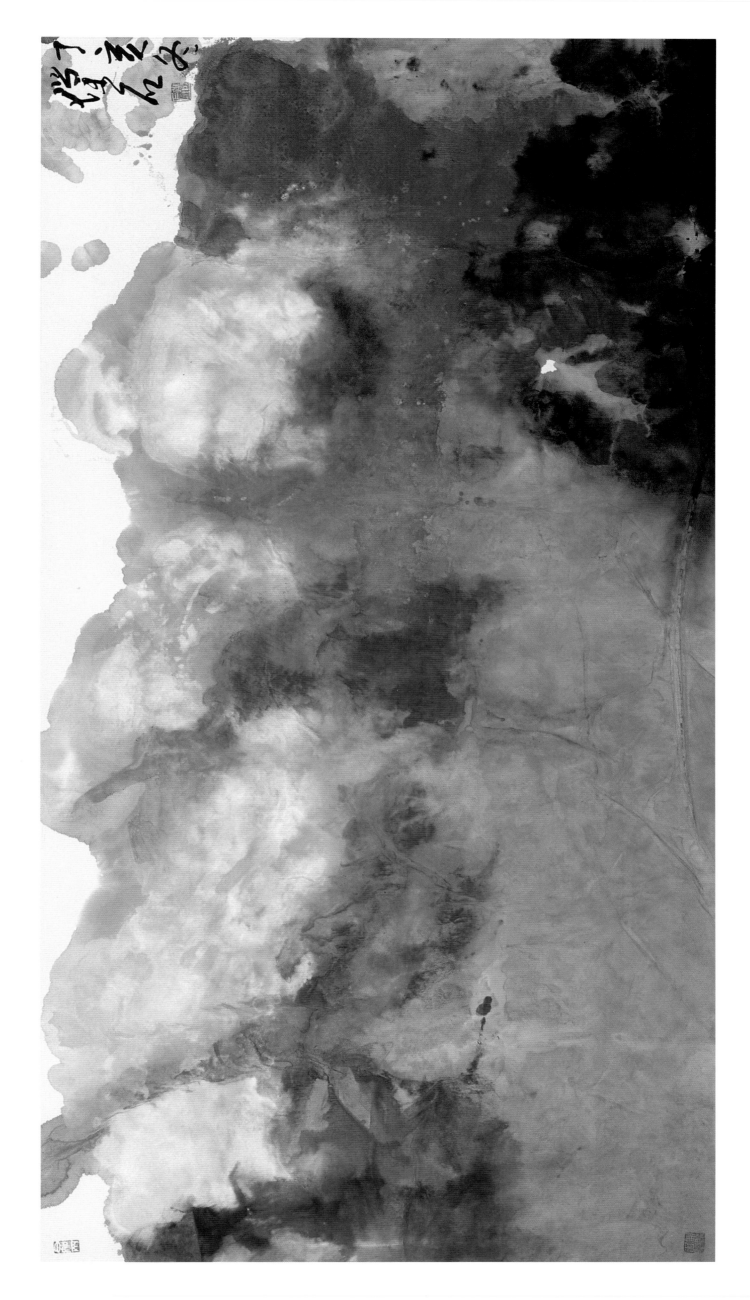

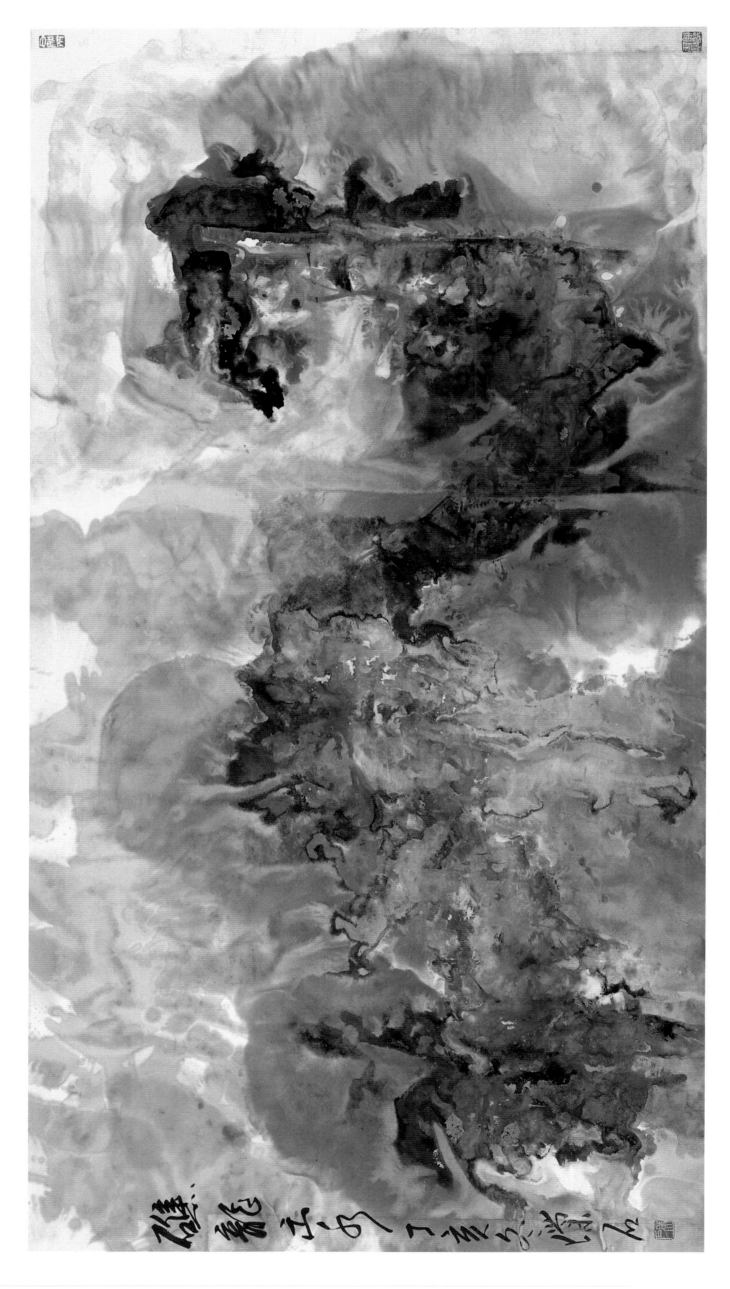

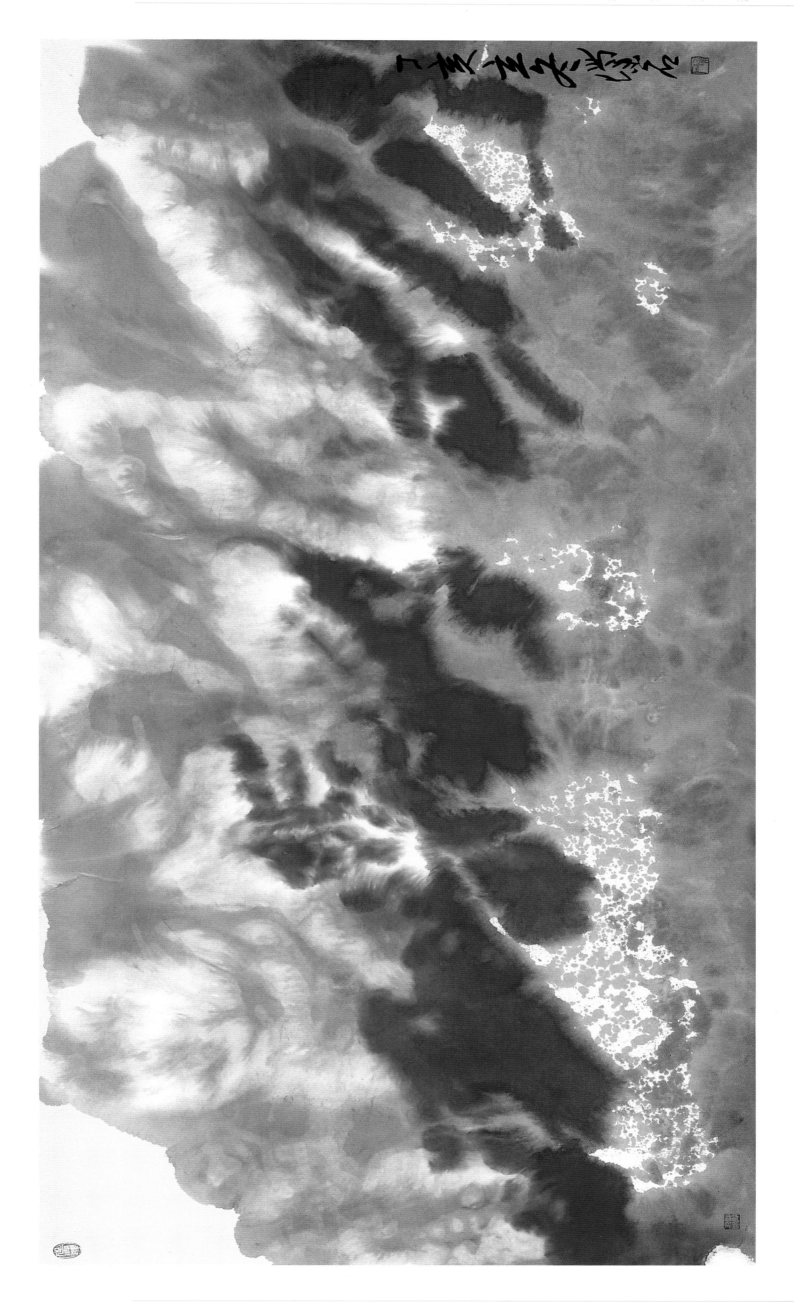

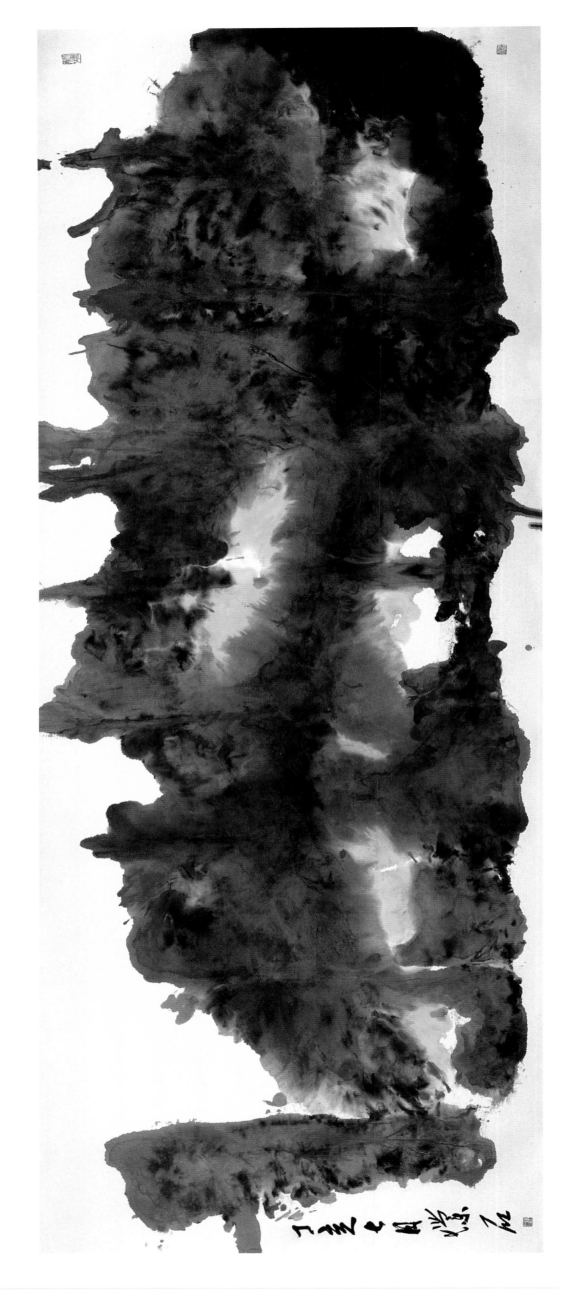

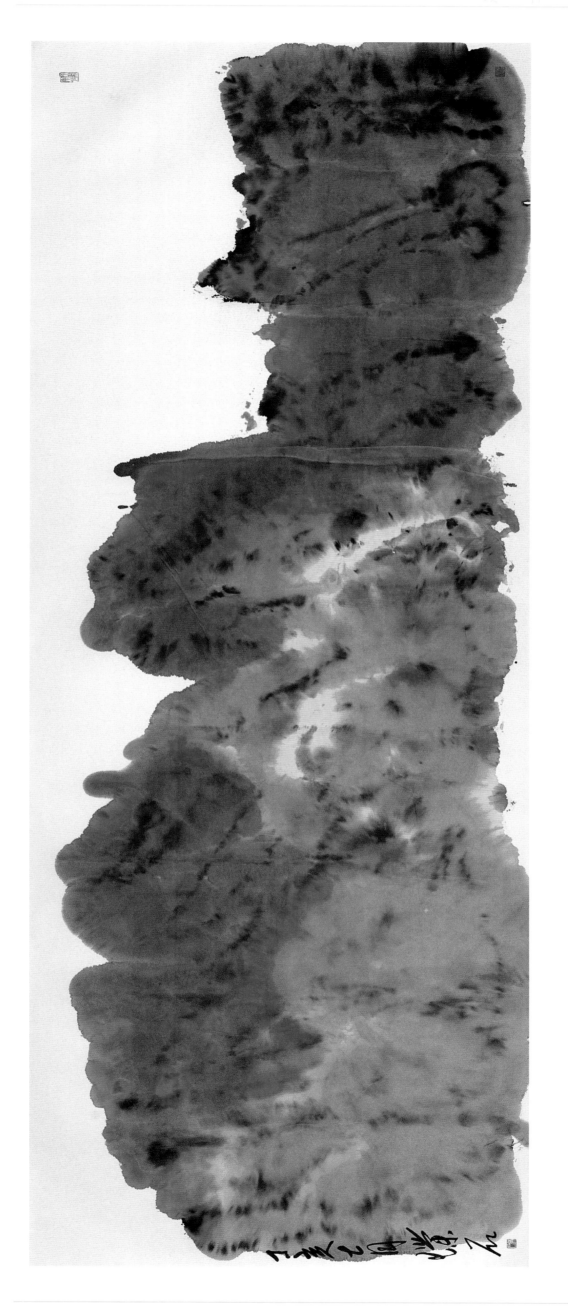

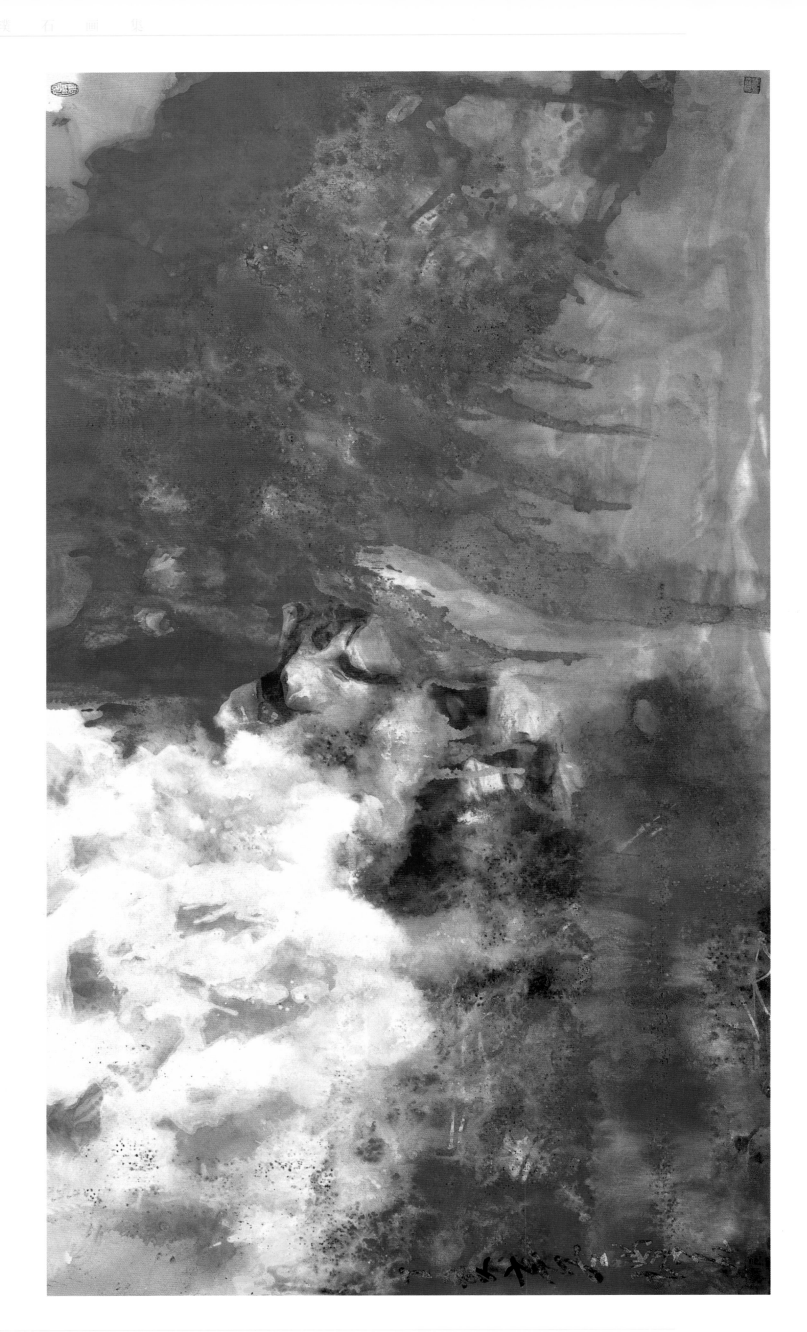

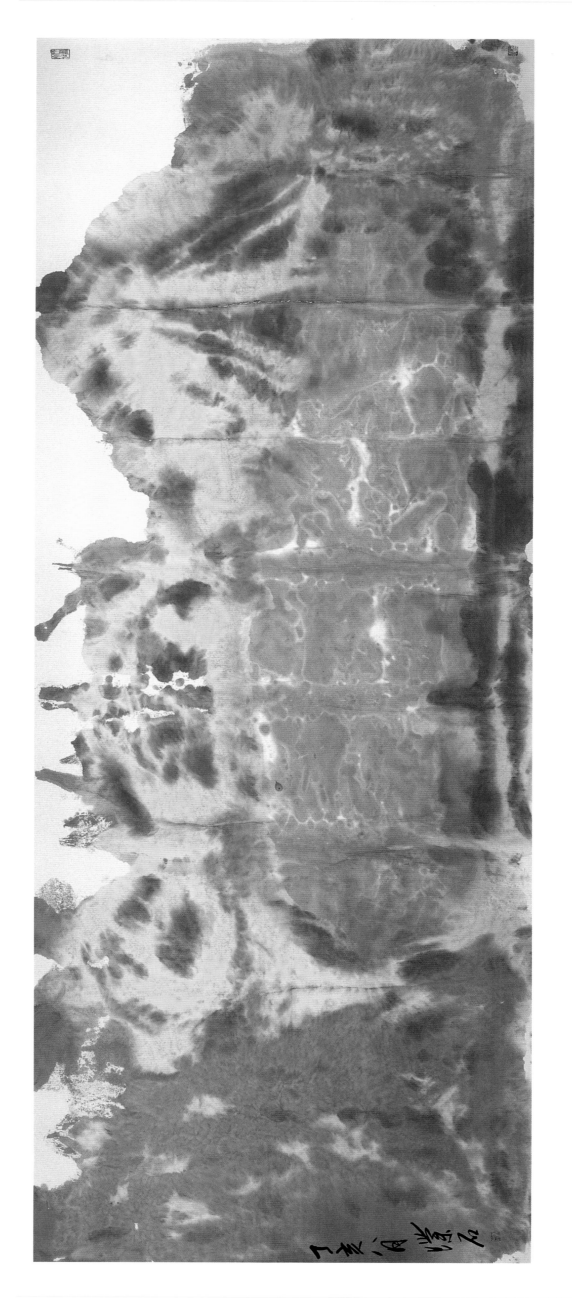

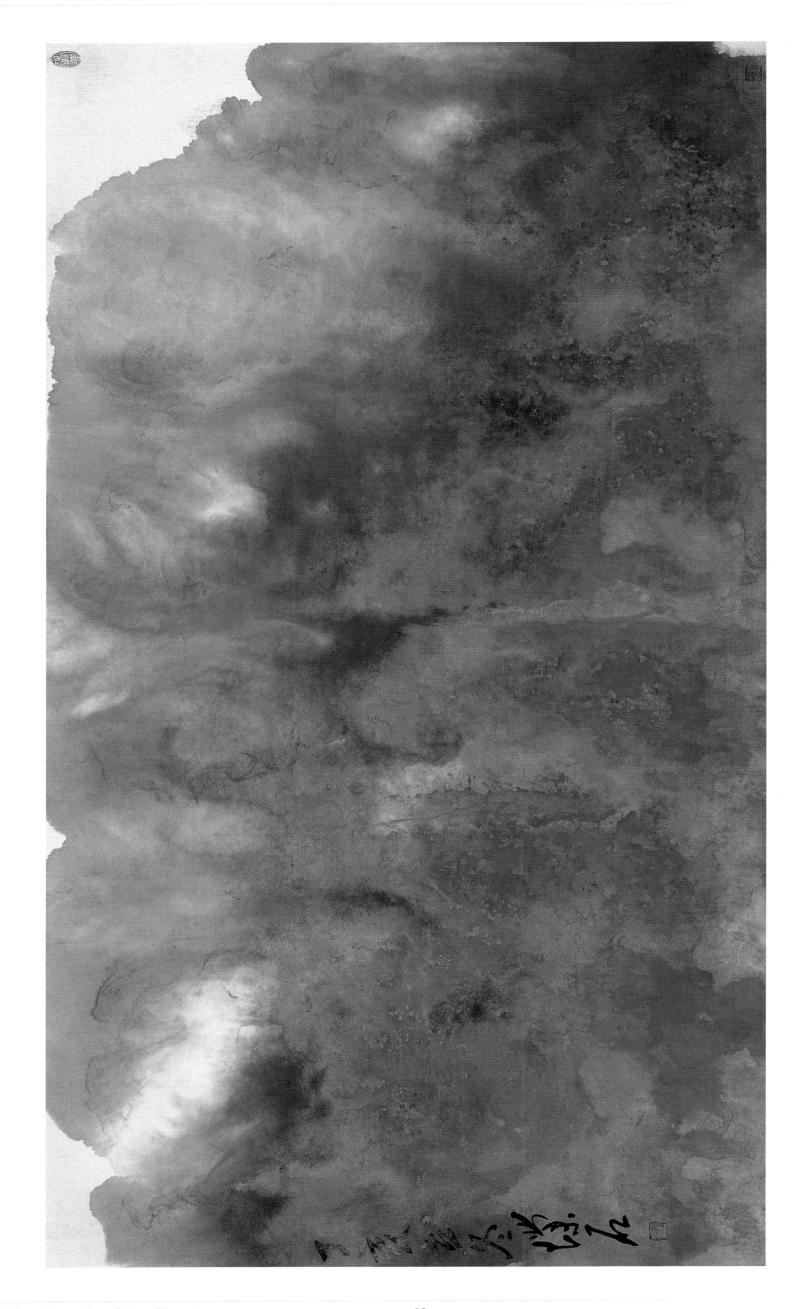

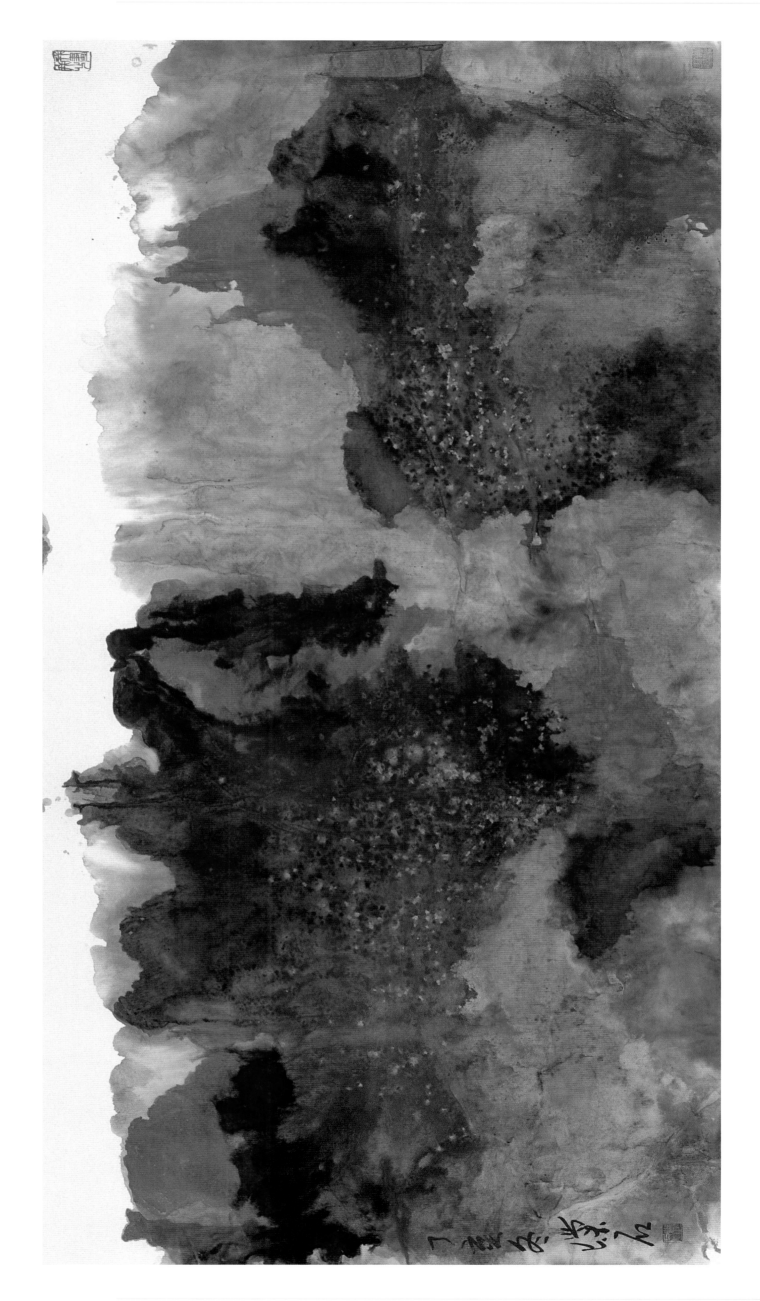

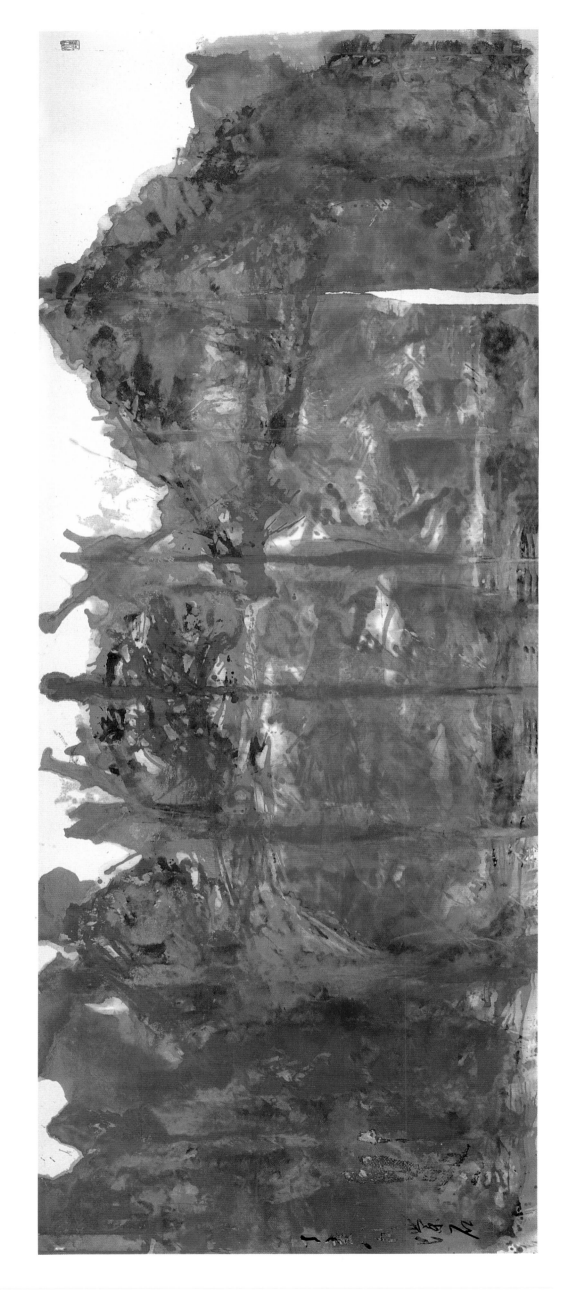

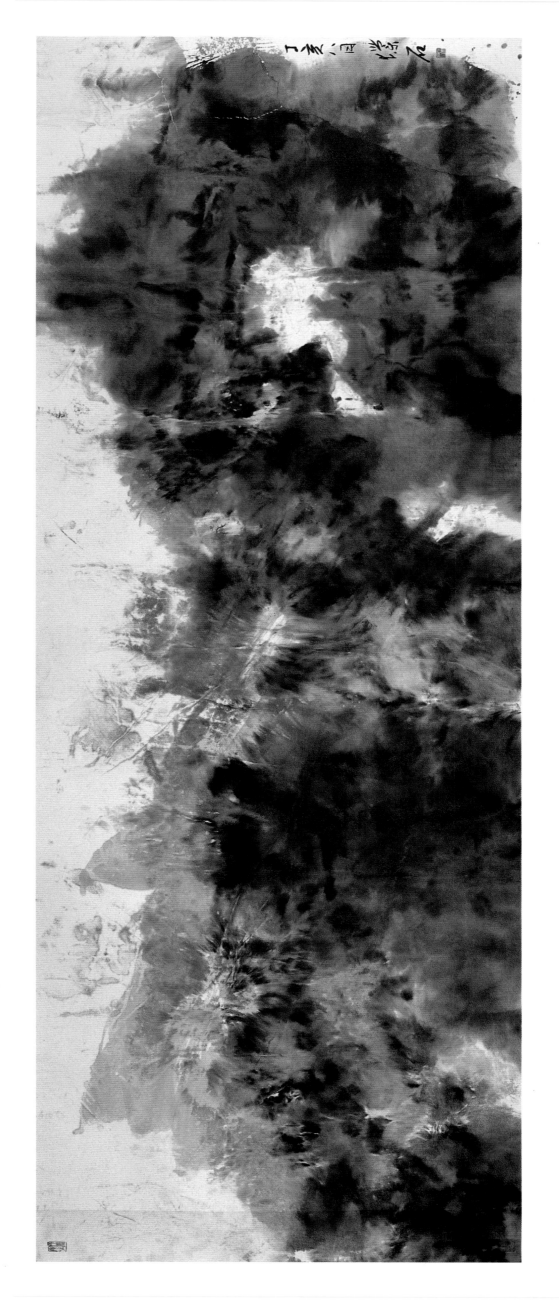

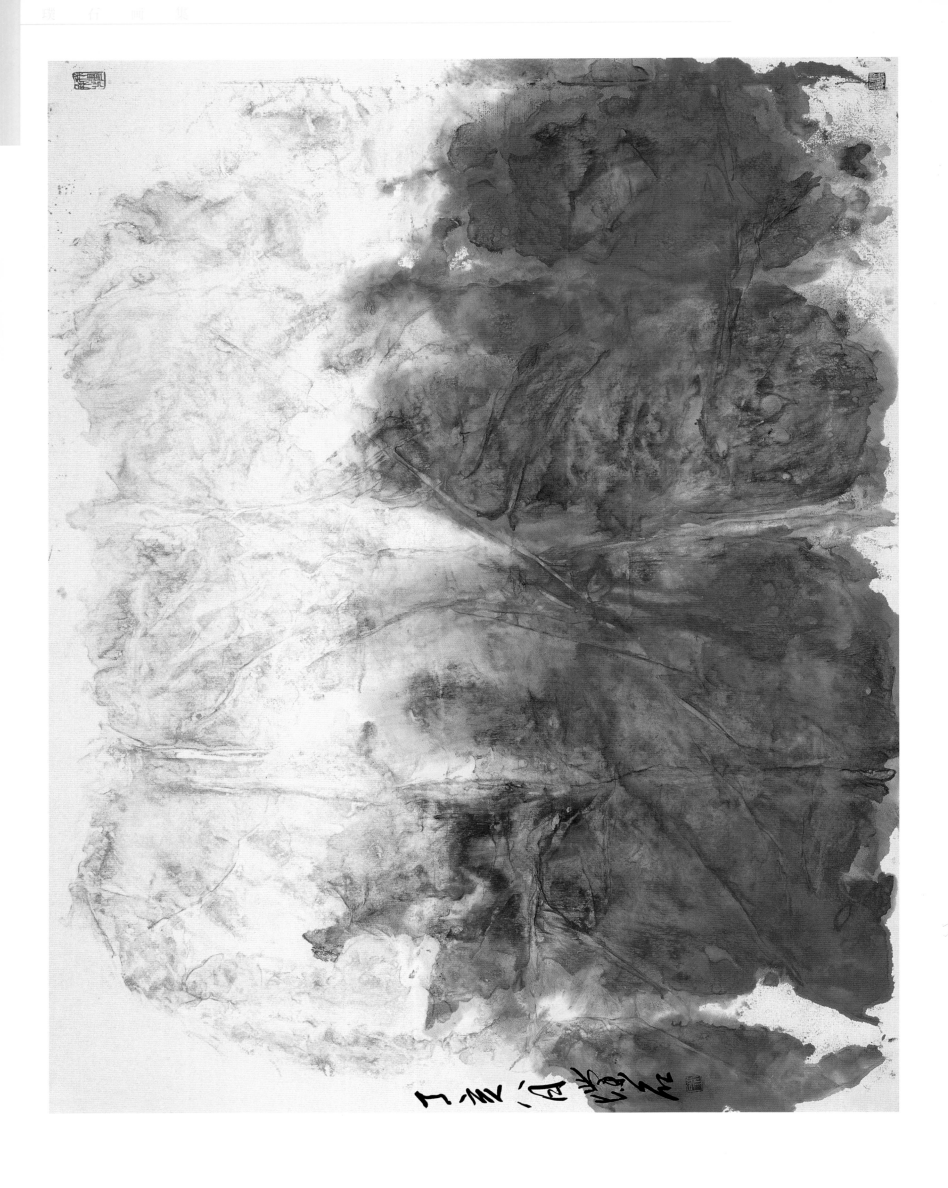

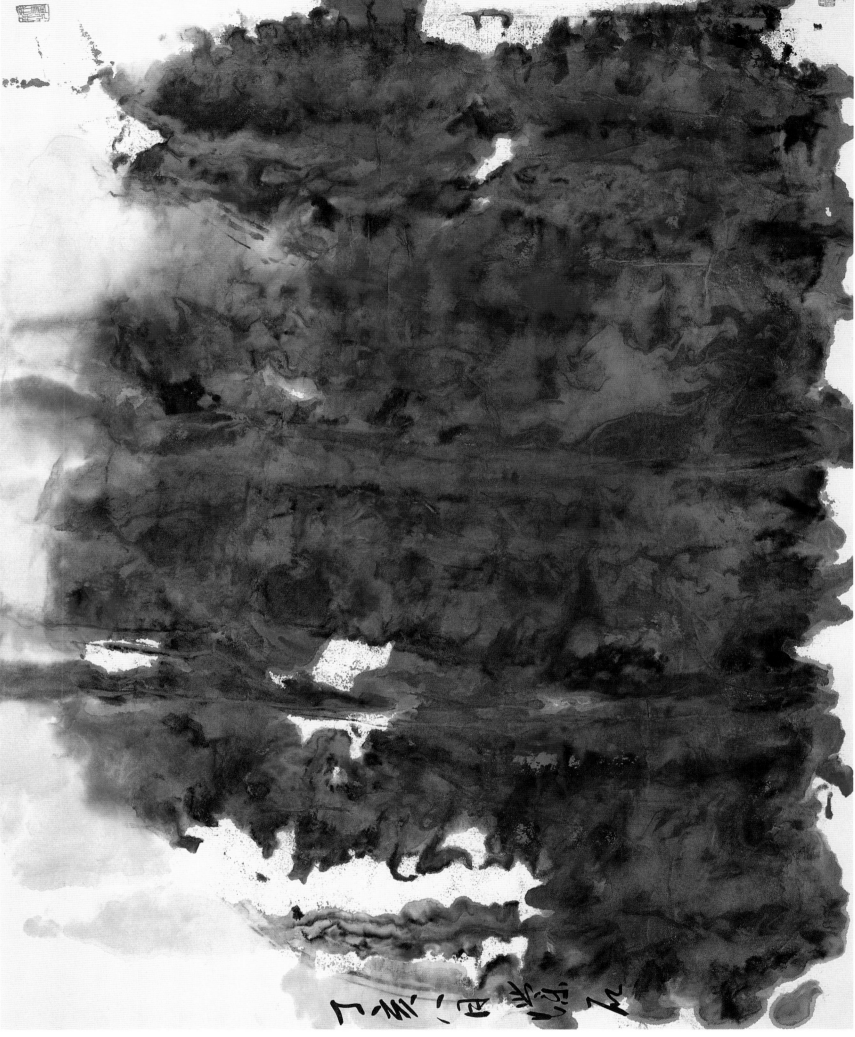

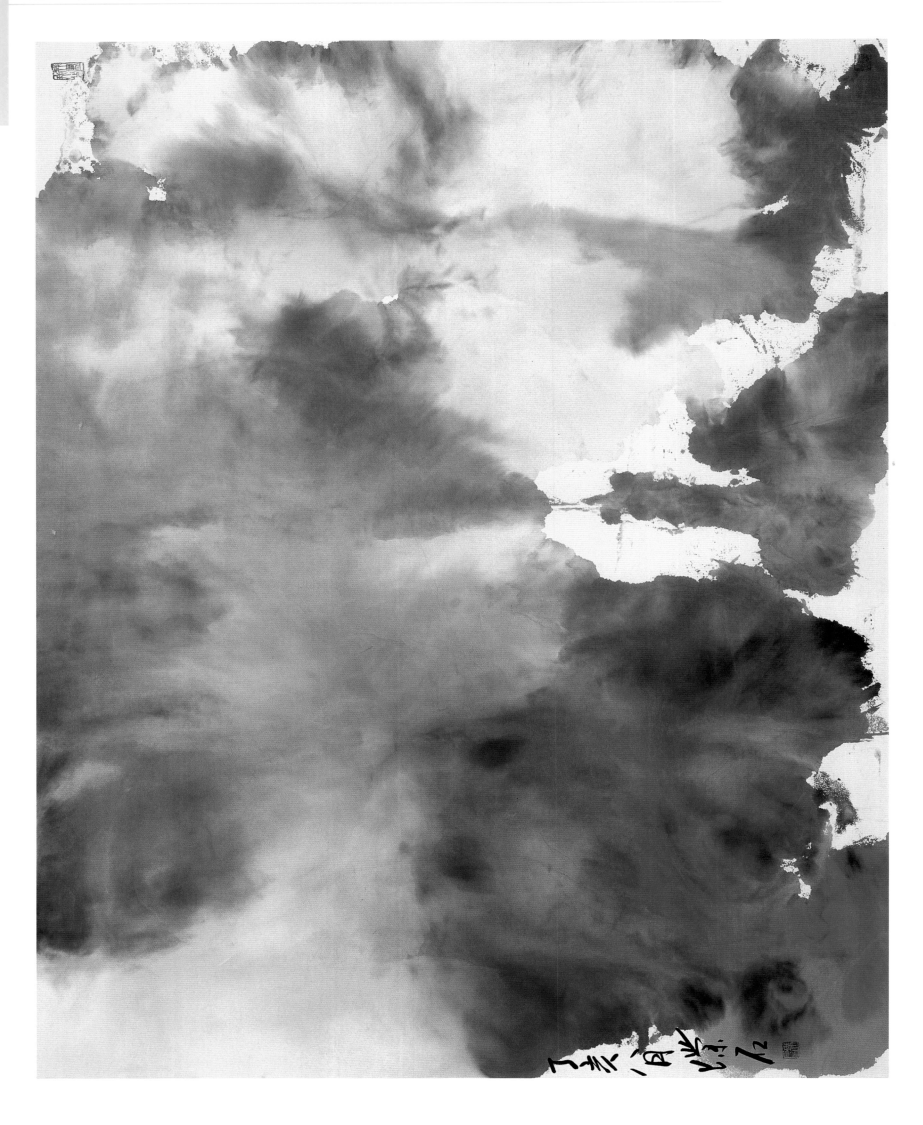

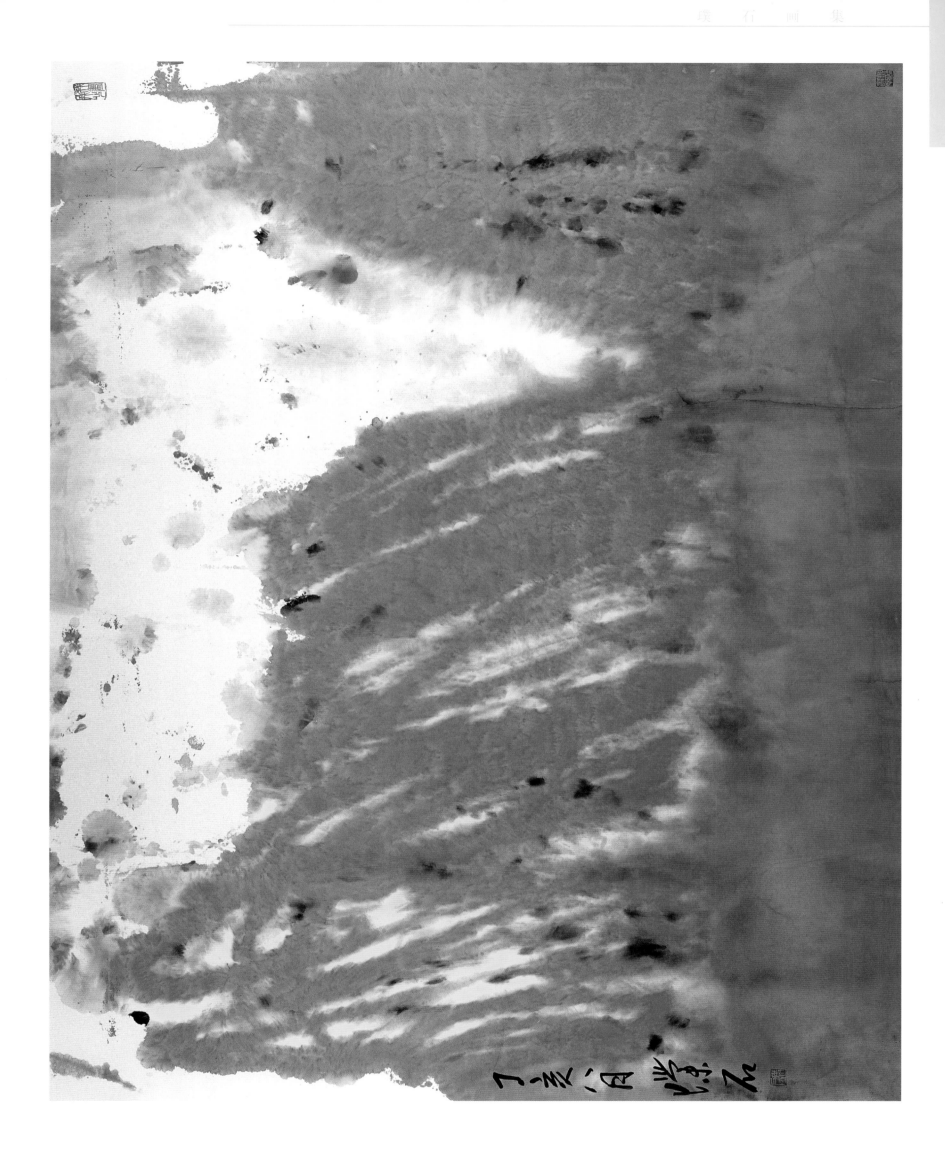

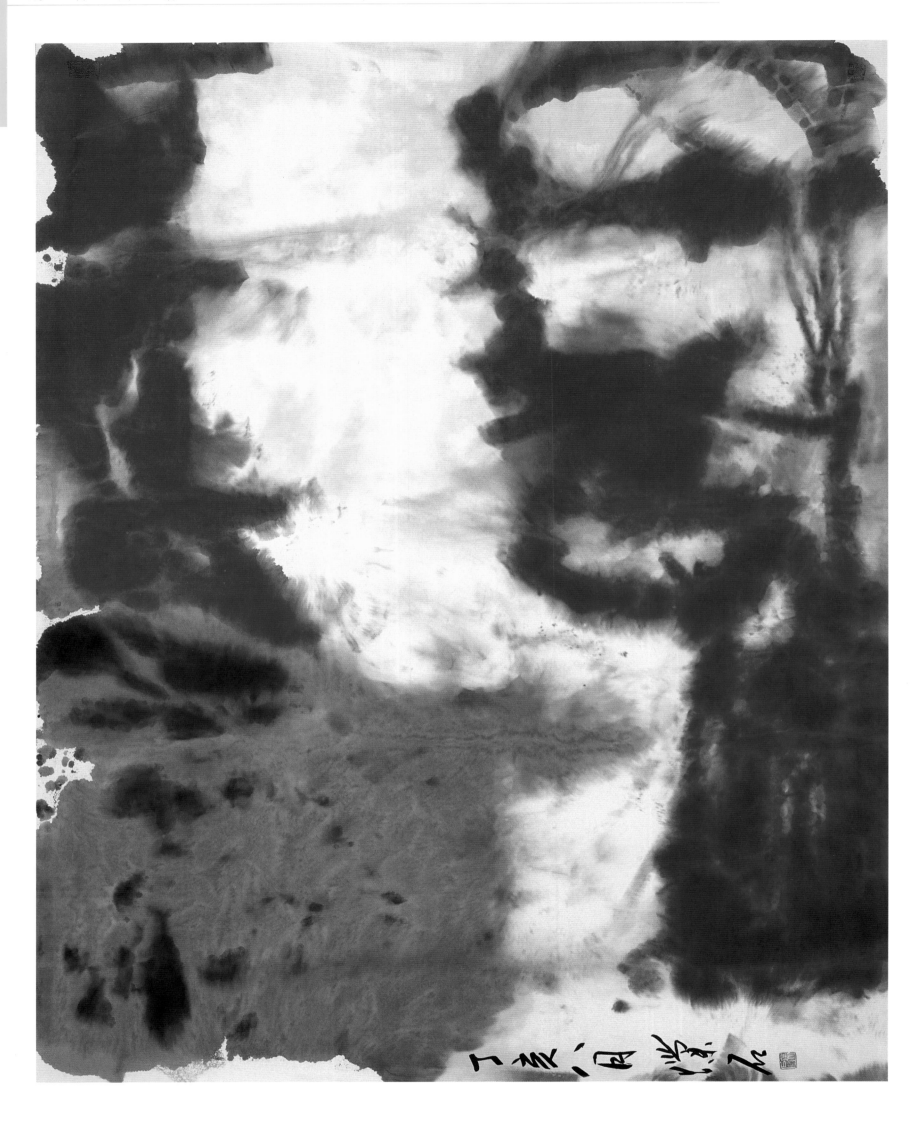

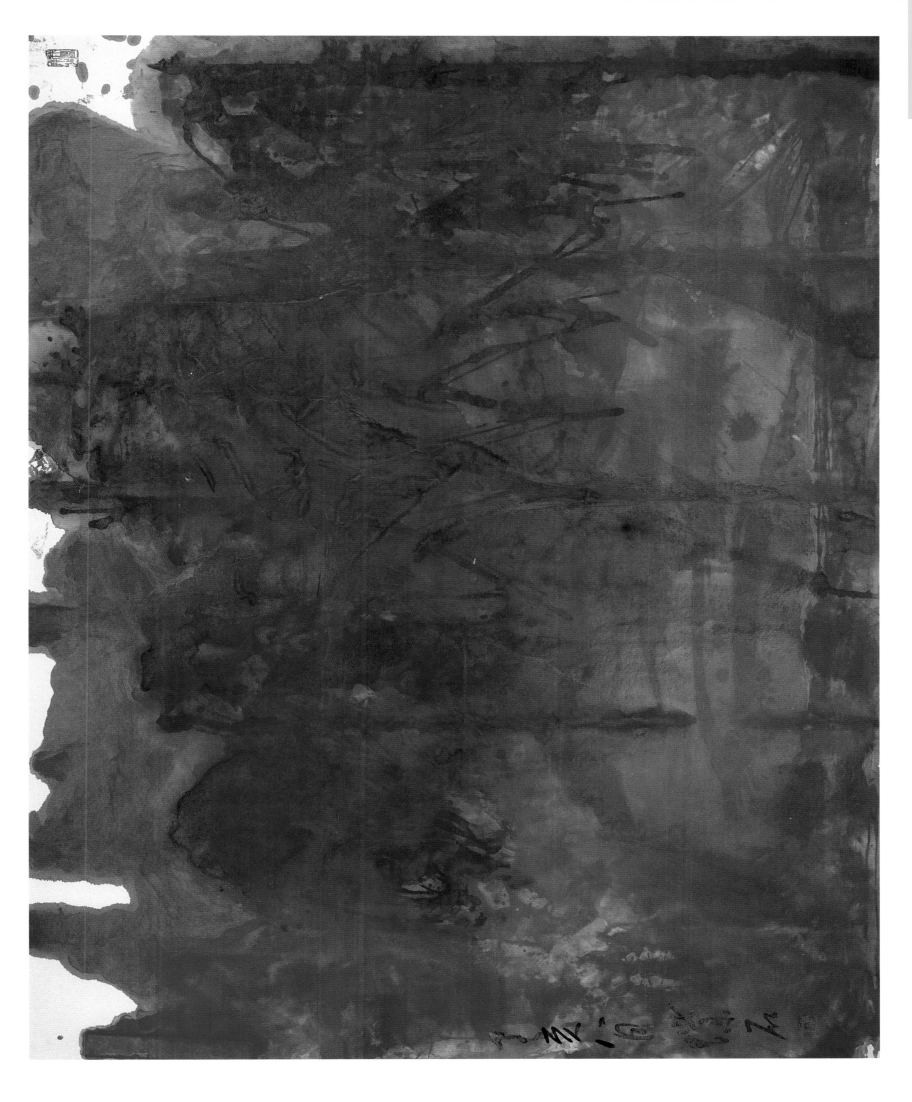

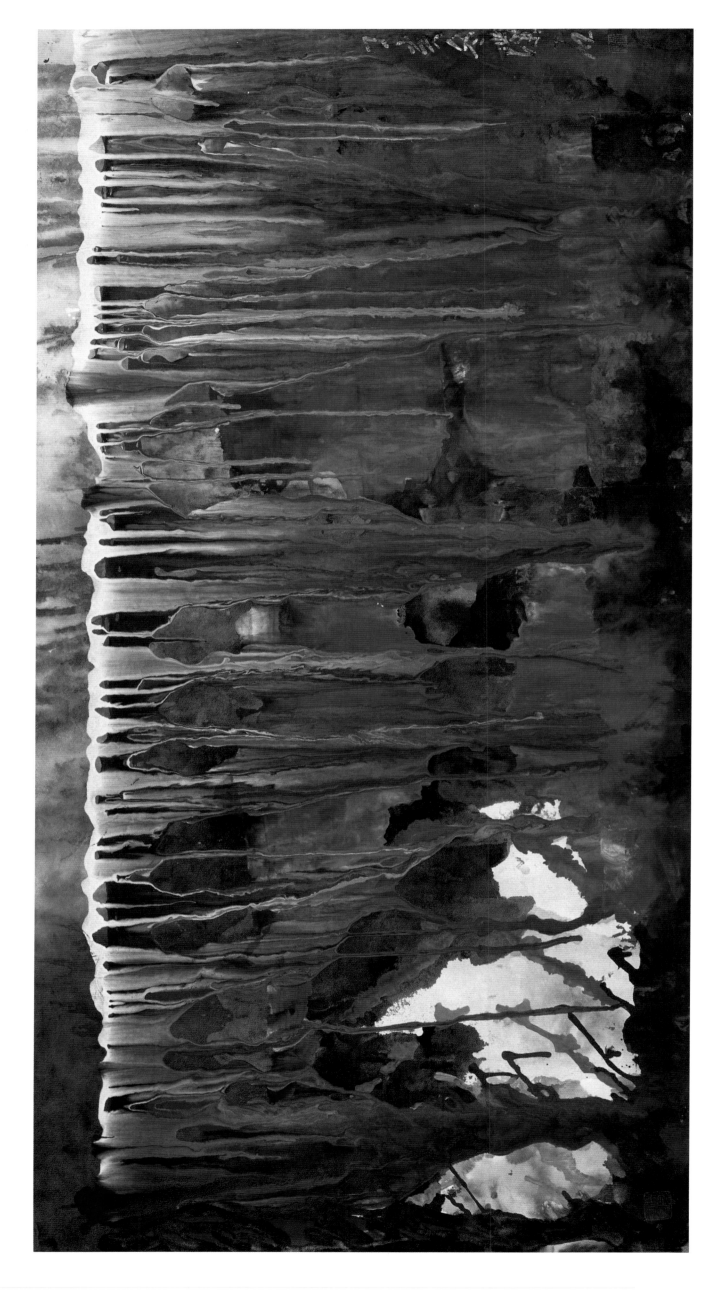

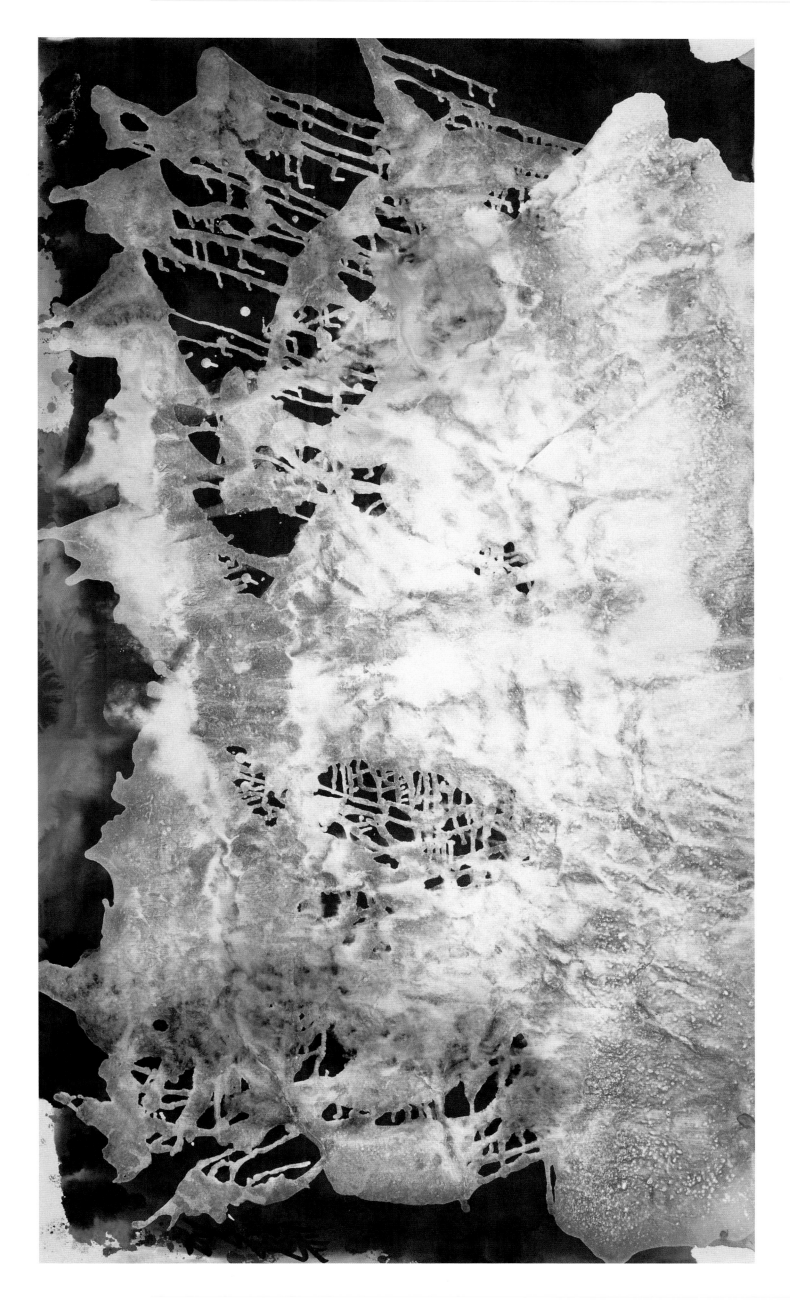

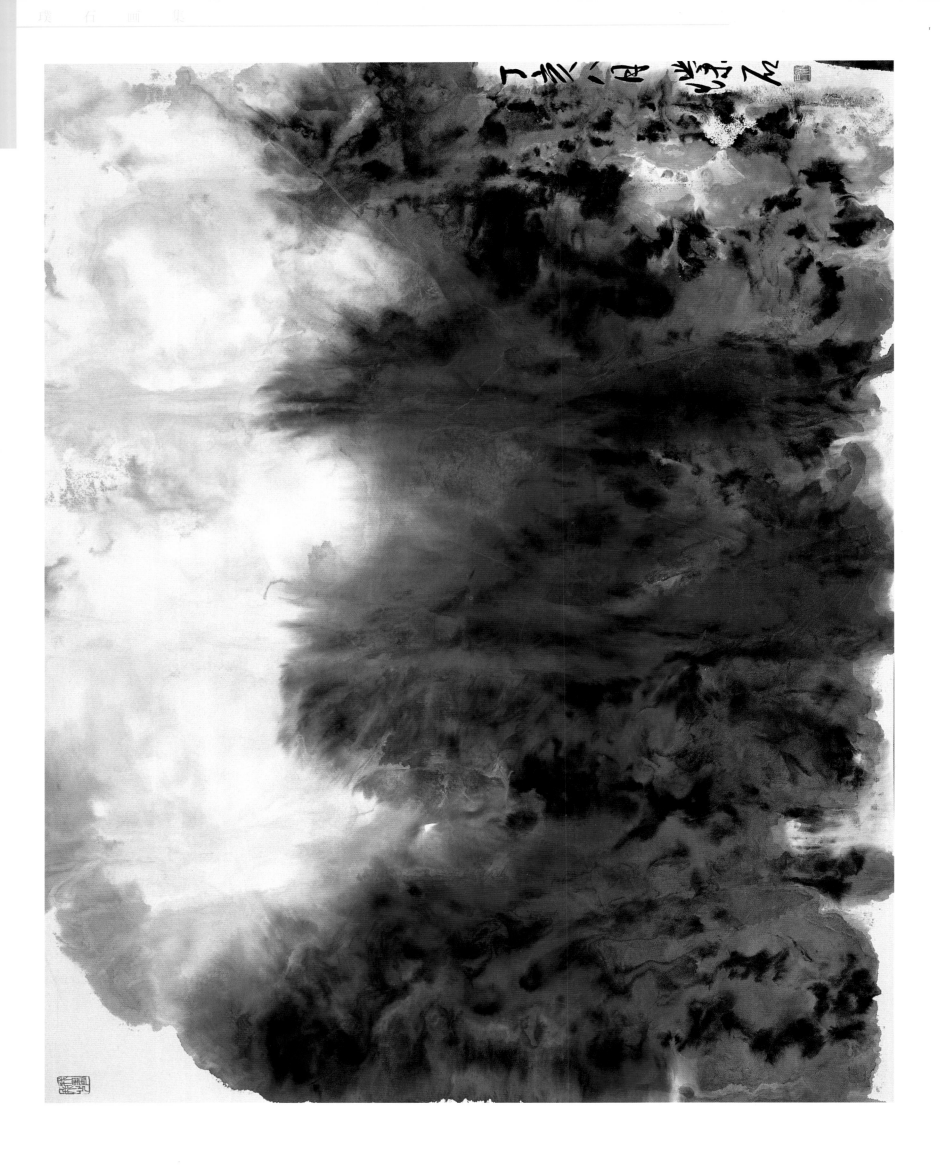

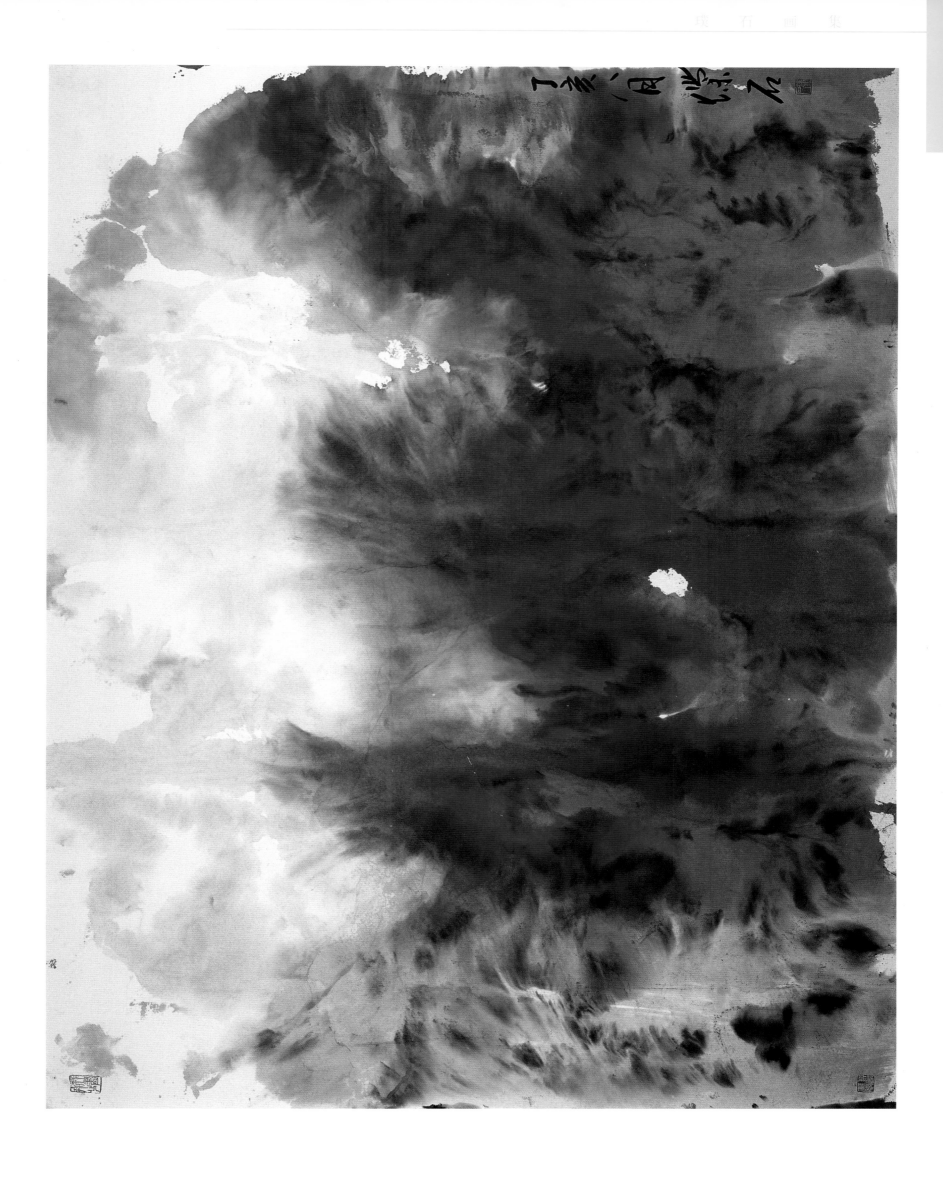

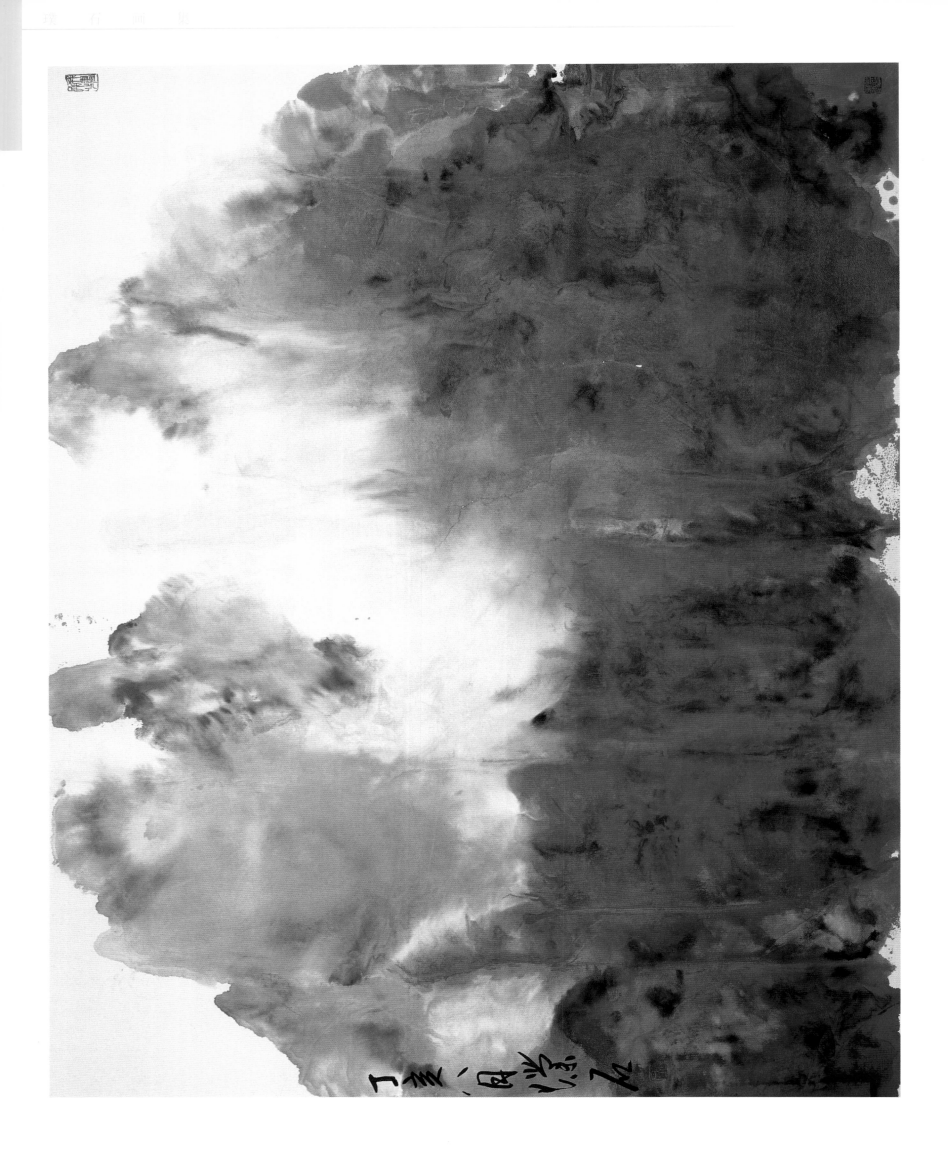

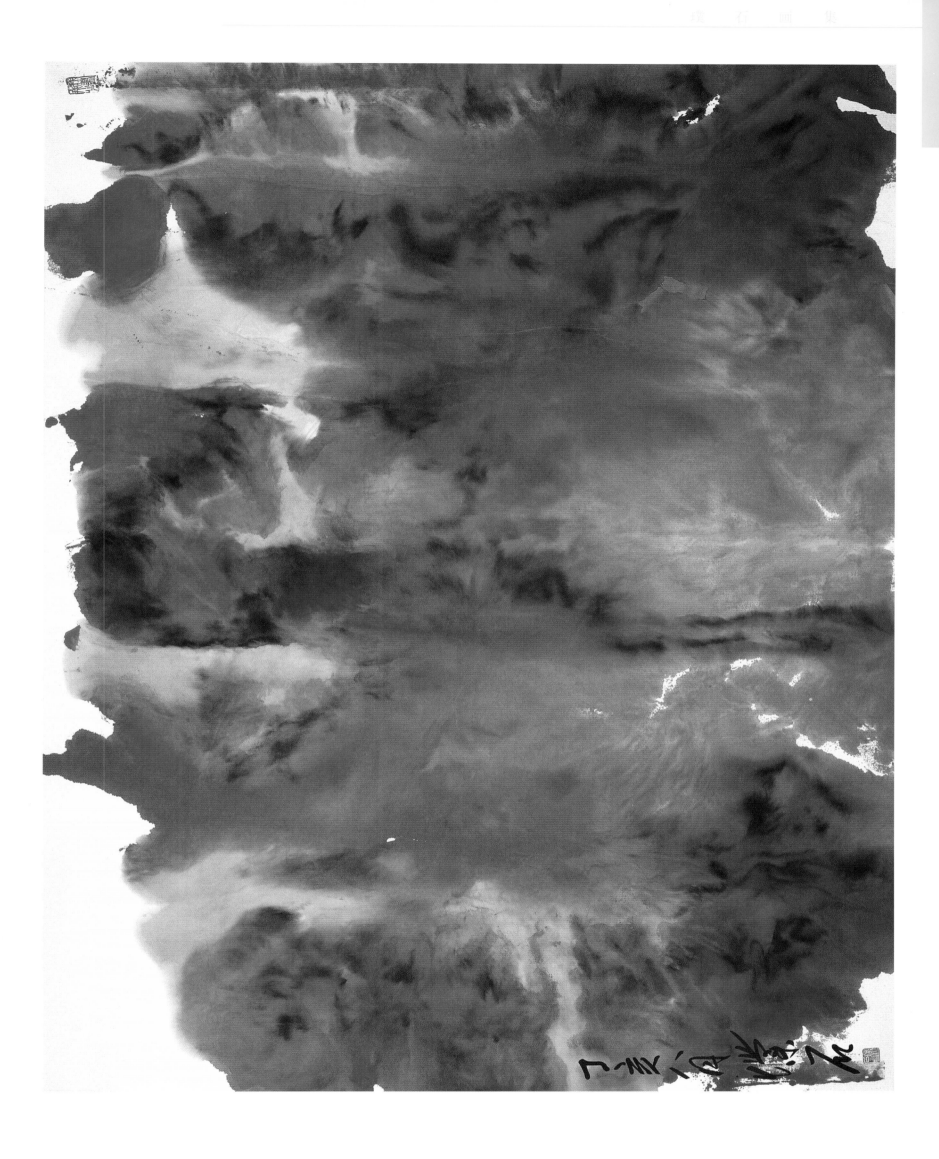

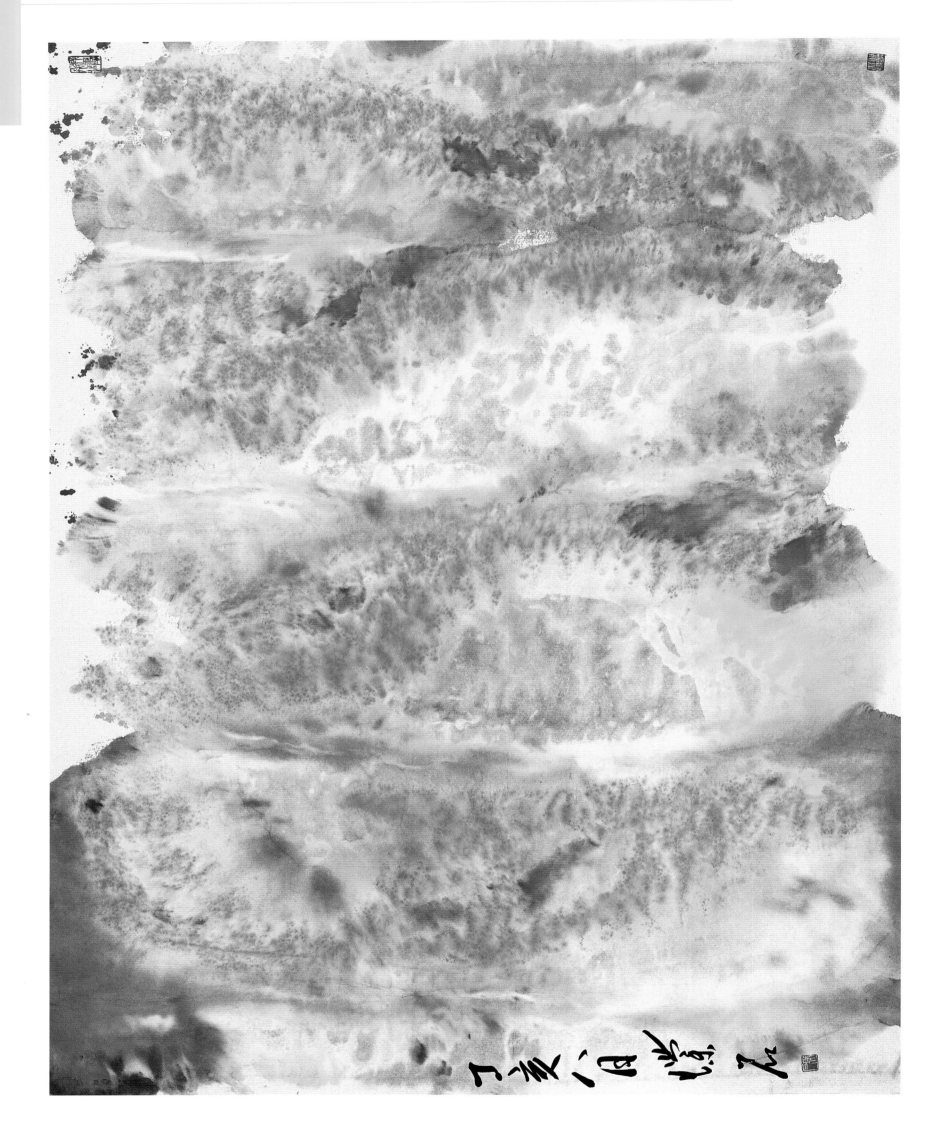

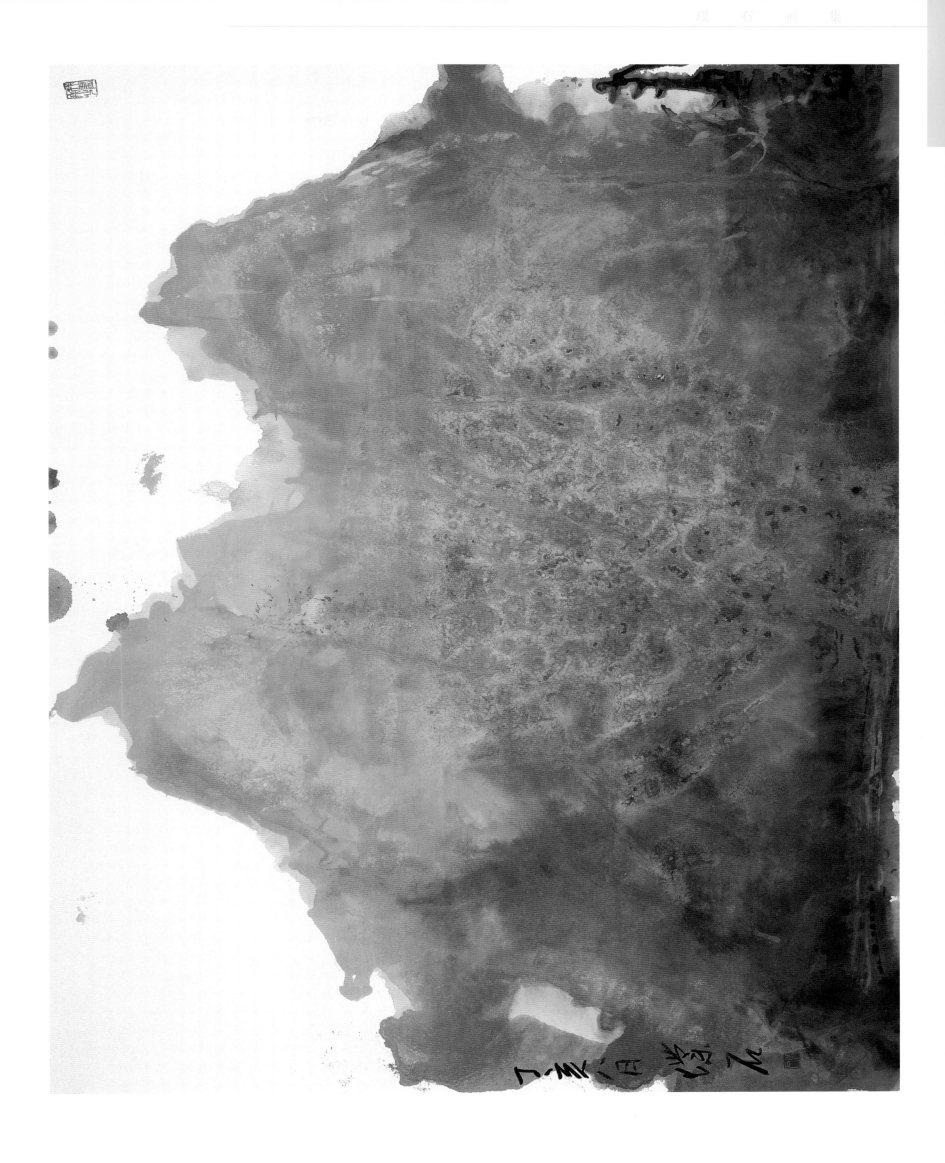

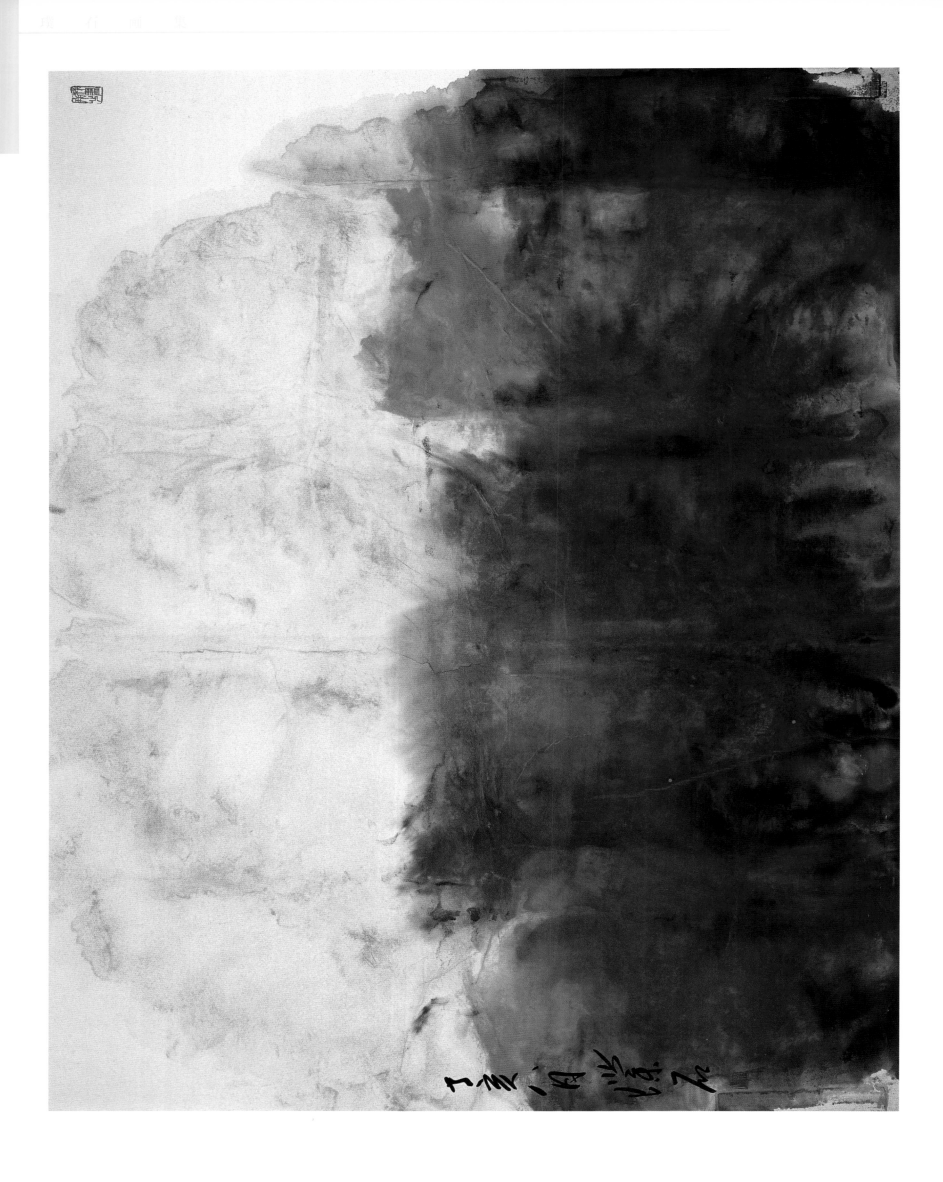

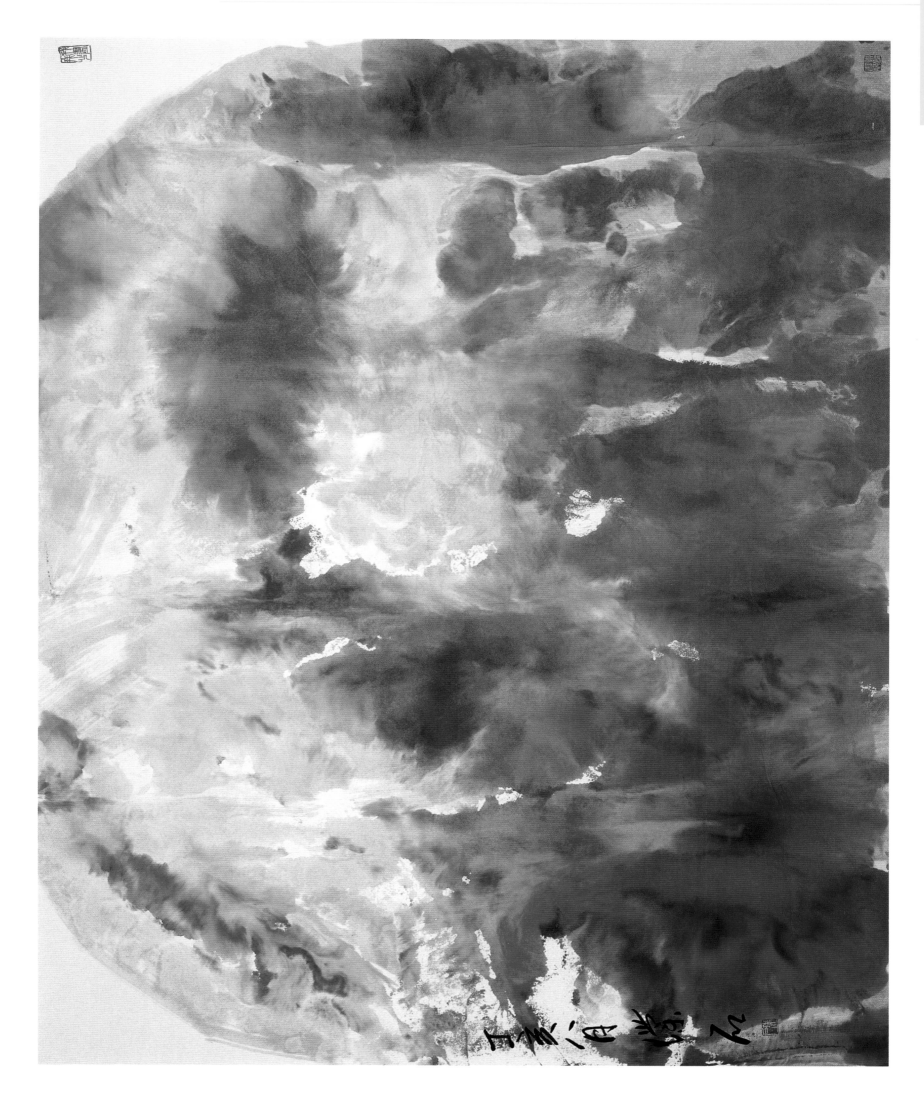

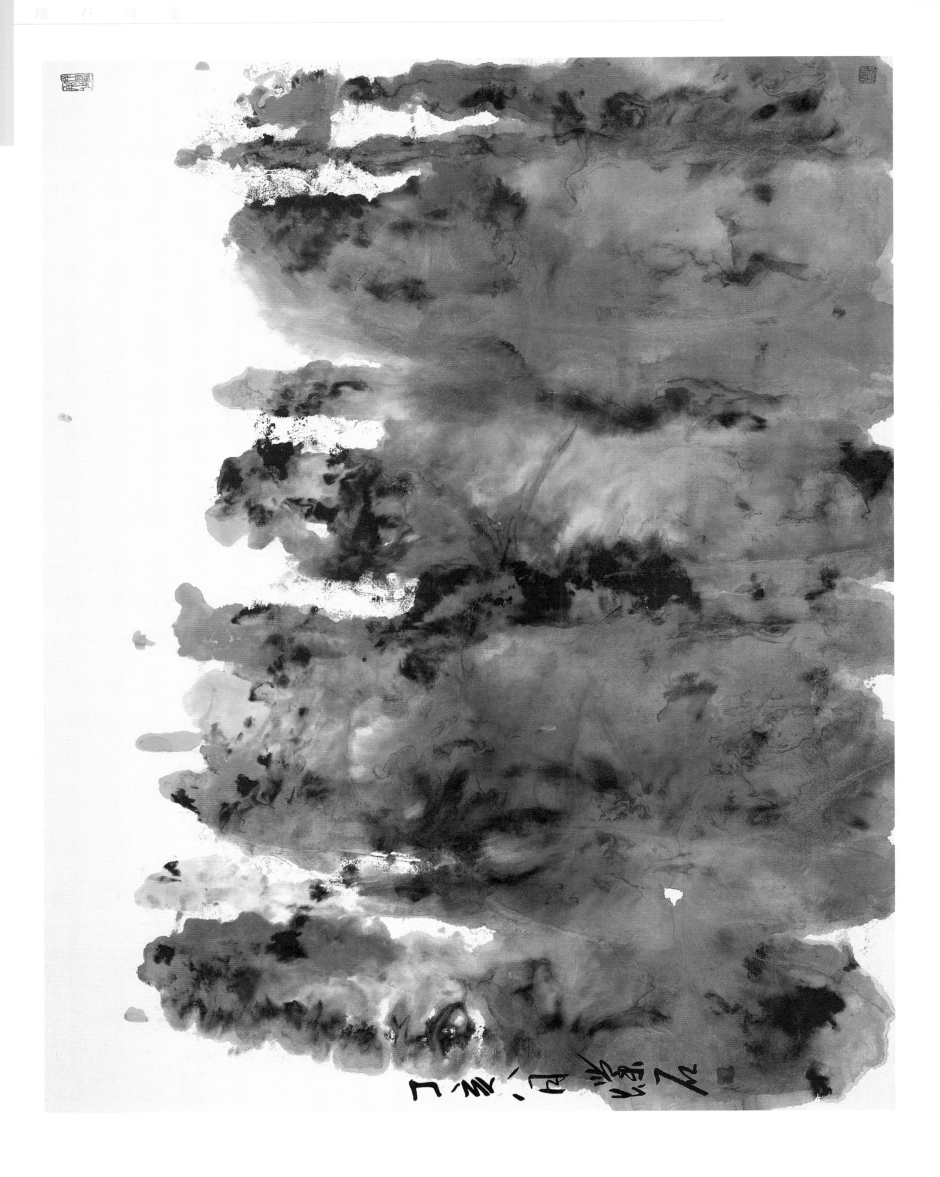

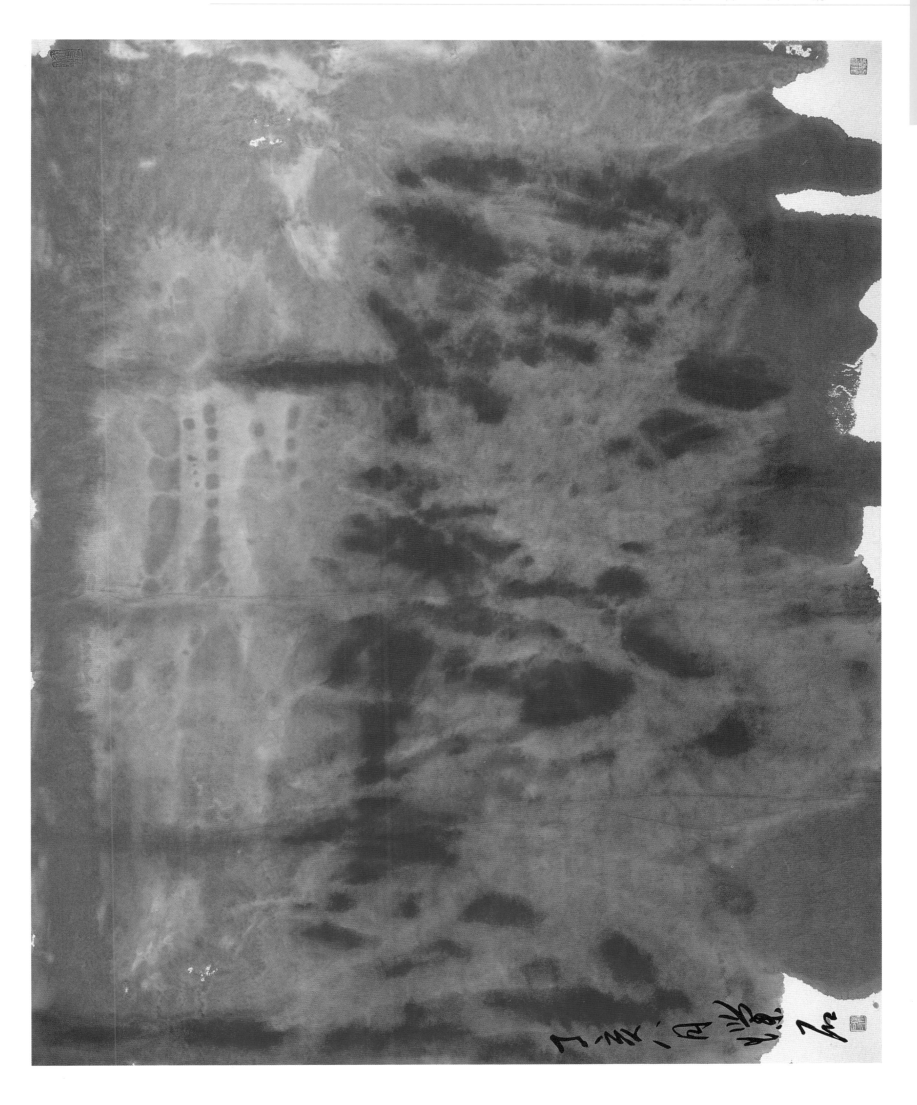

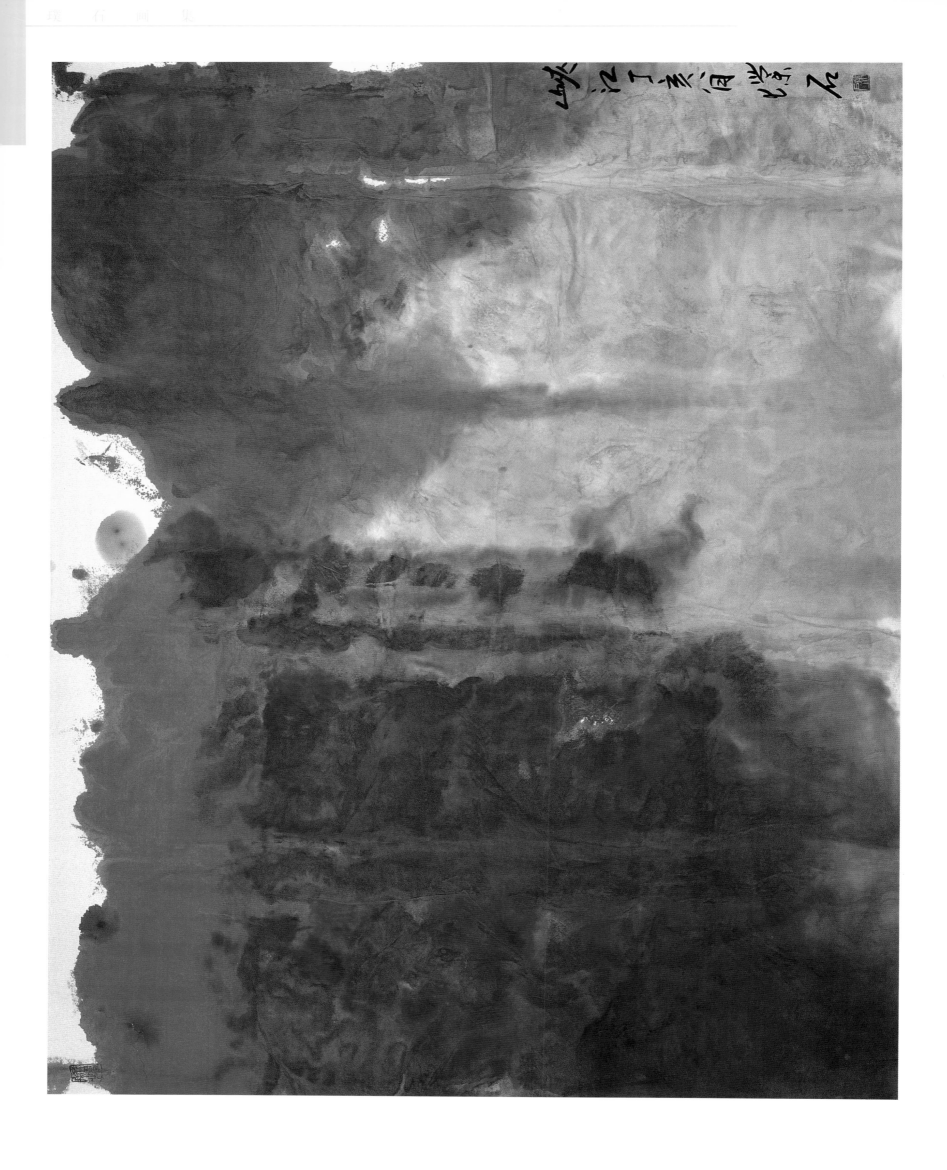

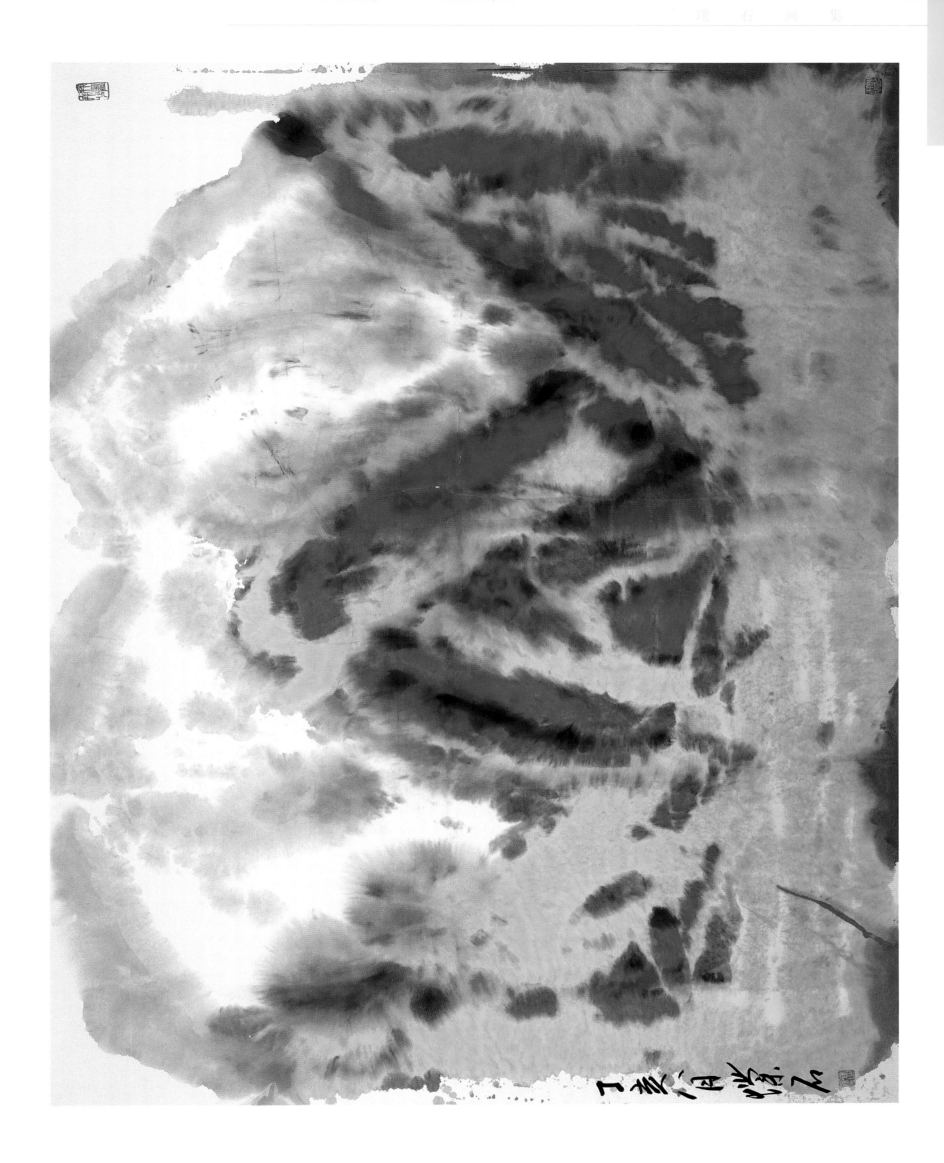

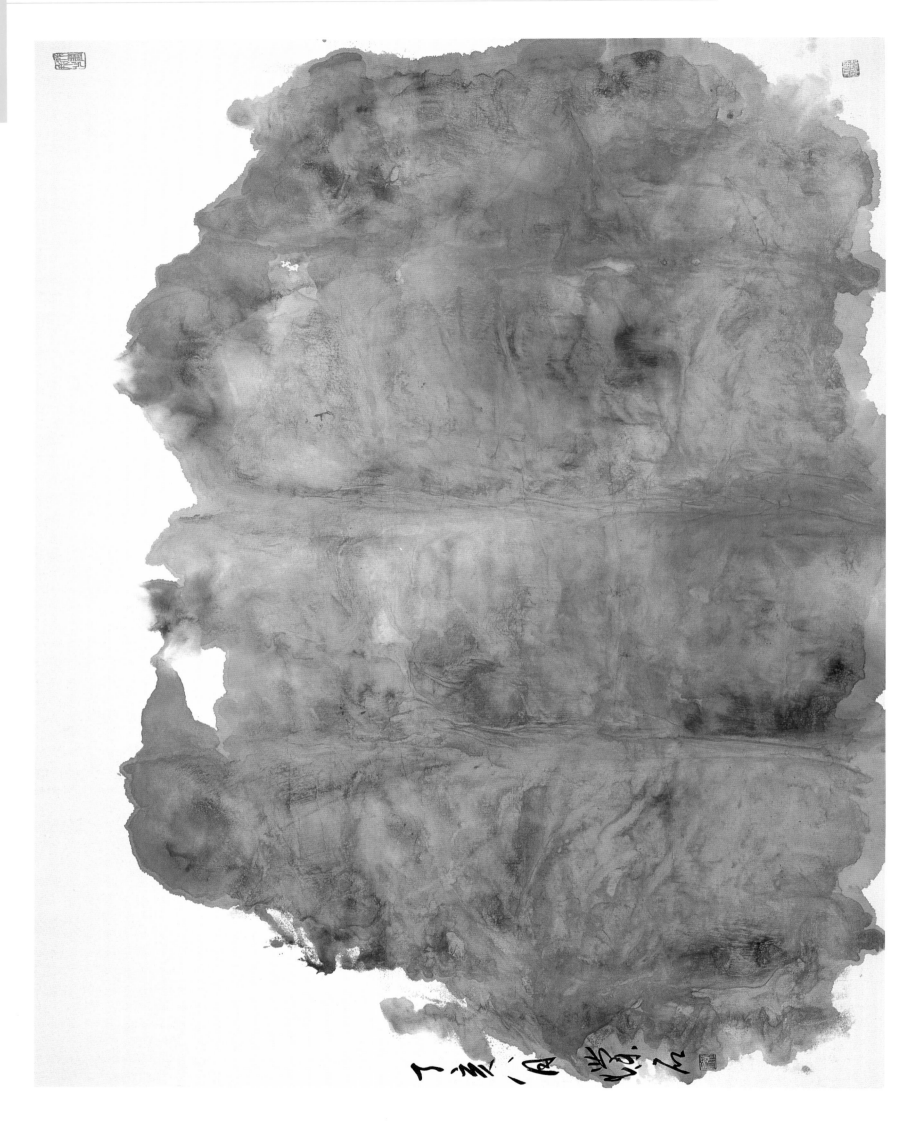

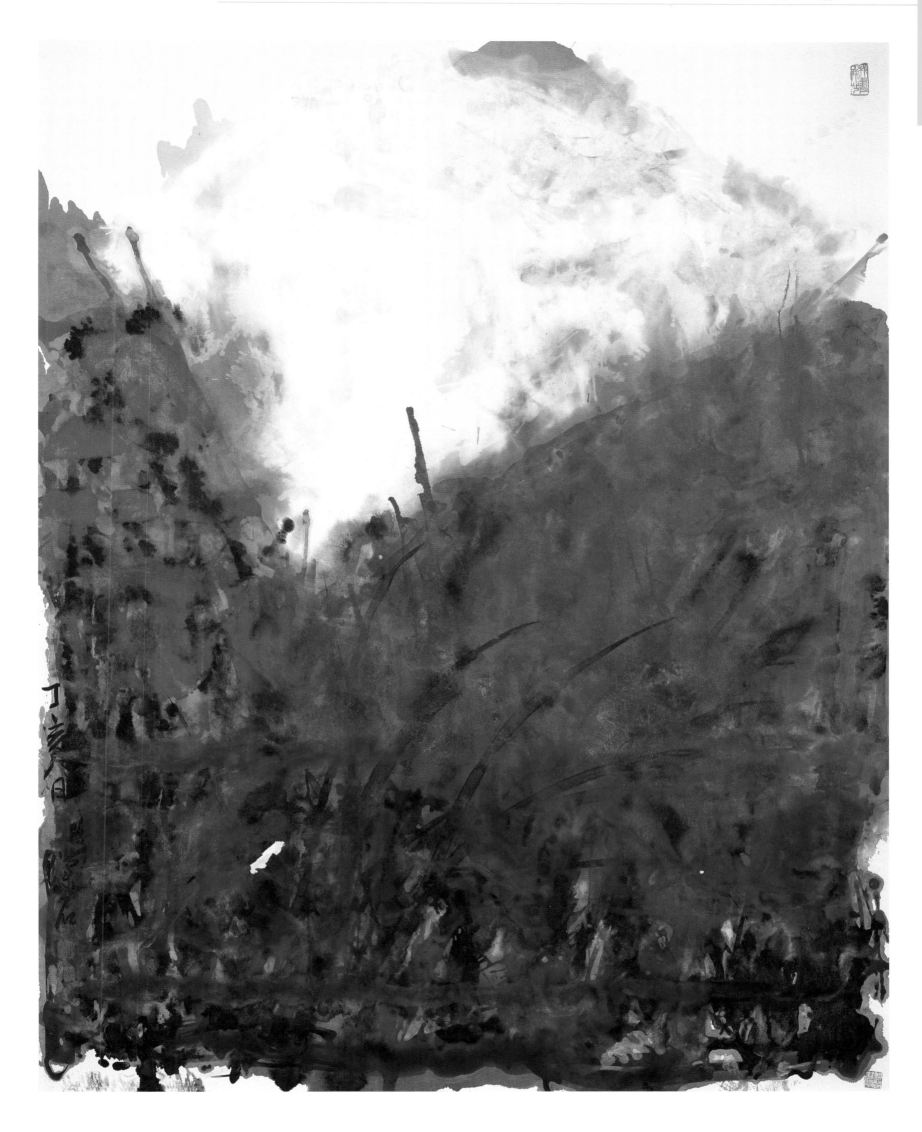

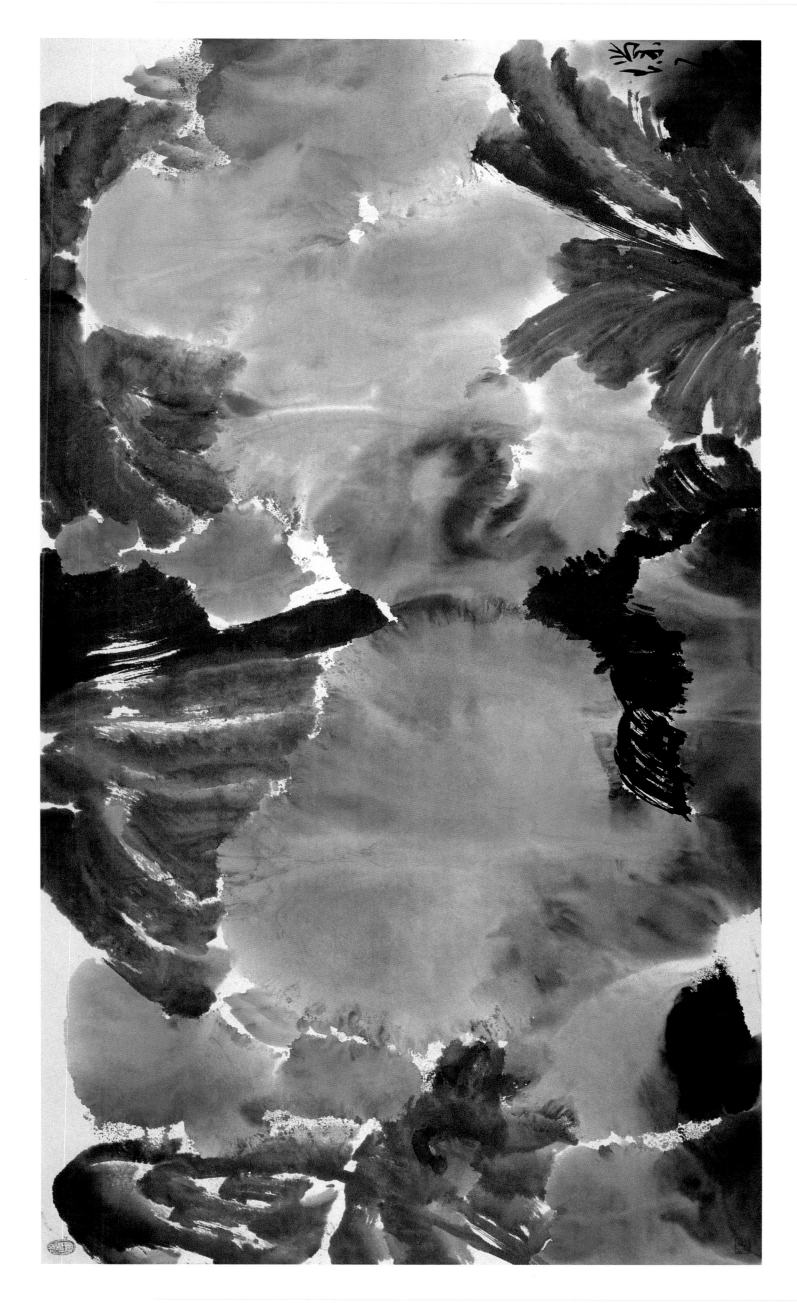

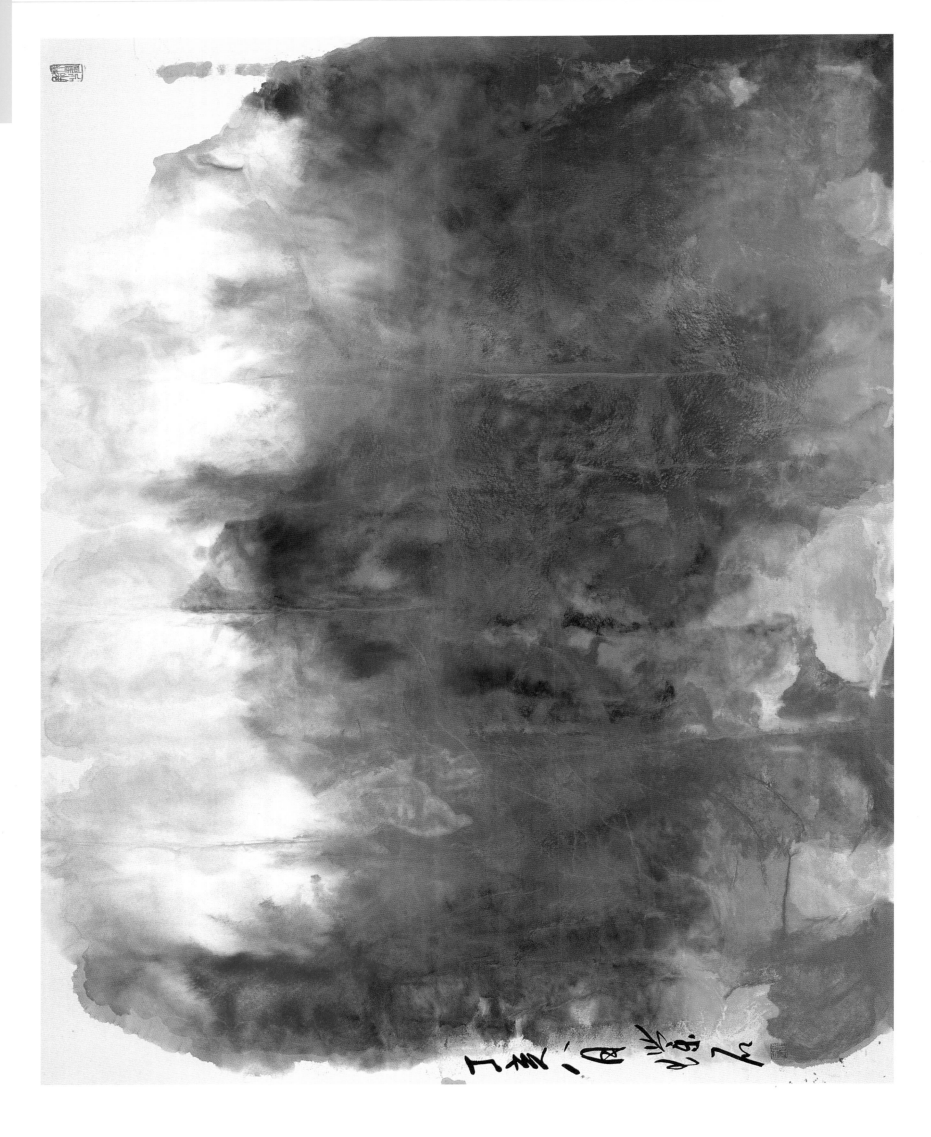

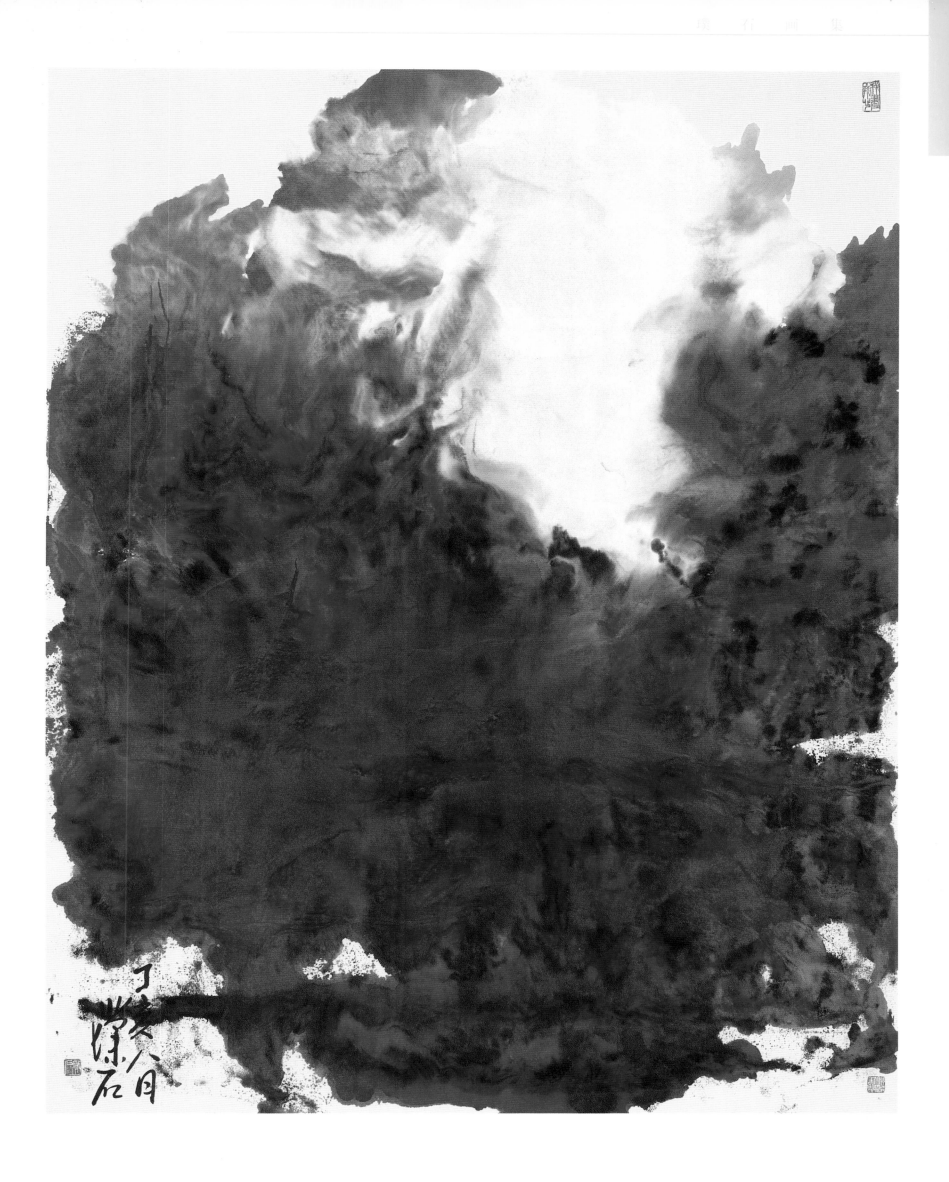

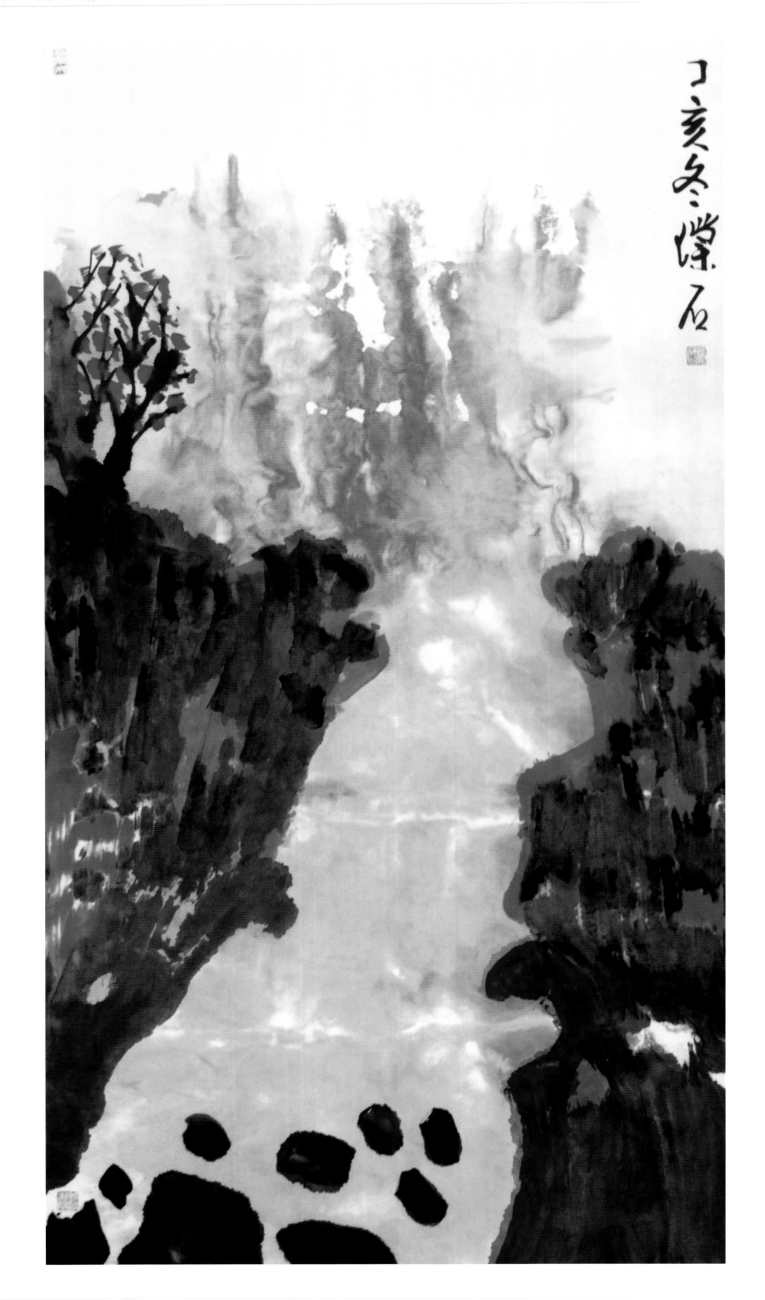

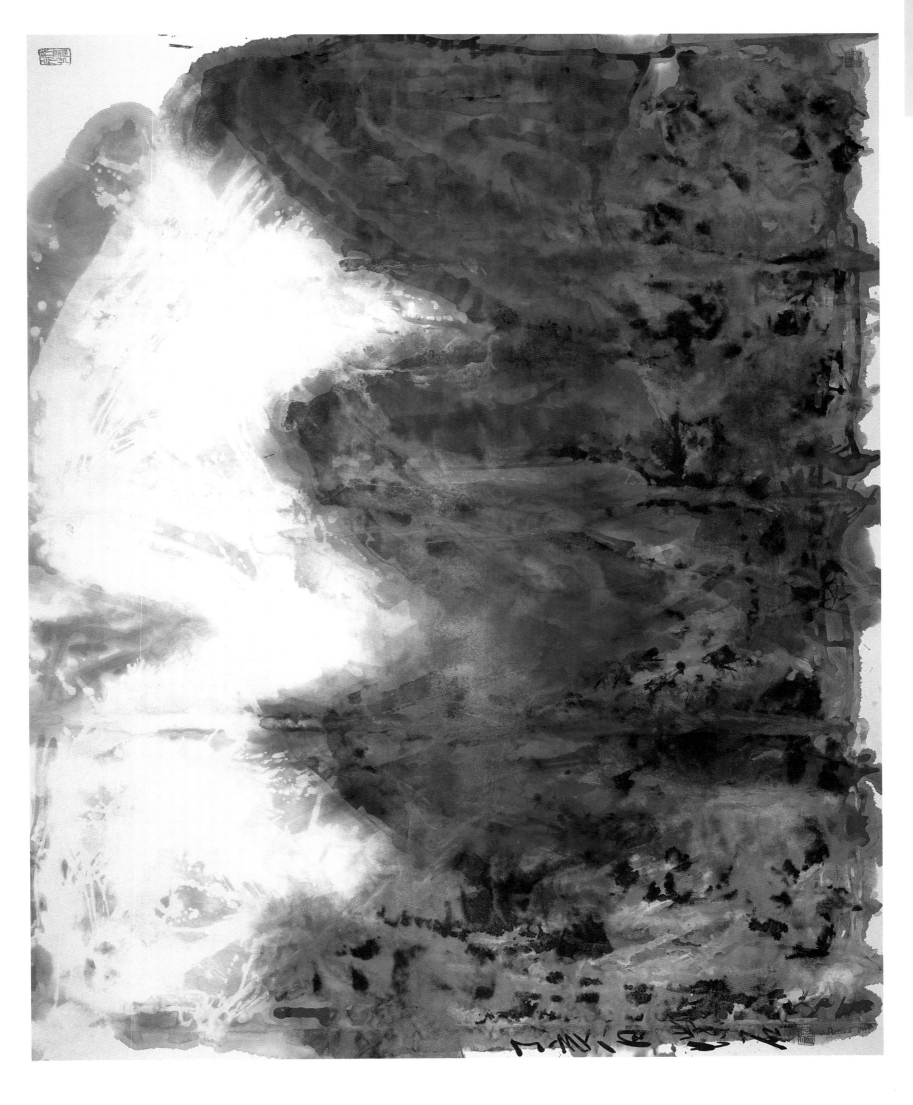

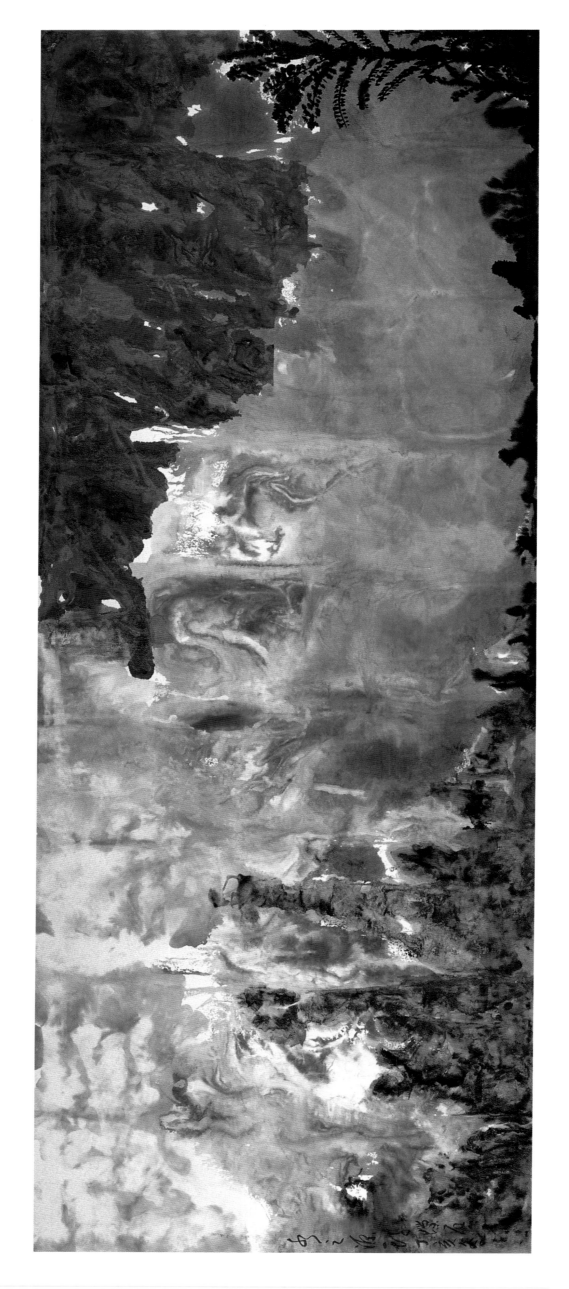

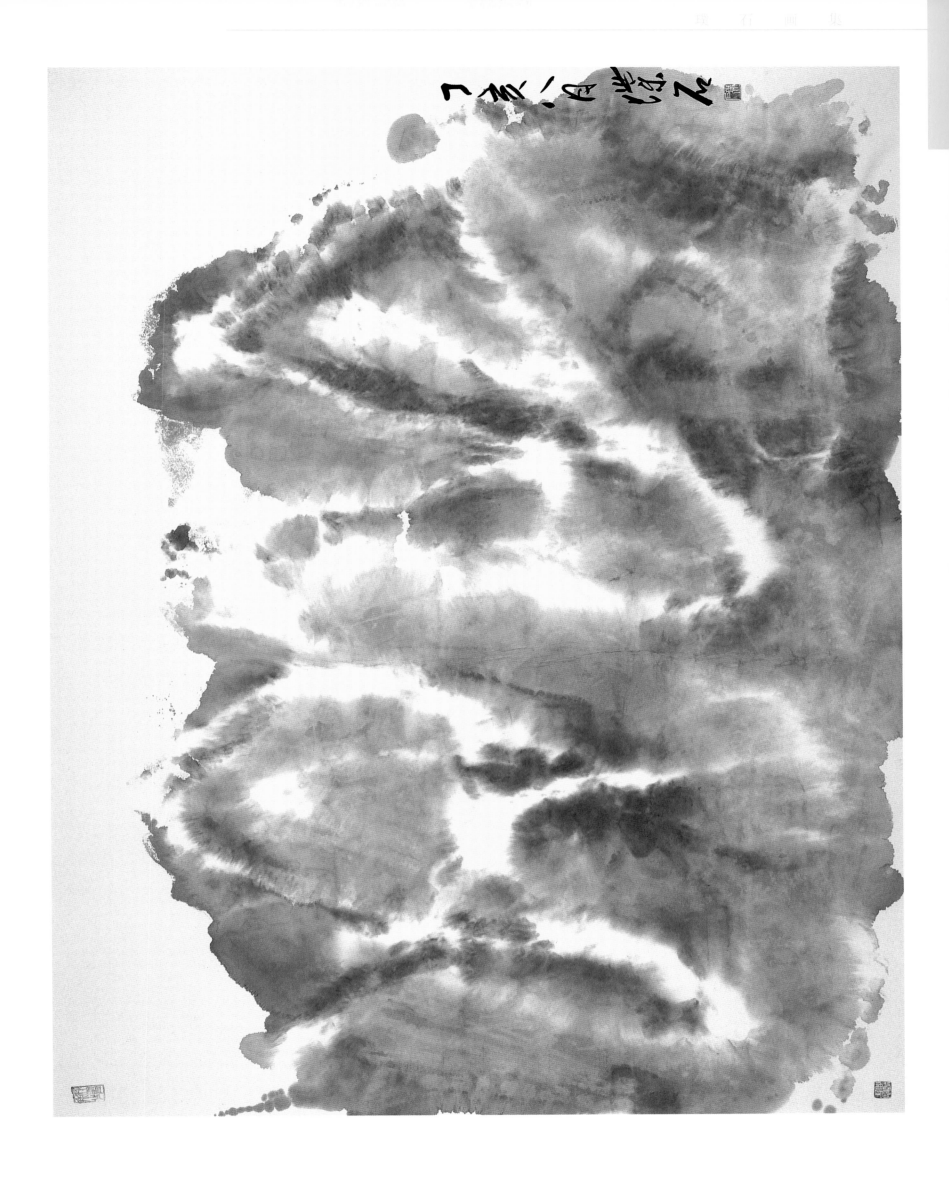

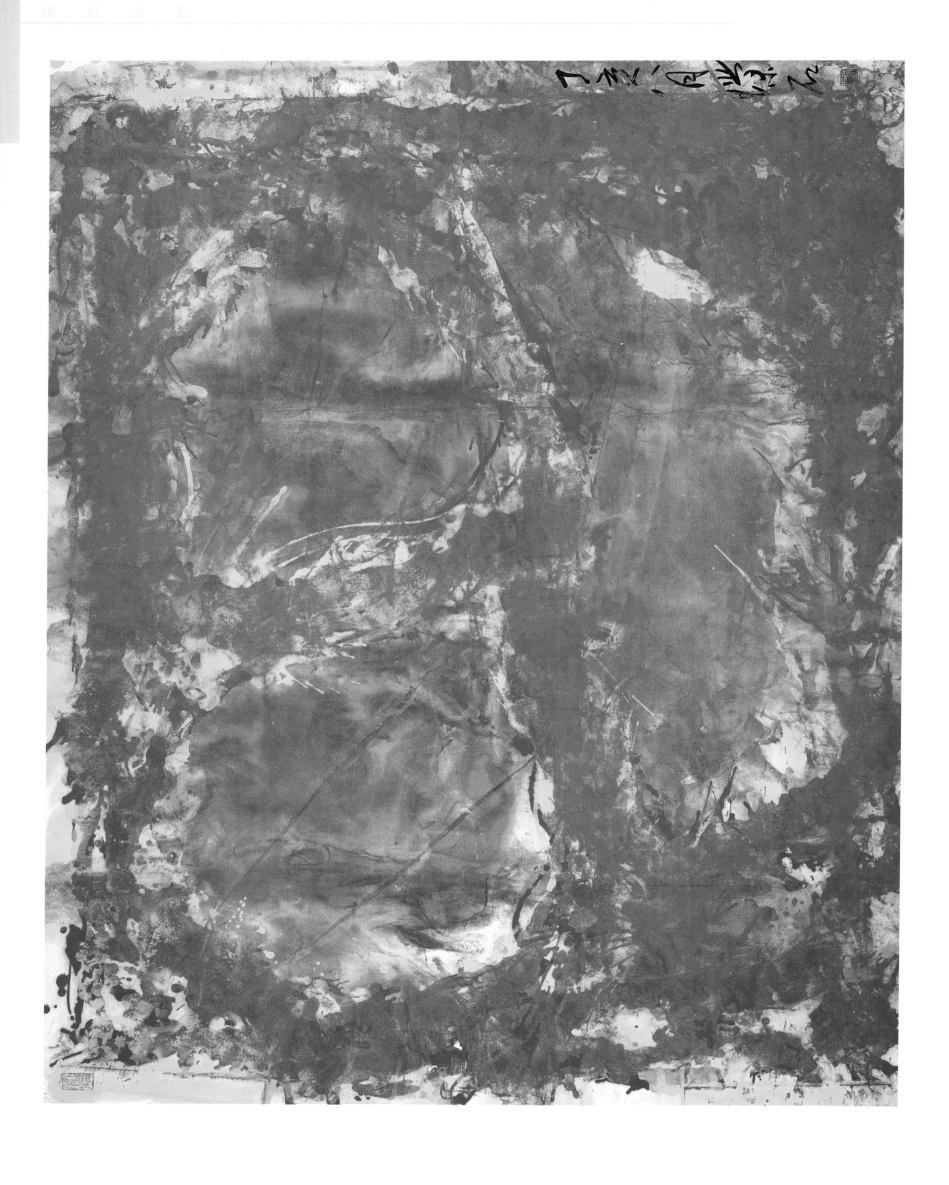

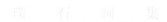

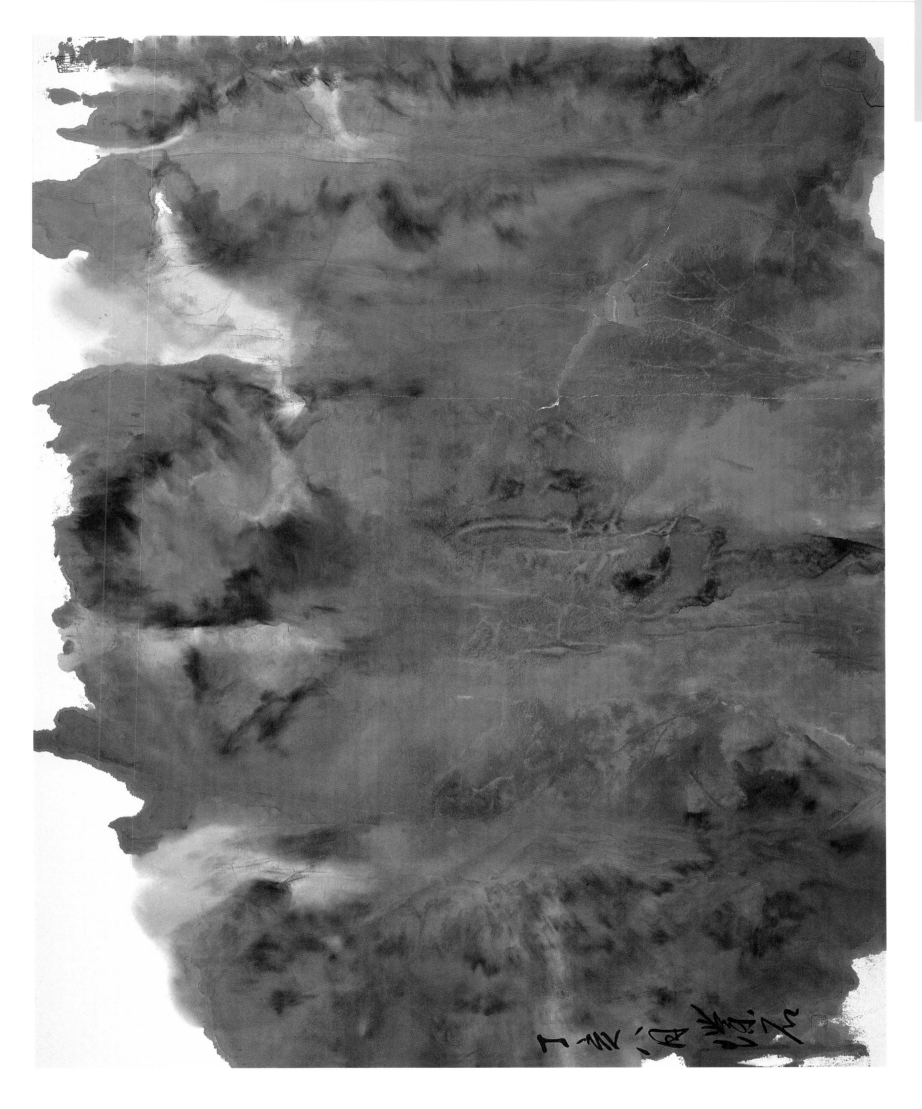

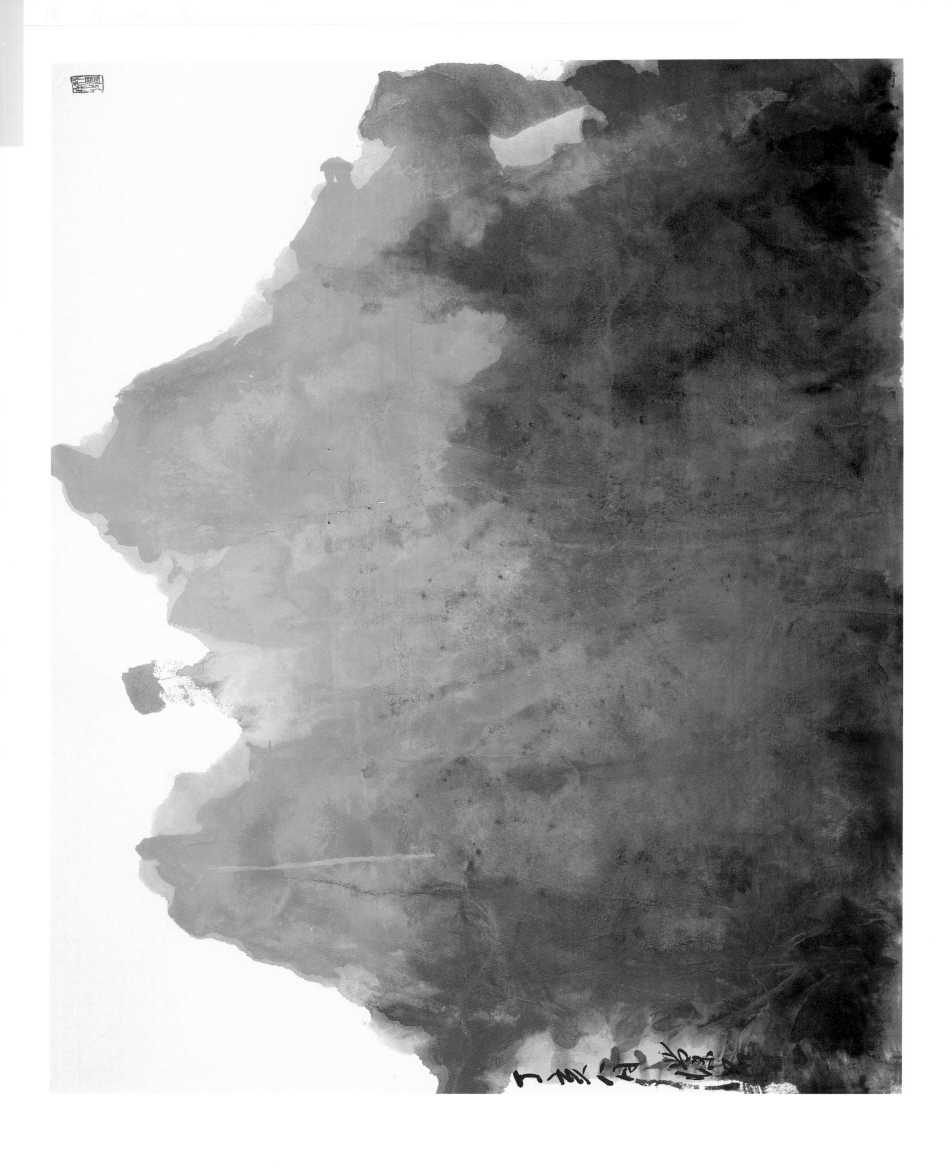

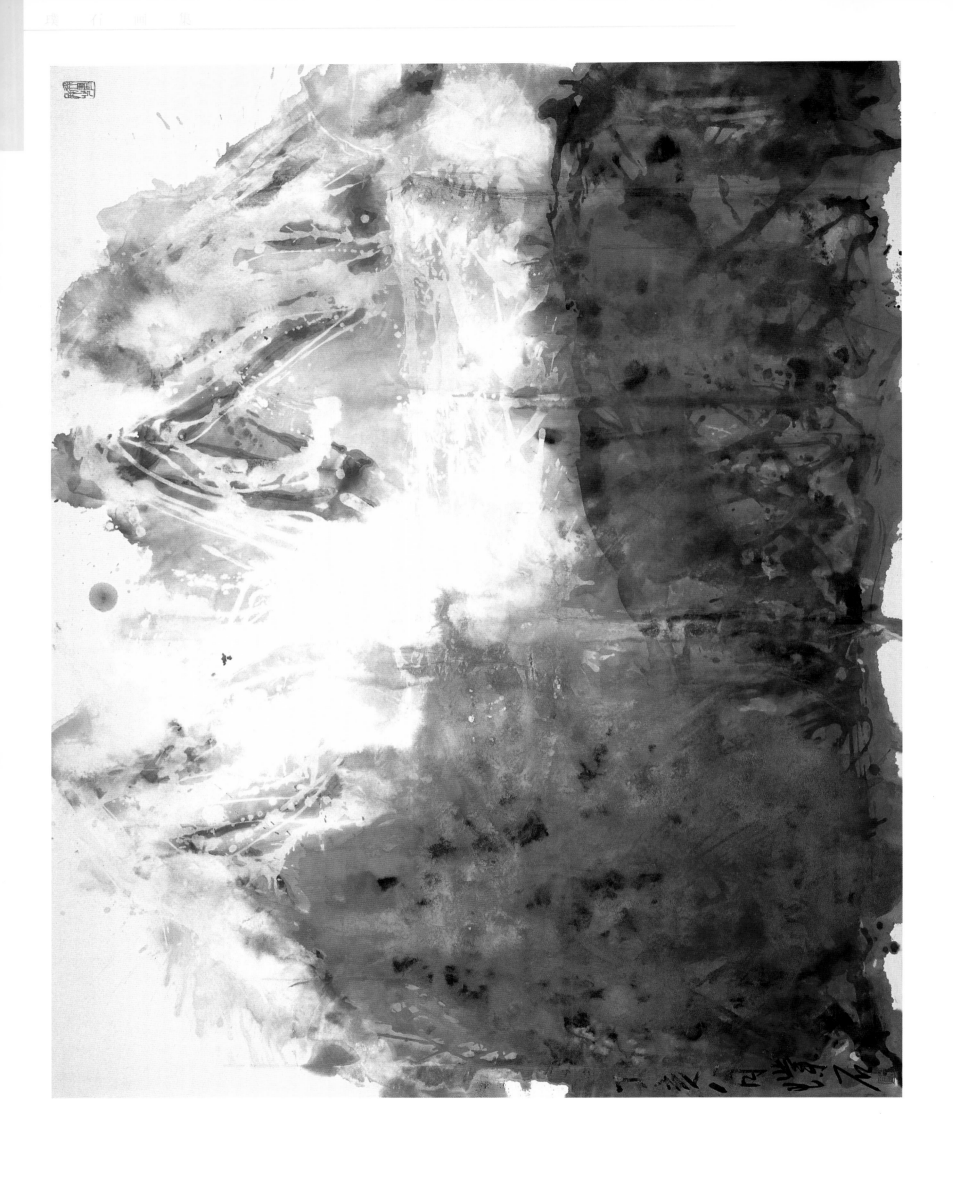

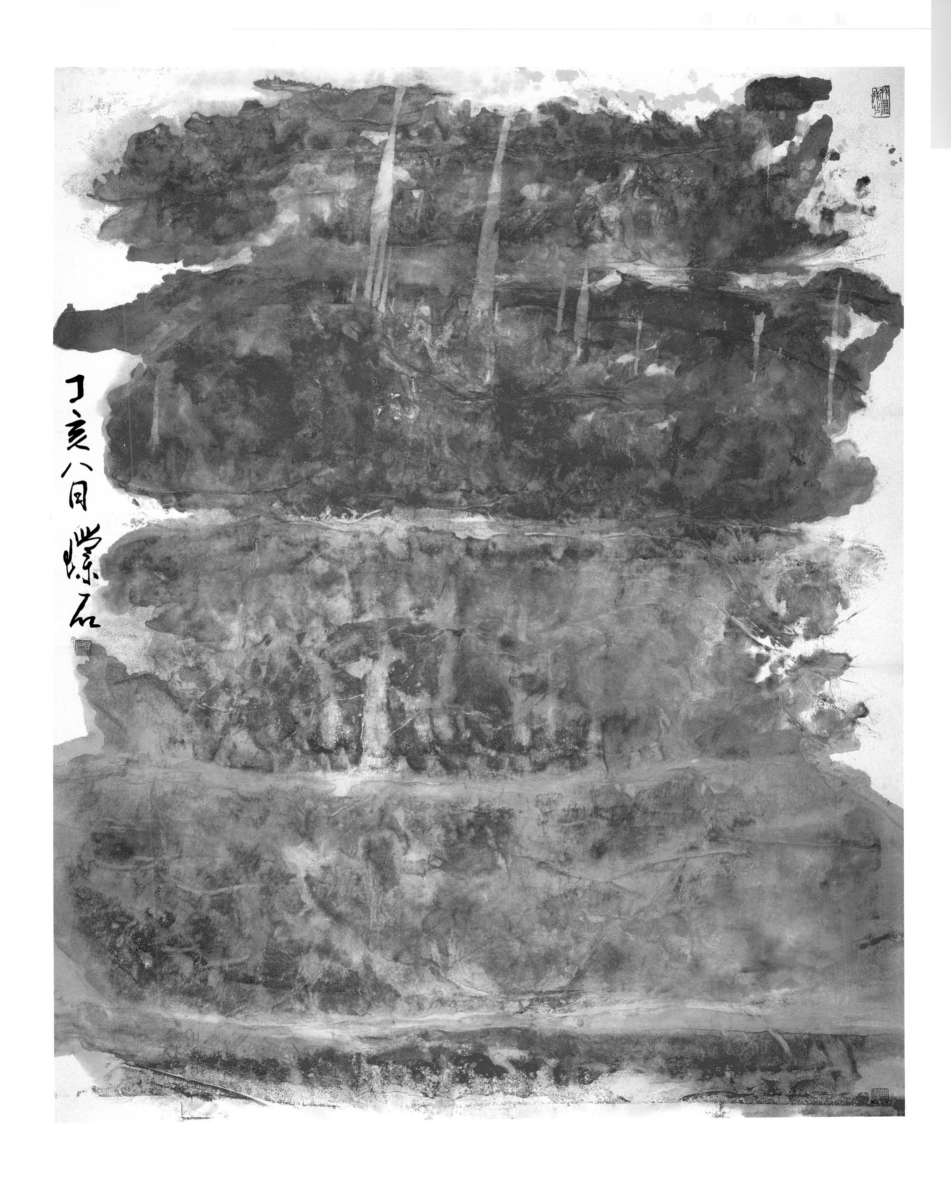

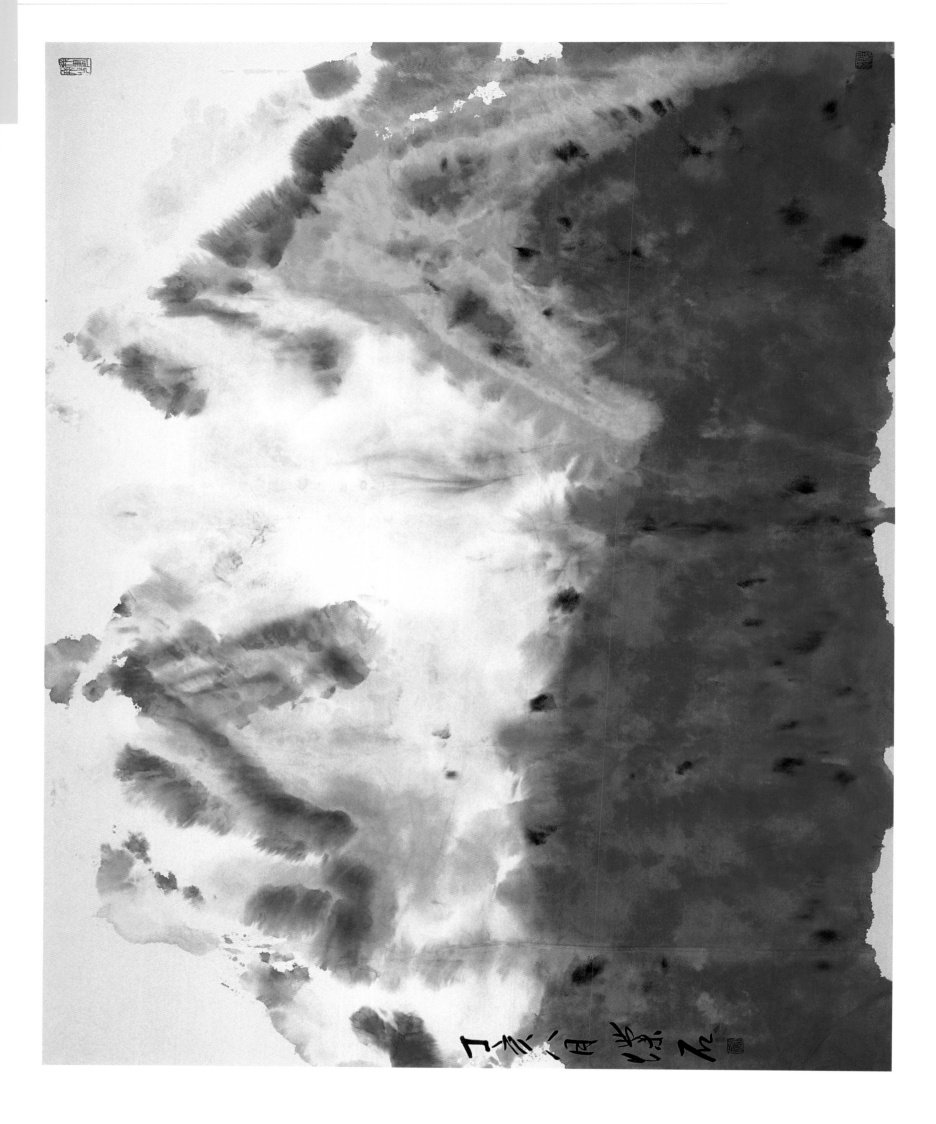

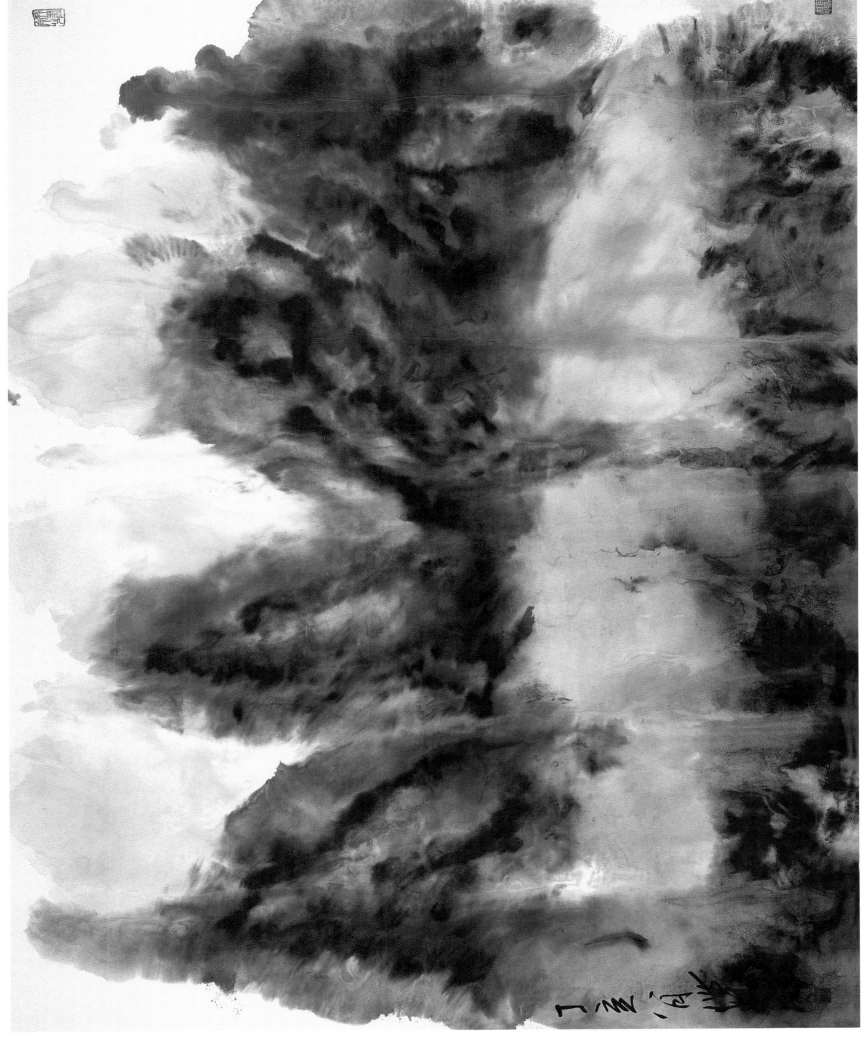

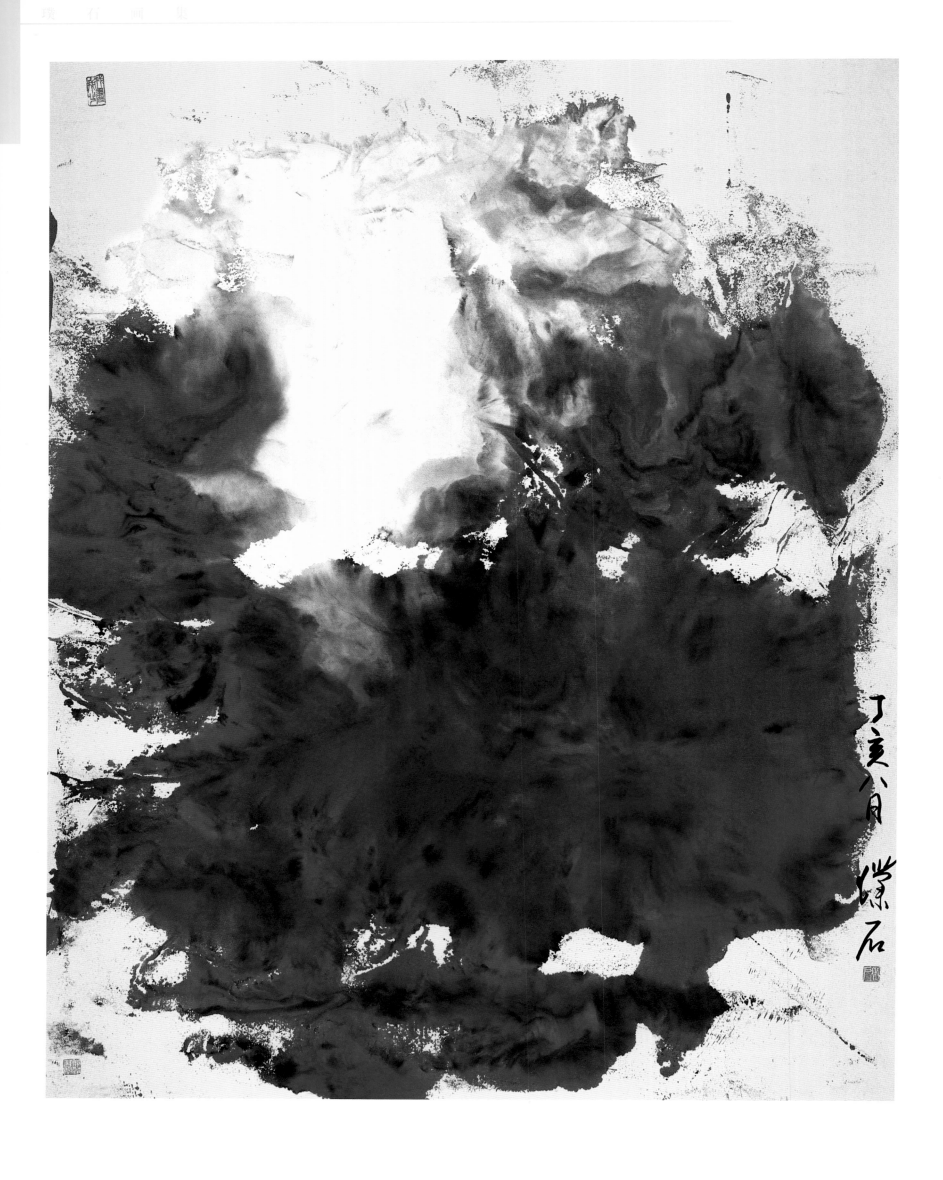

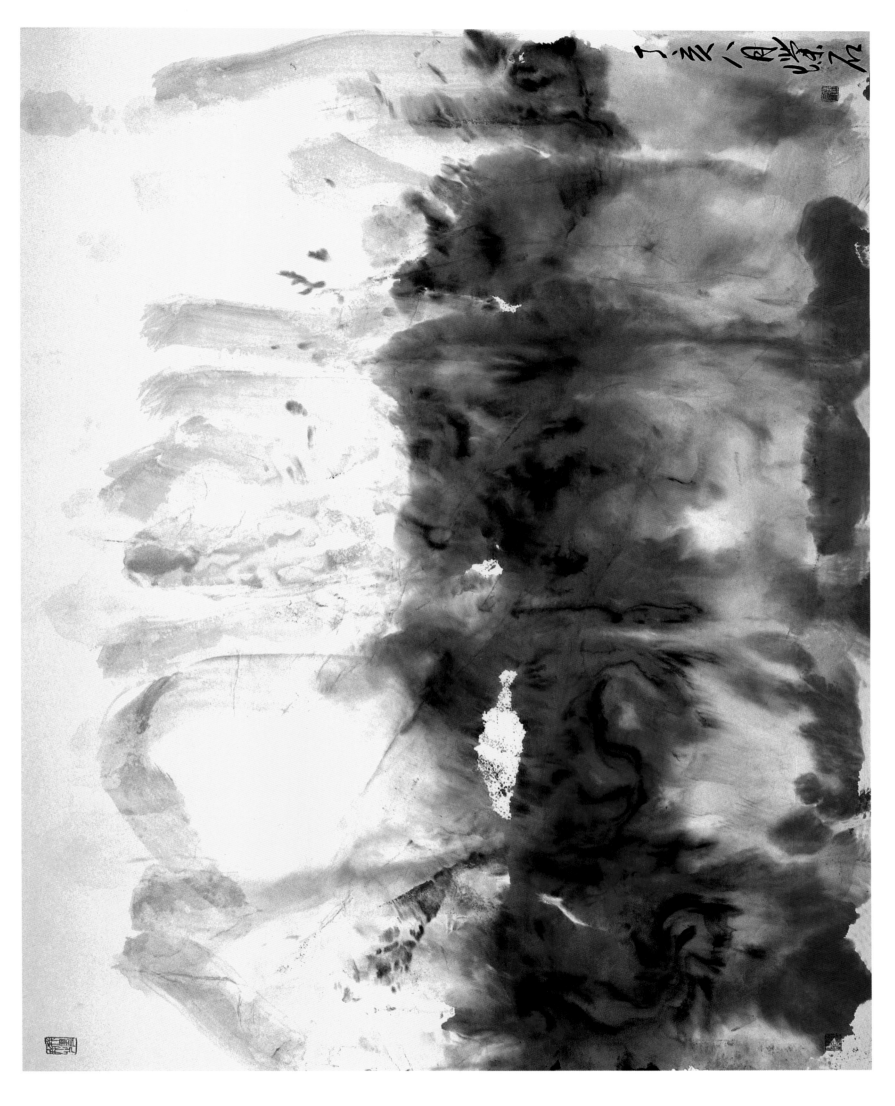

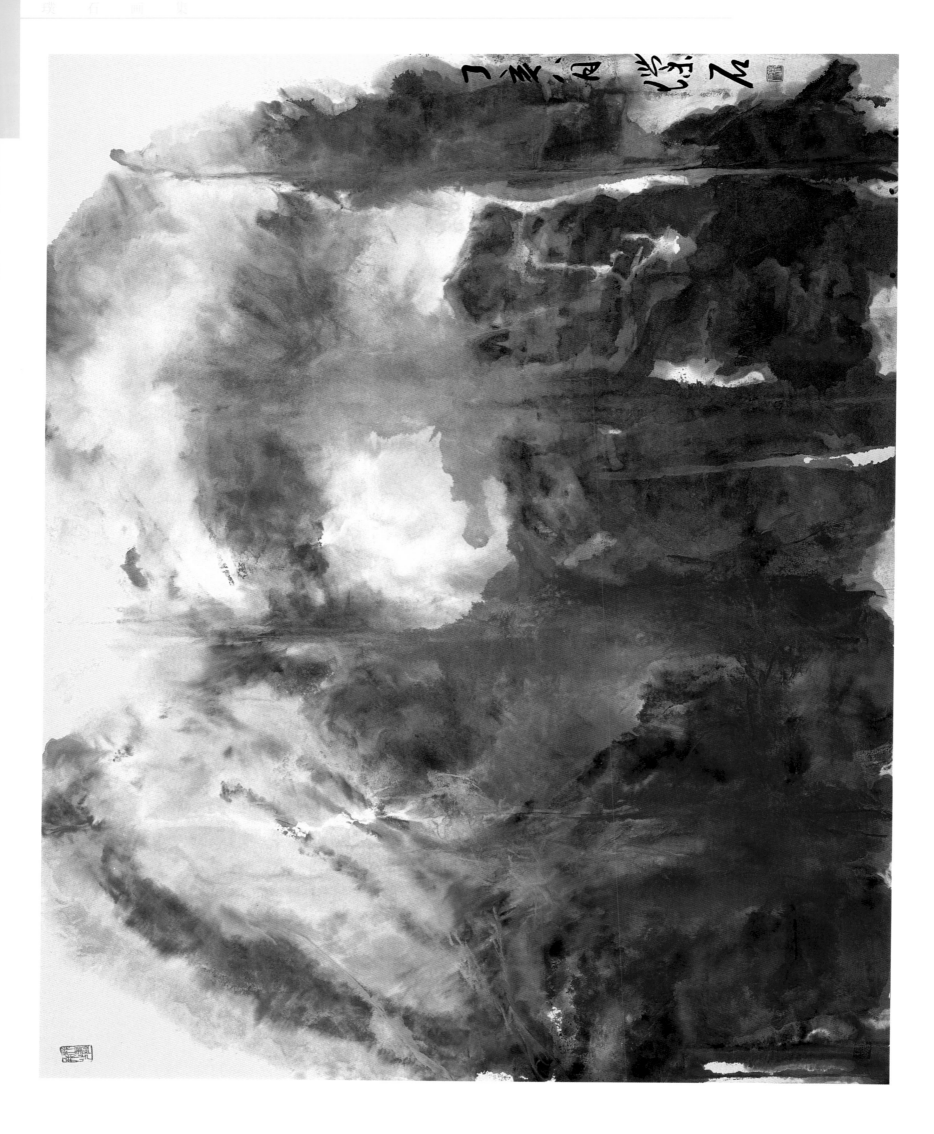

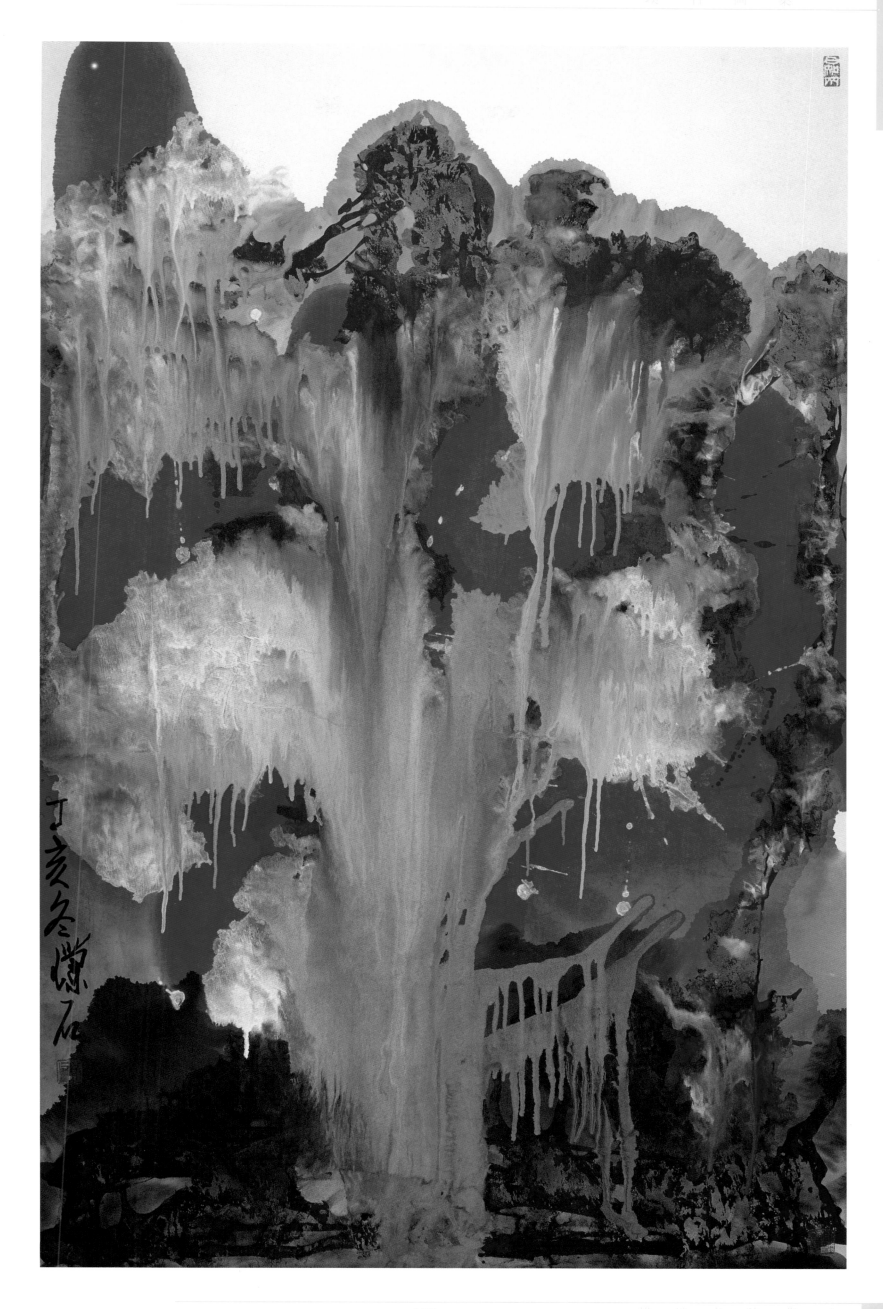

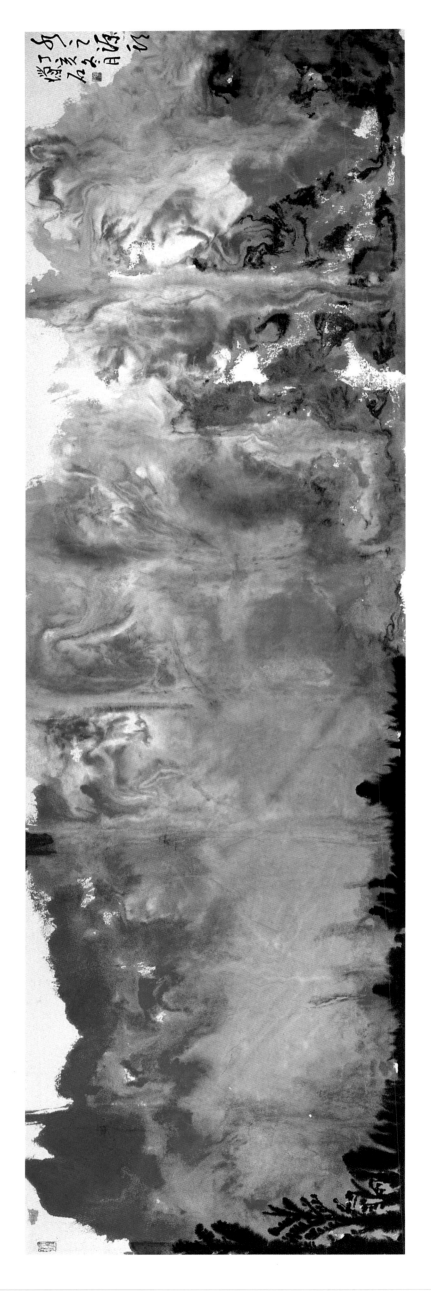

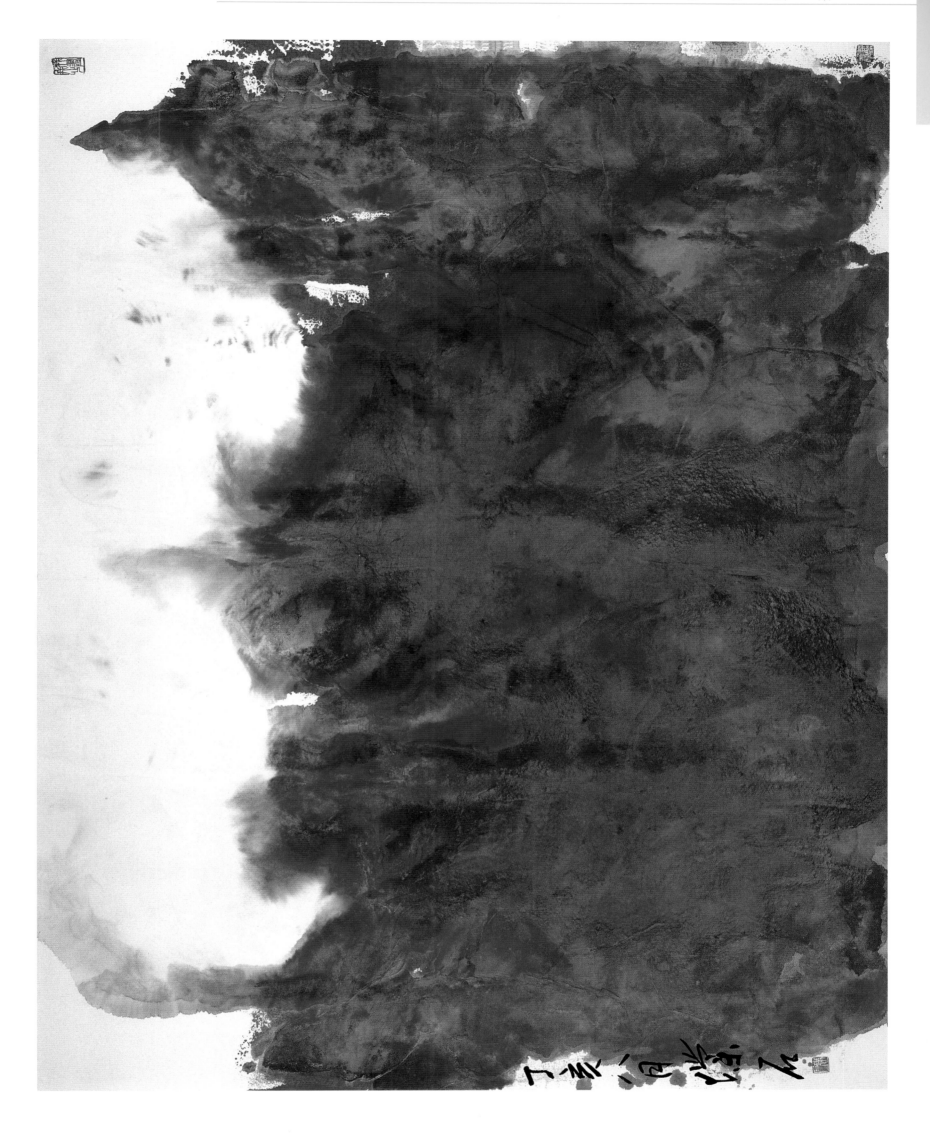

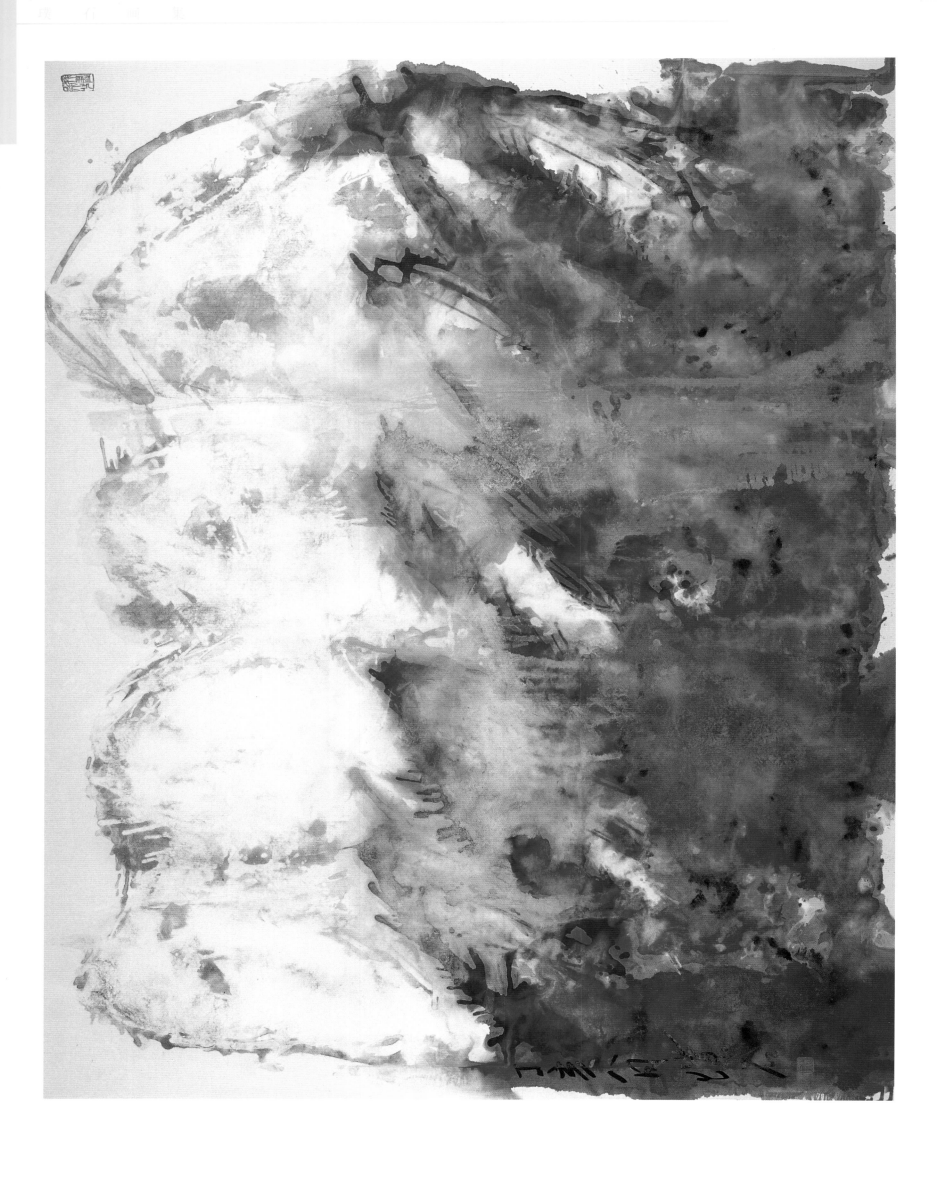

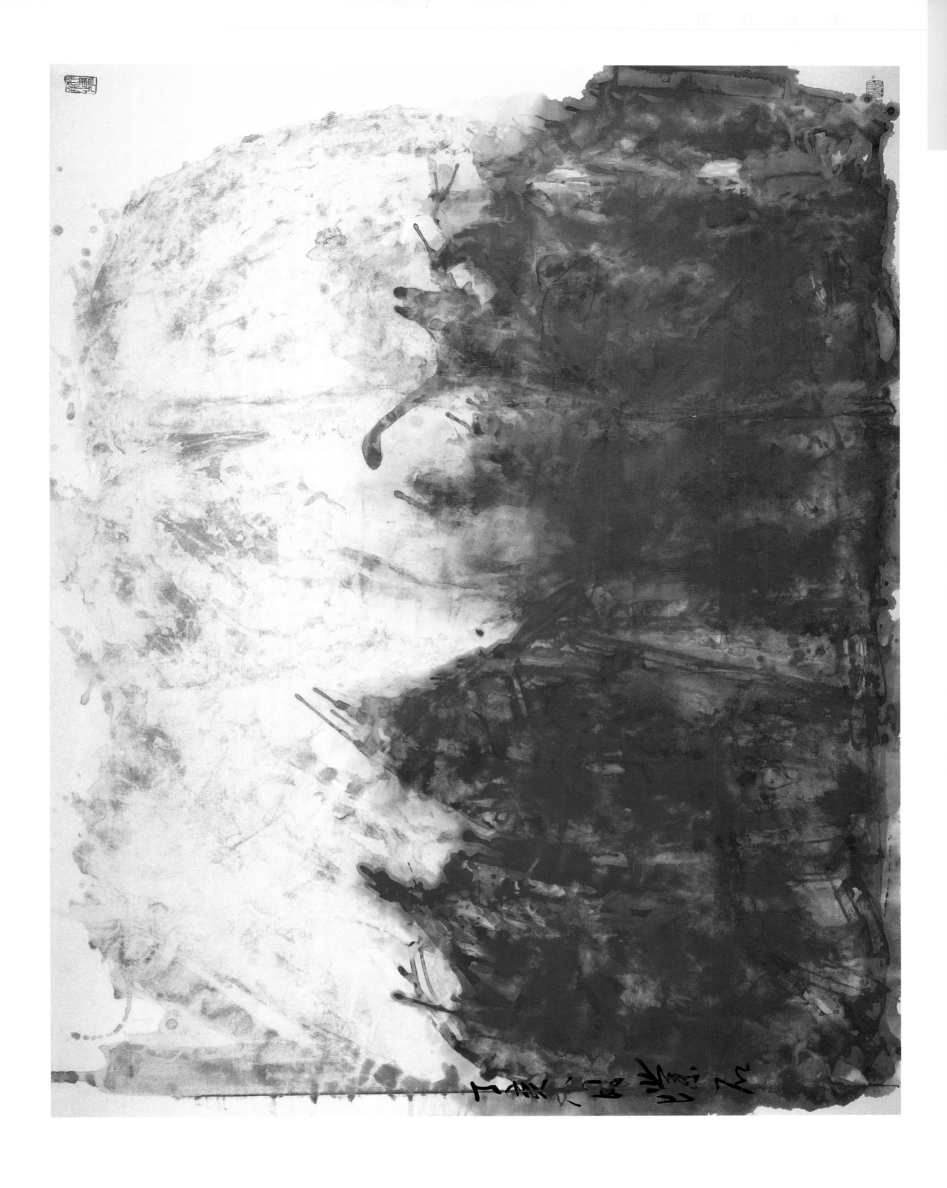

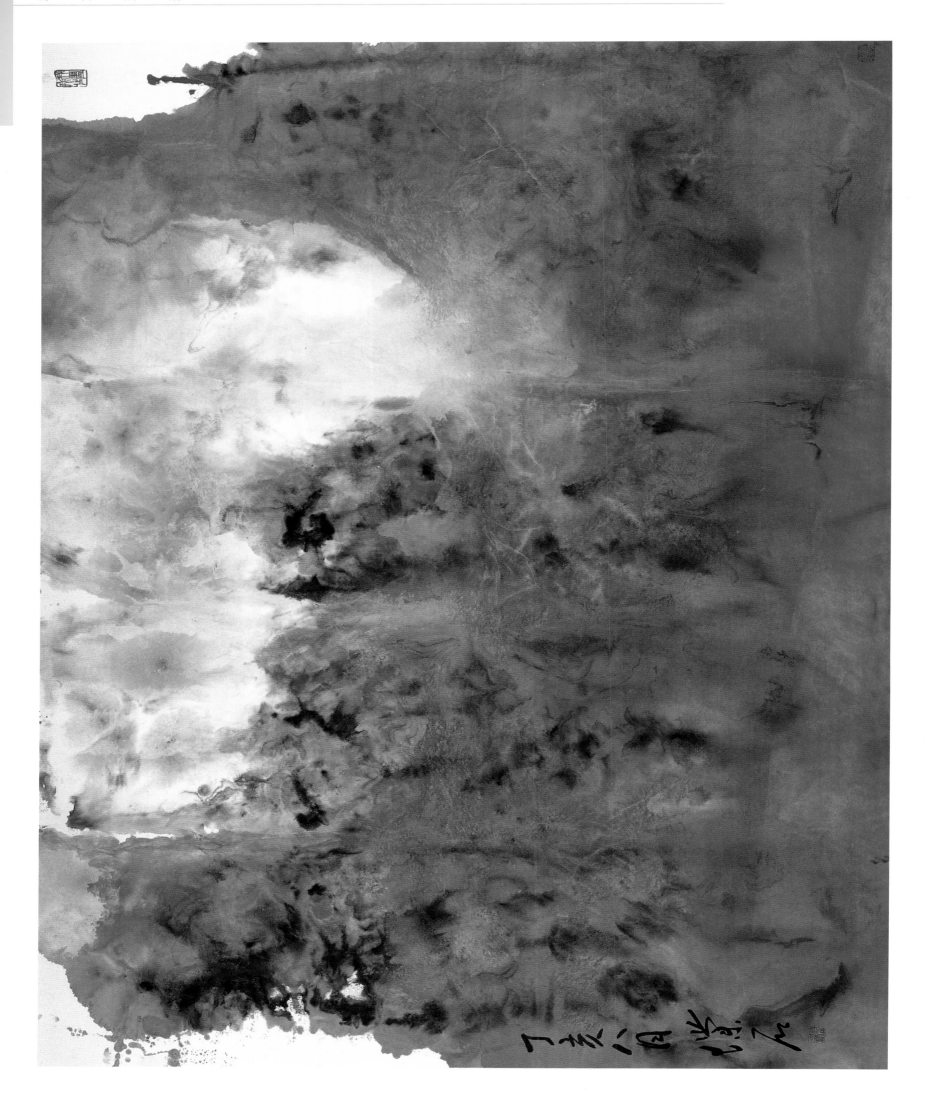

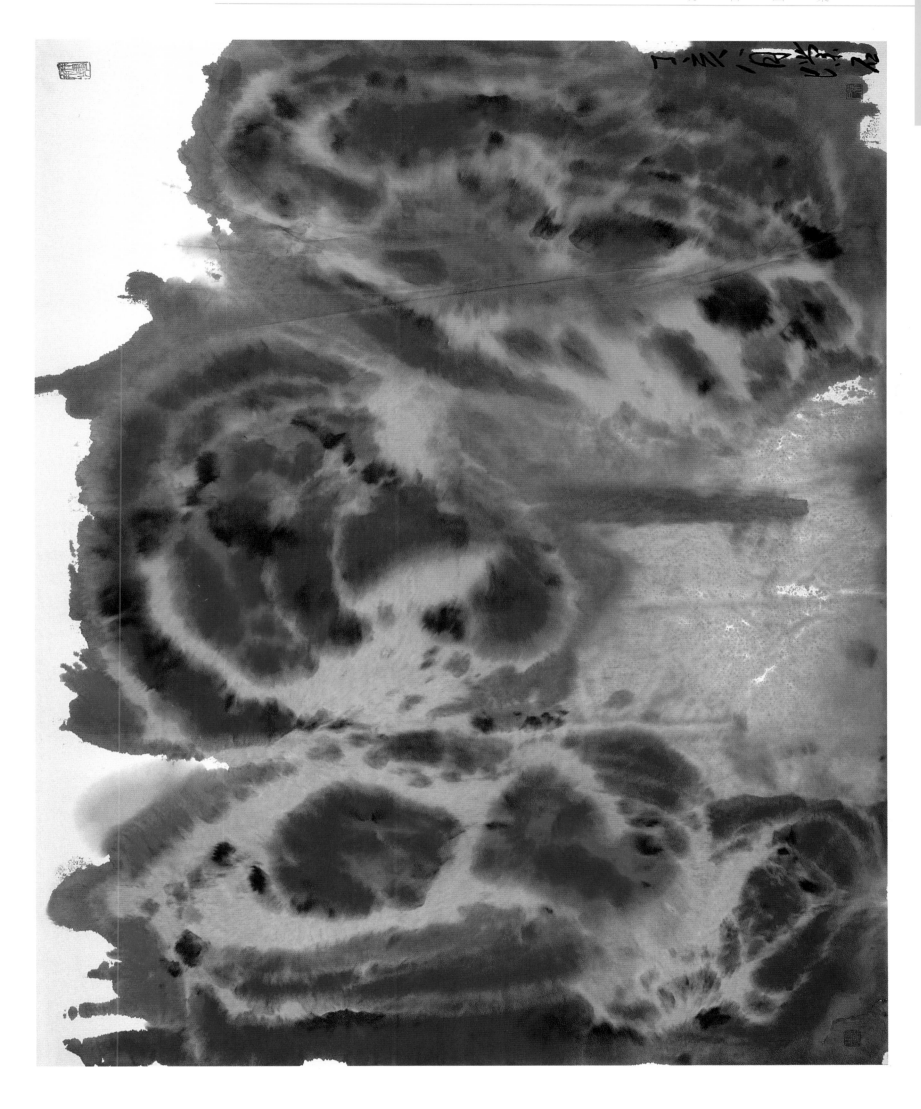

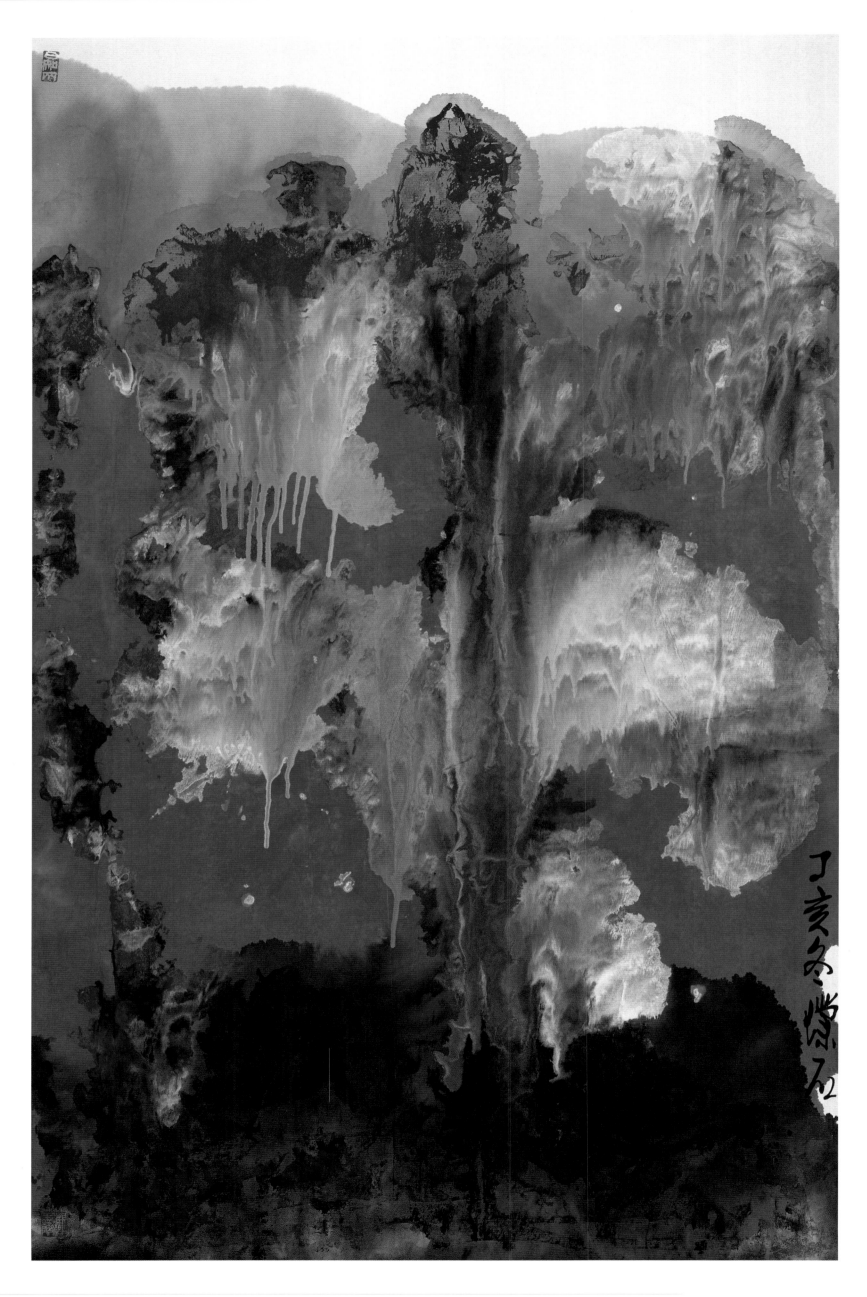

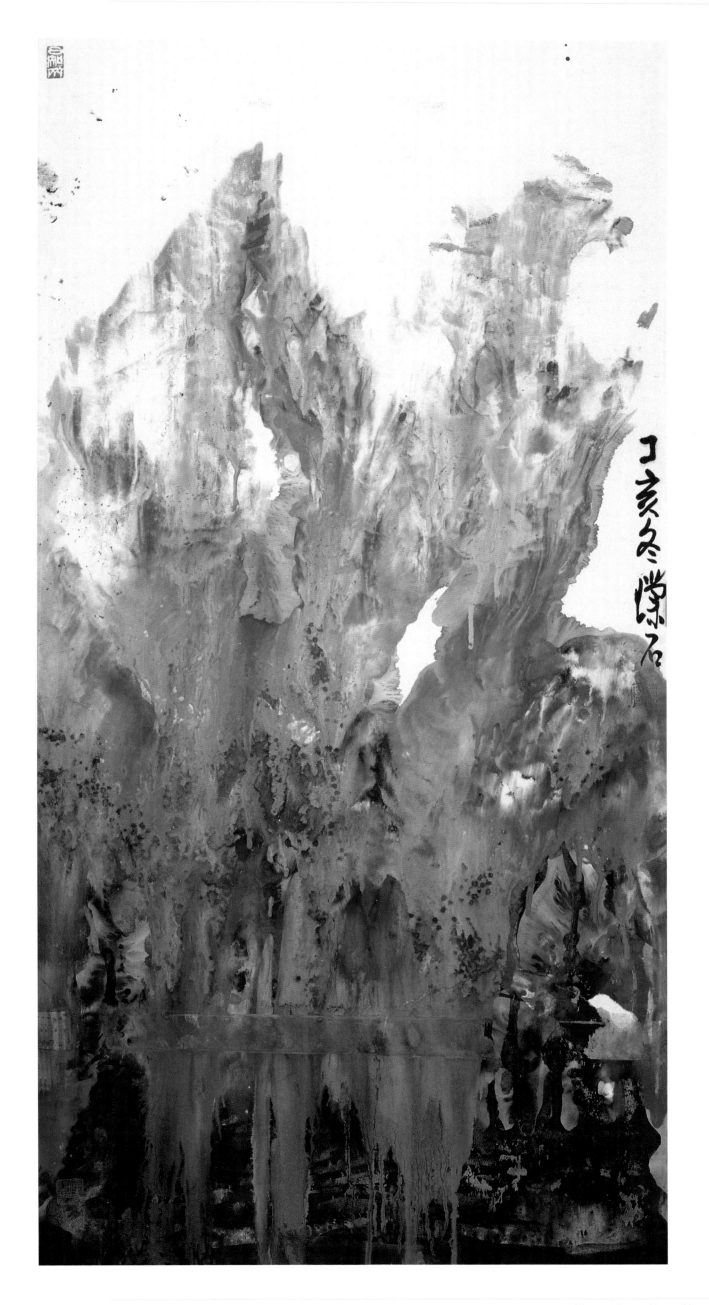

己亥冬 漢石

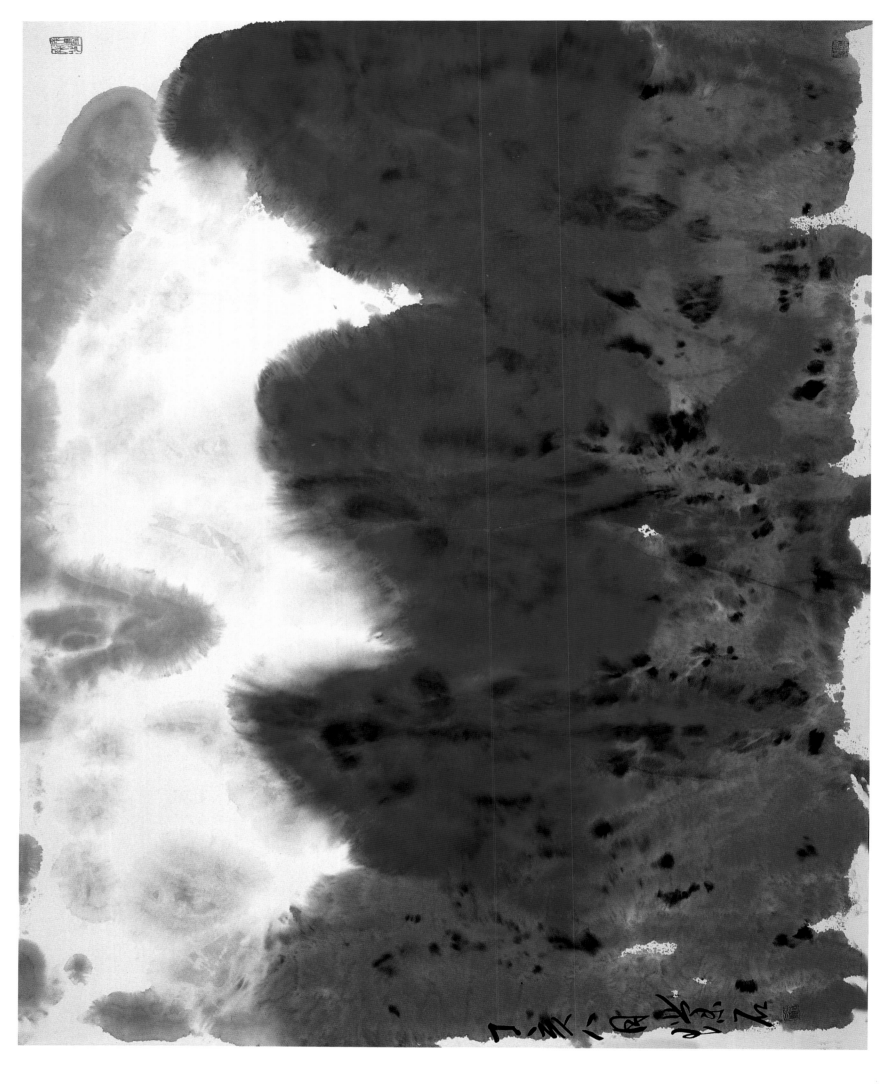

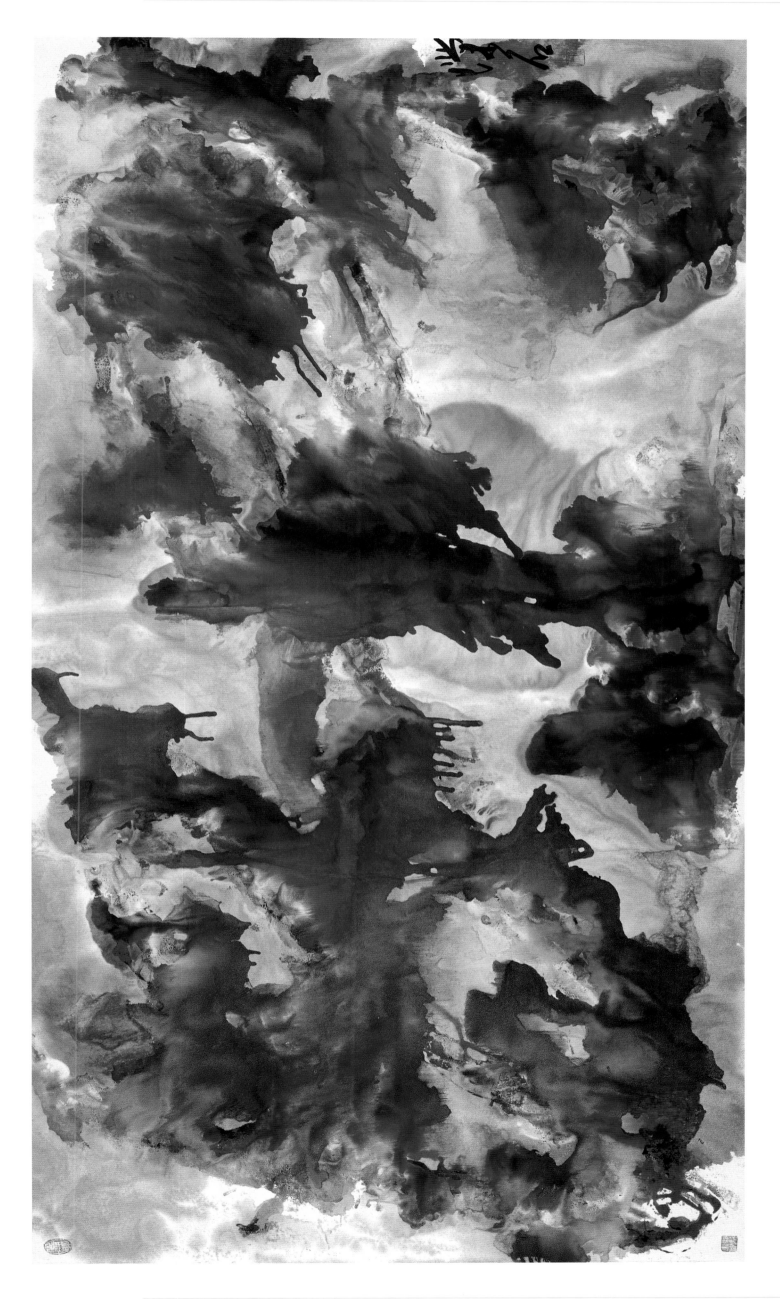

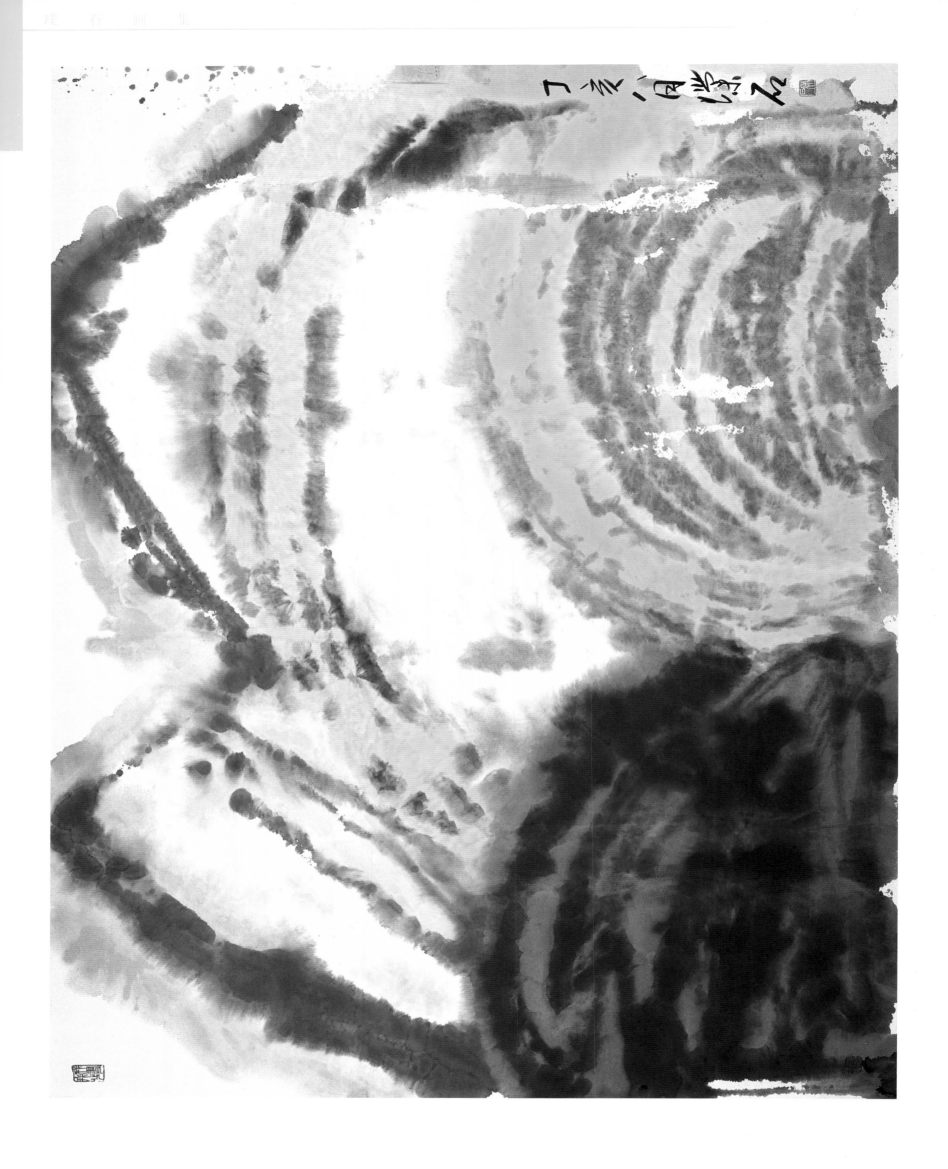

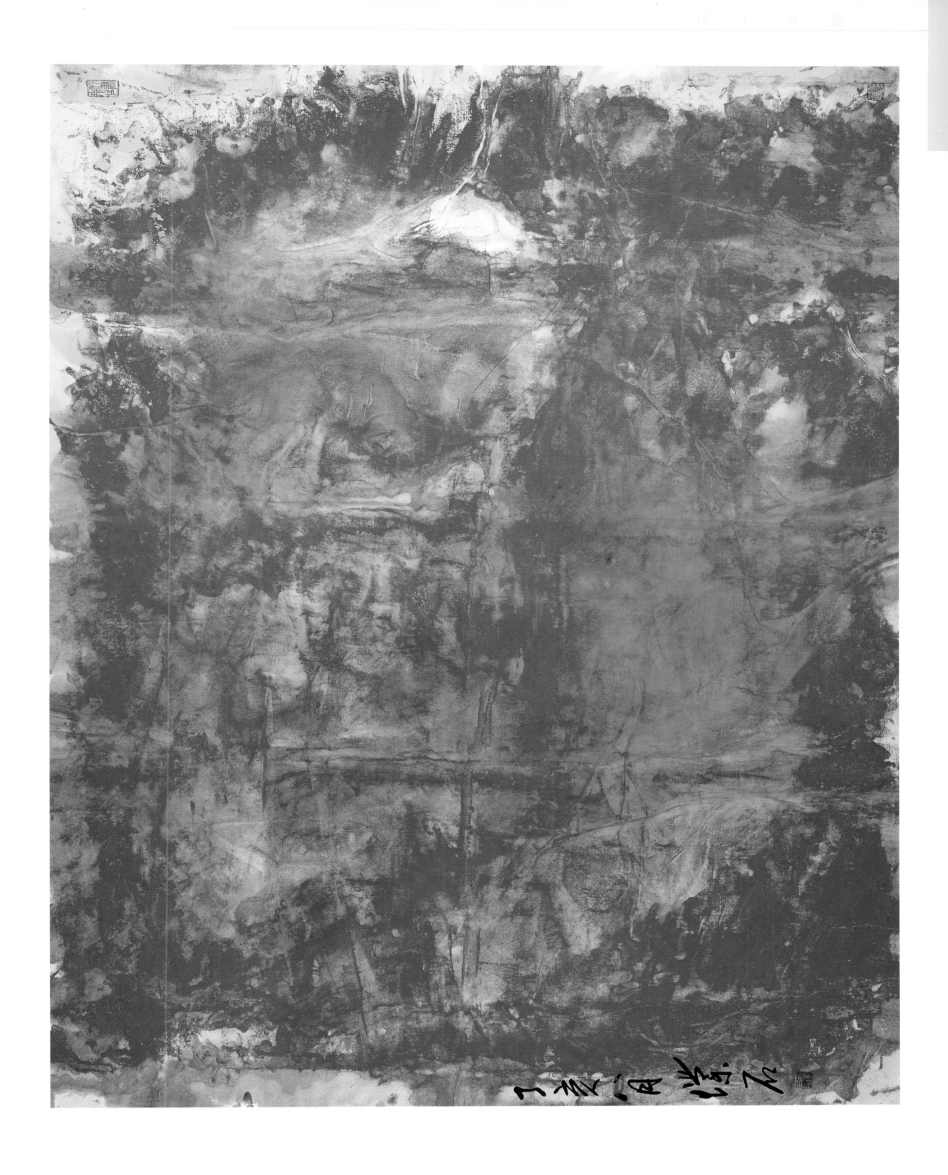

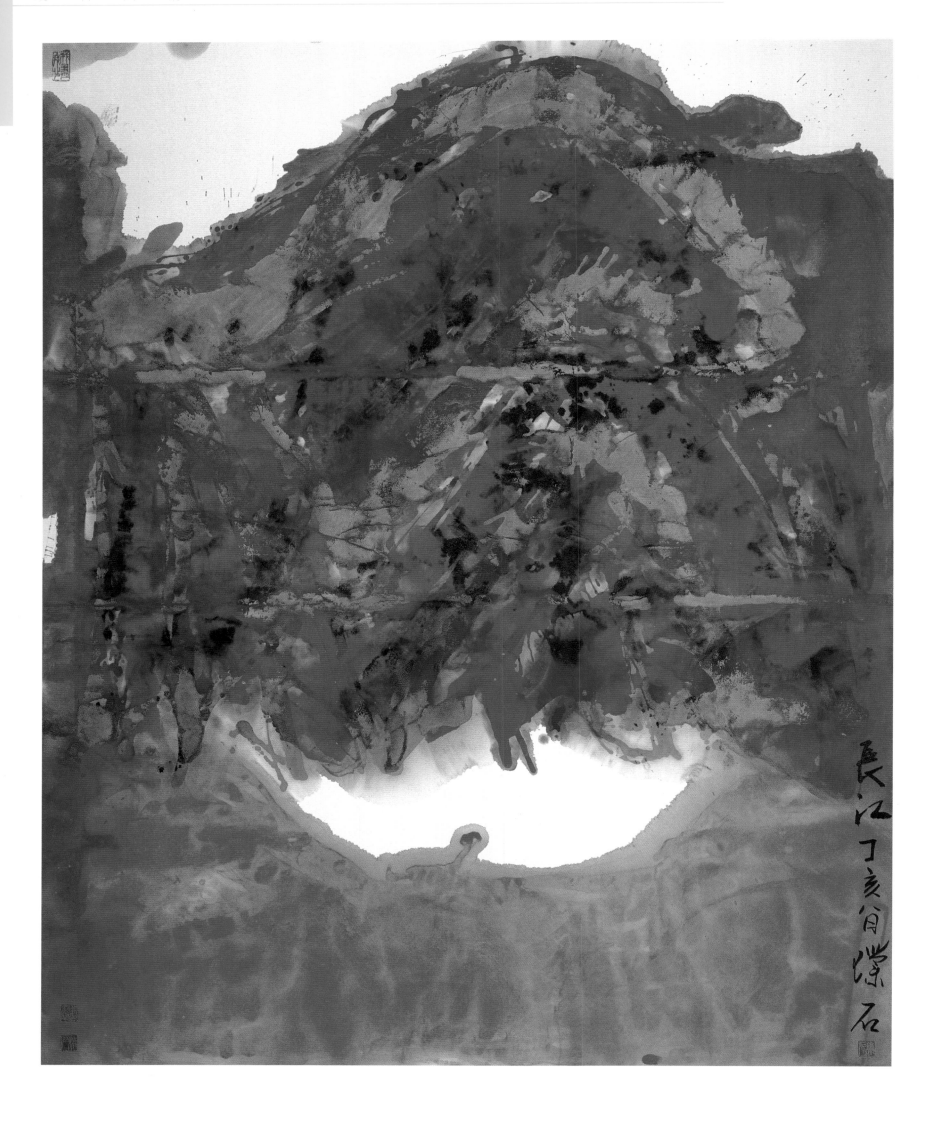

長江丁亥自漢石

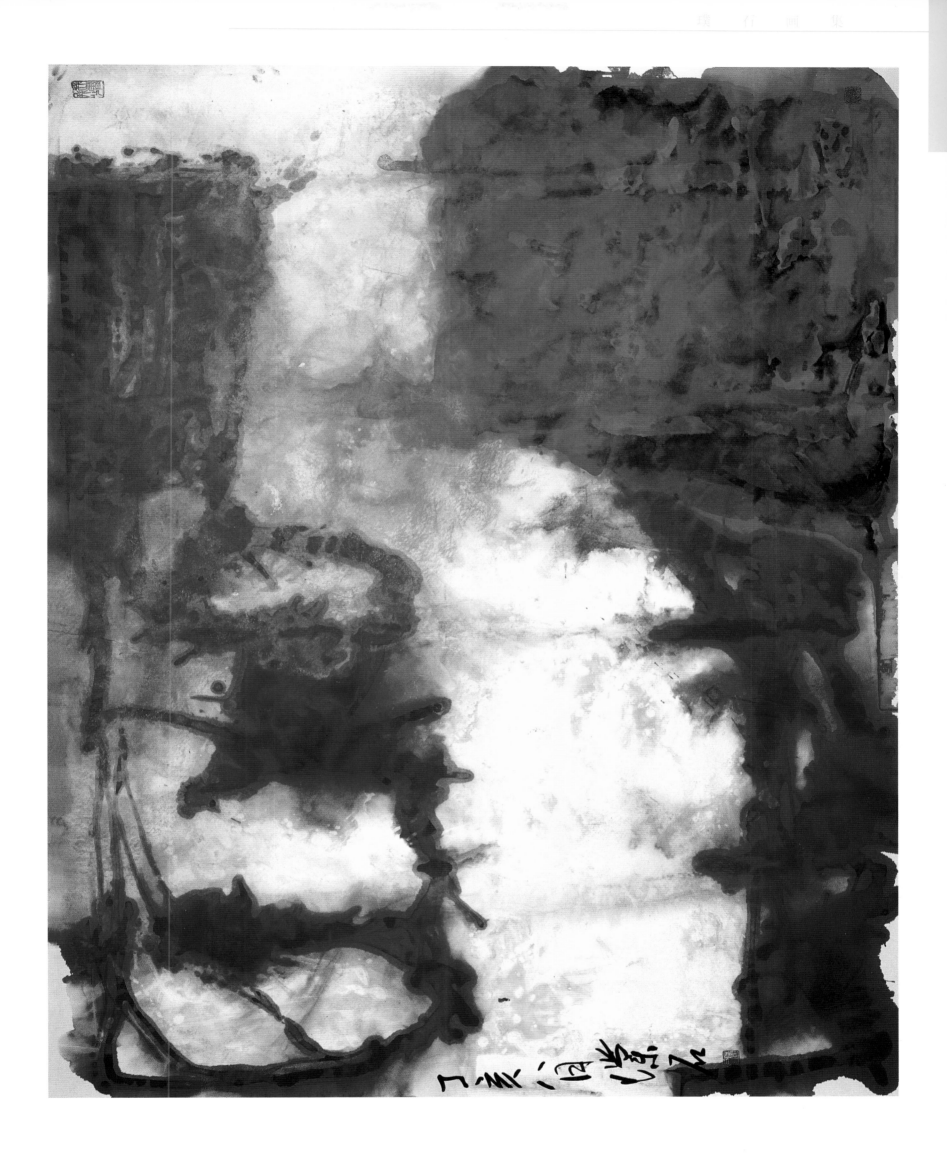

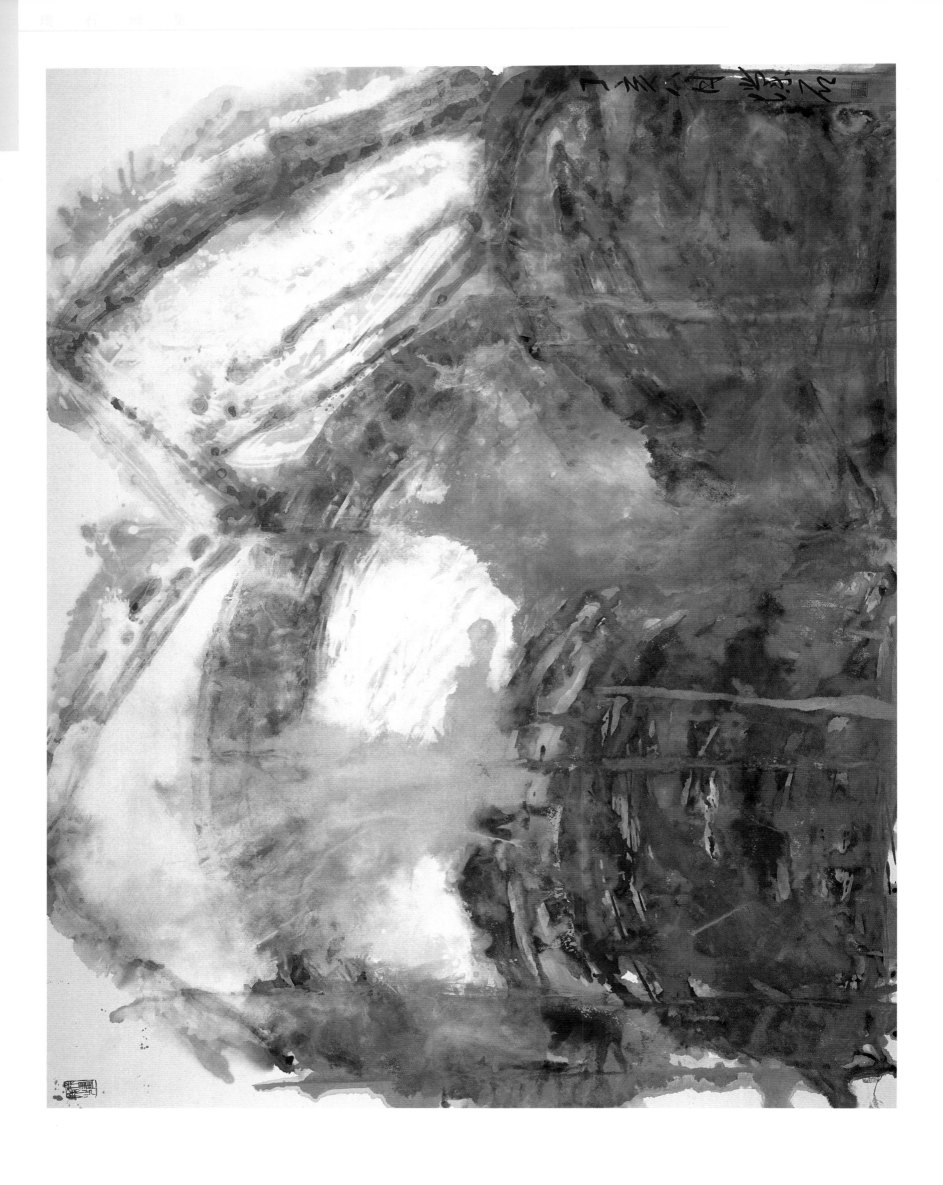

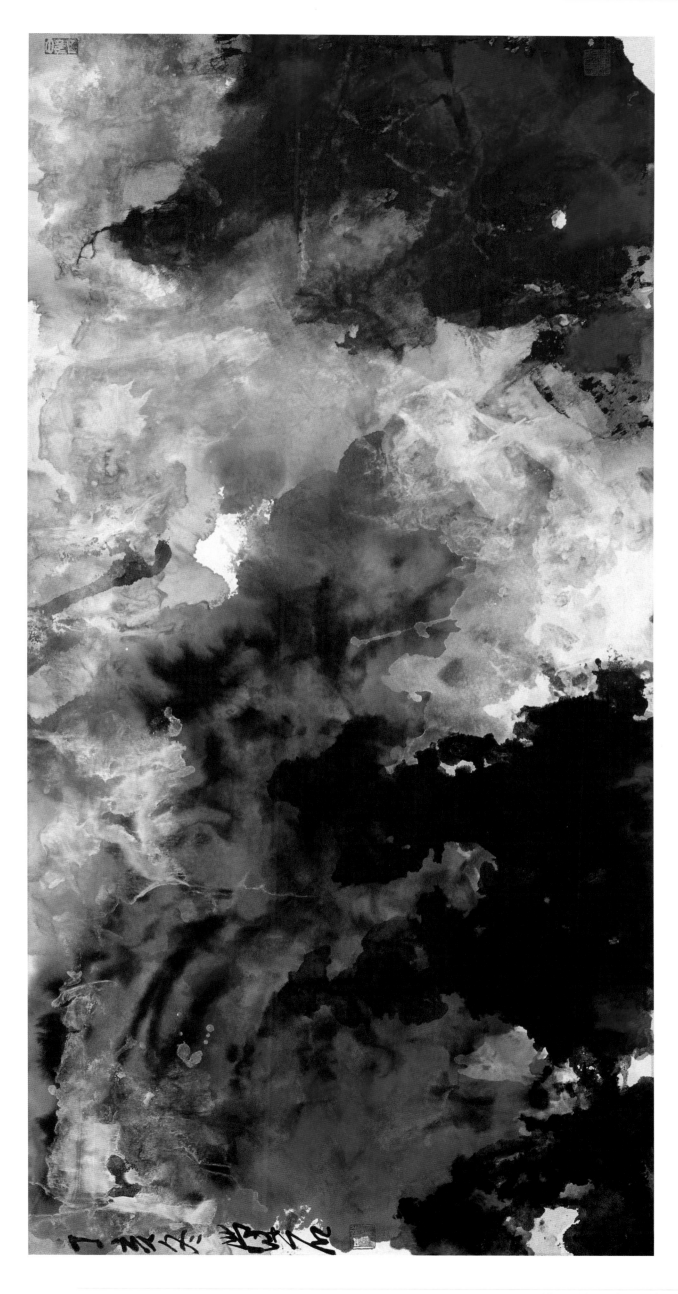

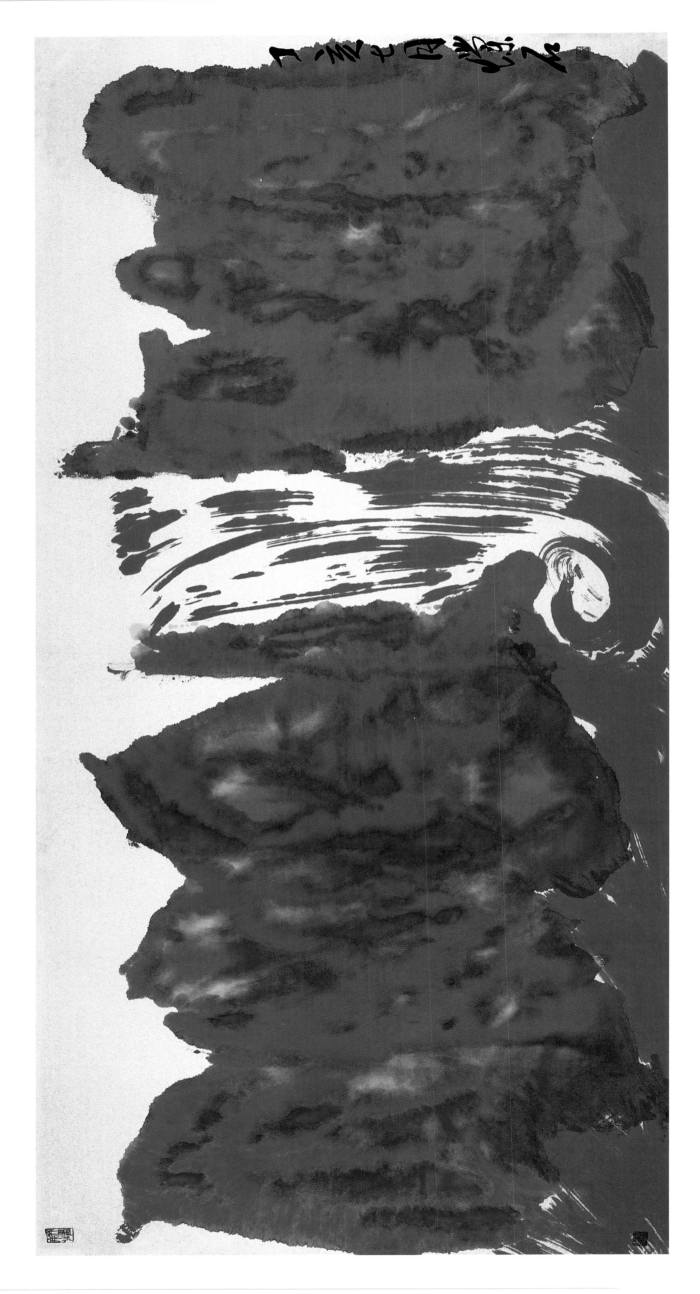

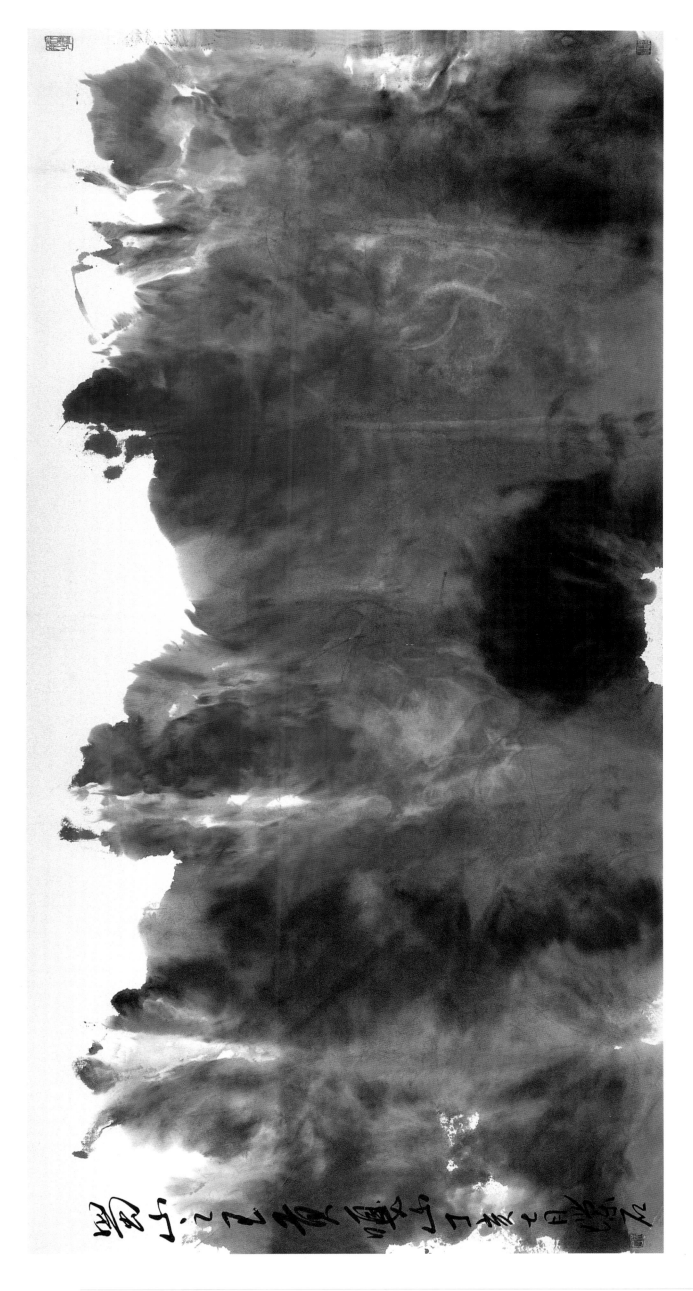

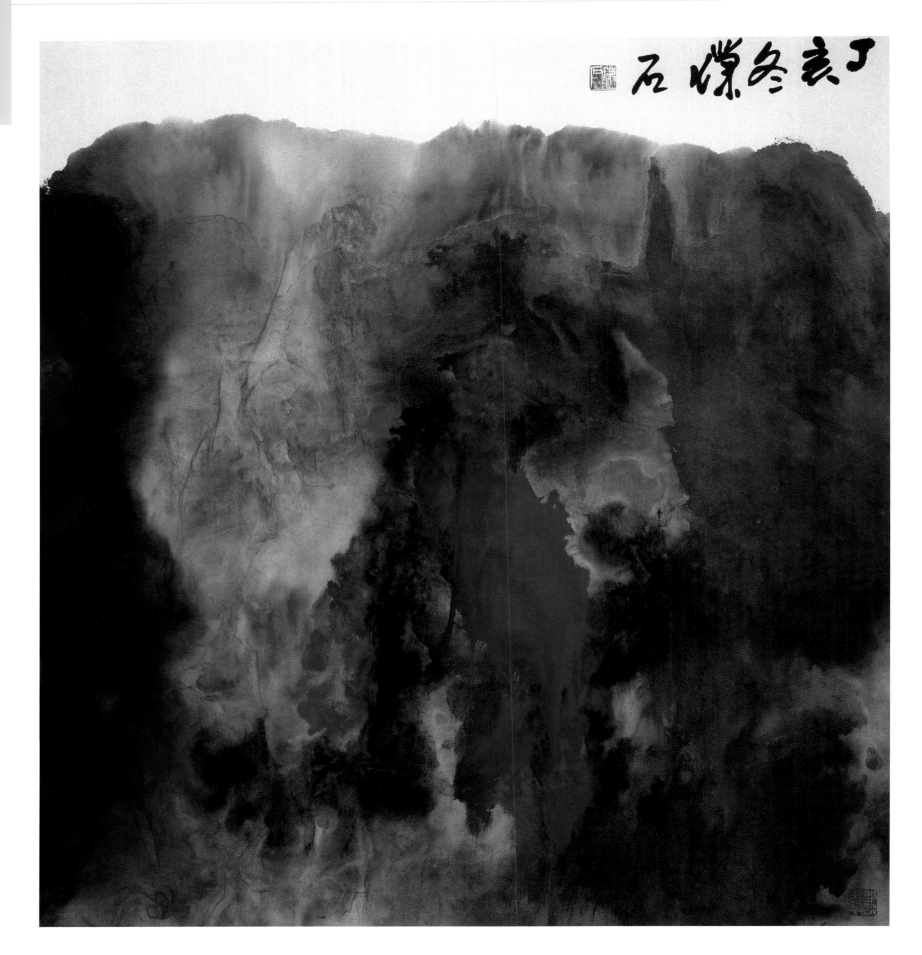

丁亥冬 璞石

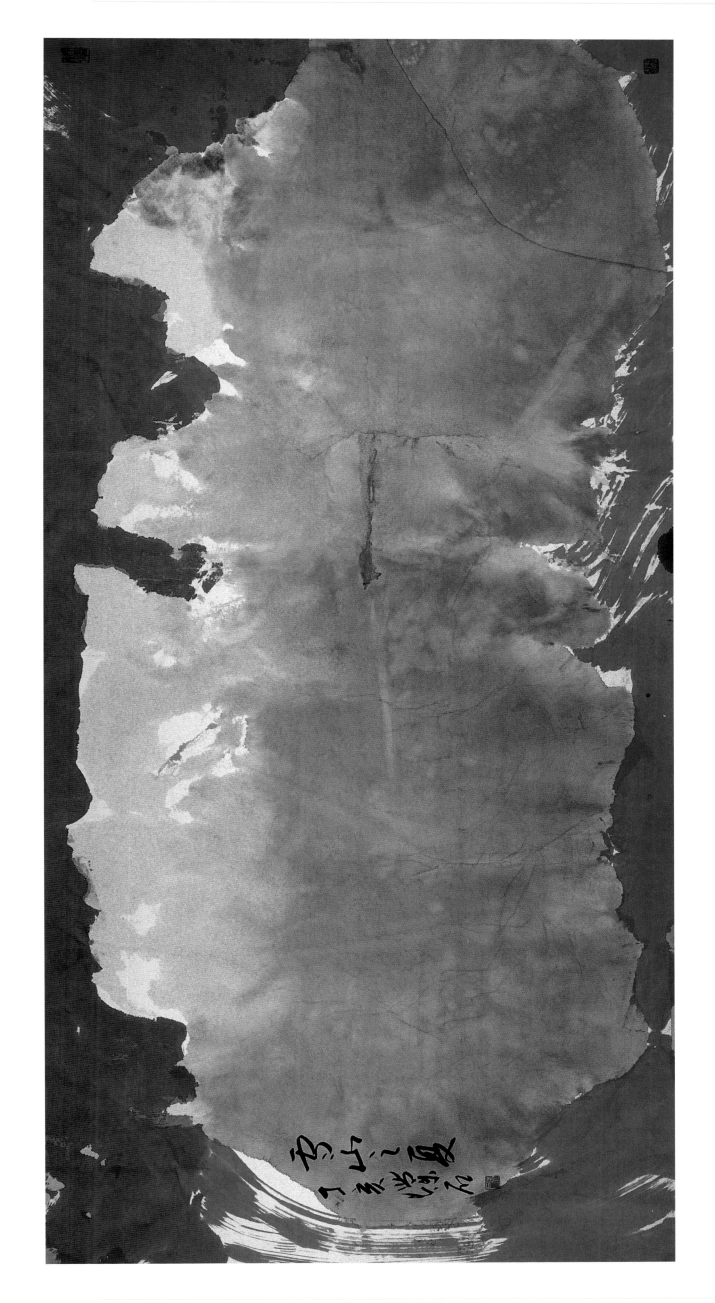

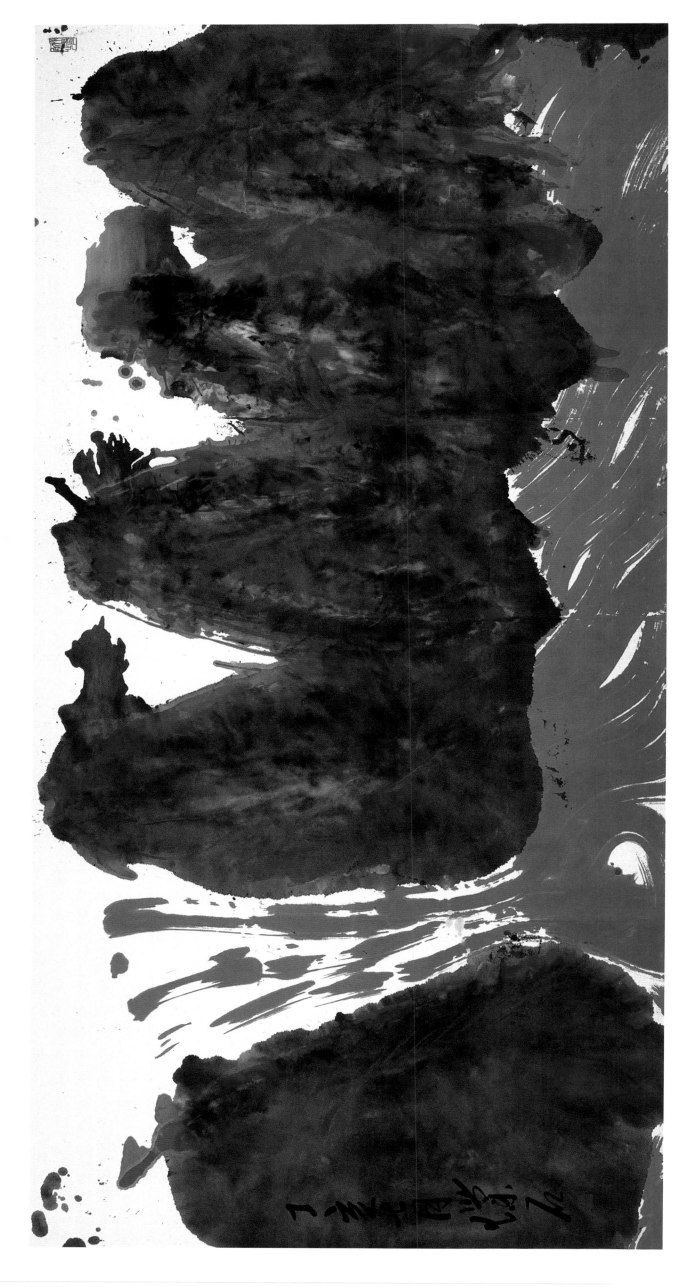

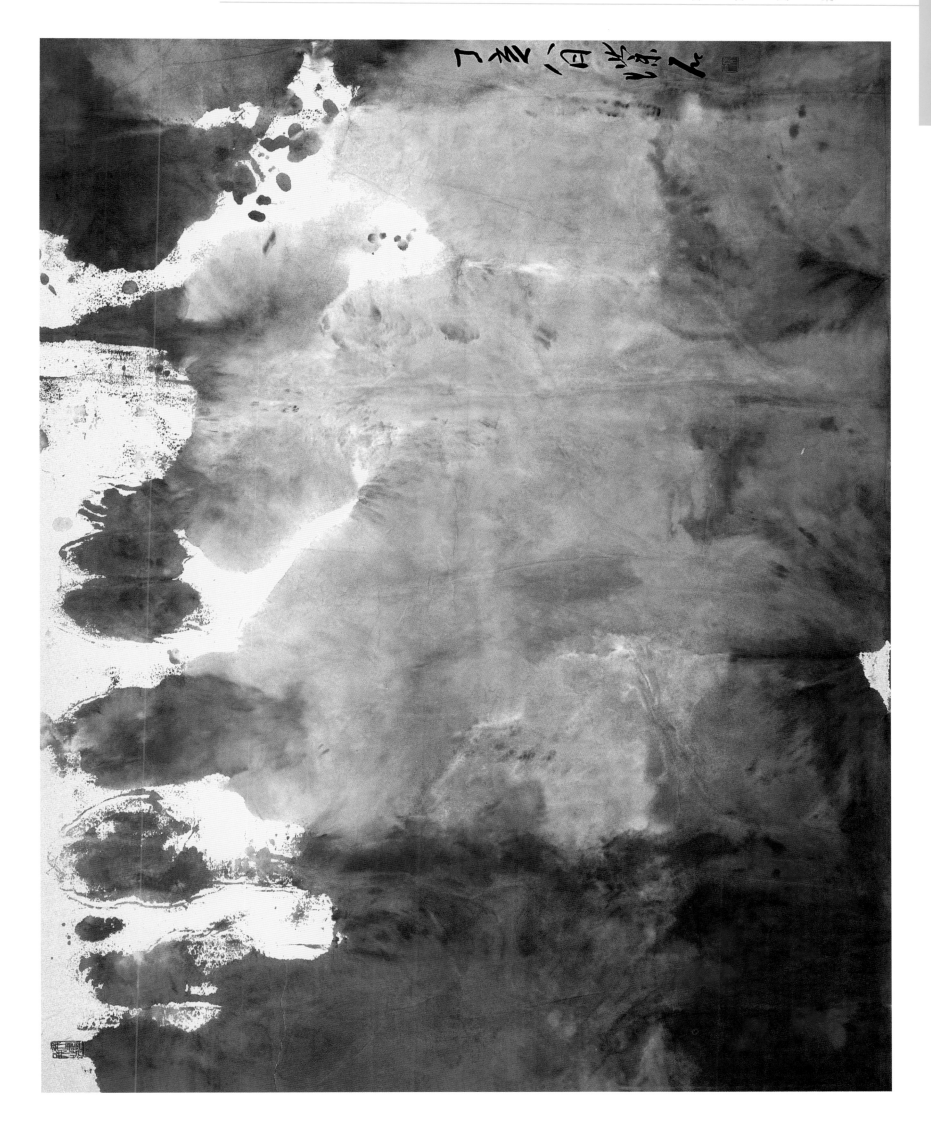

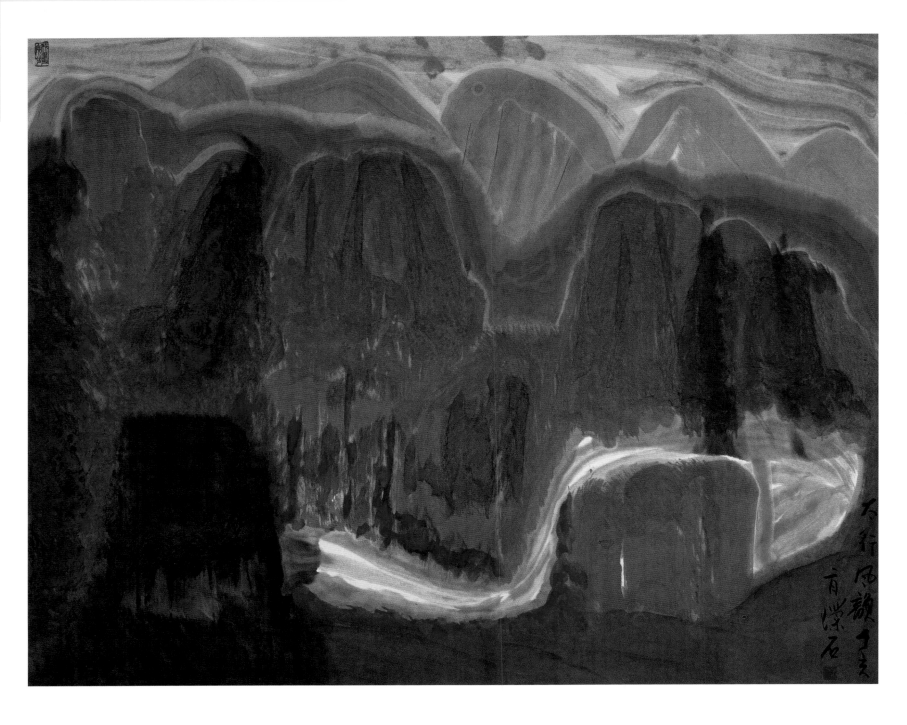

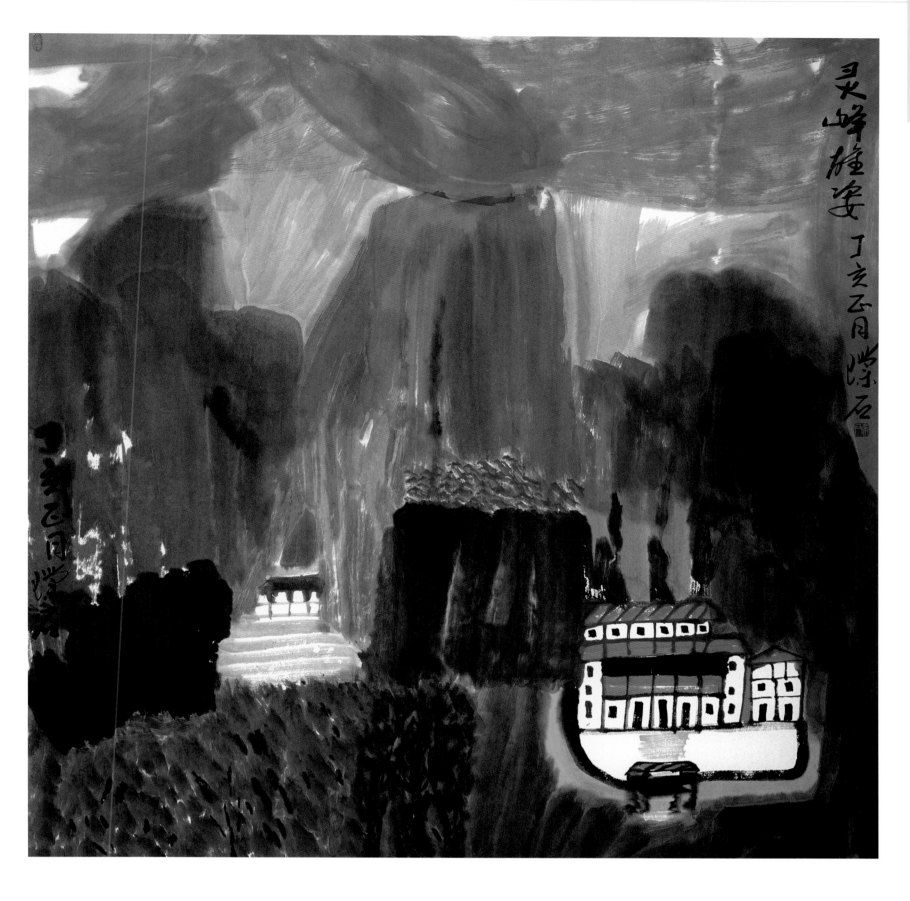

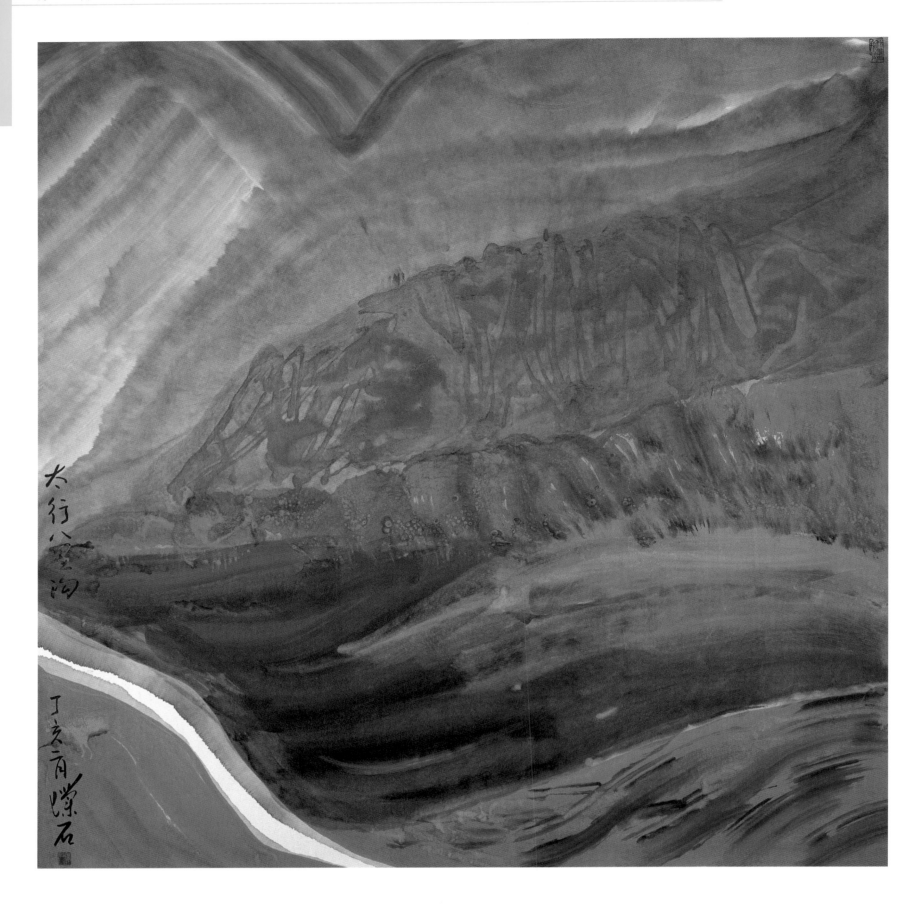

太行八坌沟

丁亥首璞石

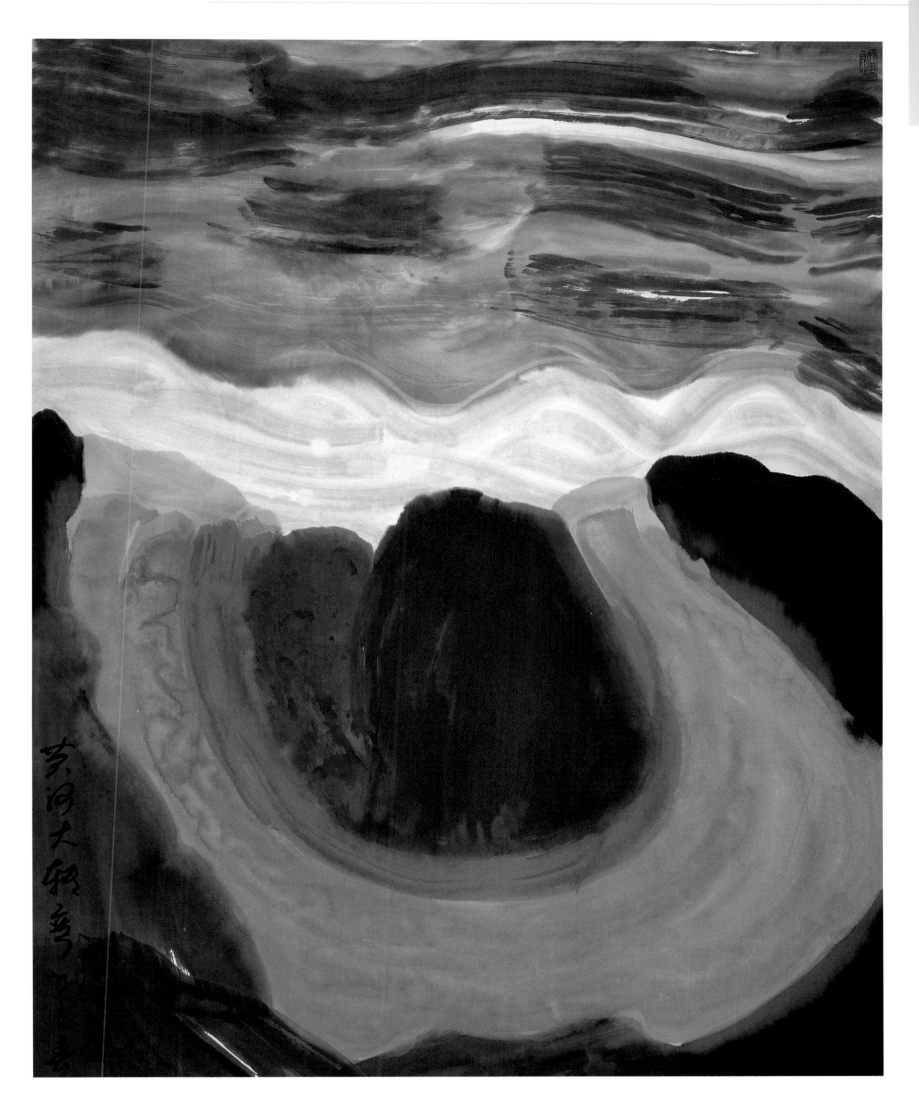

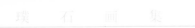

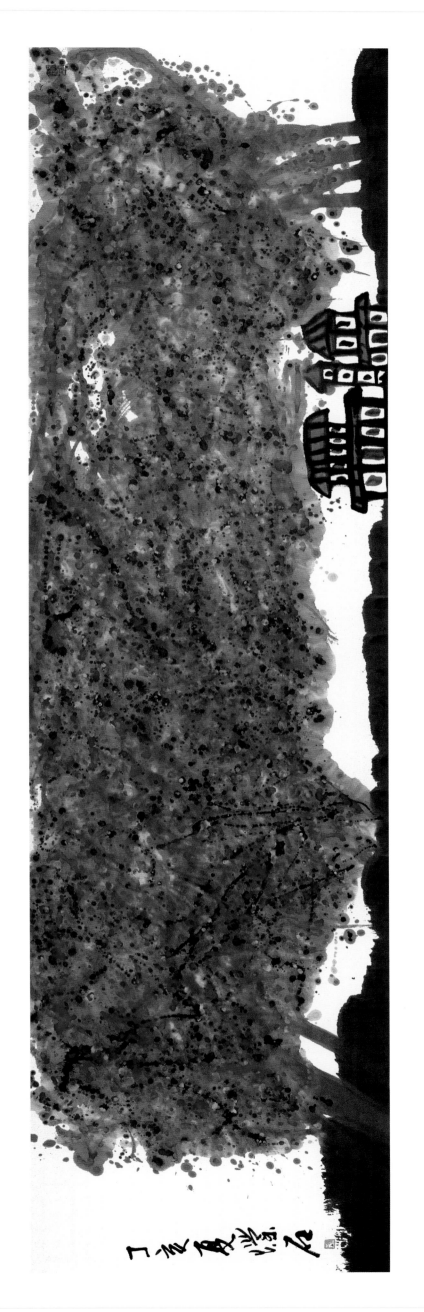

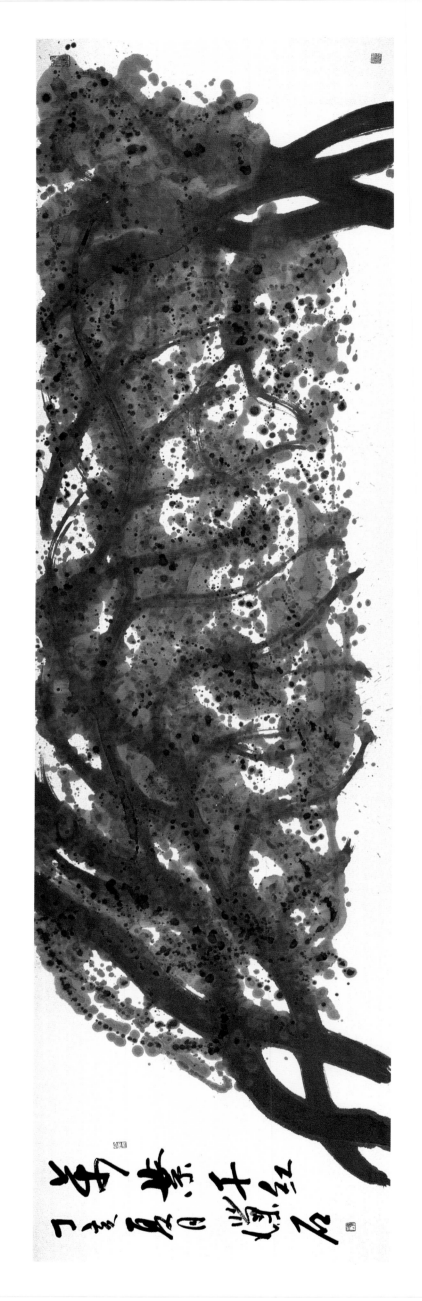

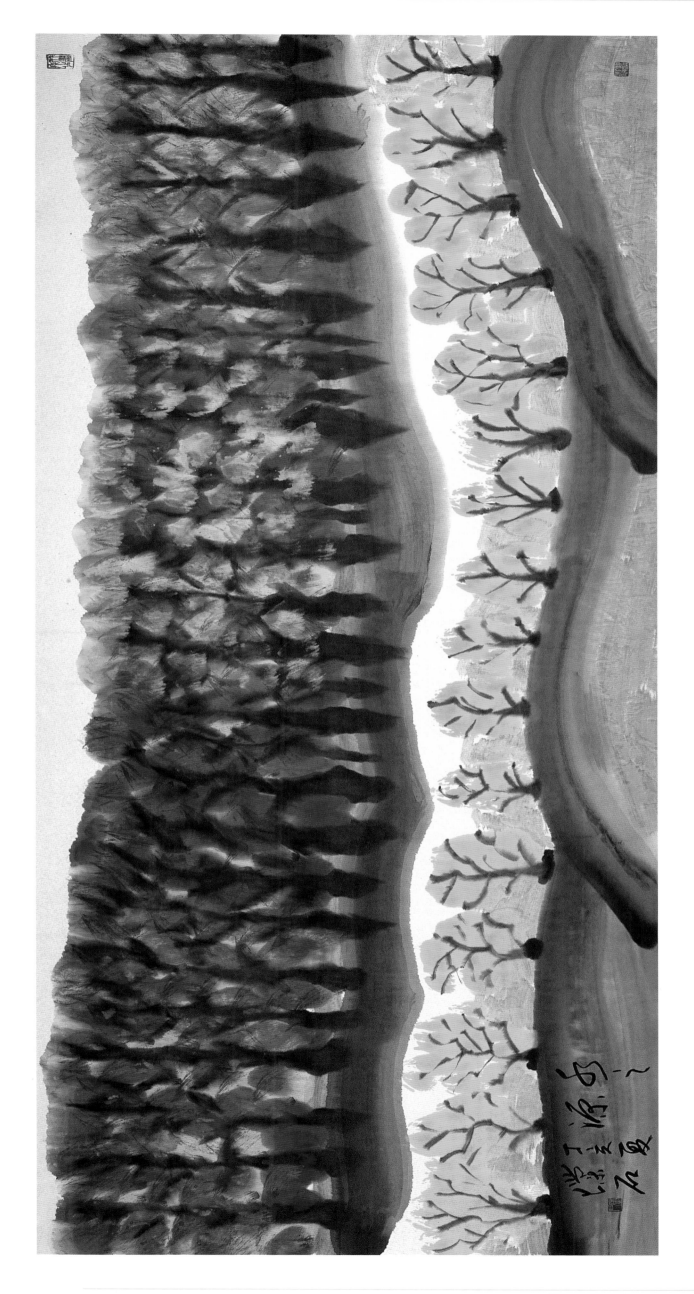

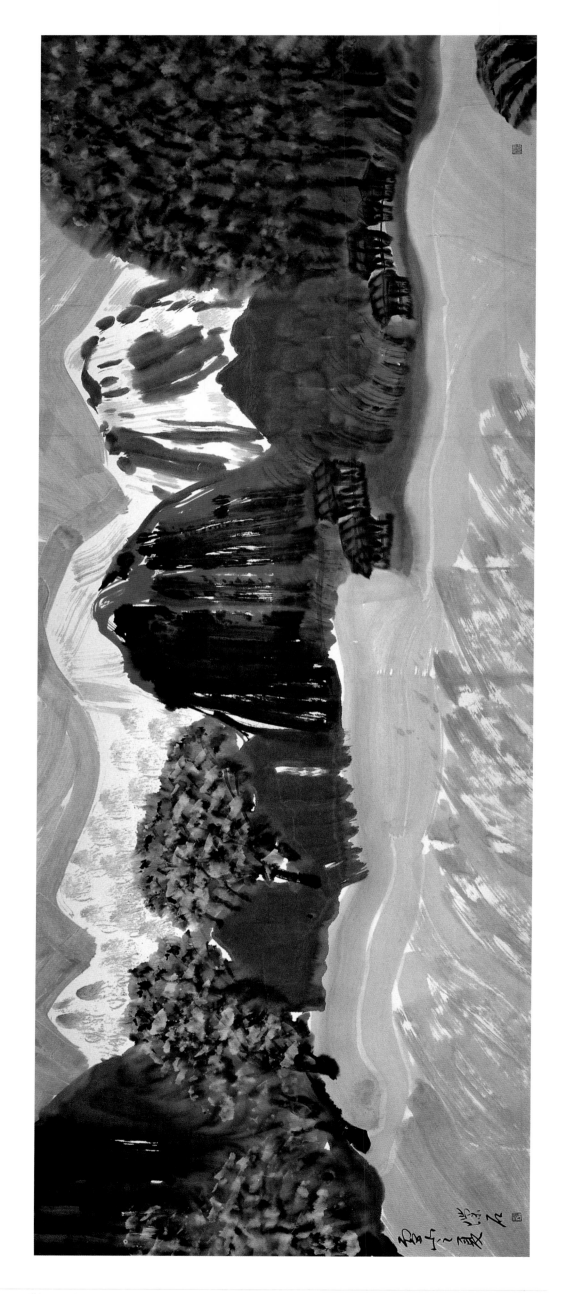

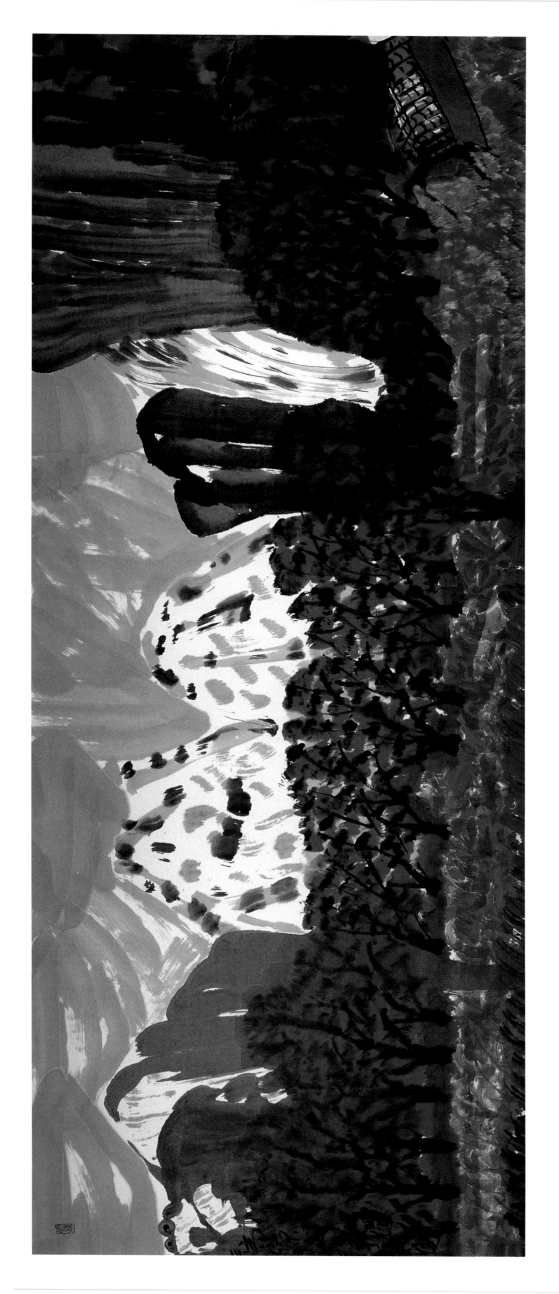

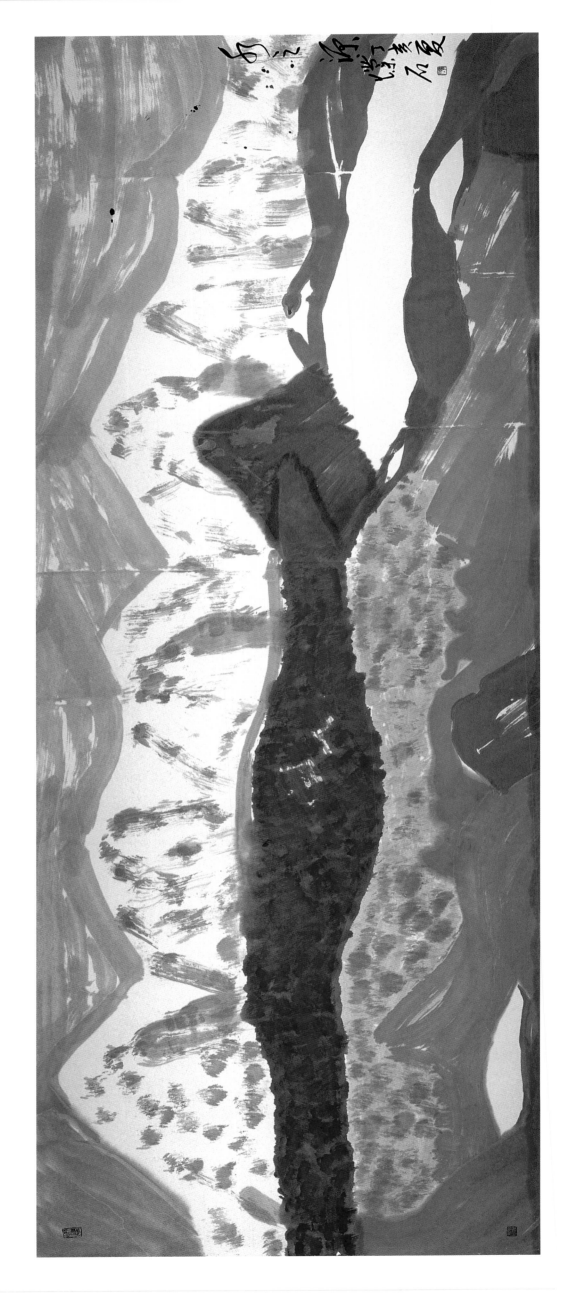

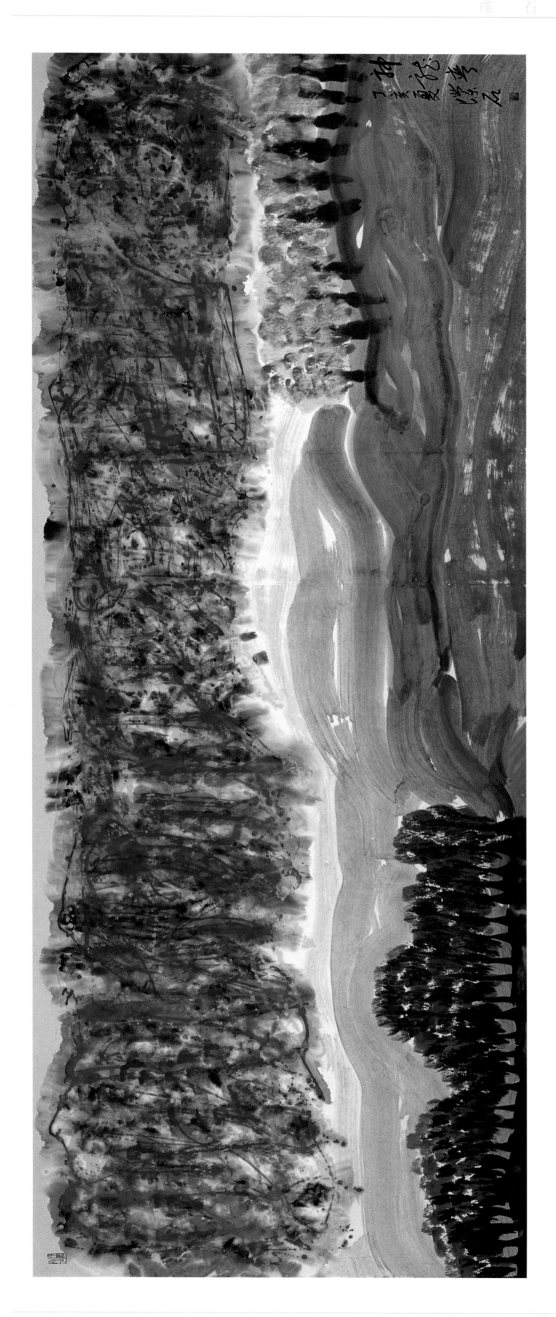

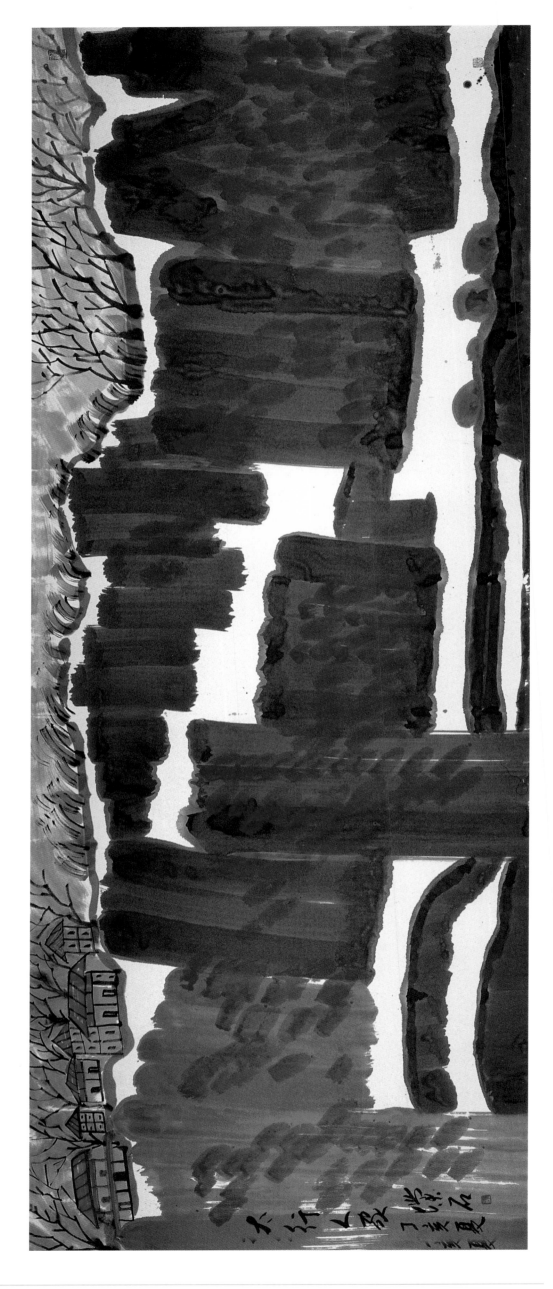

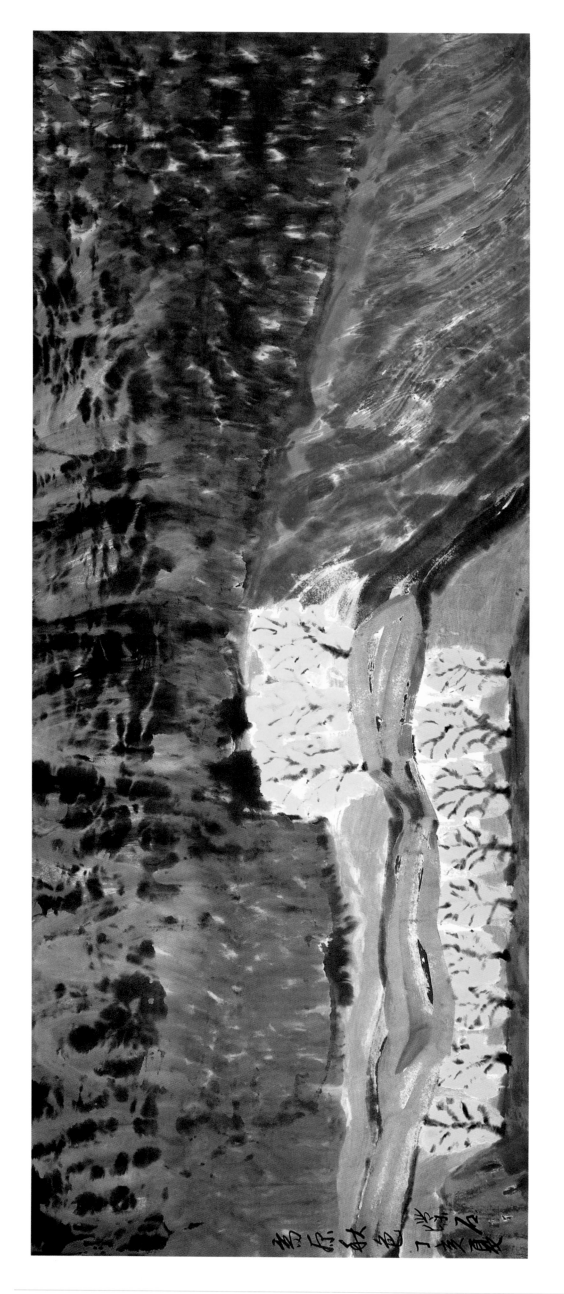

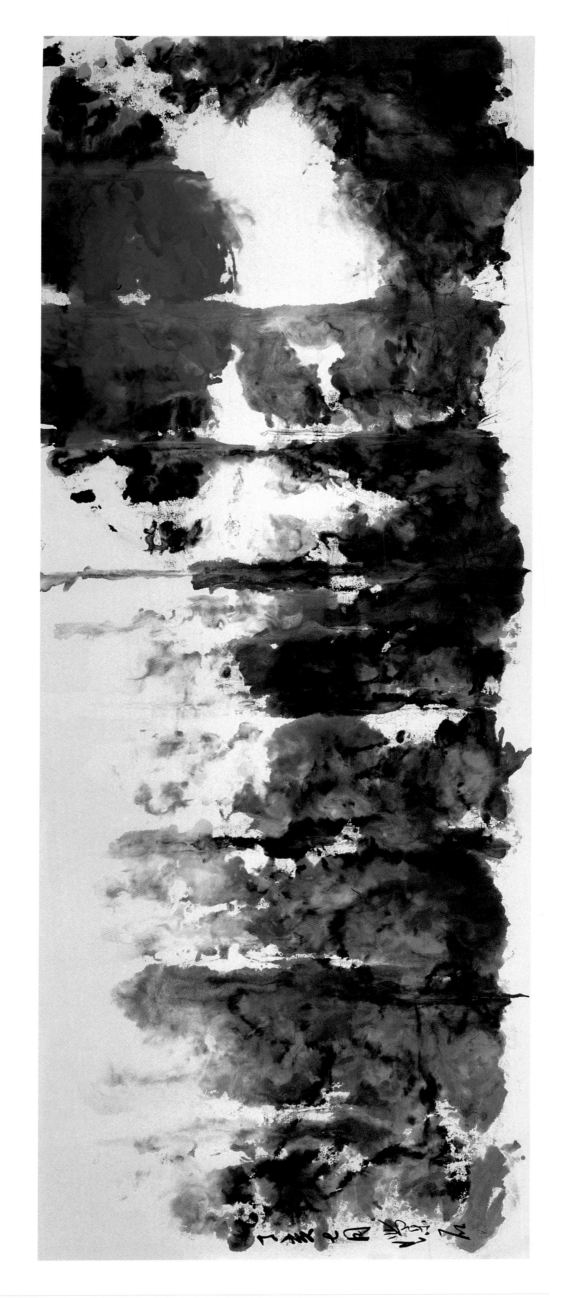

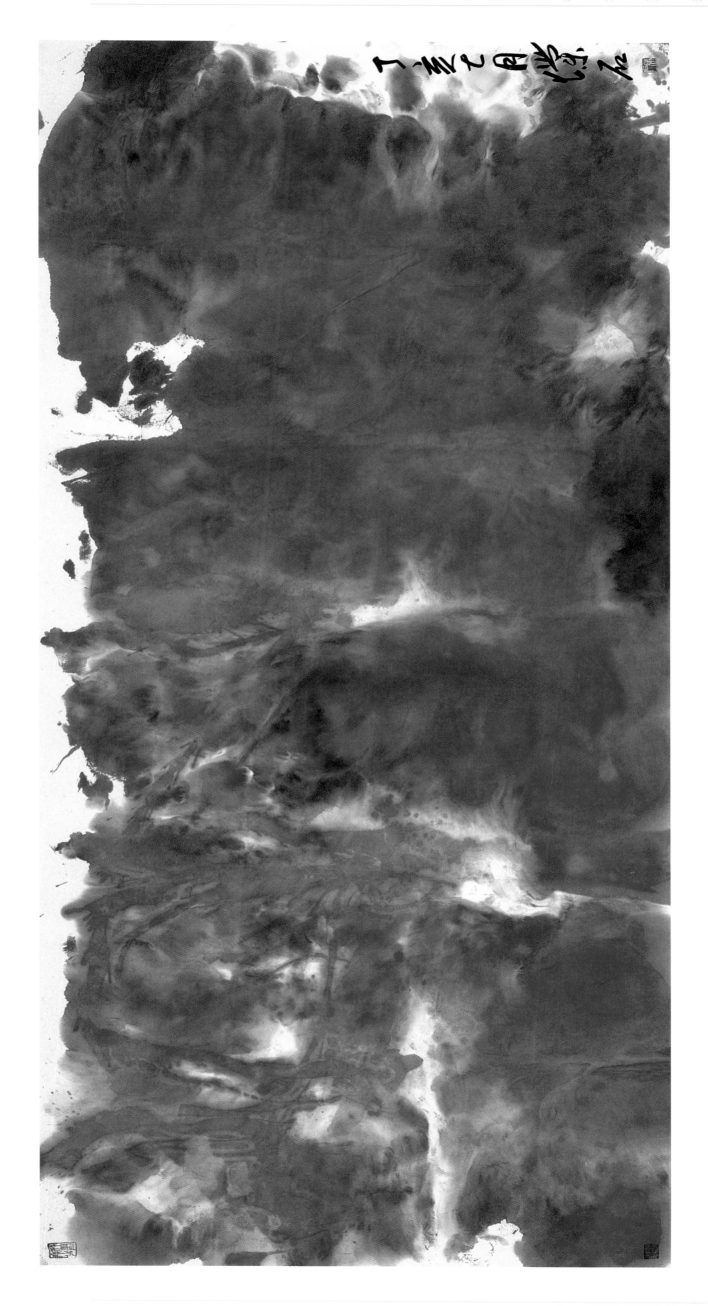

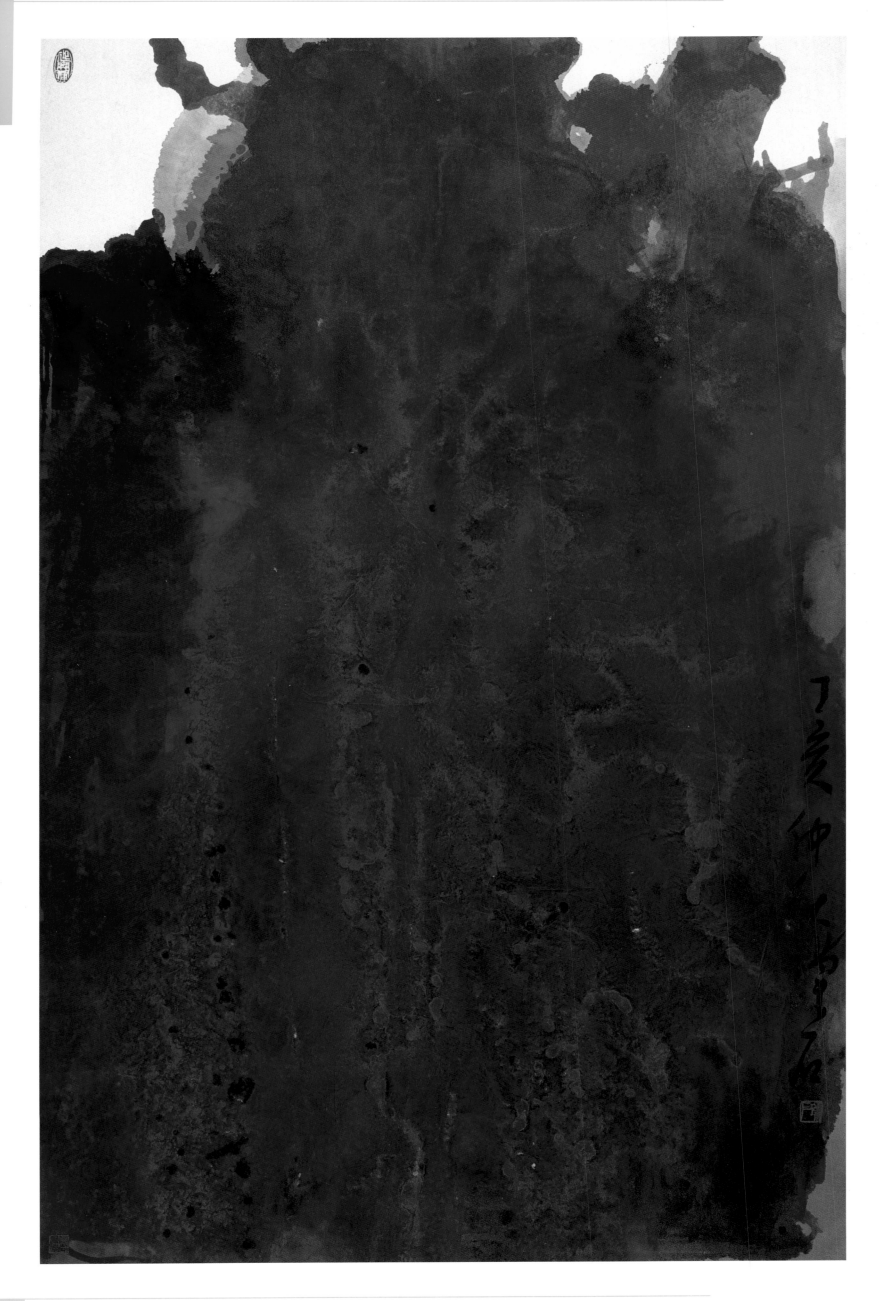

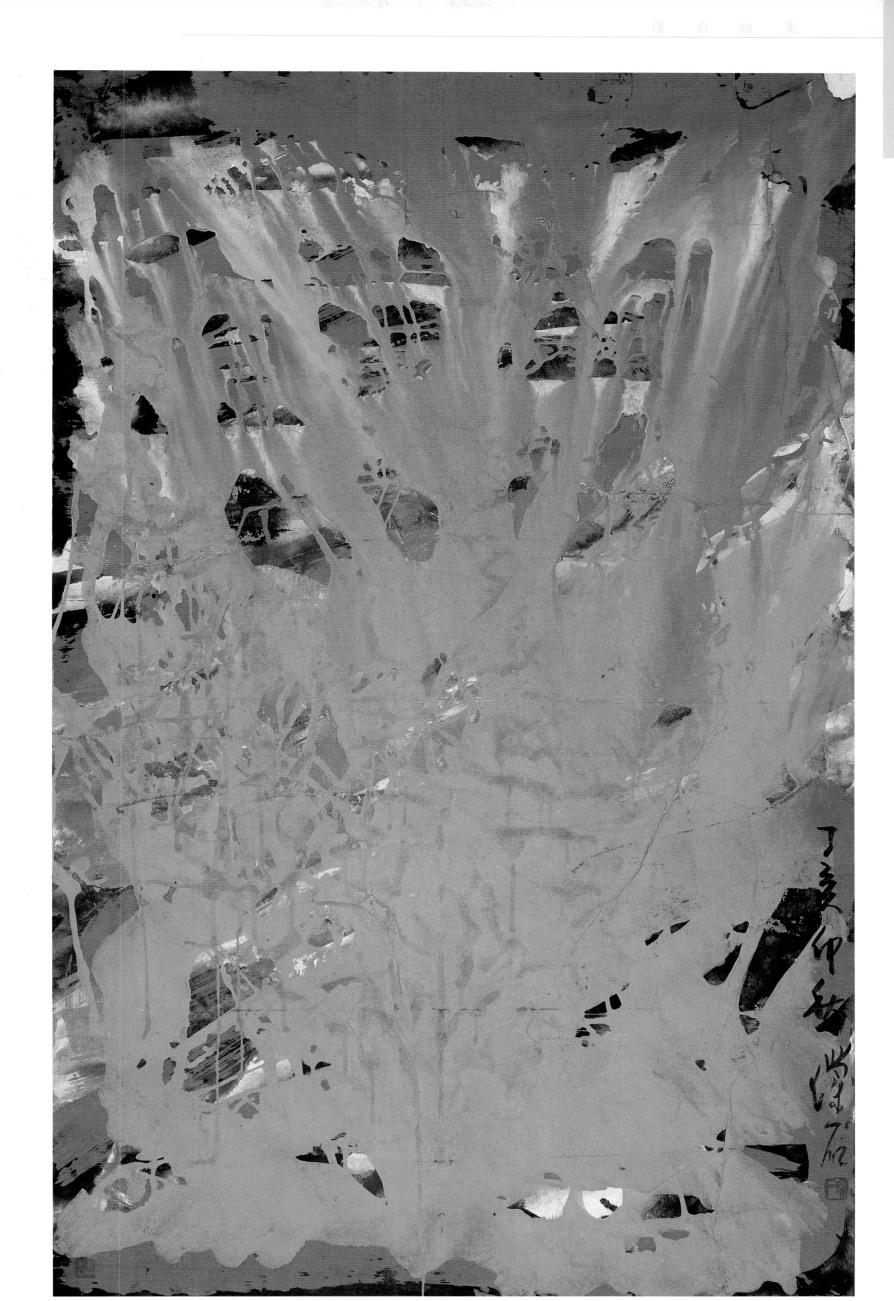

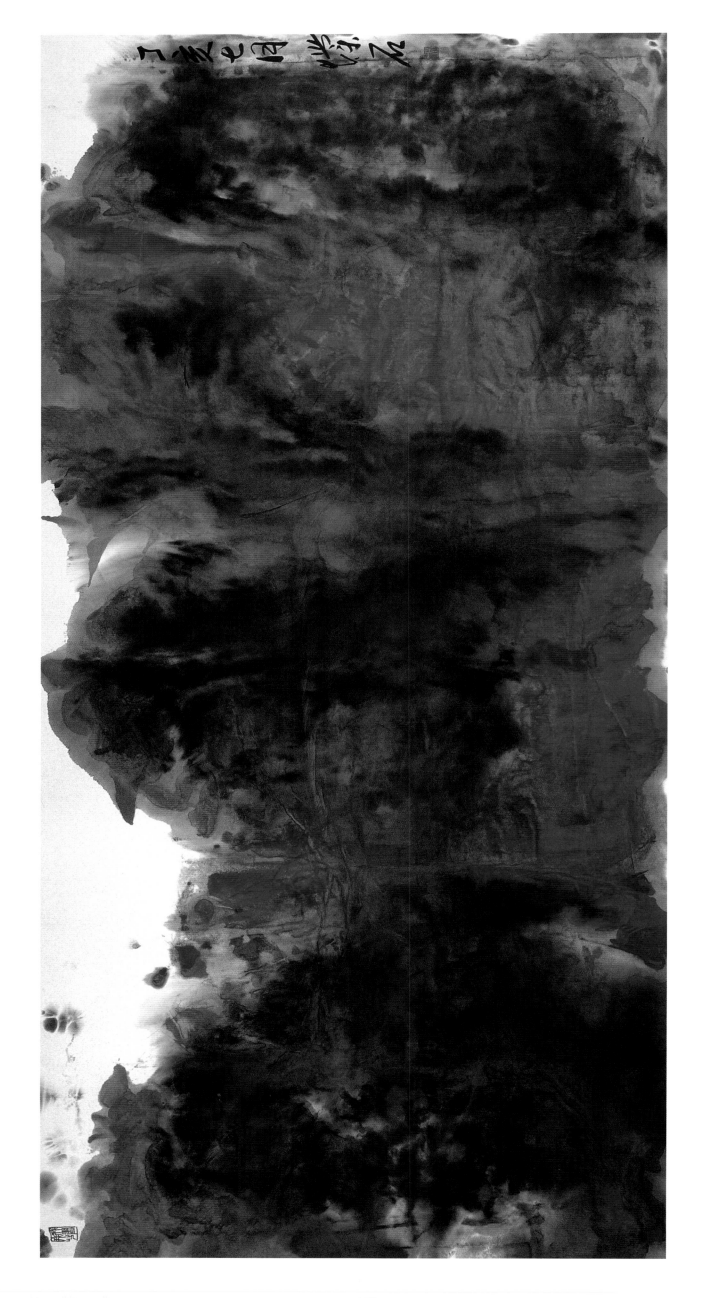

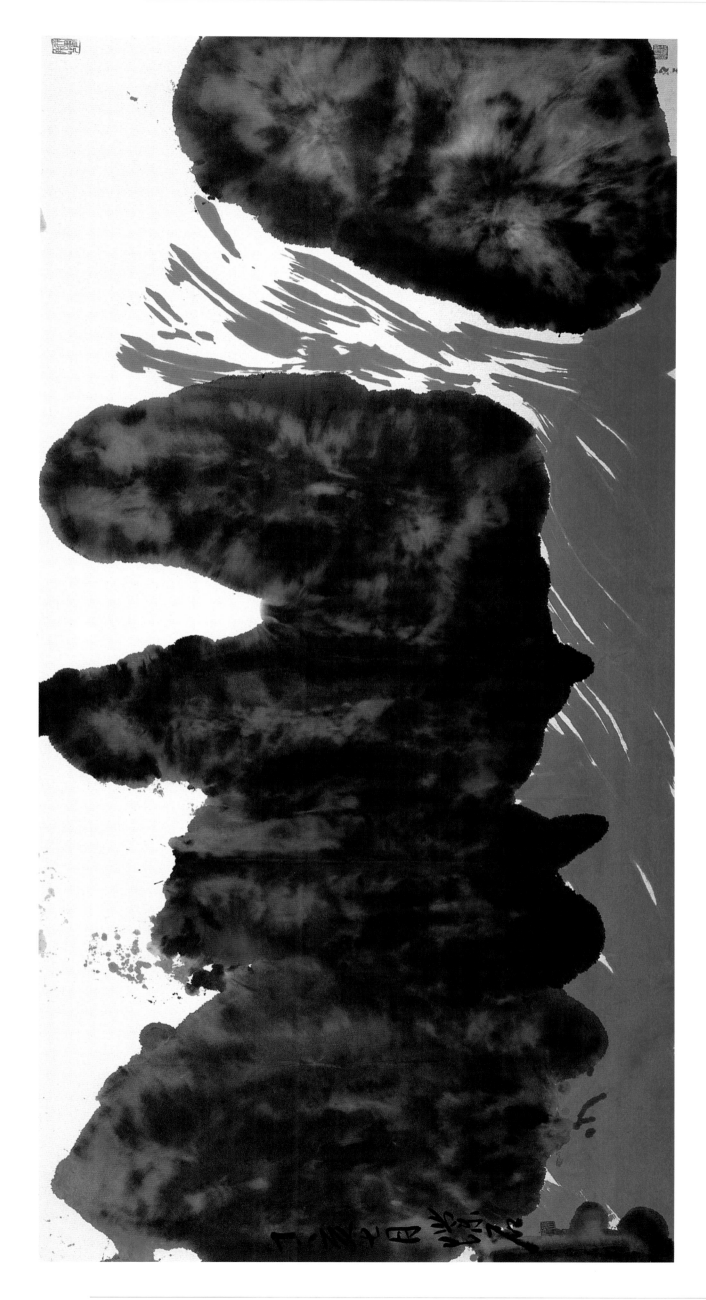

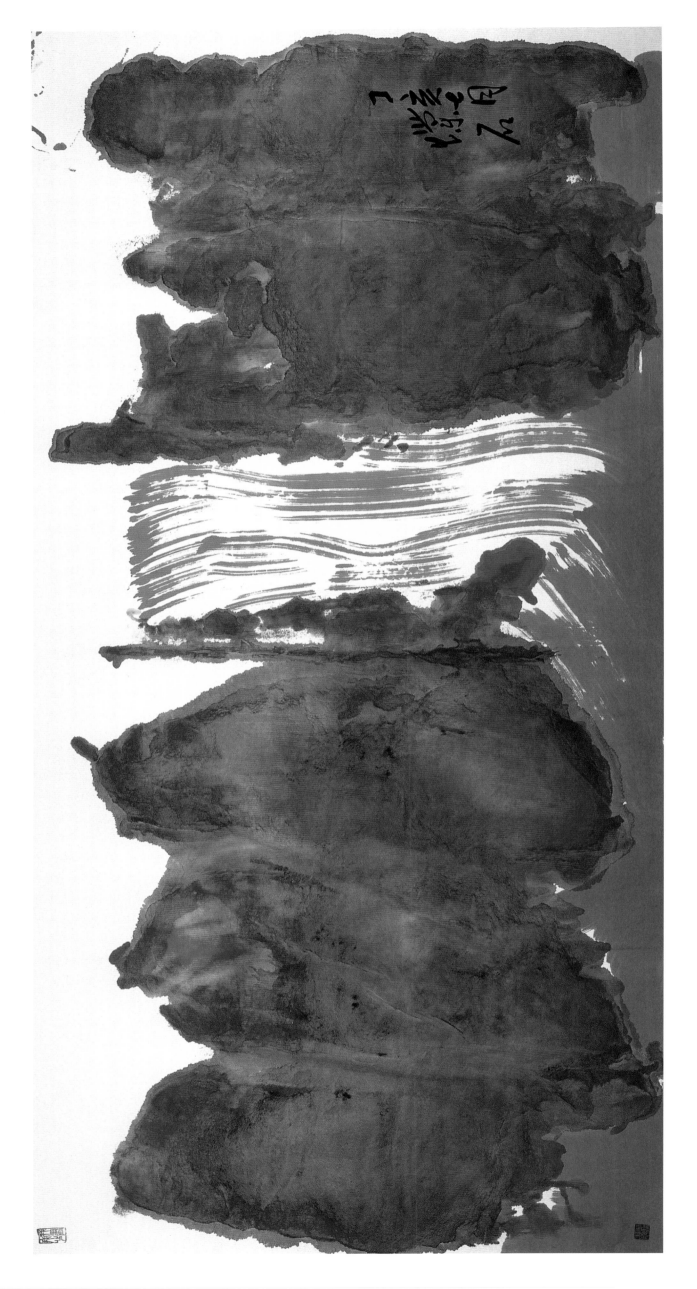

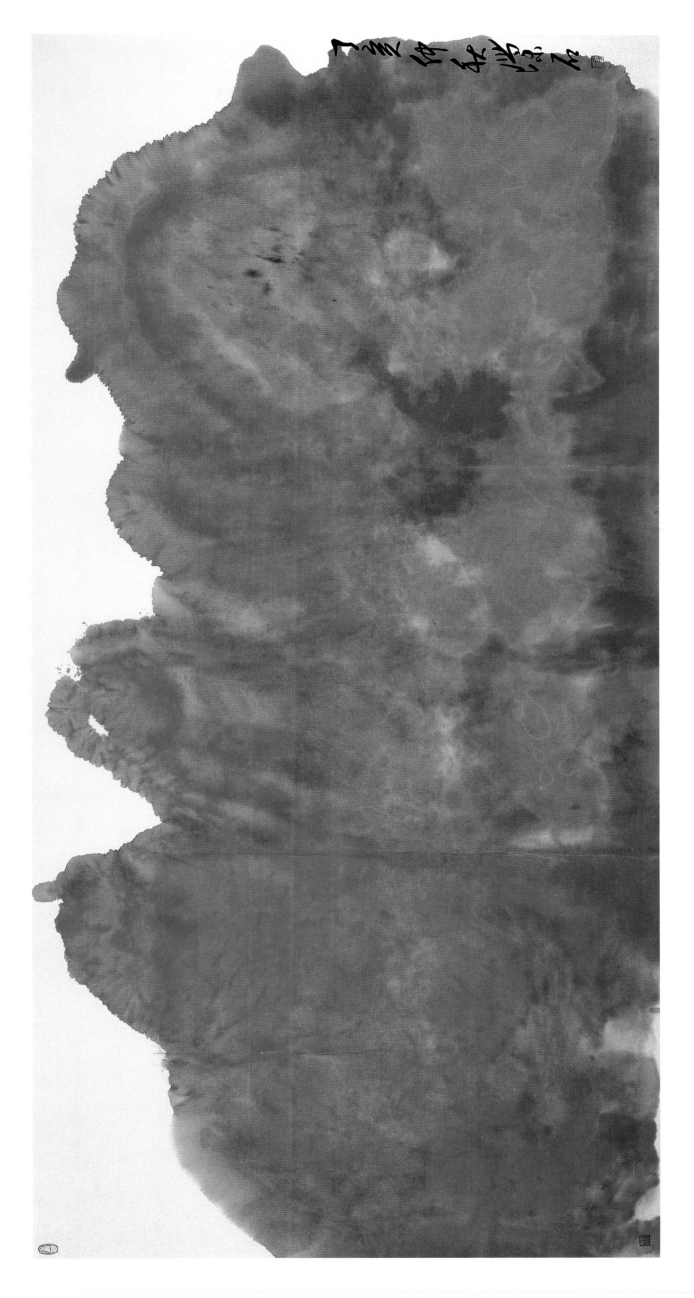

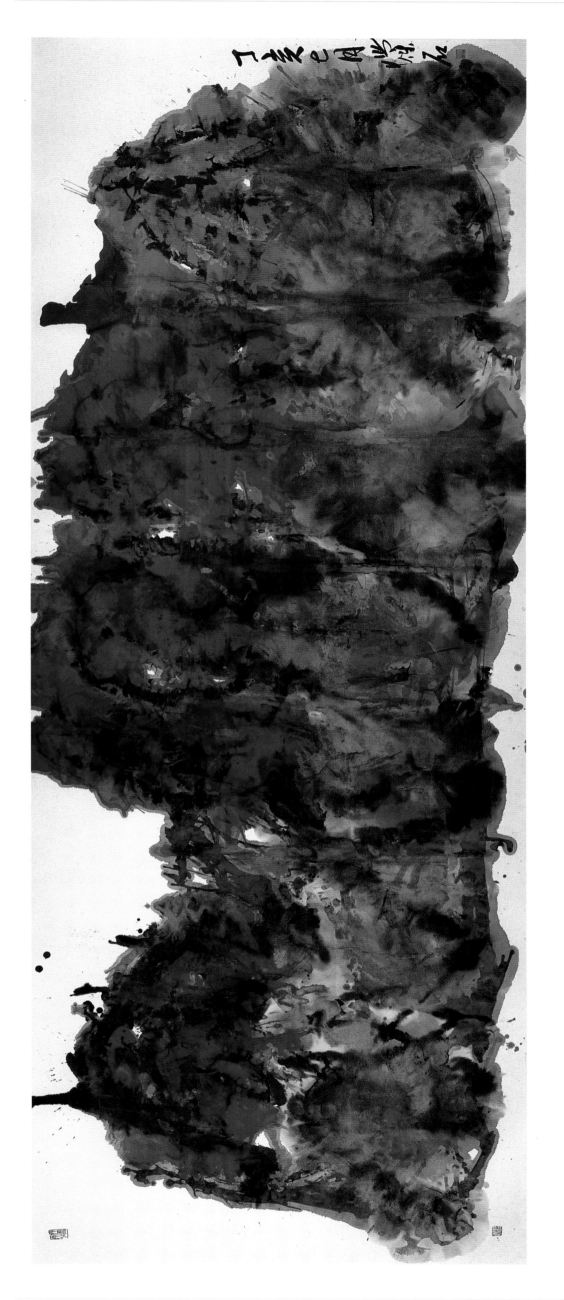

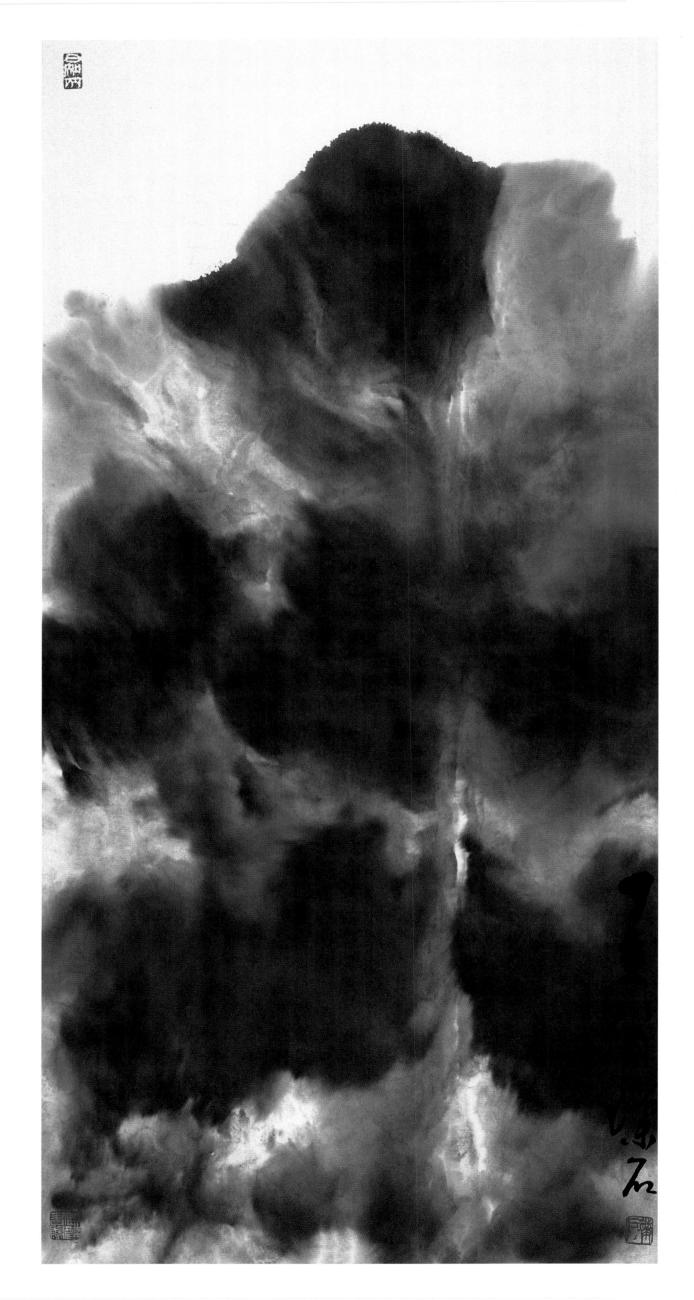

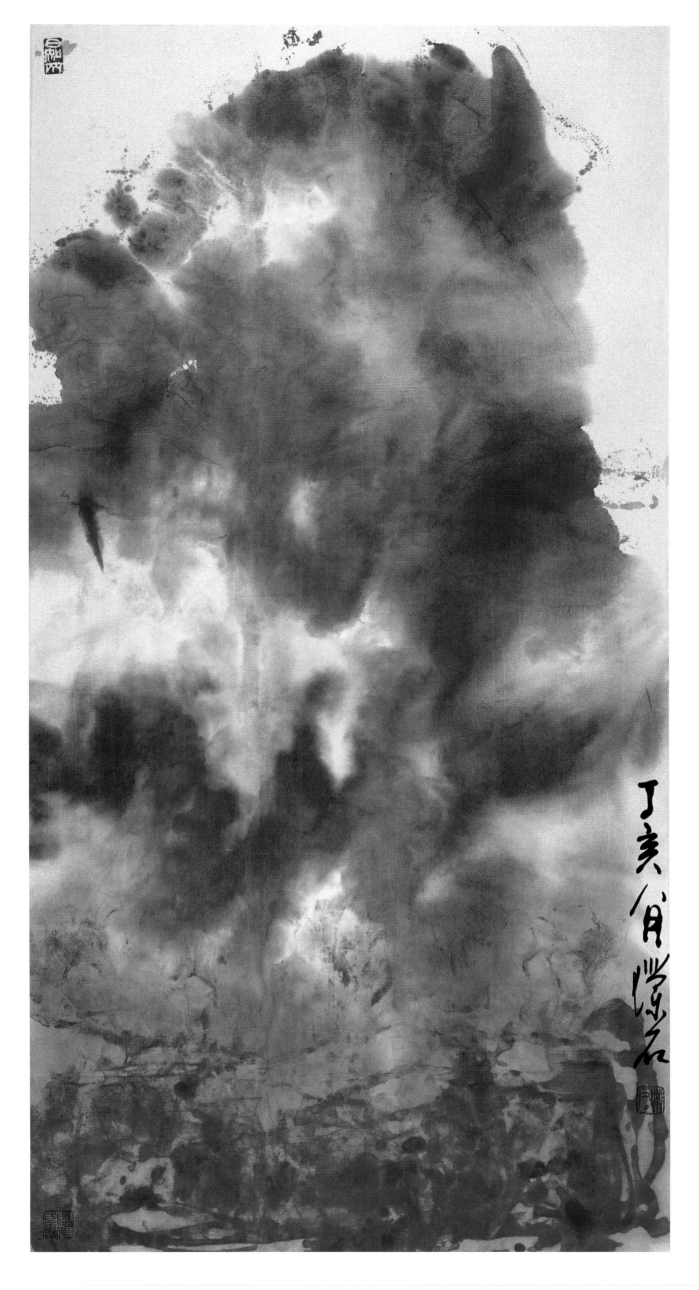

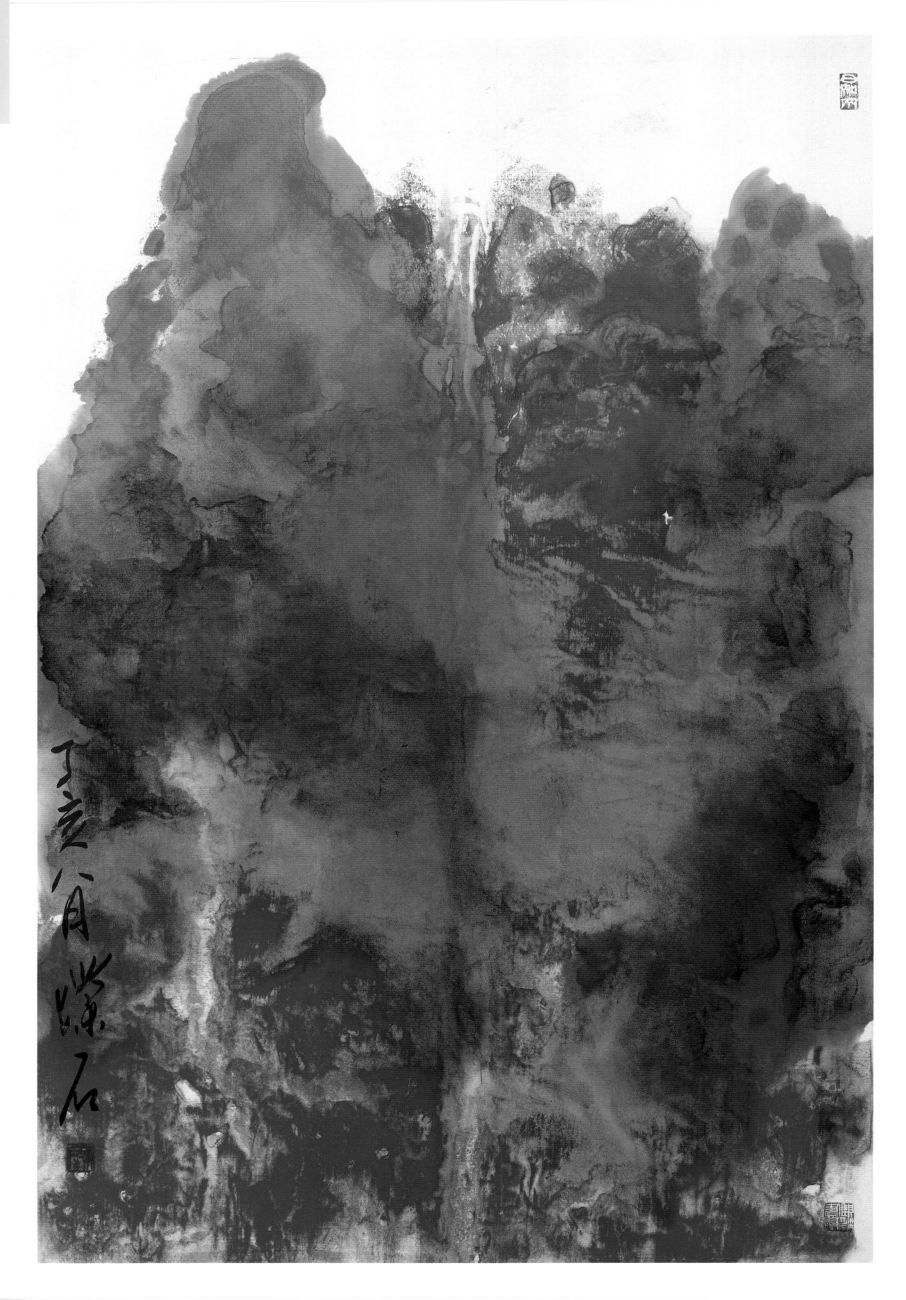

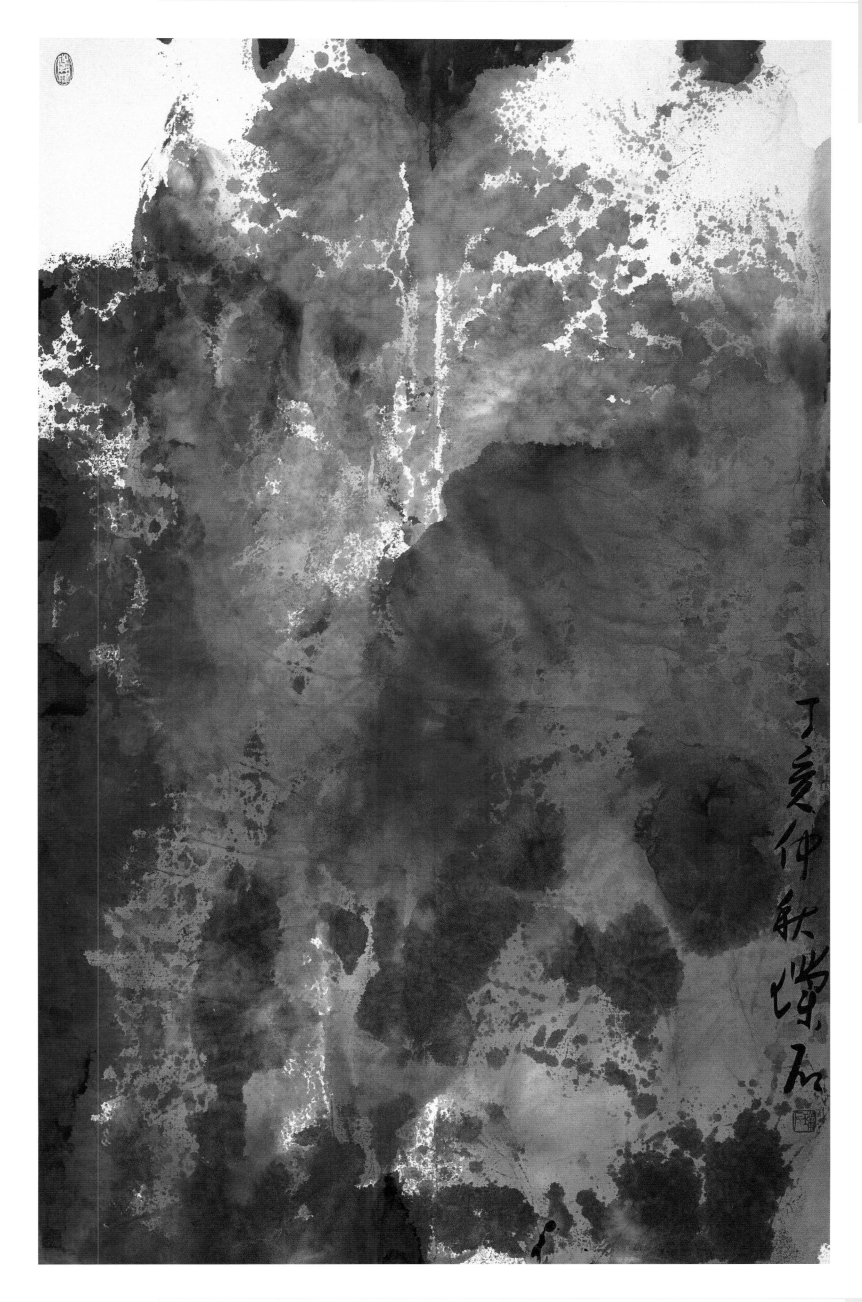

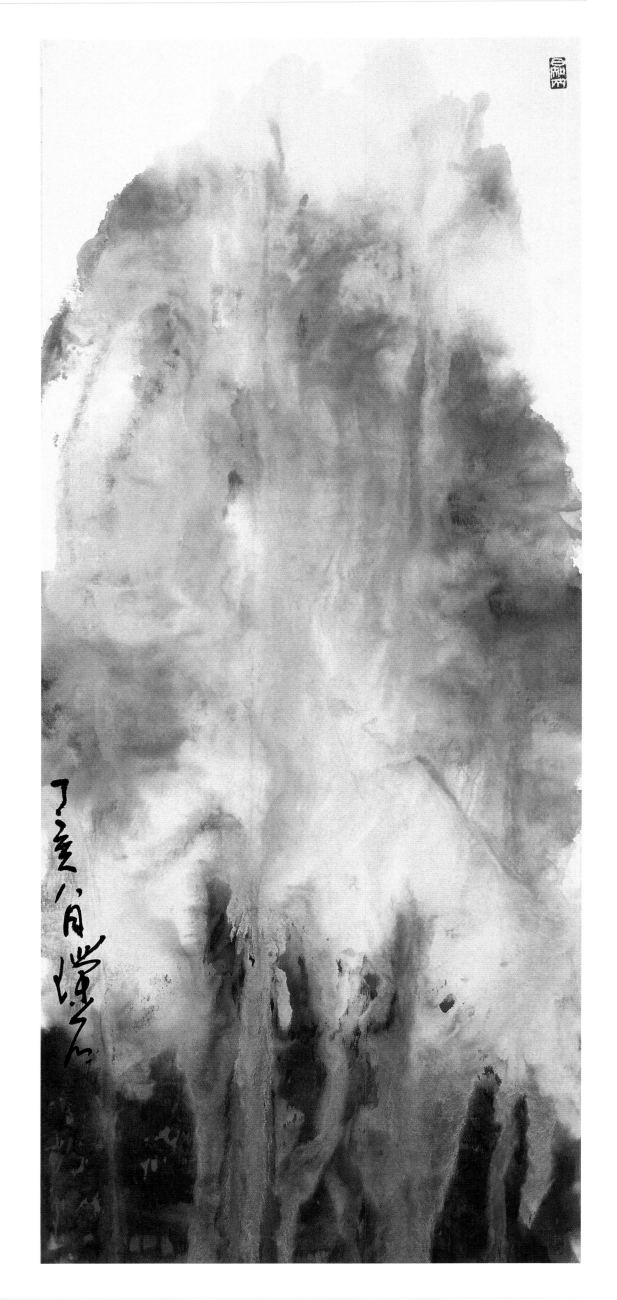

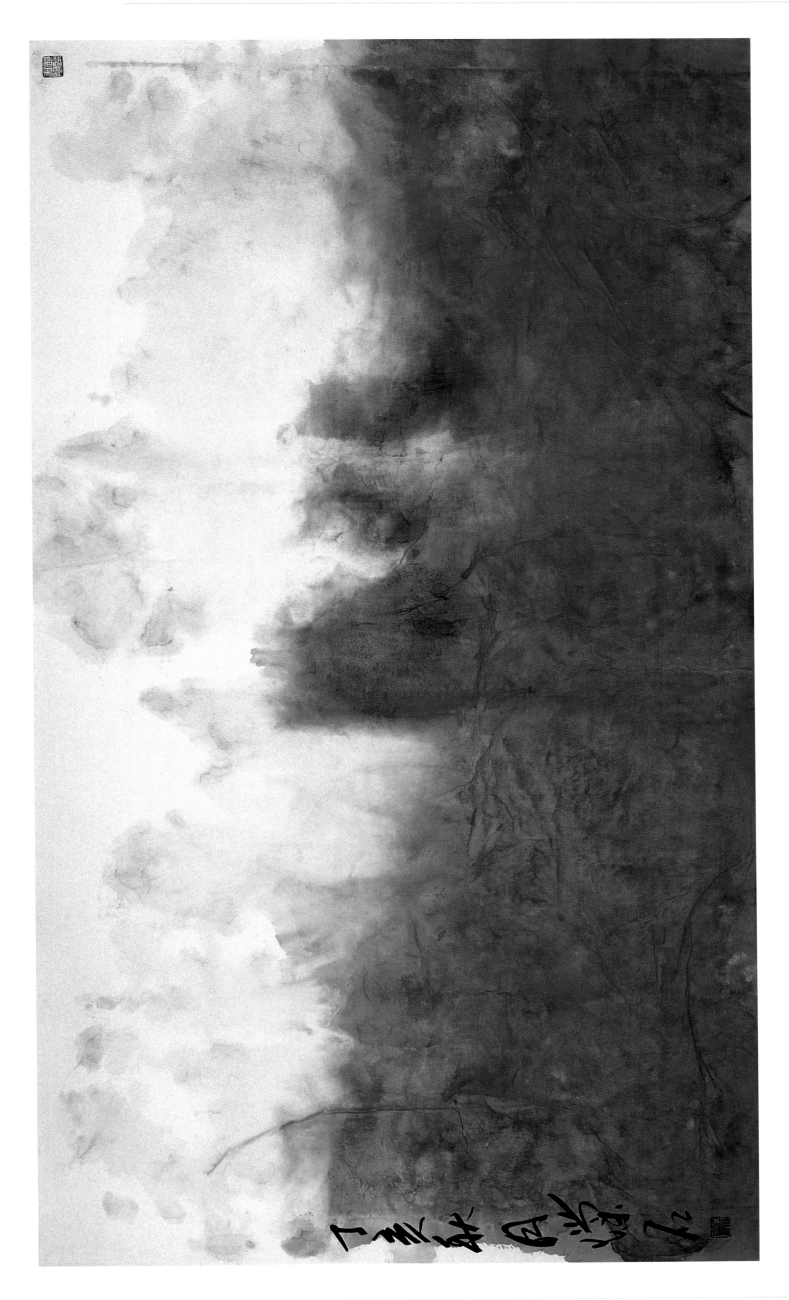

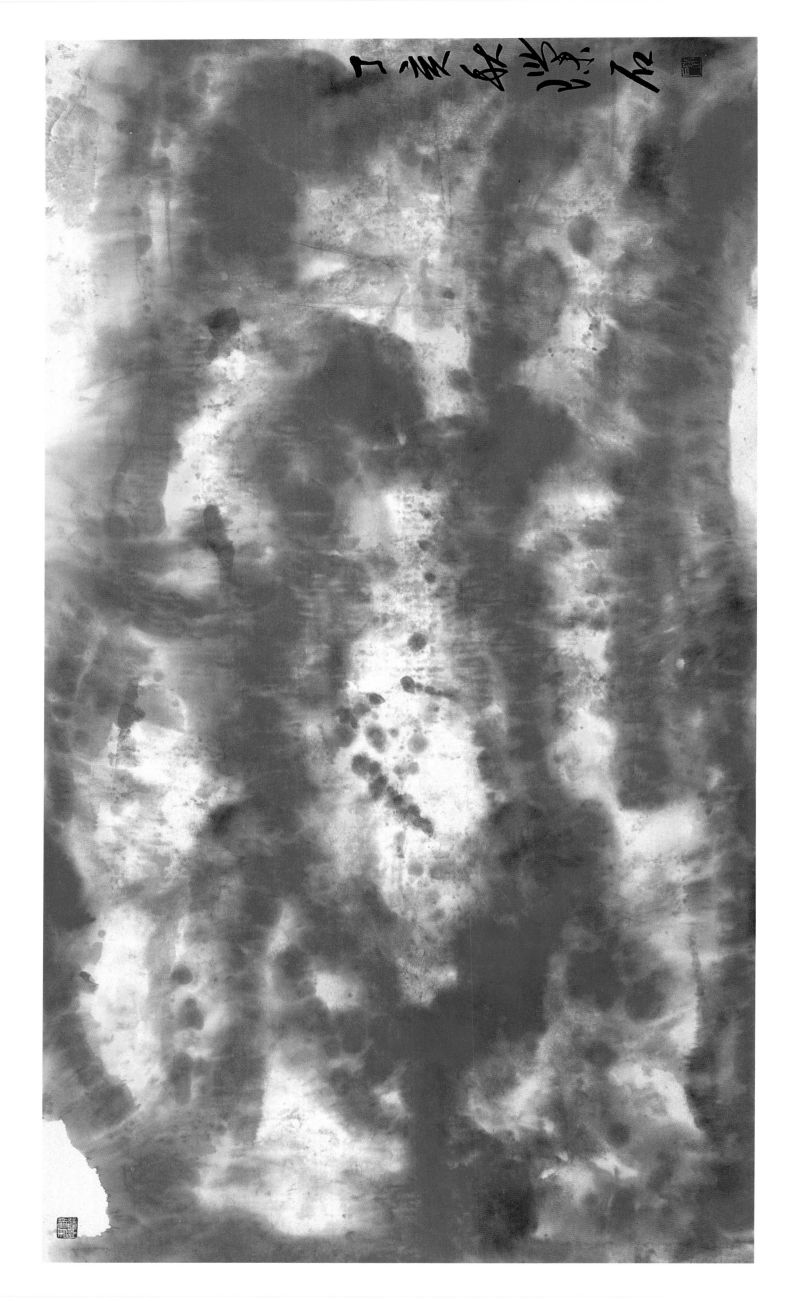

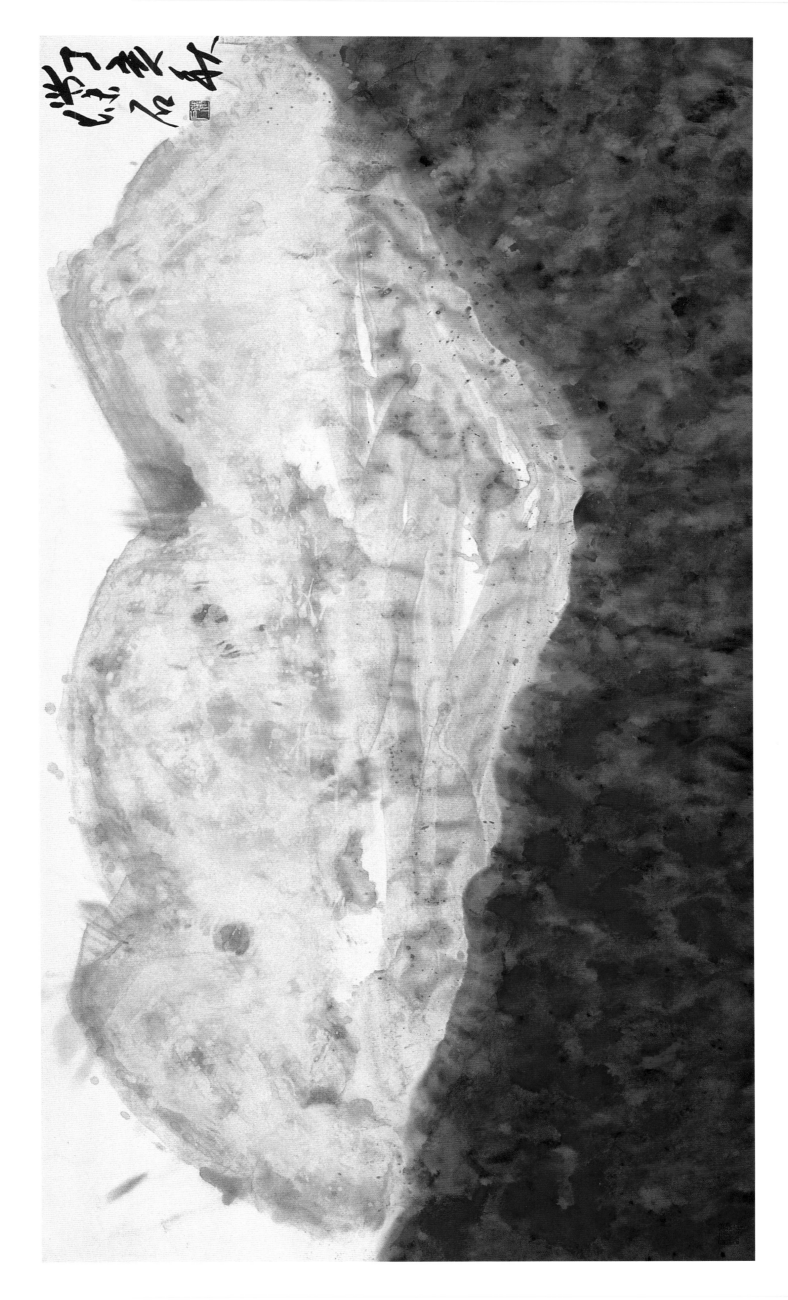

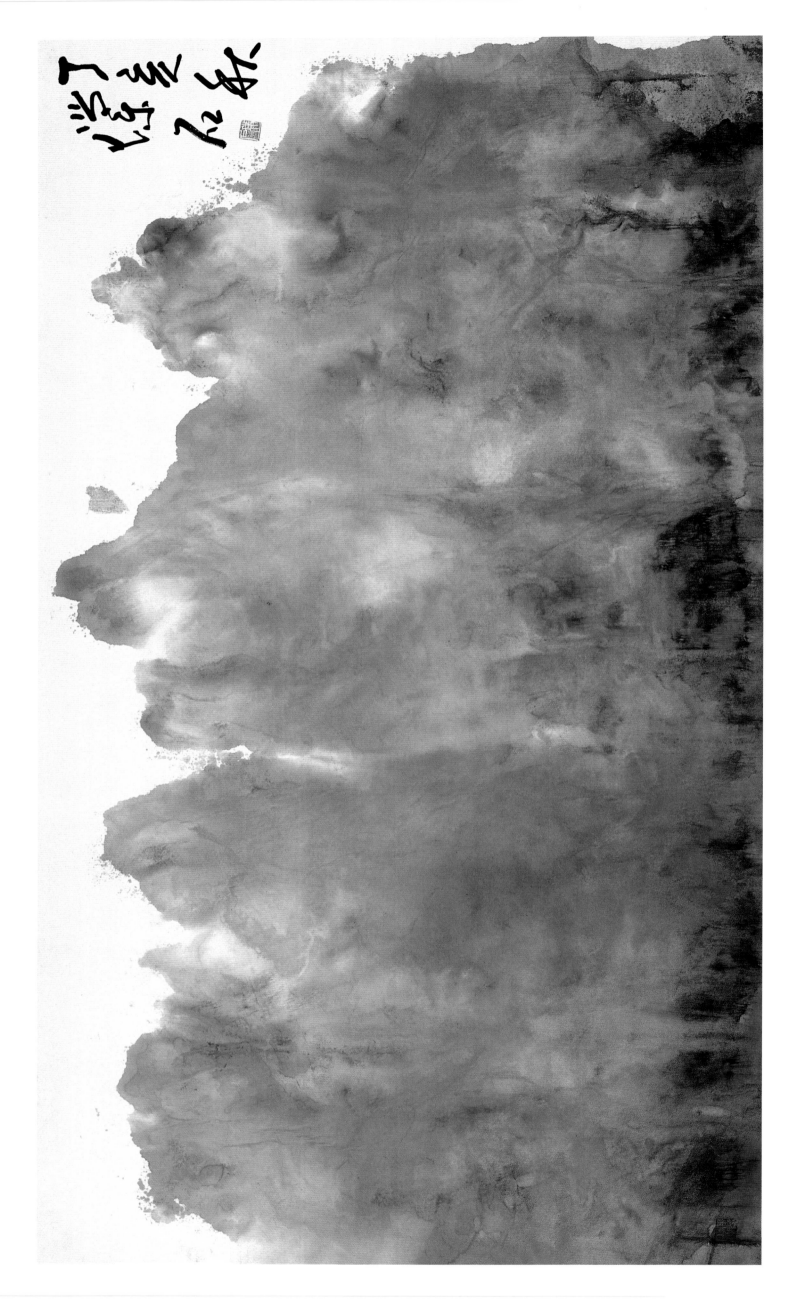

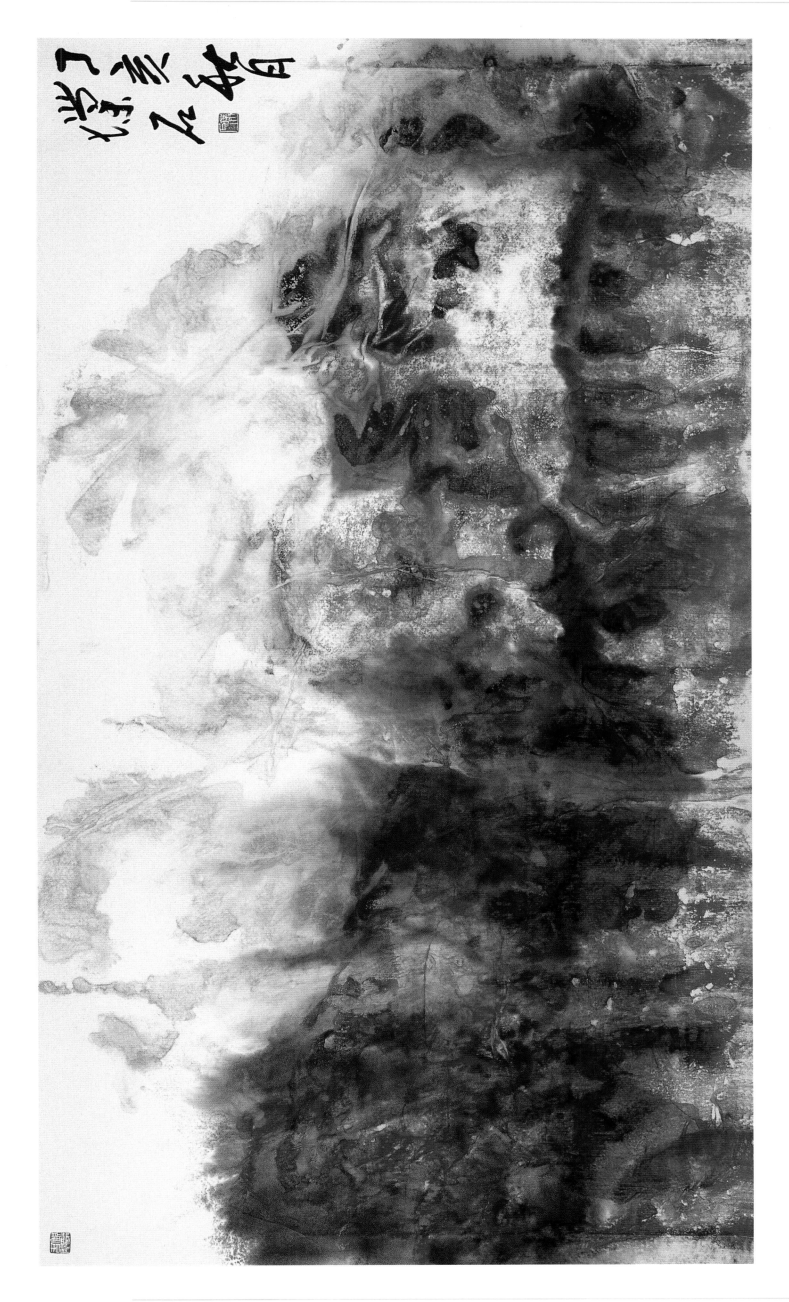

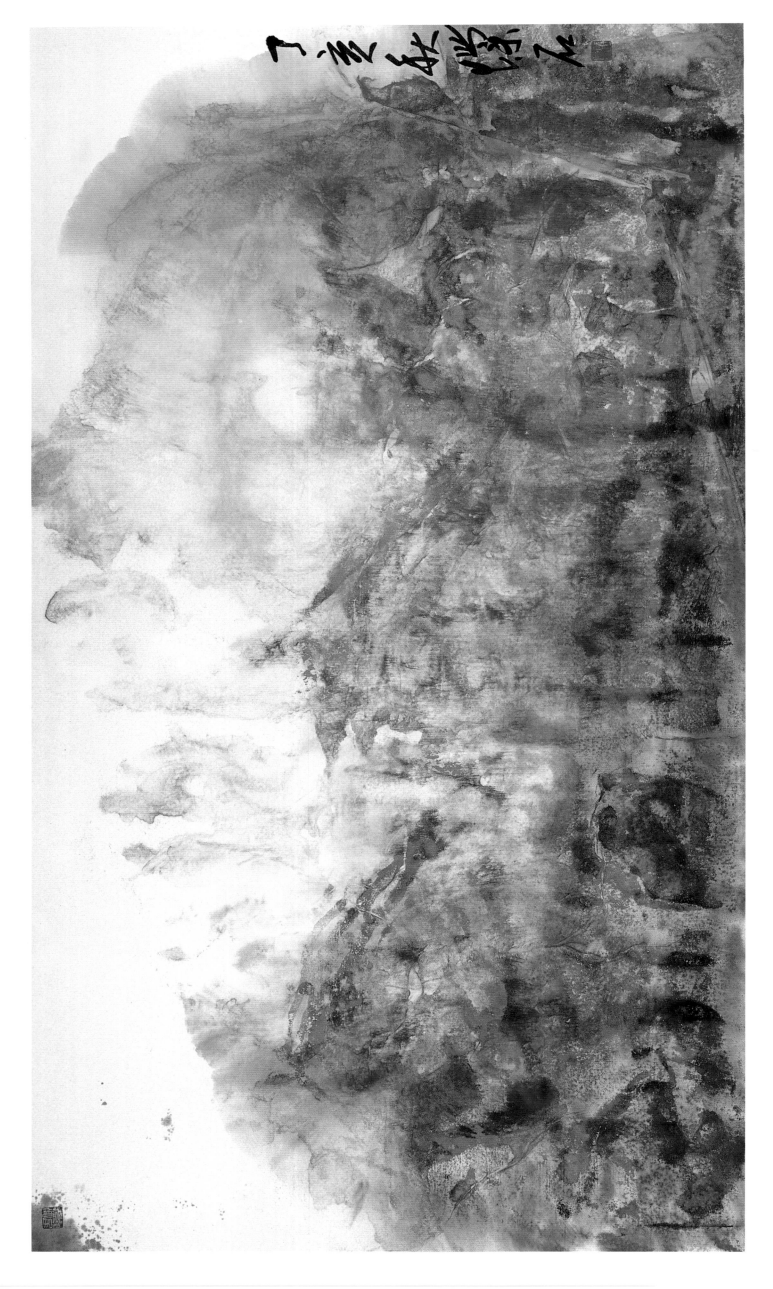

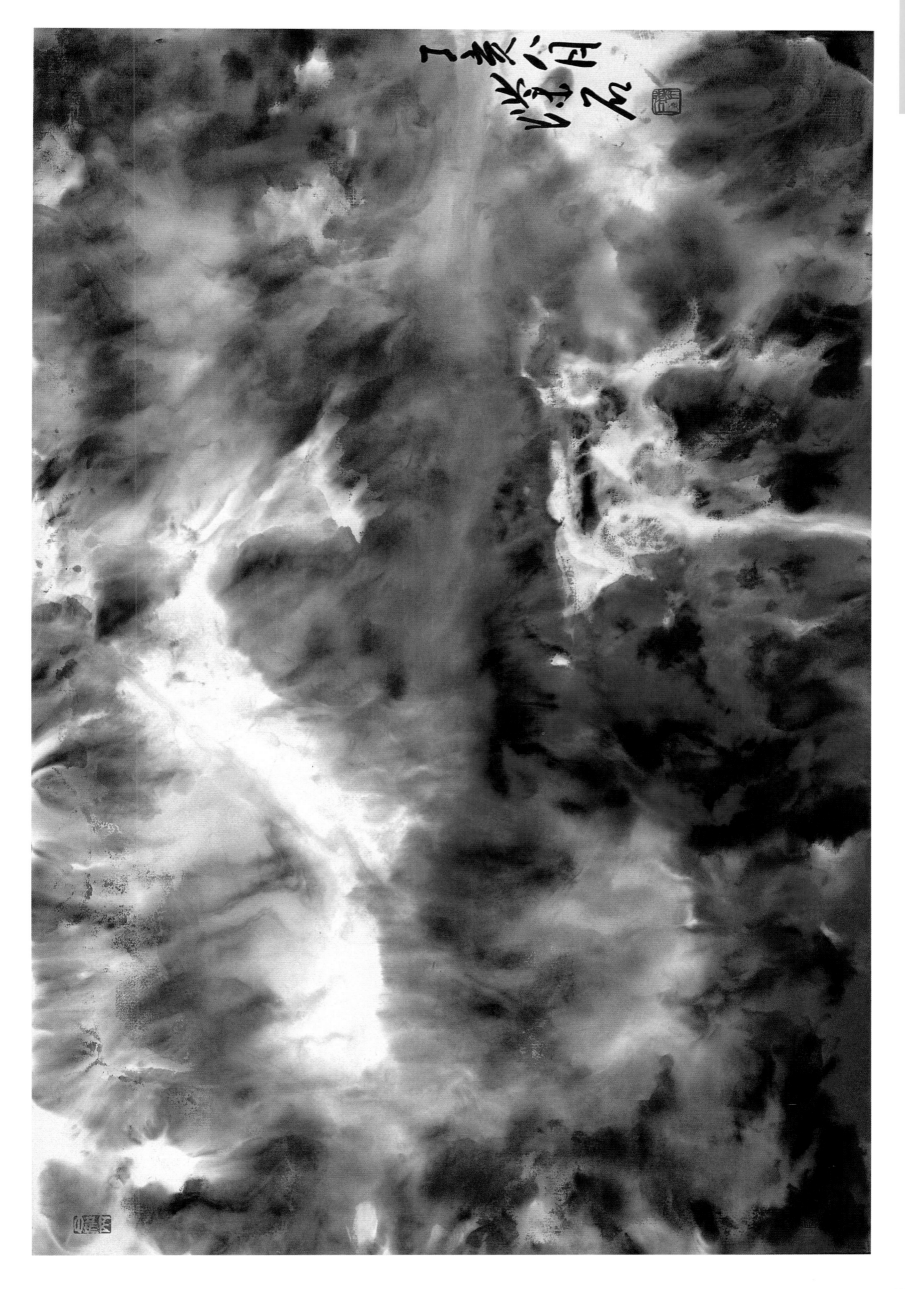

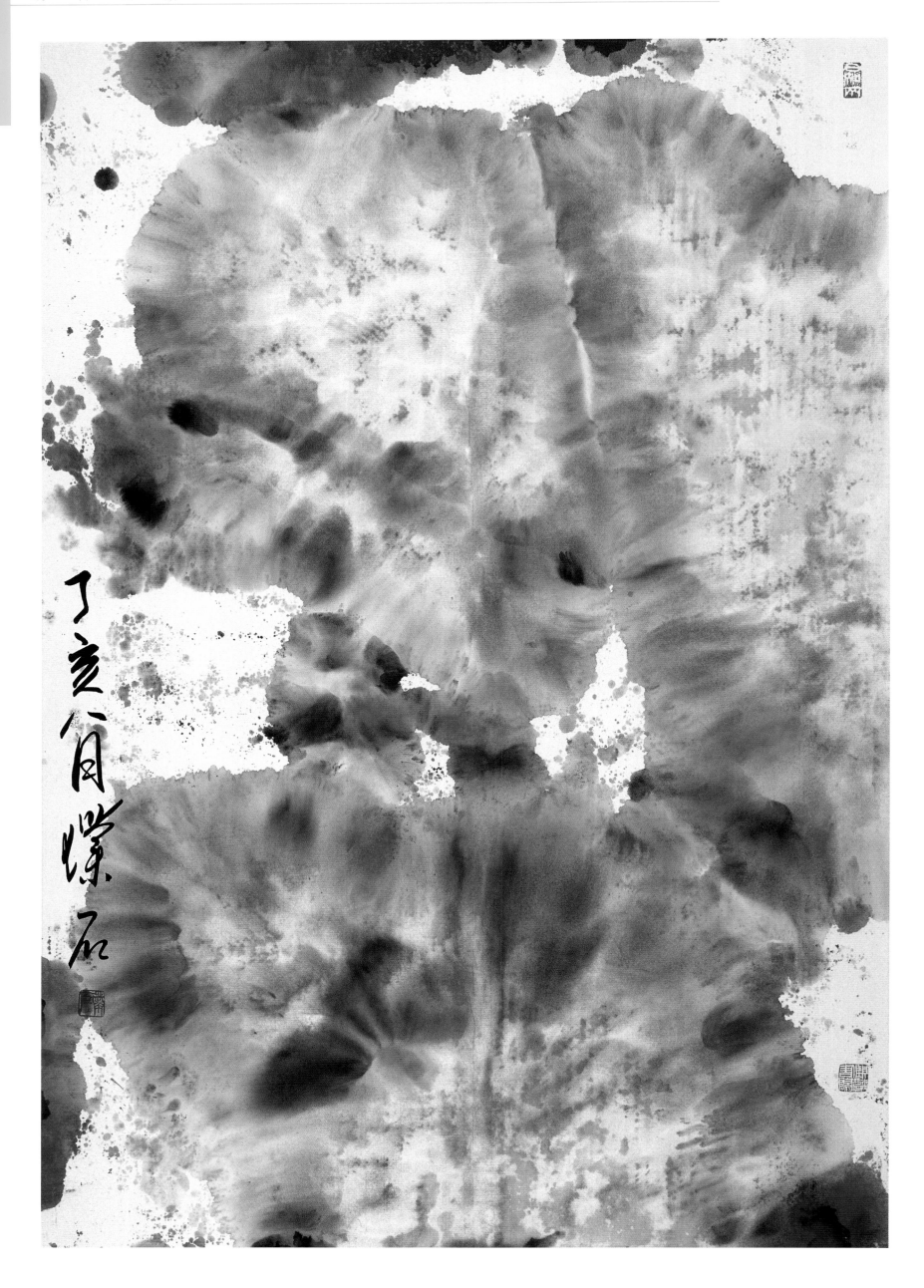

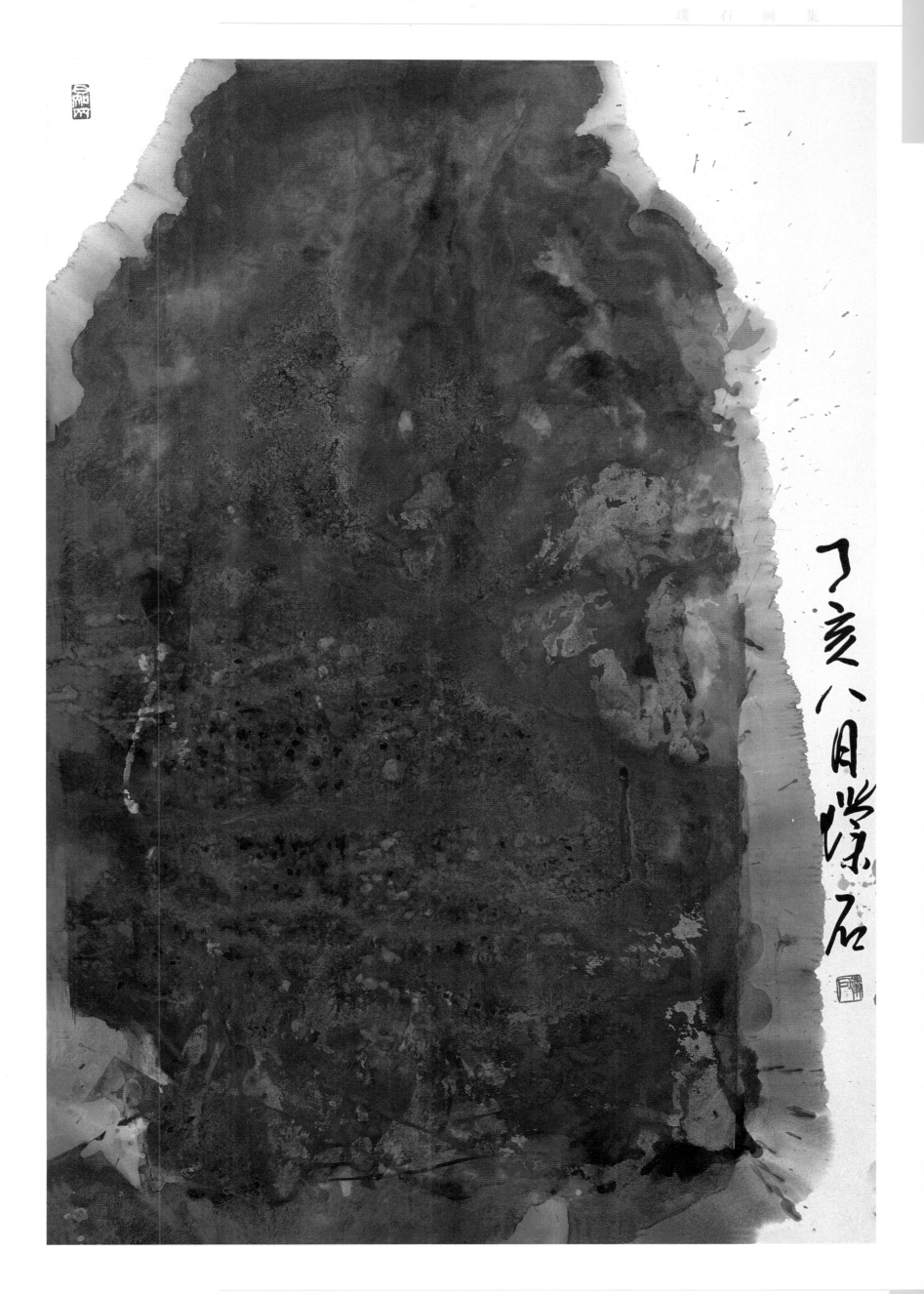

丁亥八月璞石

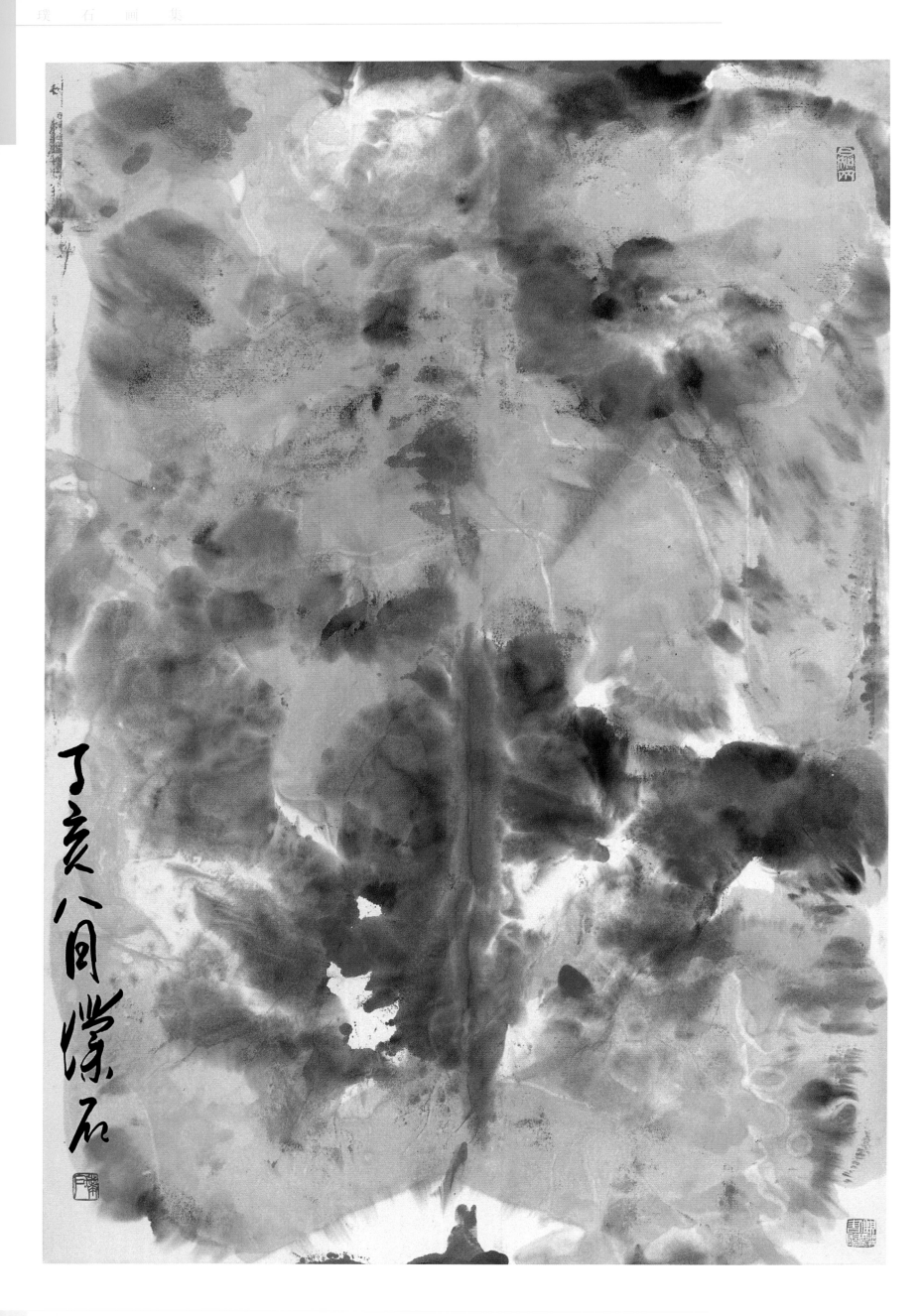

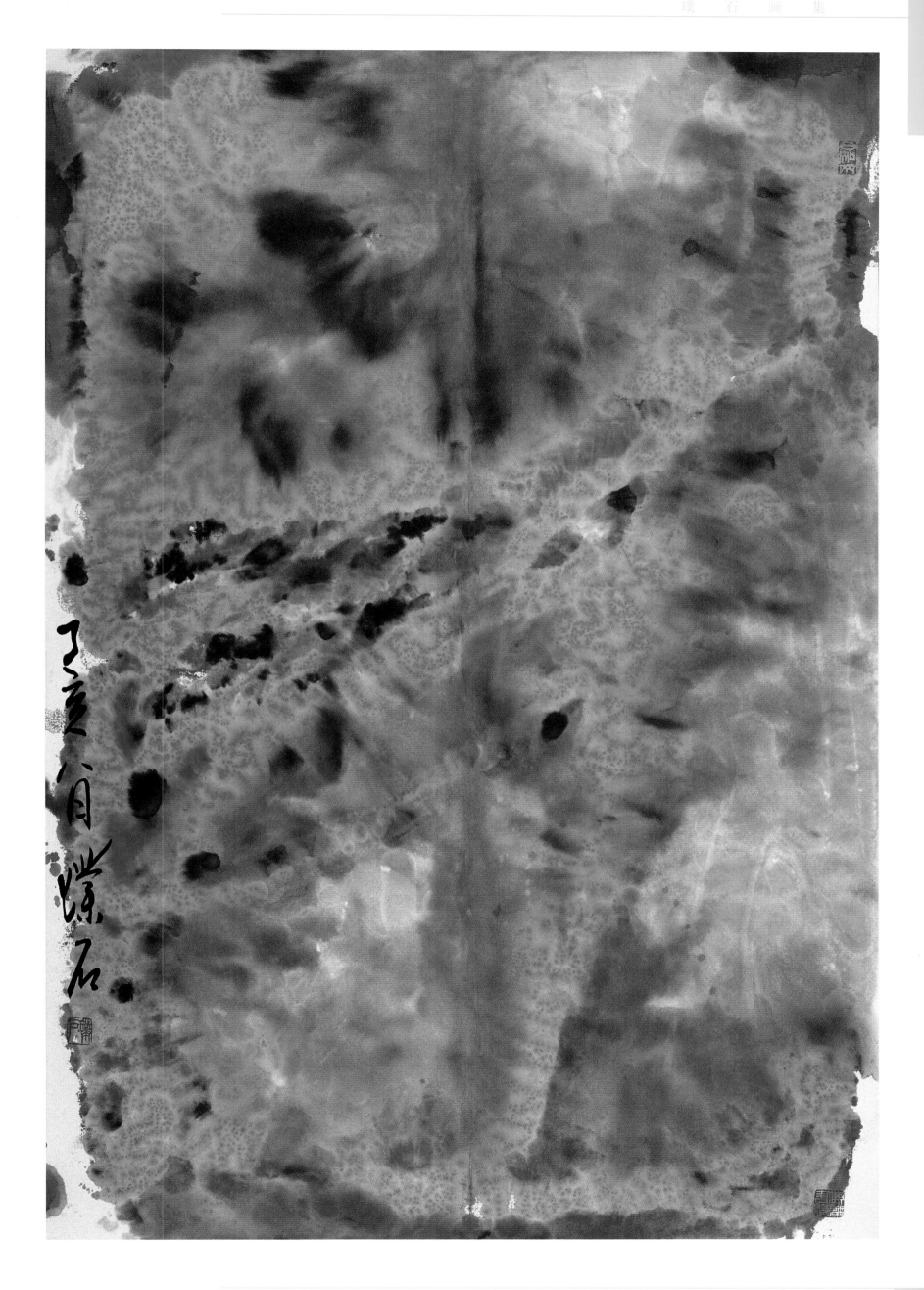

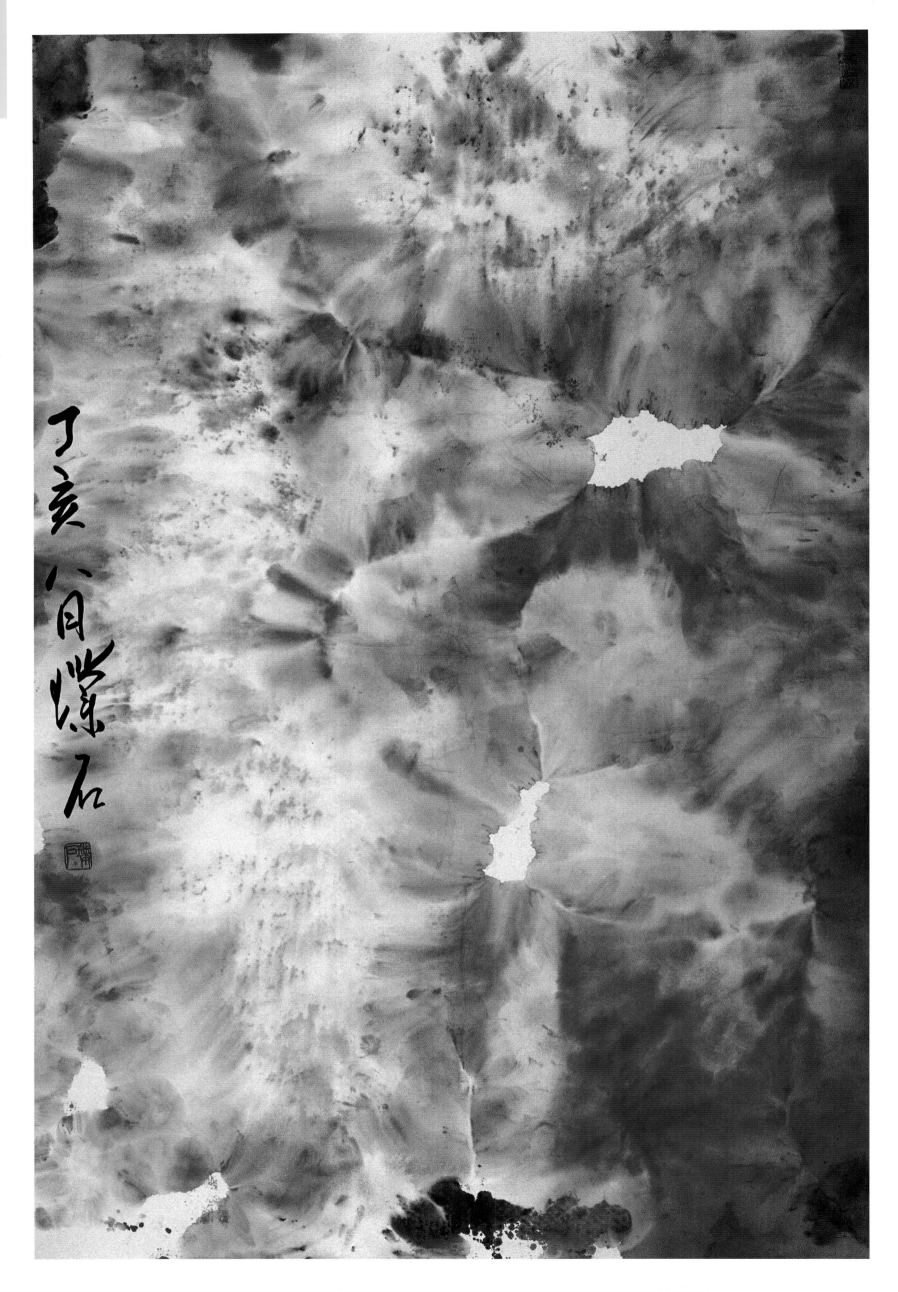

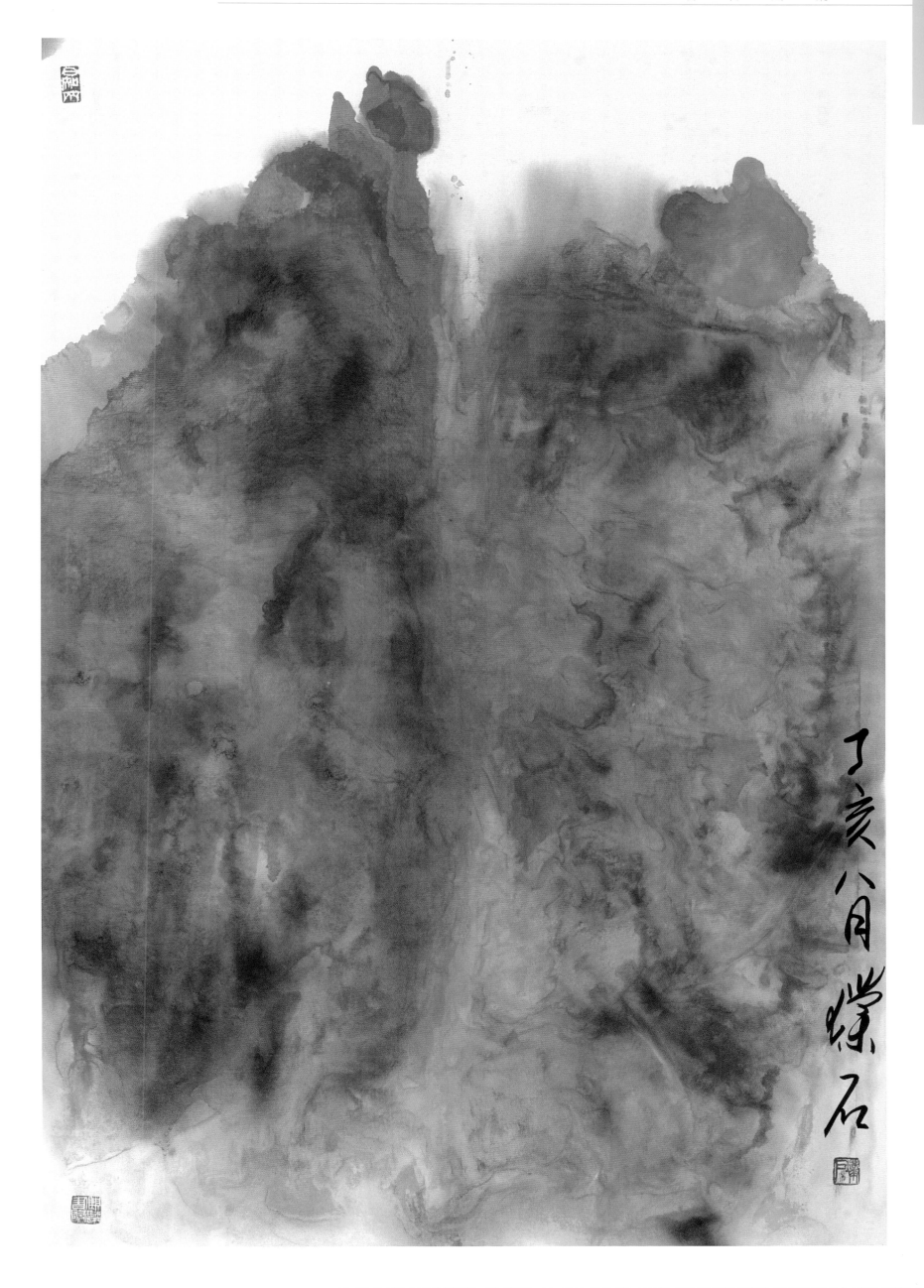

丁亥八月璞石

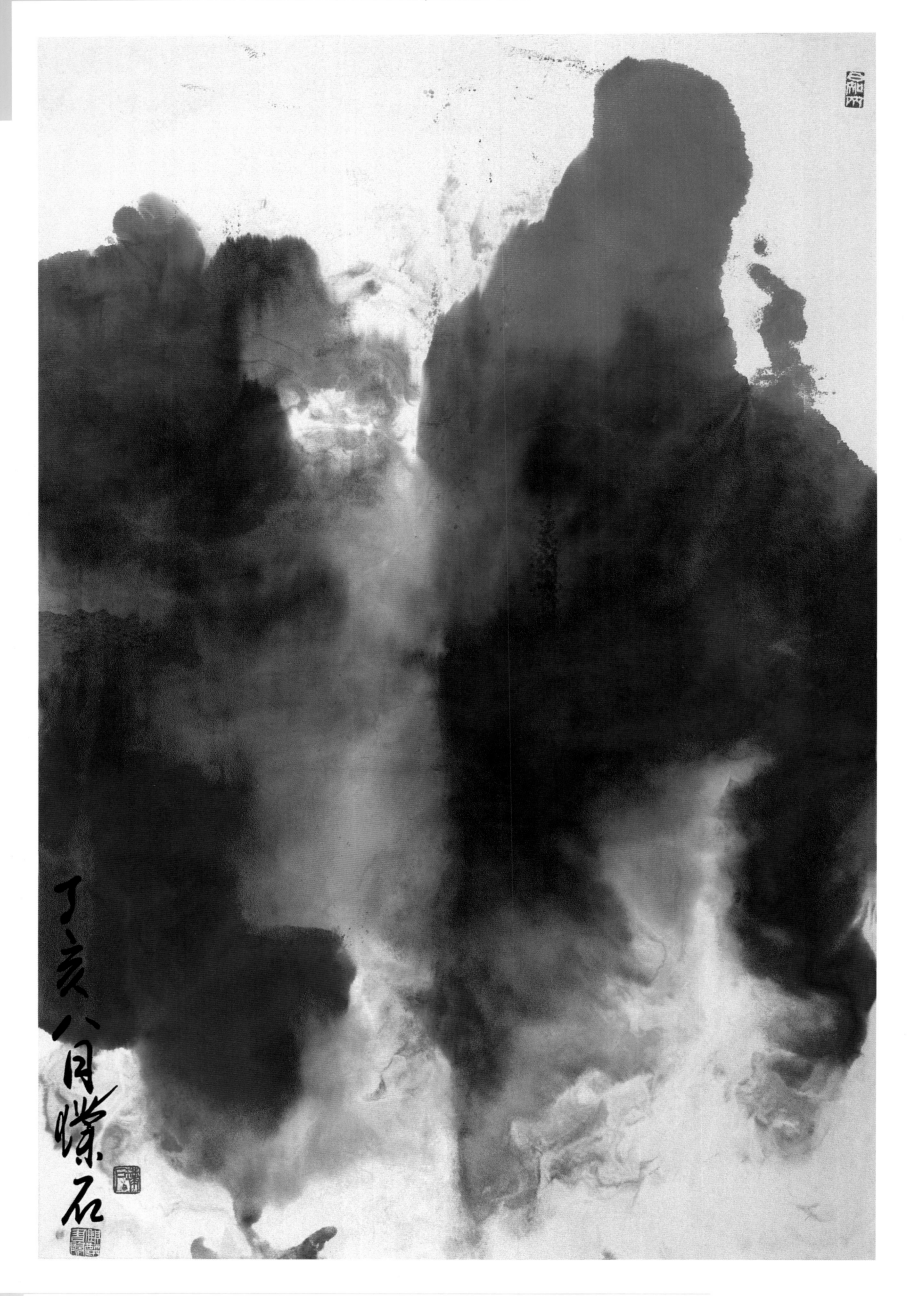

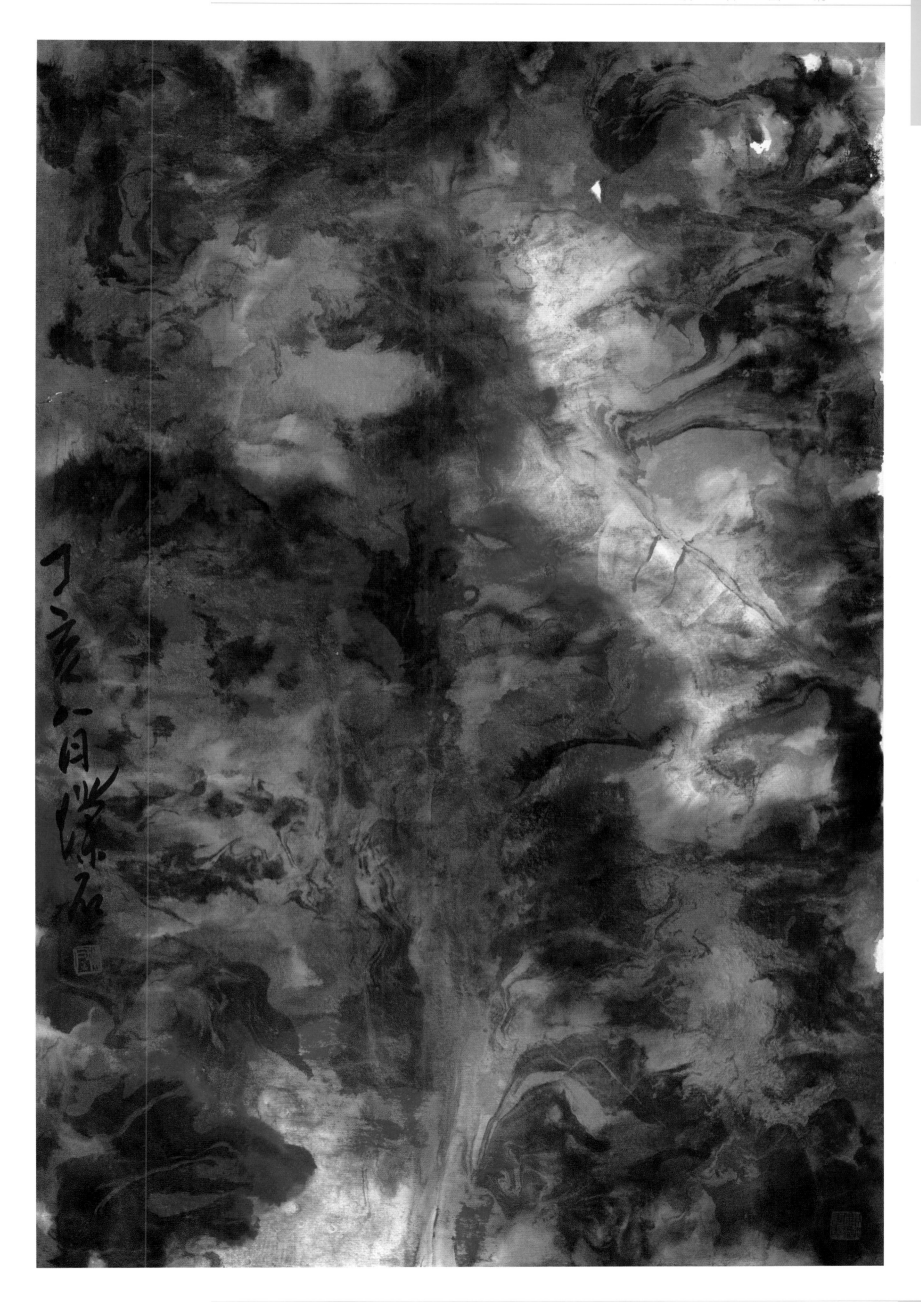

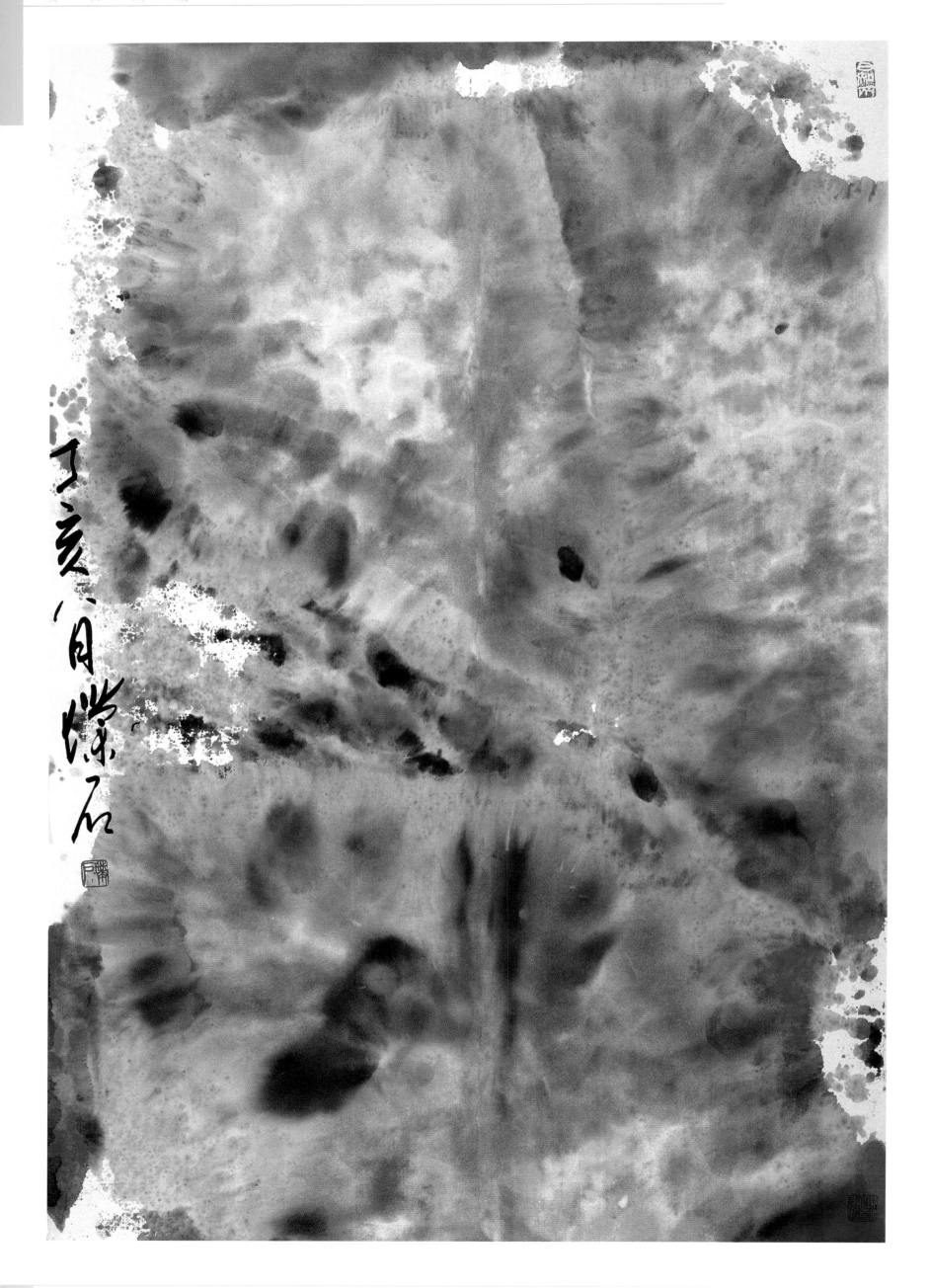

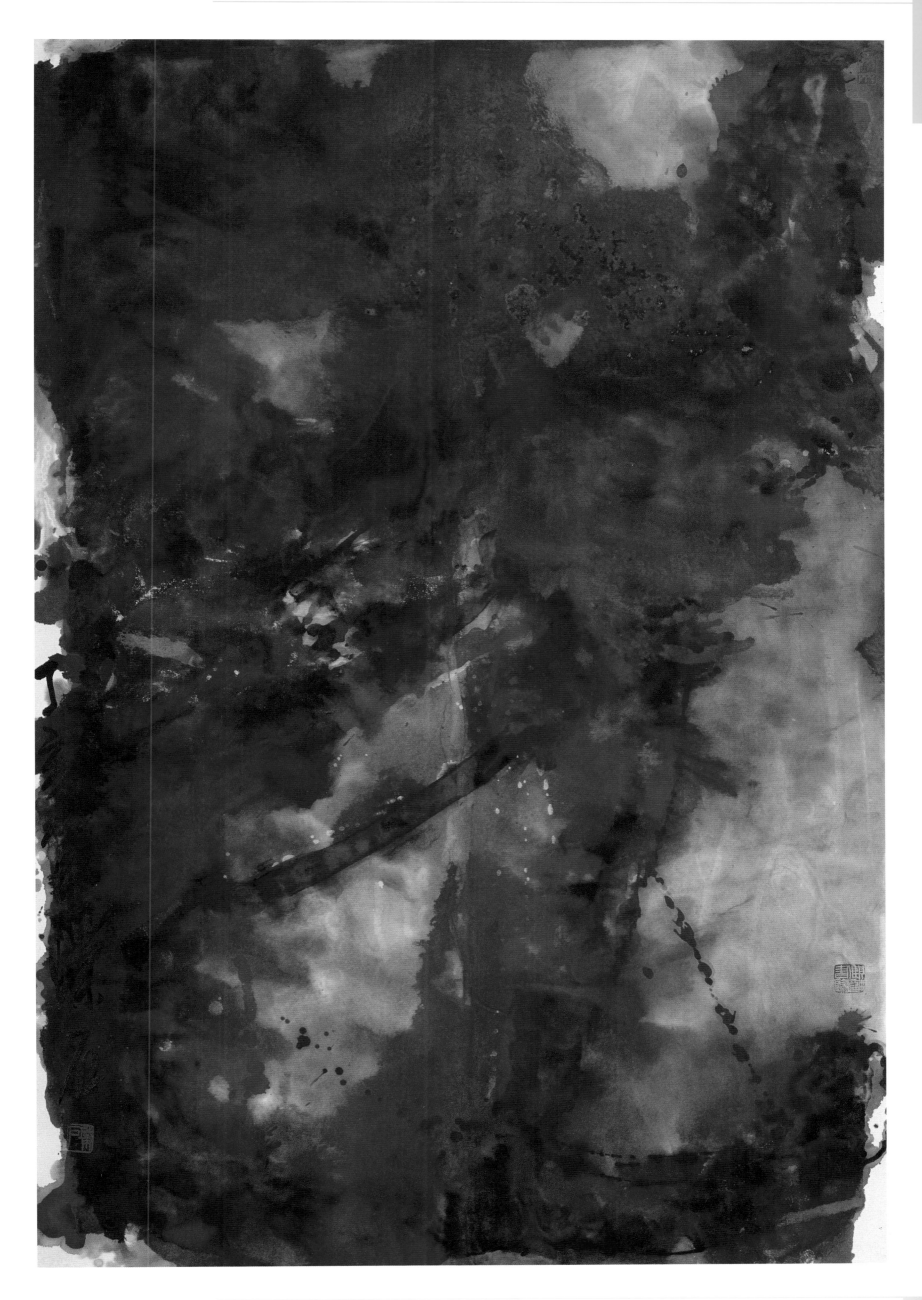

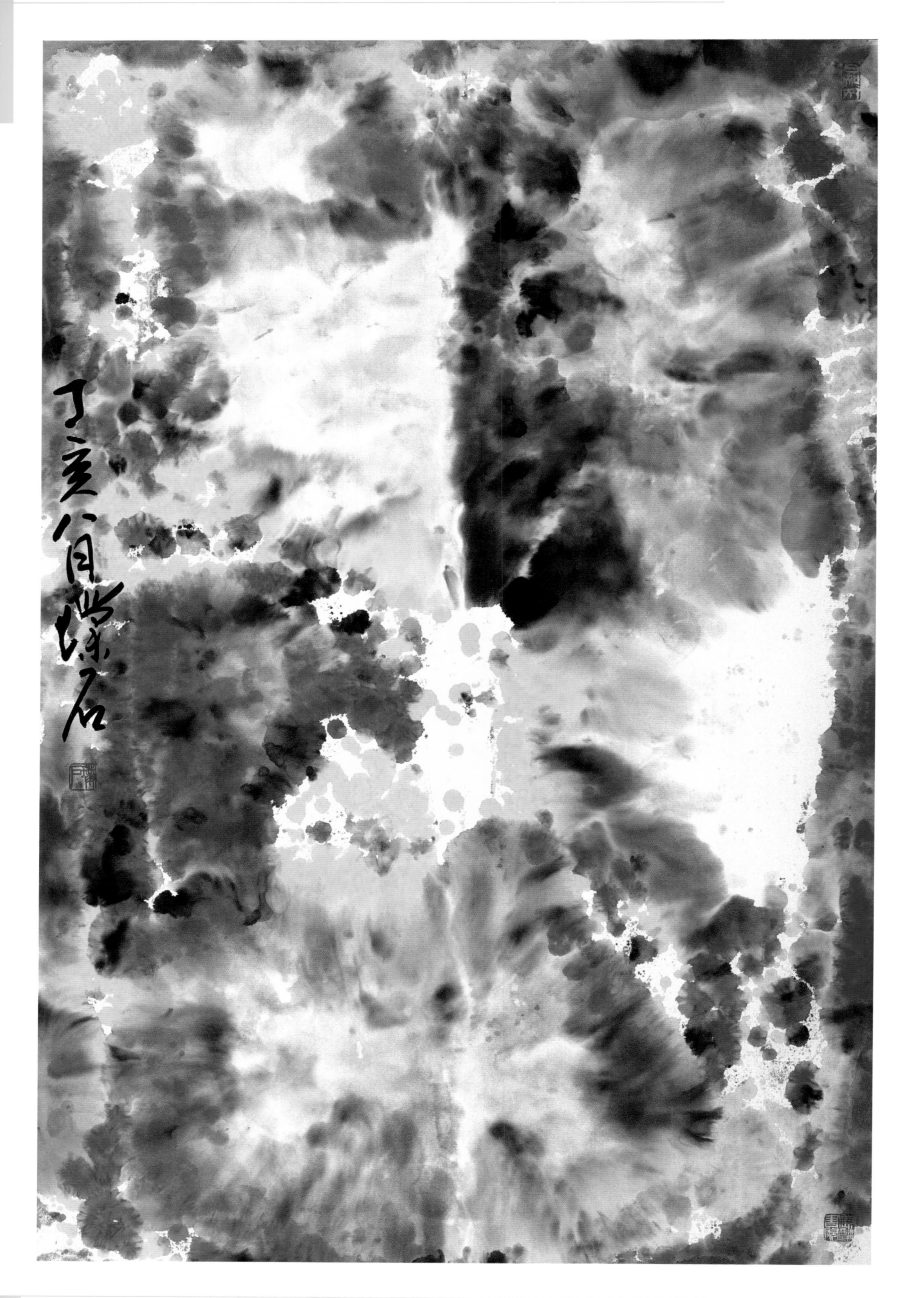

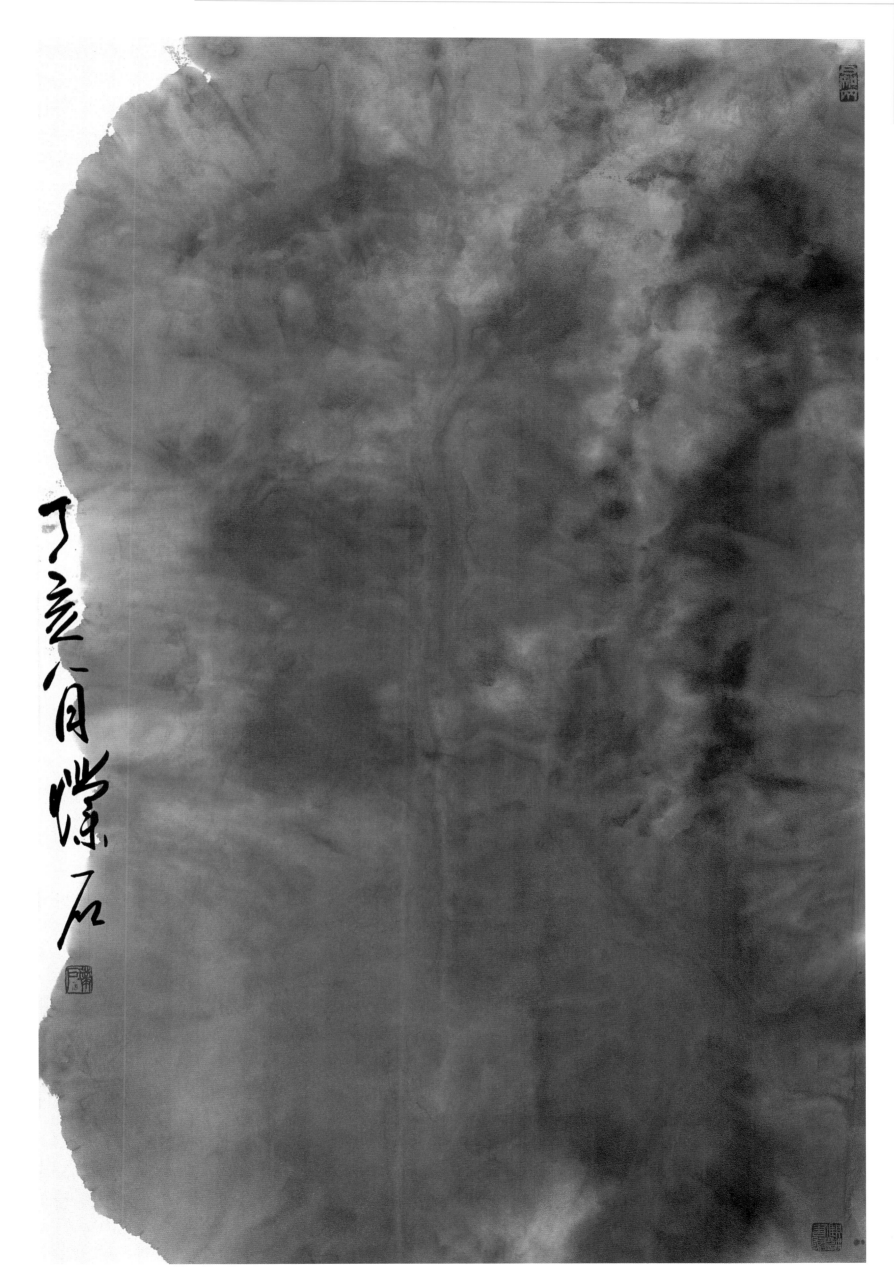

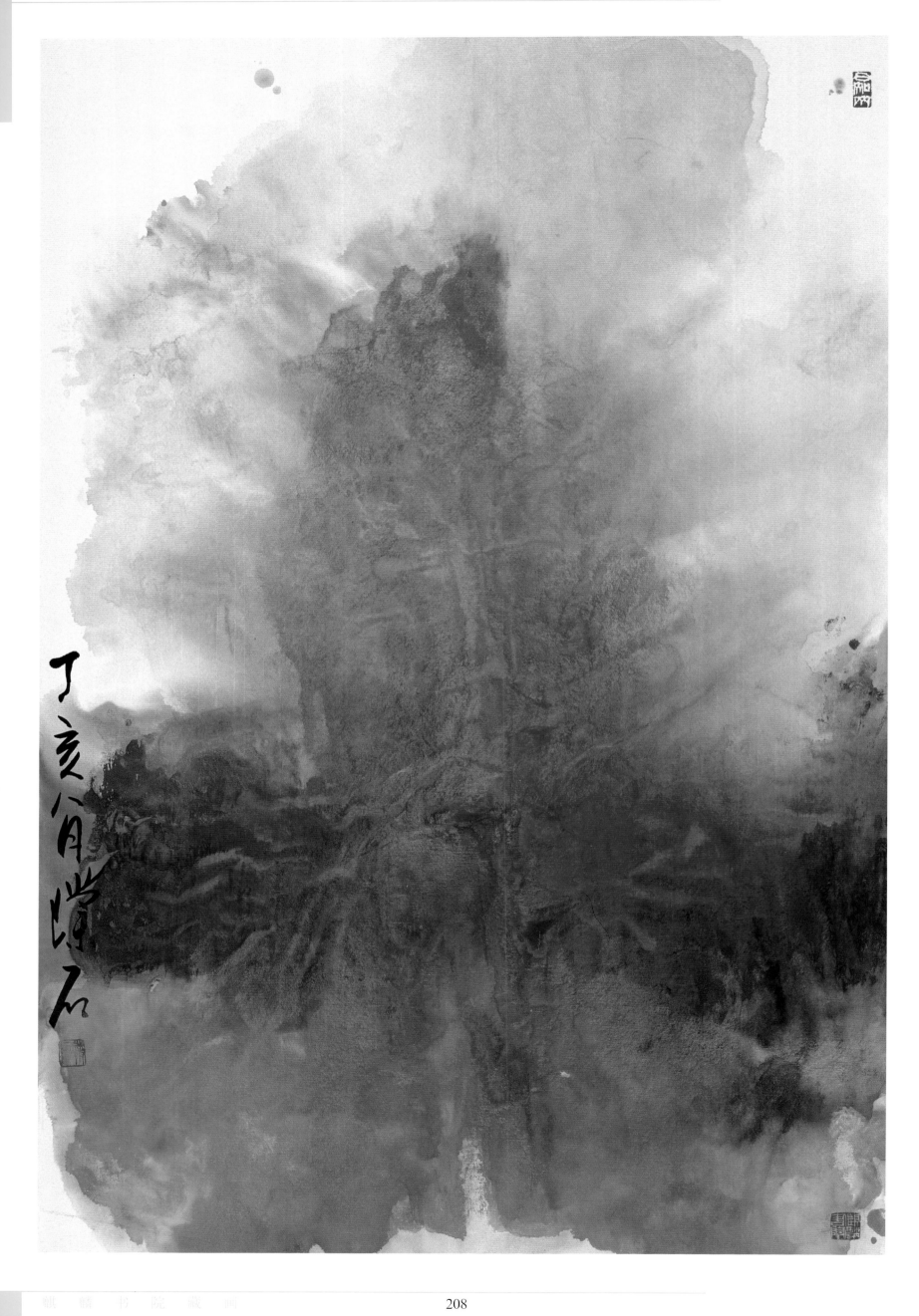

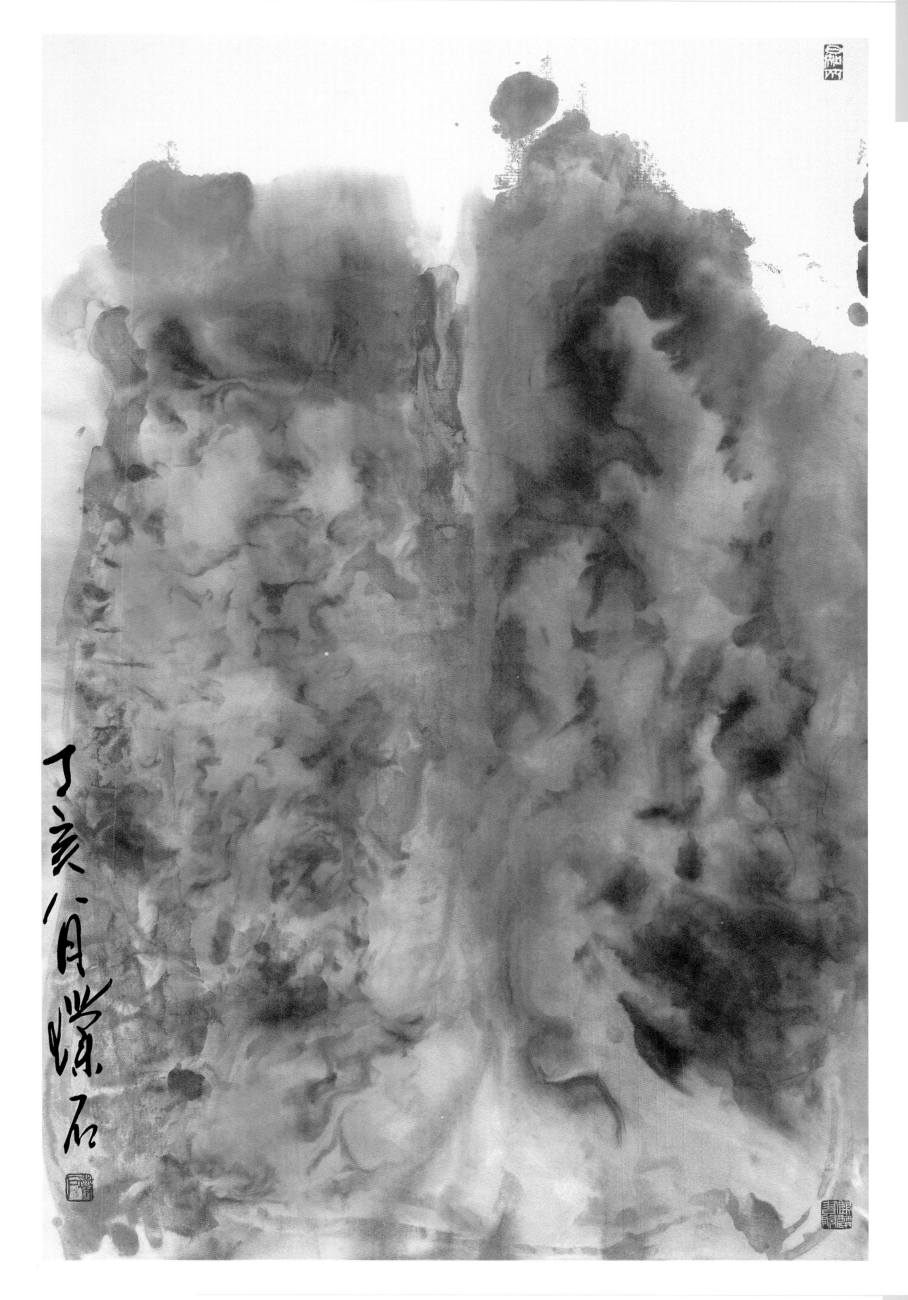

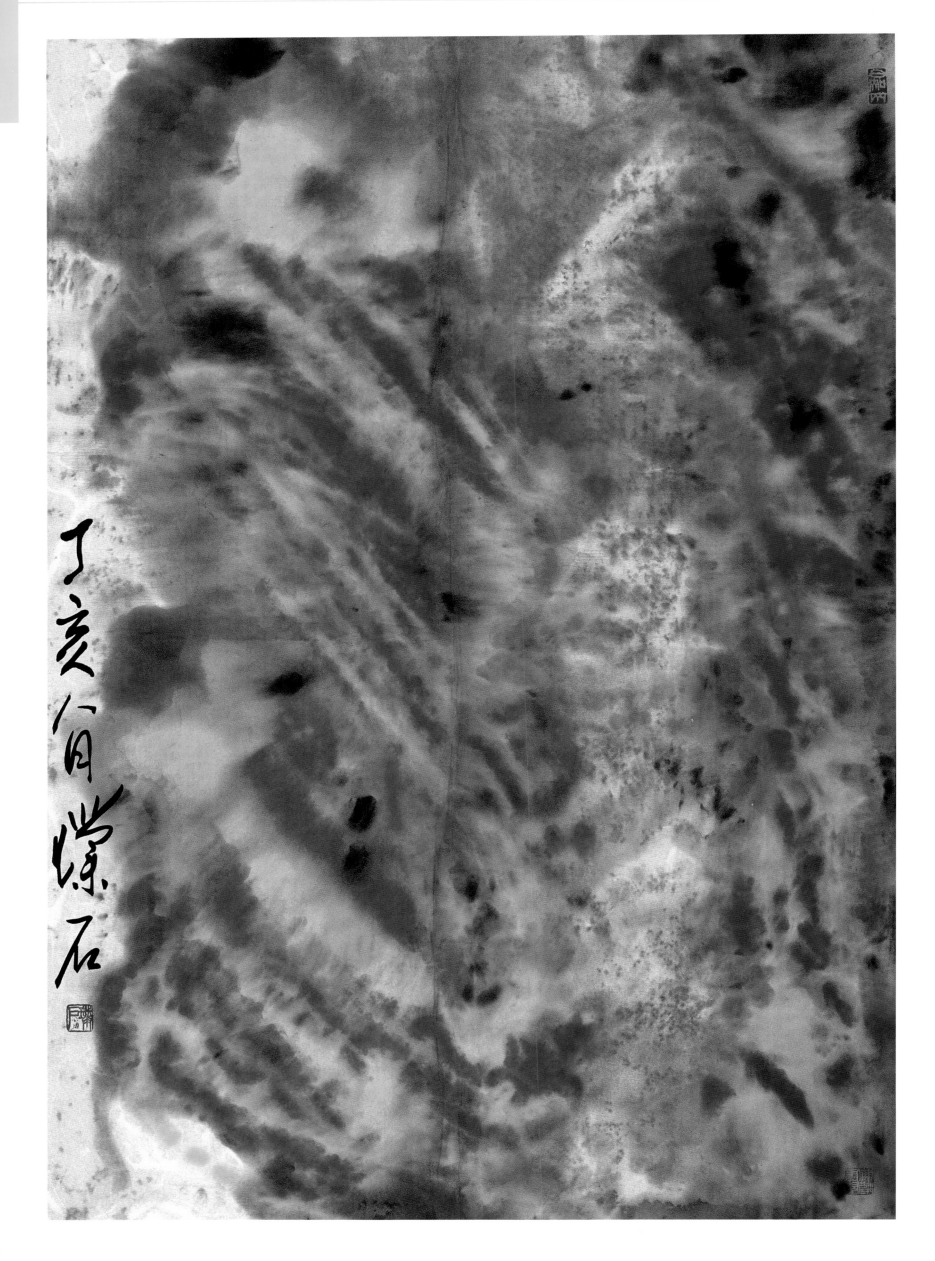

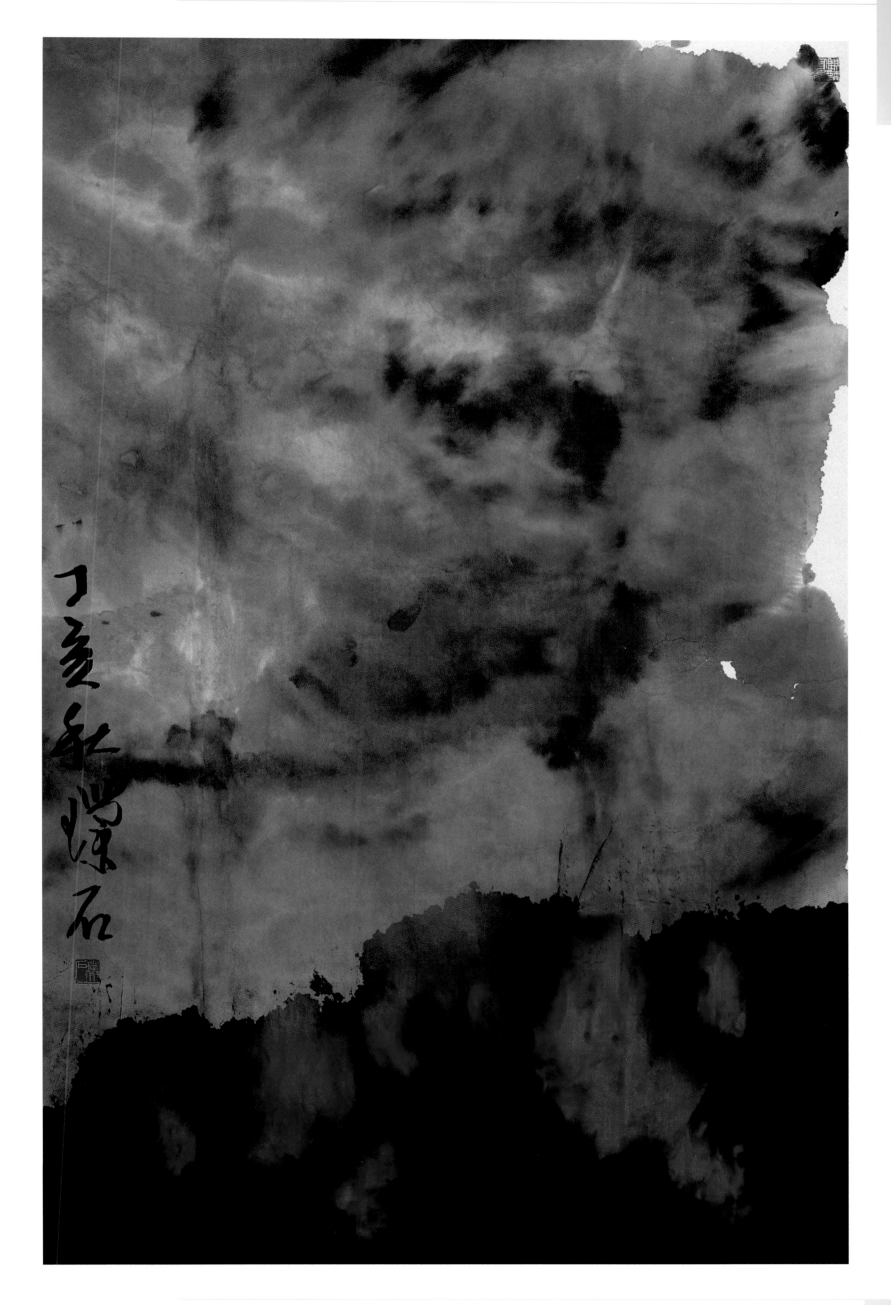

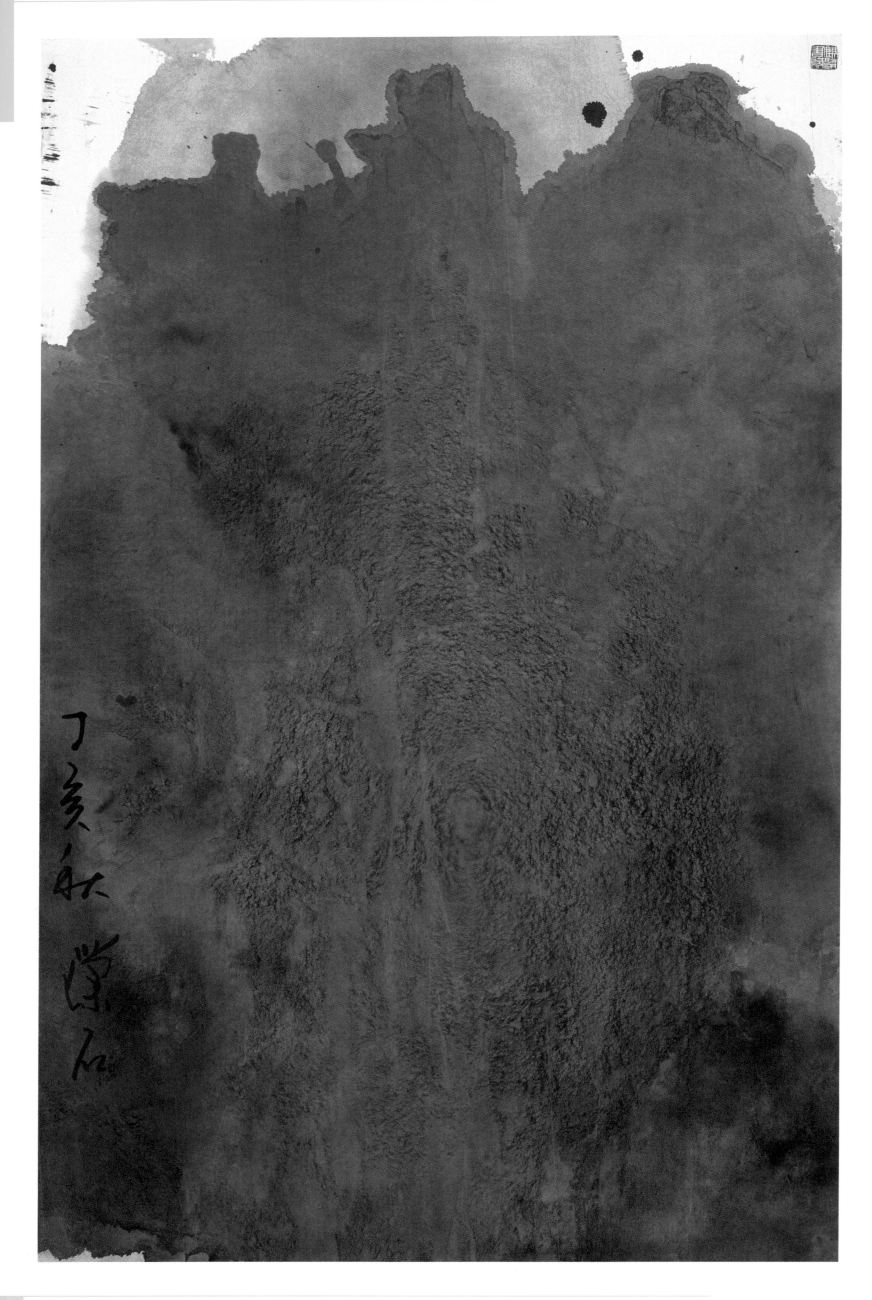

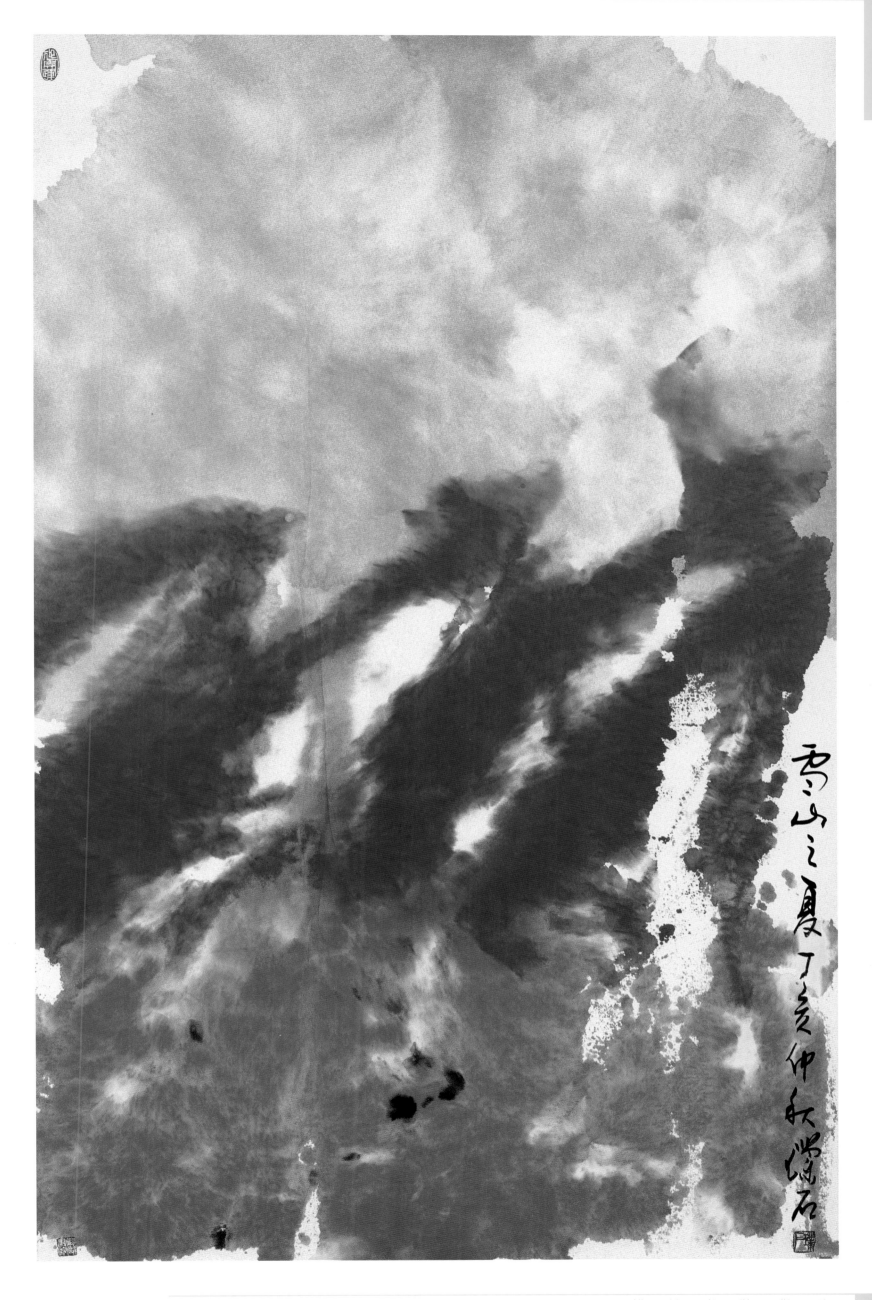

雪山之夏 丁亥仲秋 璞石

奇石　WONDERFUL　STONE

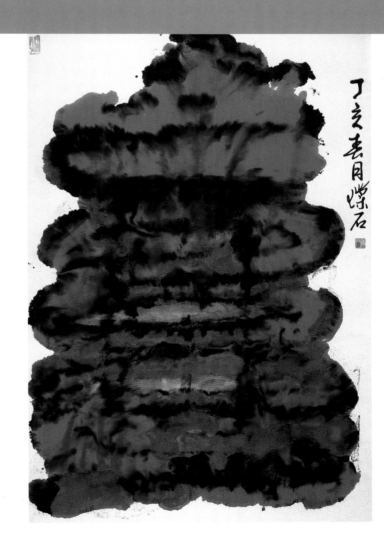

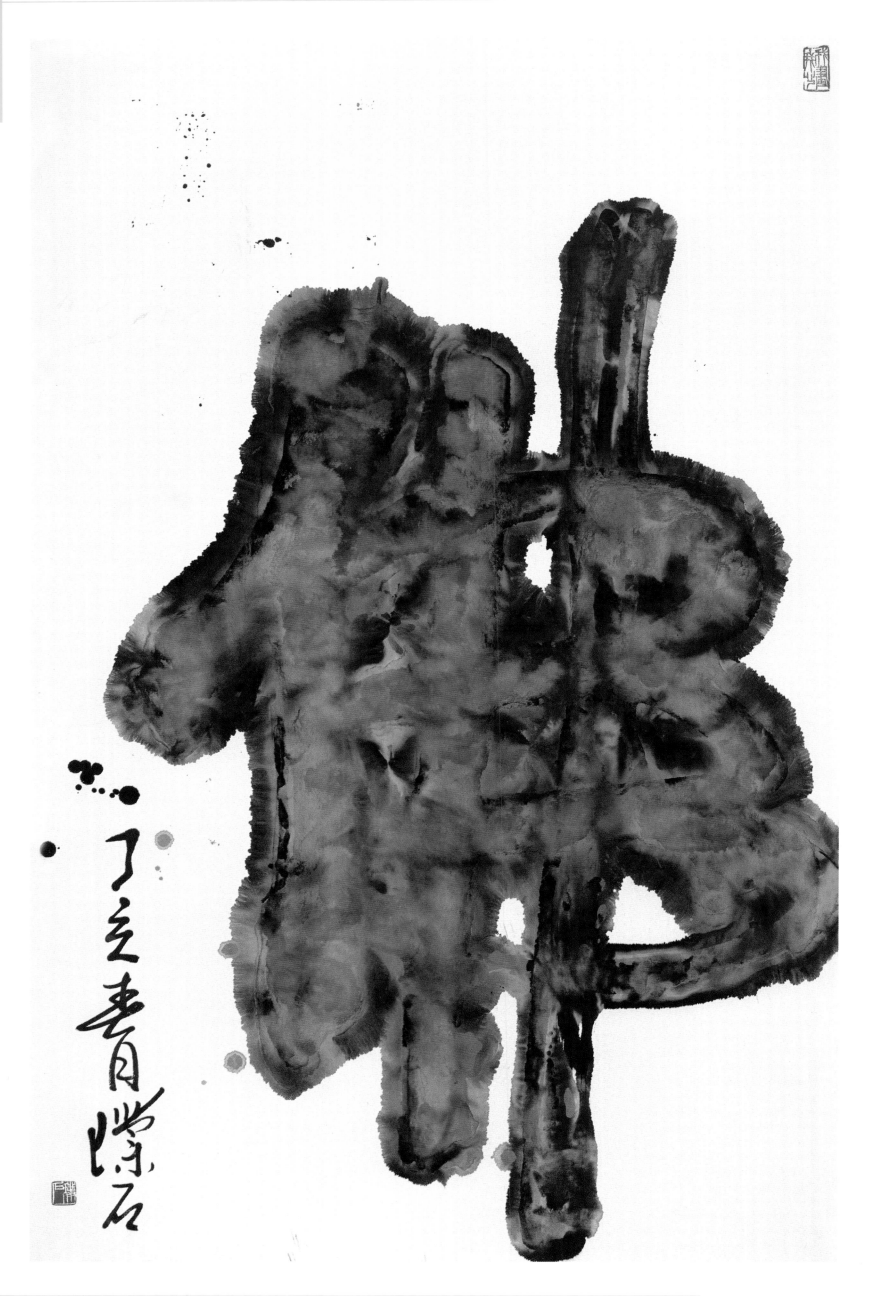

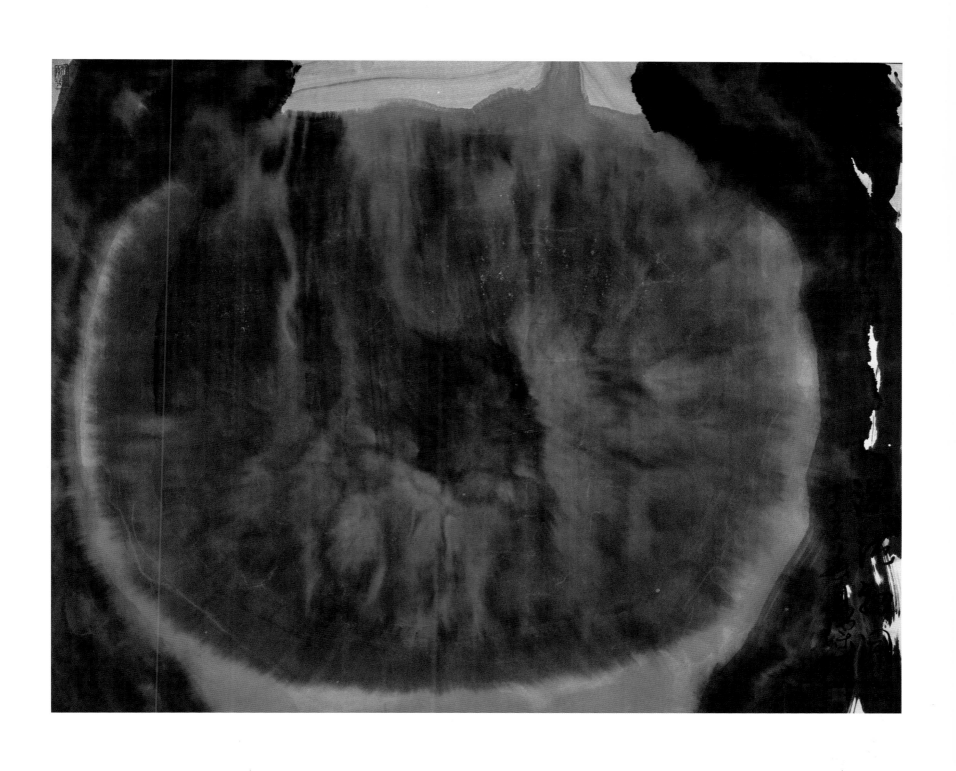

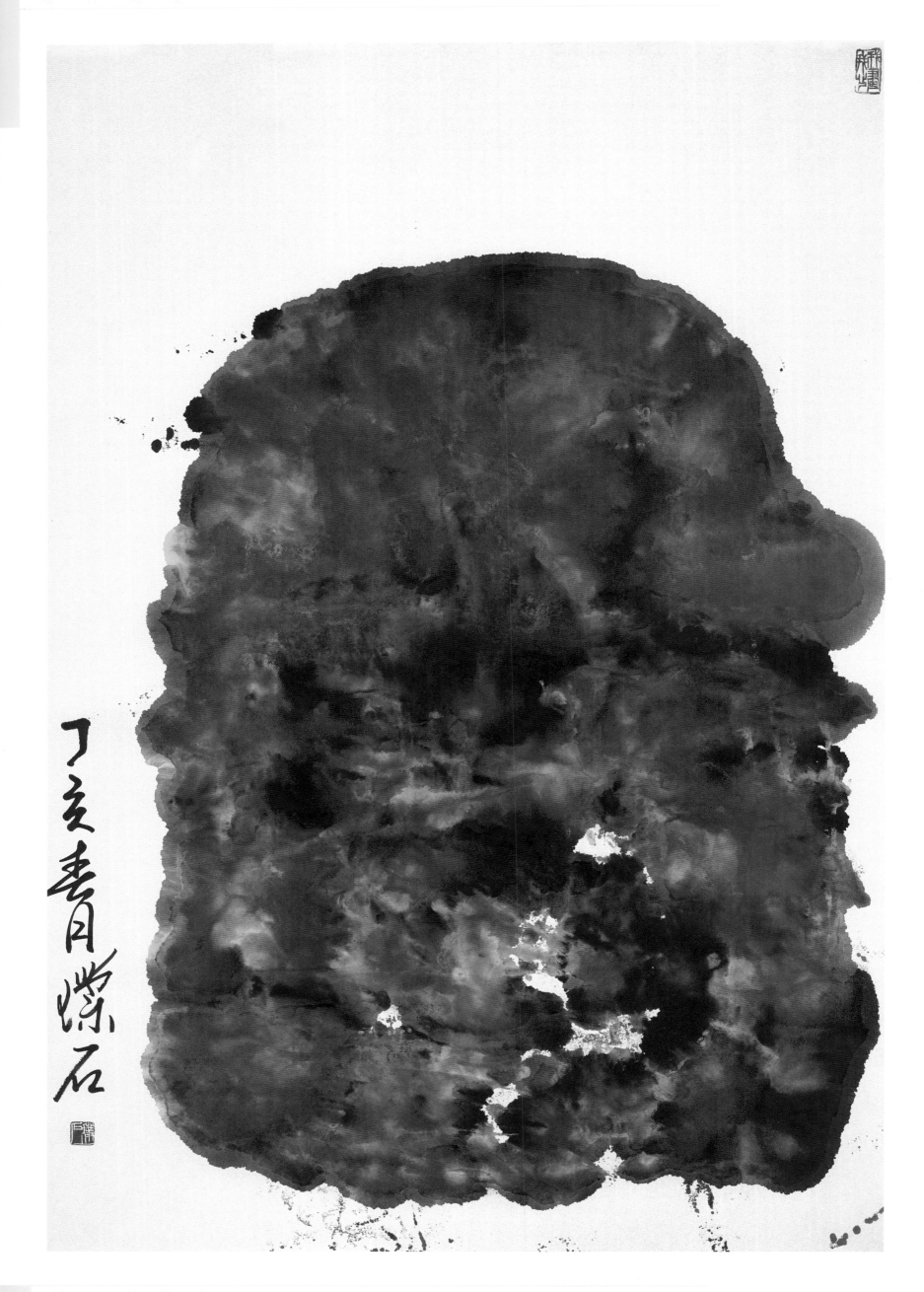

丁亥青月滦石

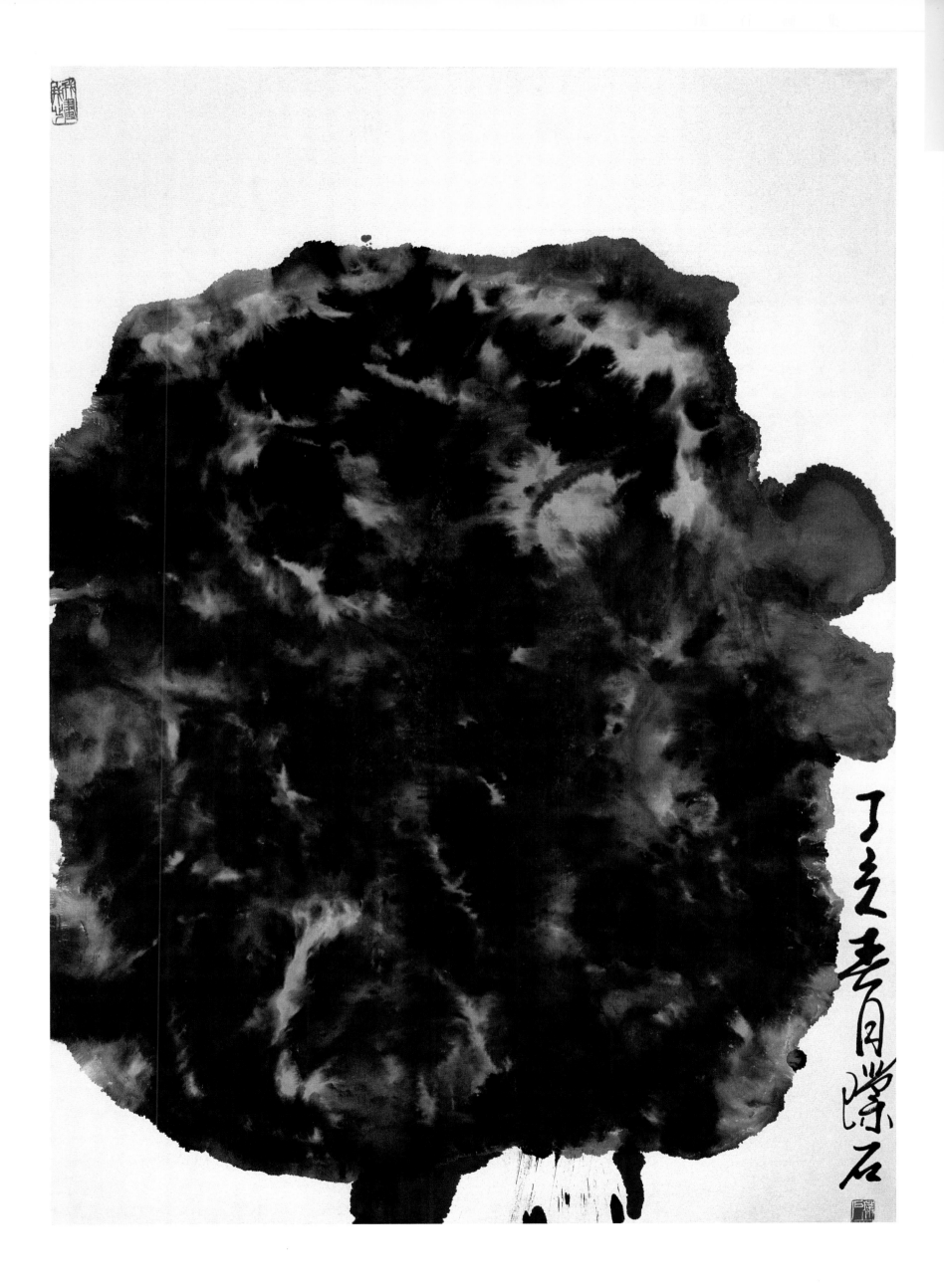

丁亥春月自榮石

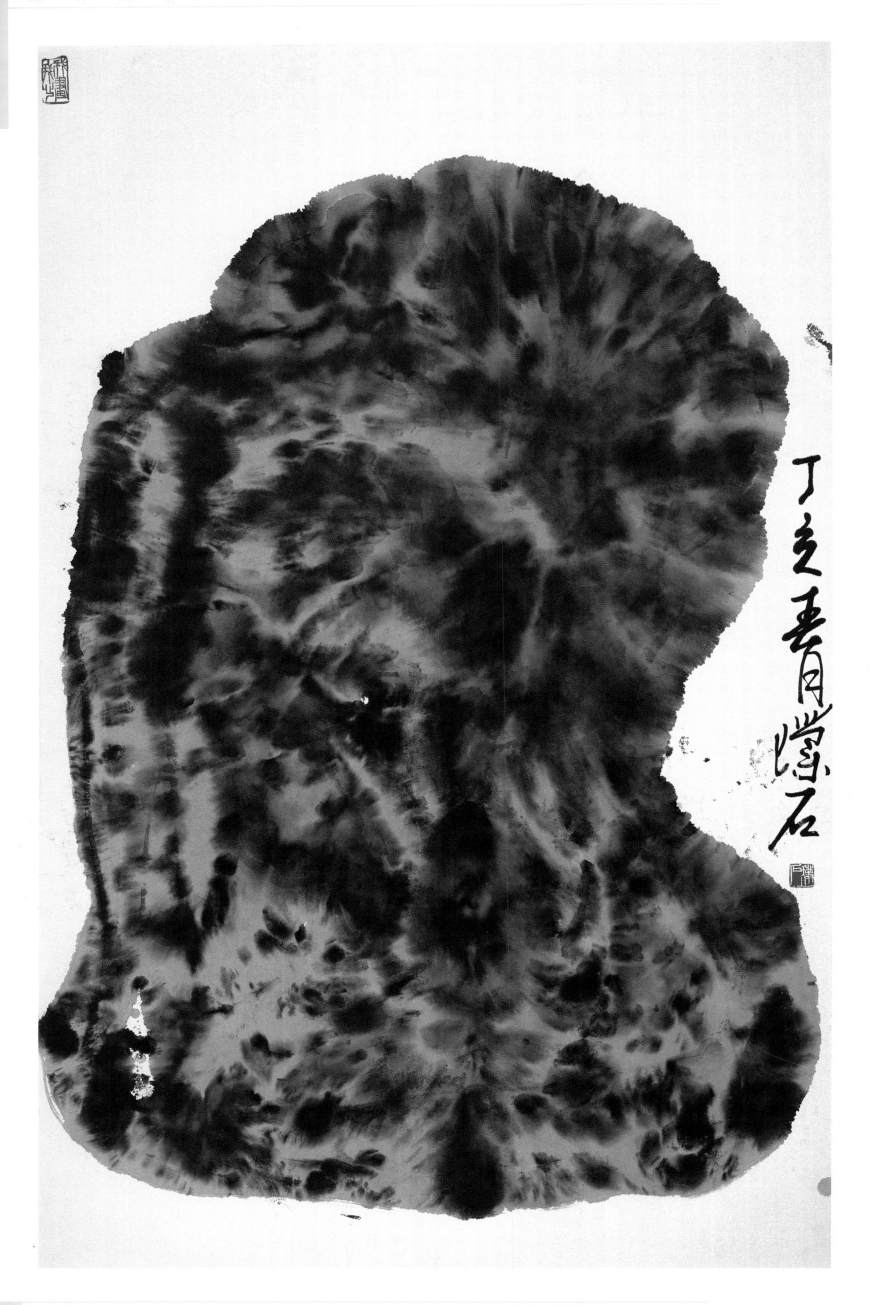

丁亥春月燈石

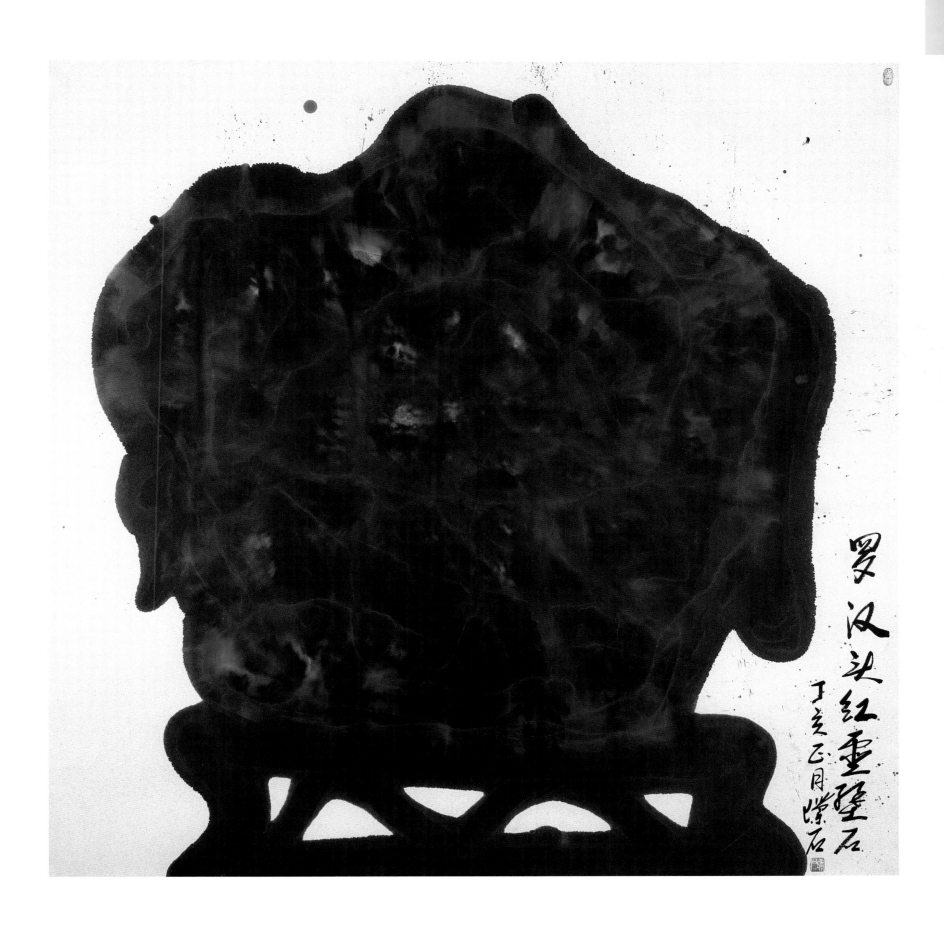

罗汉状红灵璧石
丁亥正月 憔石

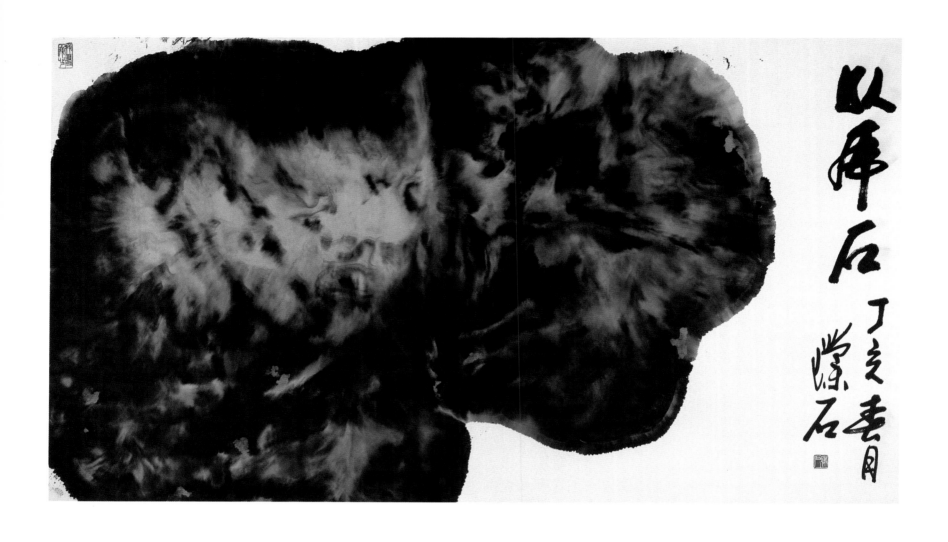

以屏石 丁亥春月 燥石

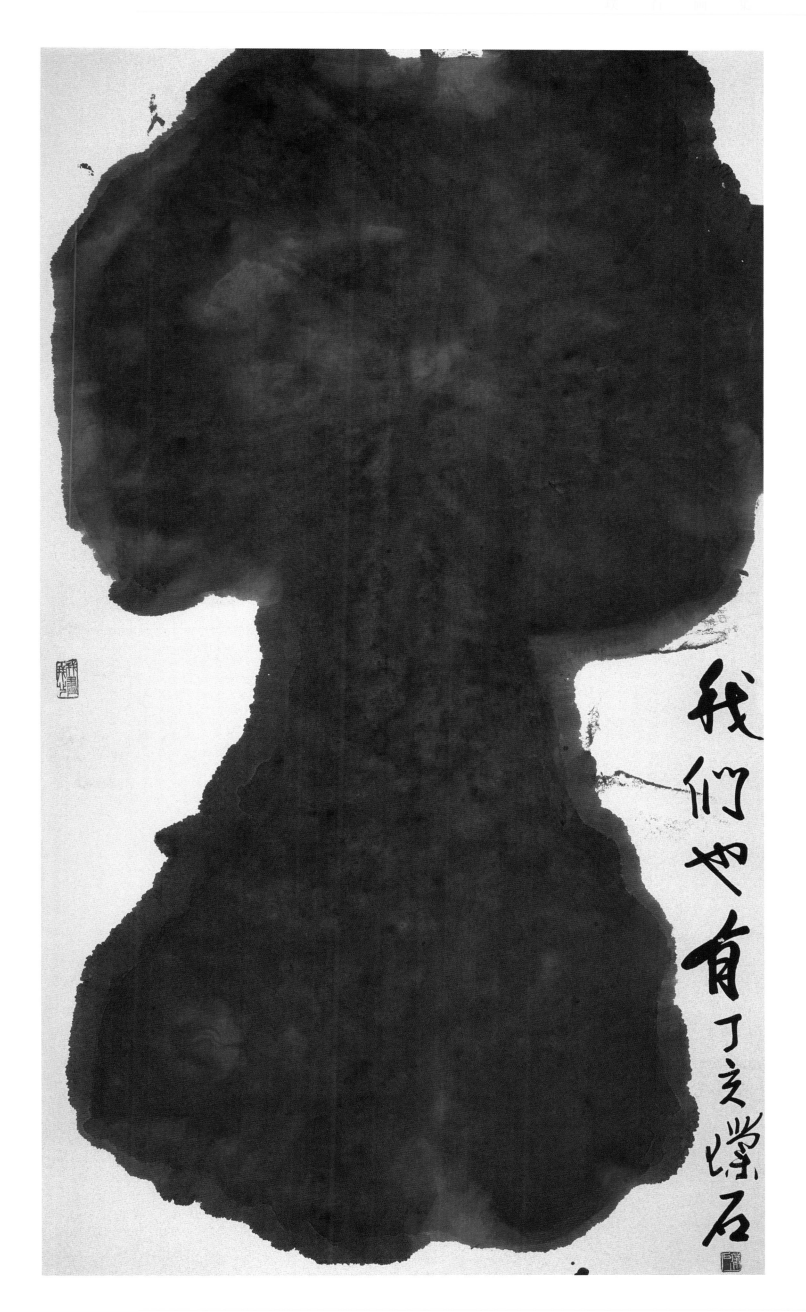

我们也有

丁亥紫石

五彩靈壁

丁亥夏燦石

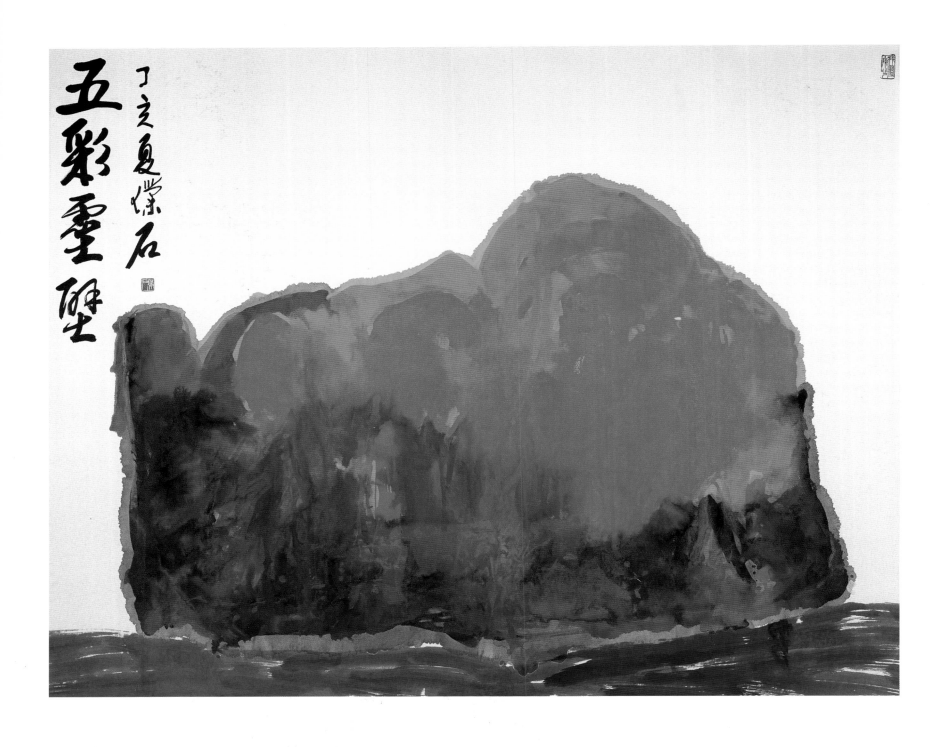

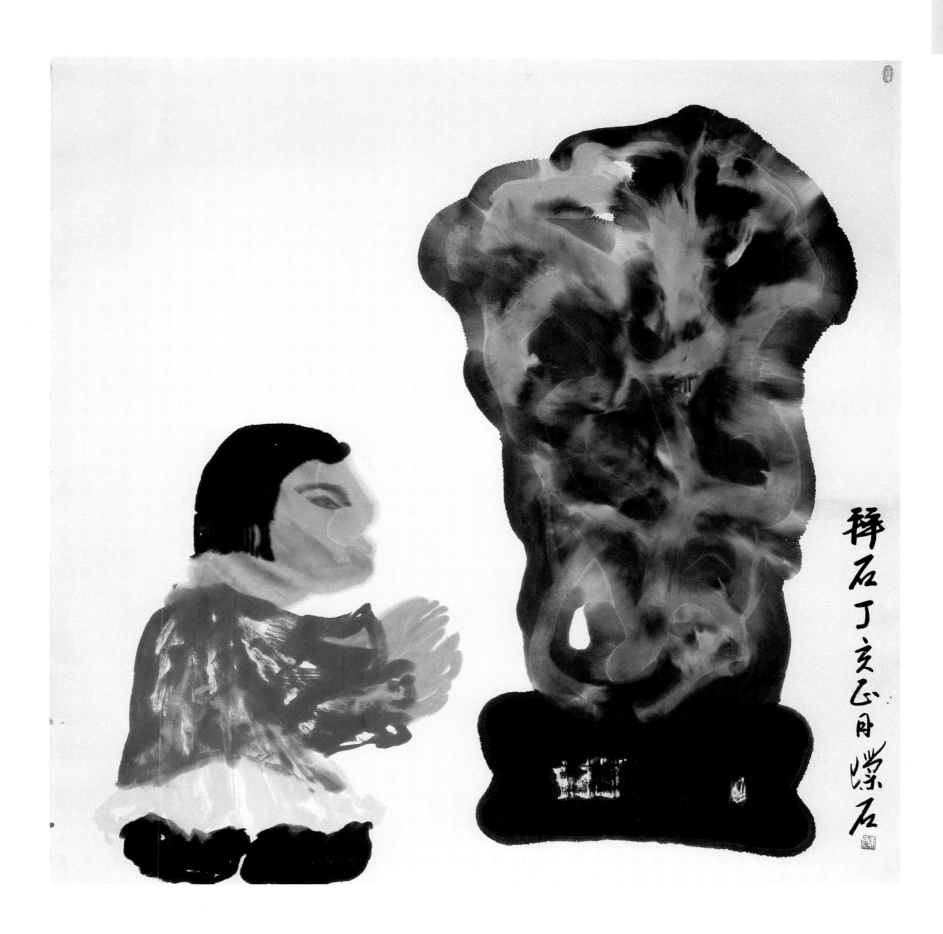

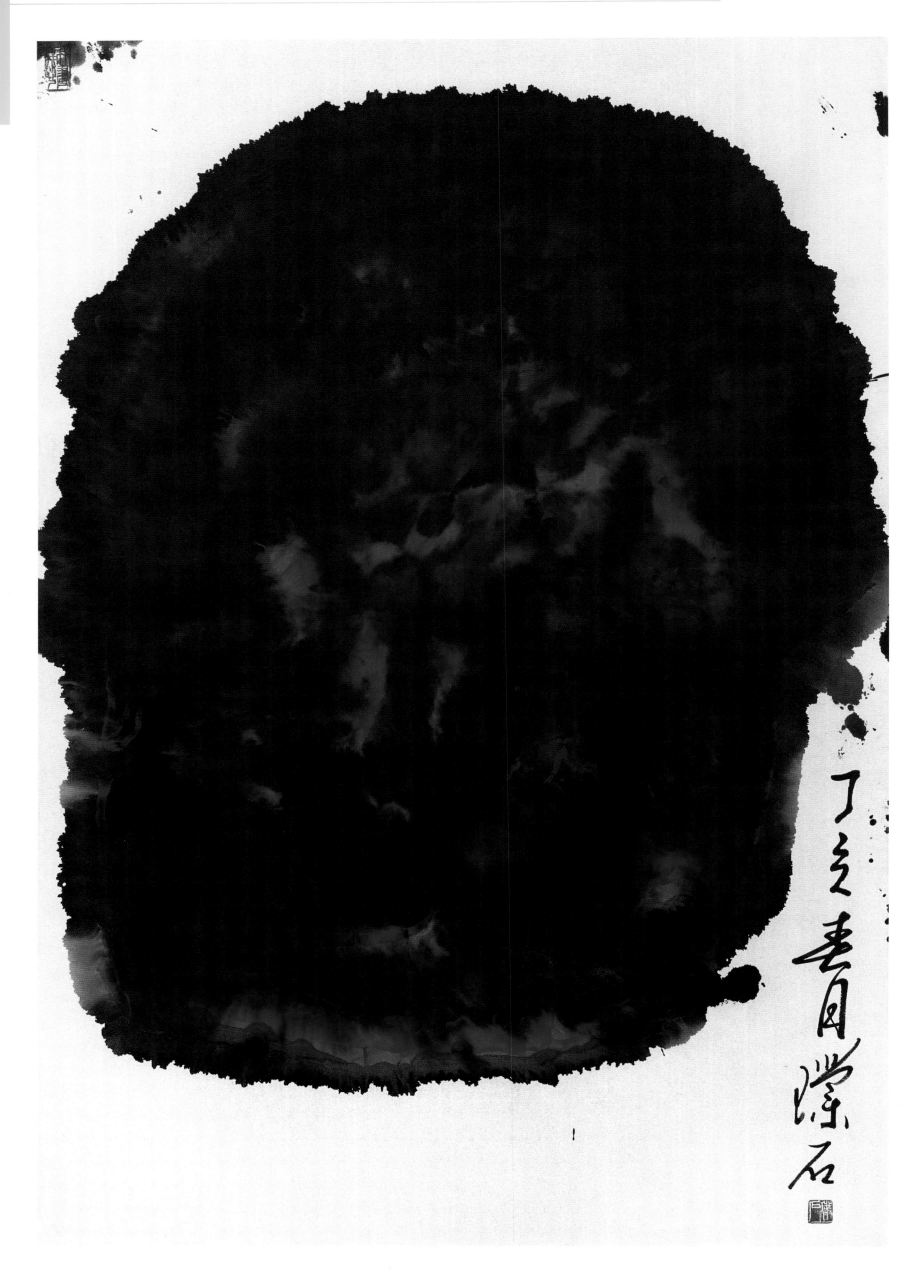

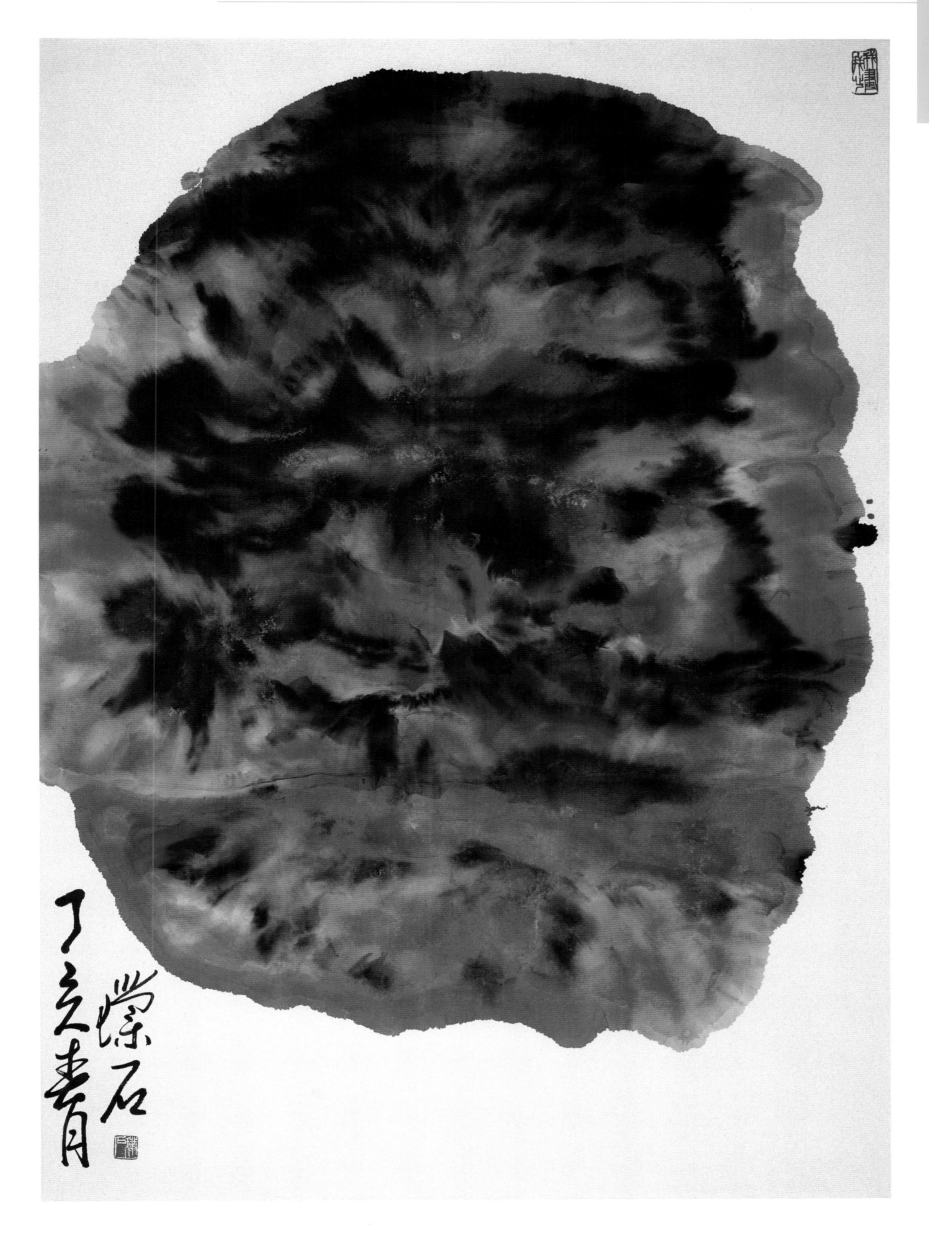

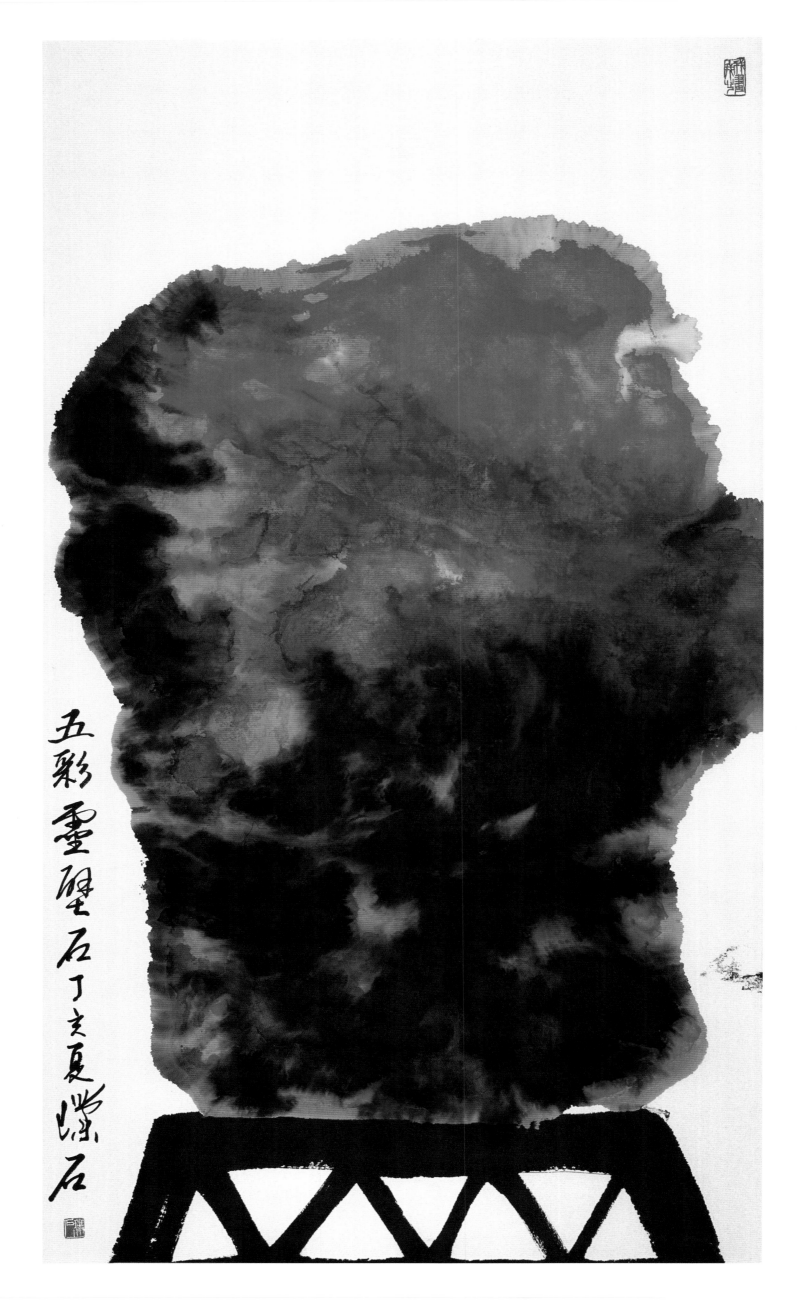

五彩靈壁石 丁亥夏 紫石

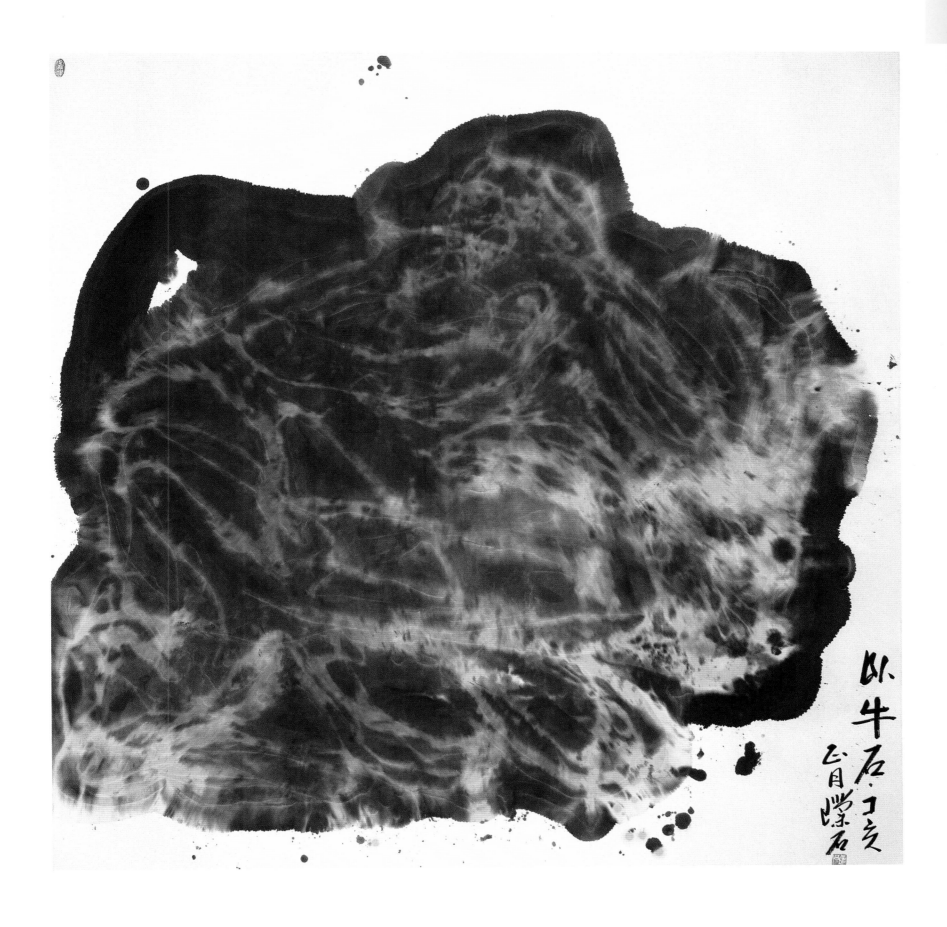

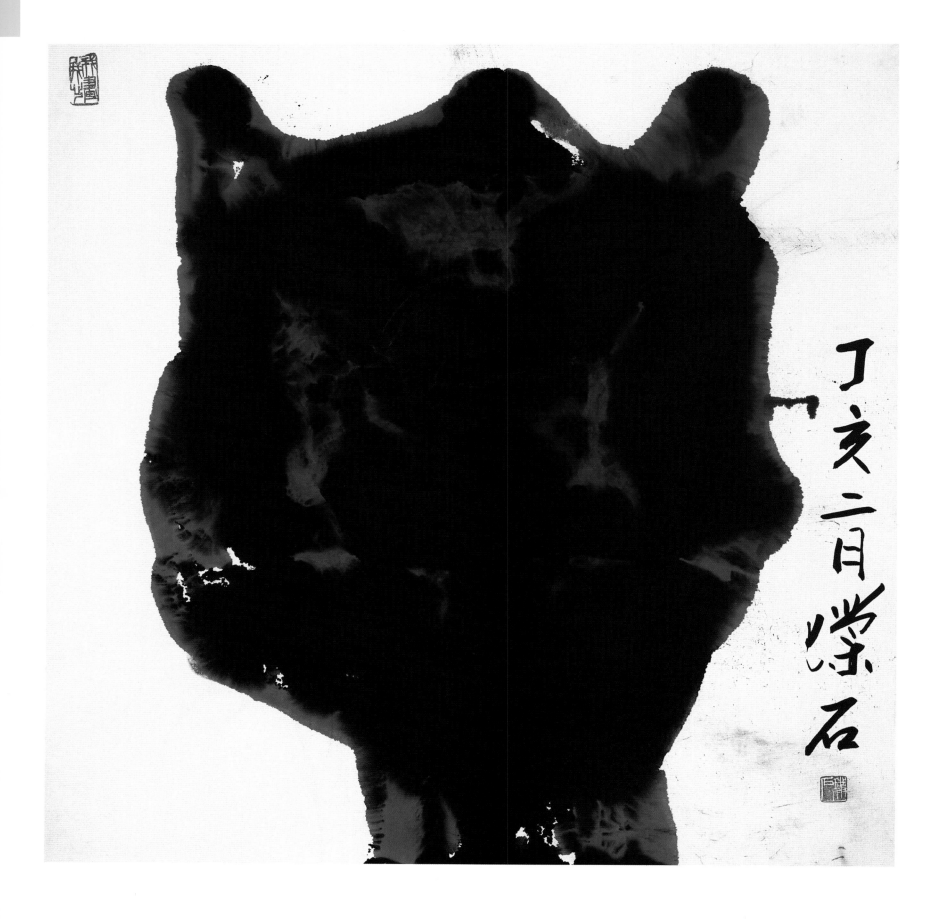

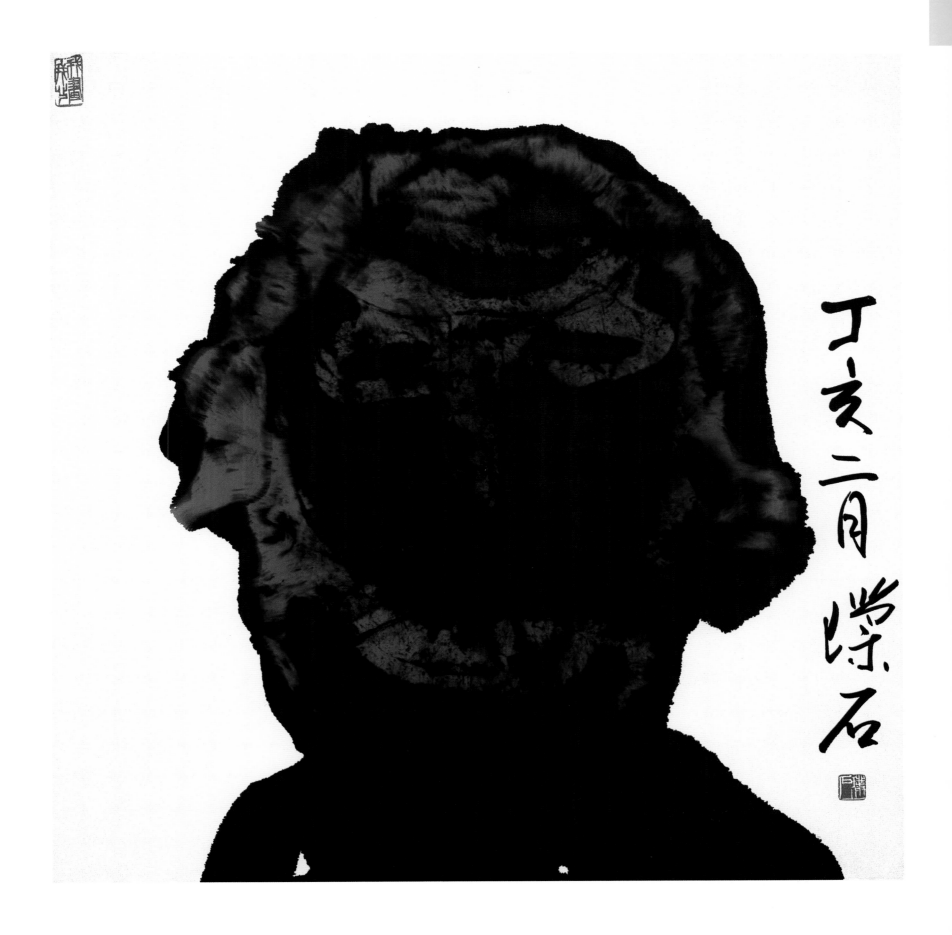

丁亥二月 璞石

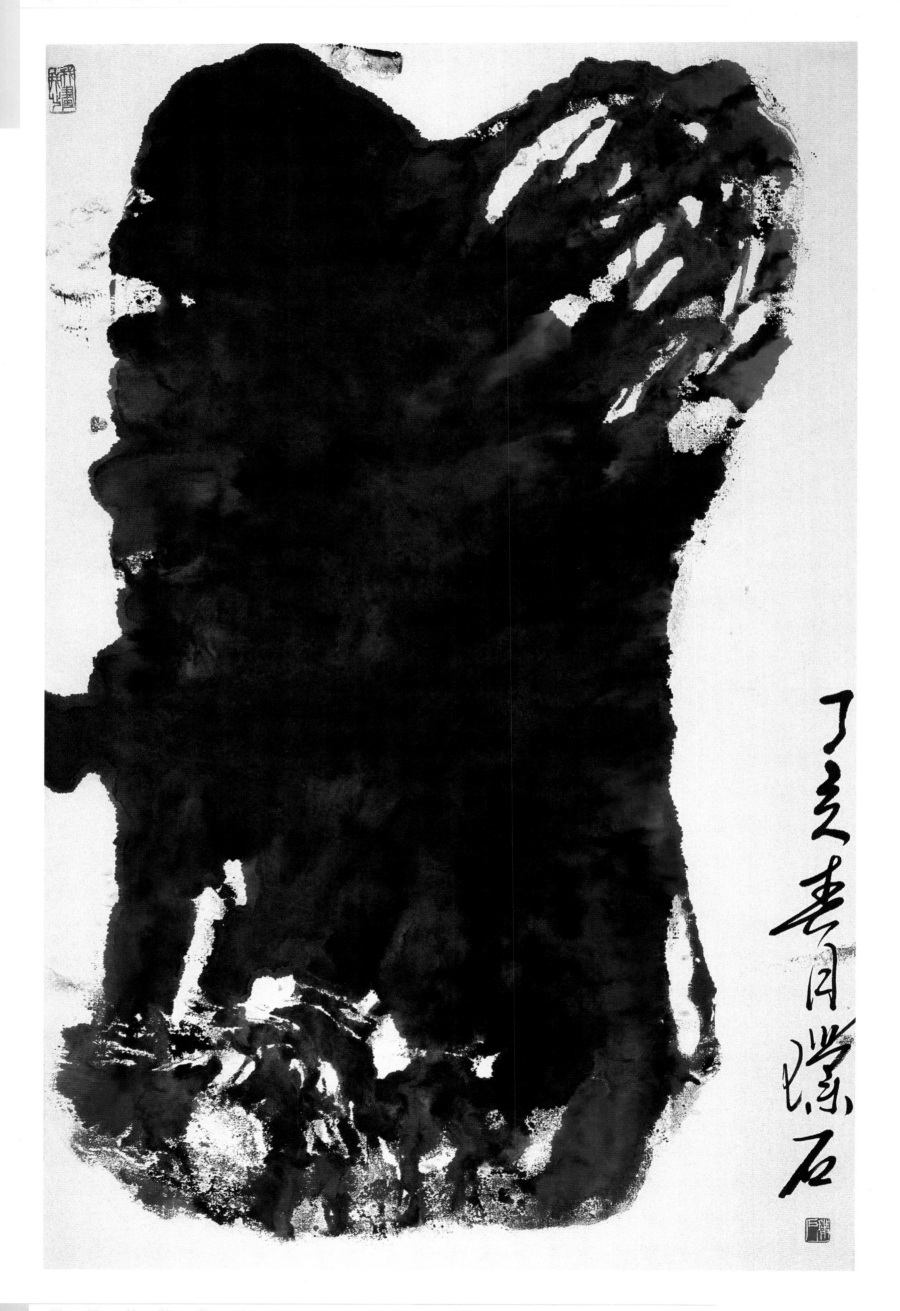

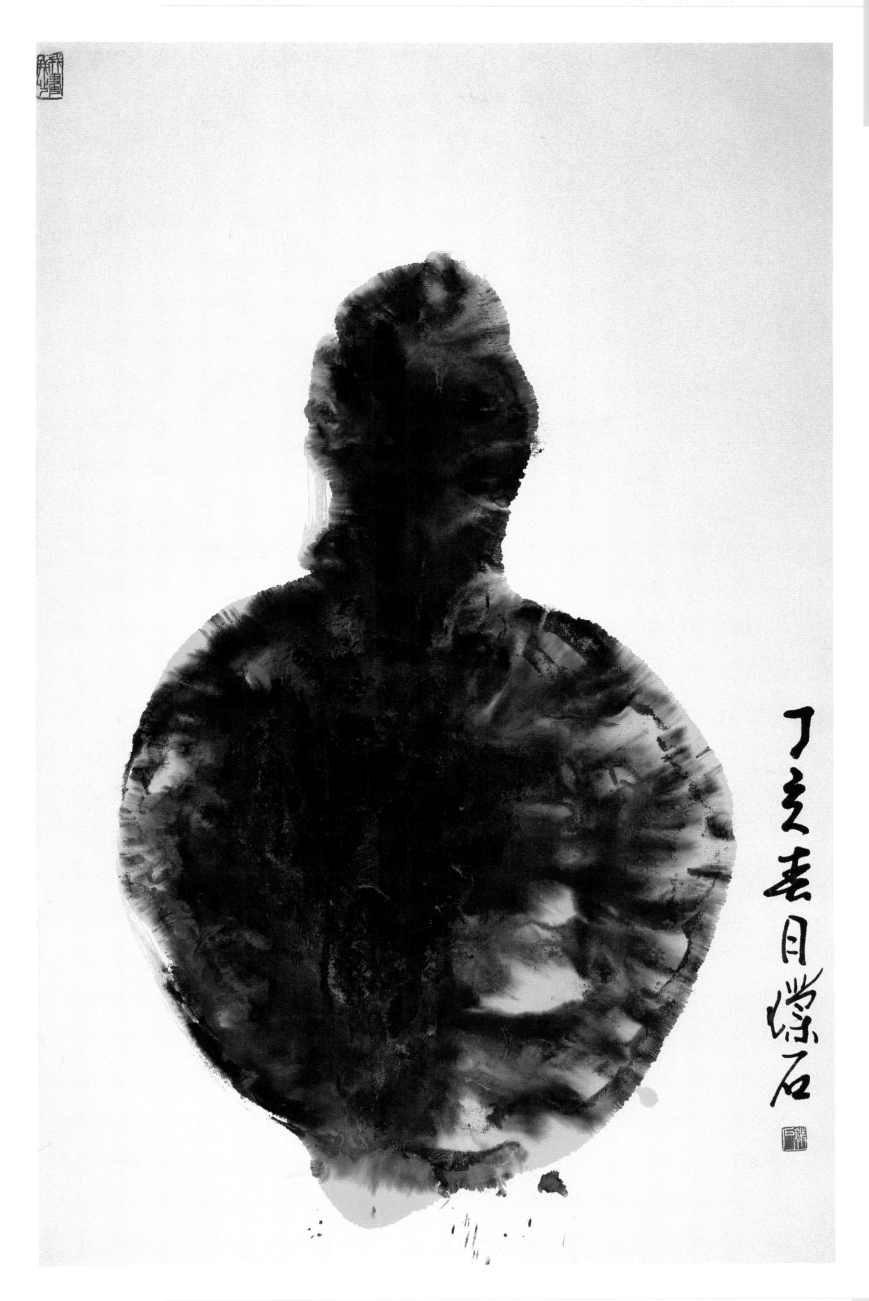

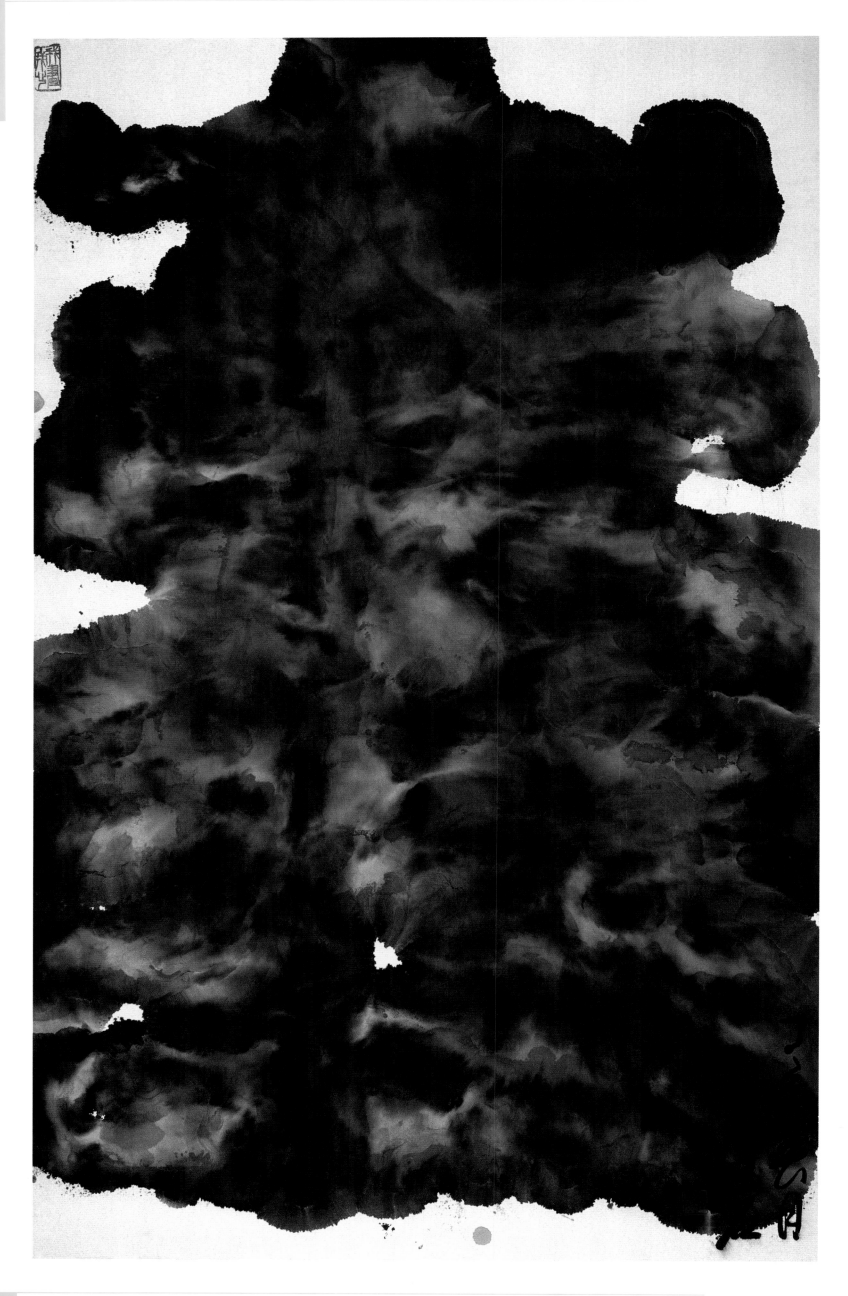

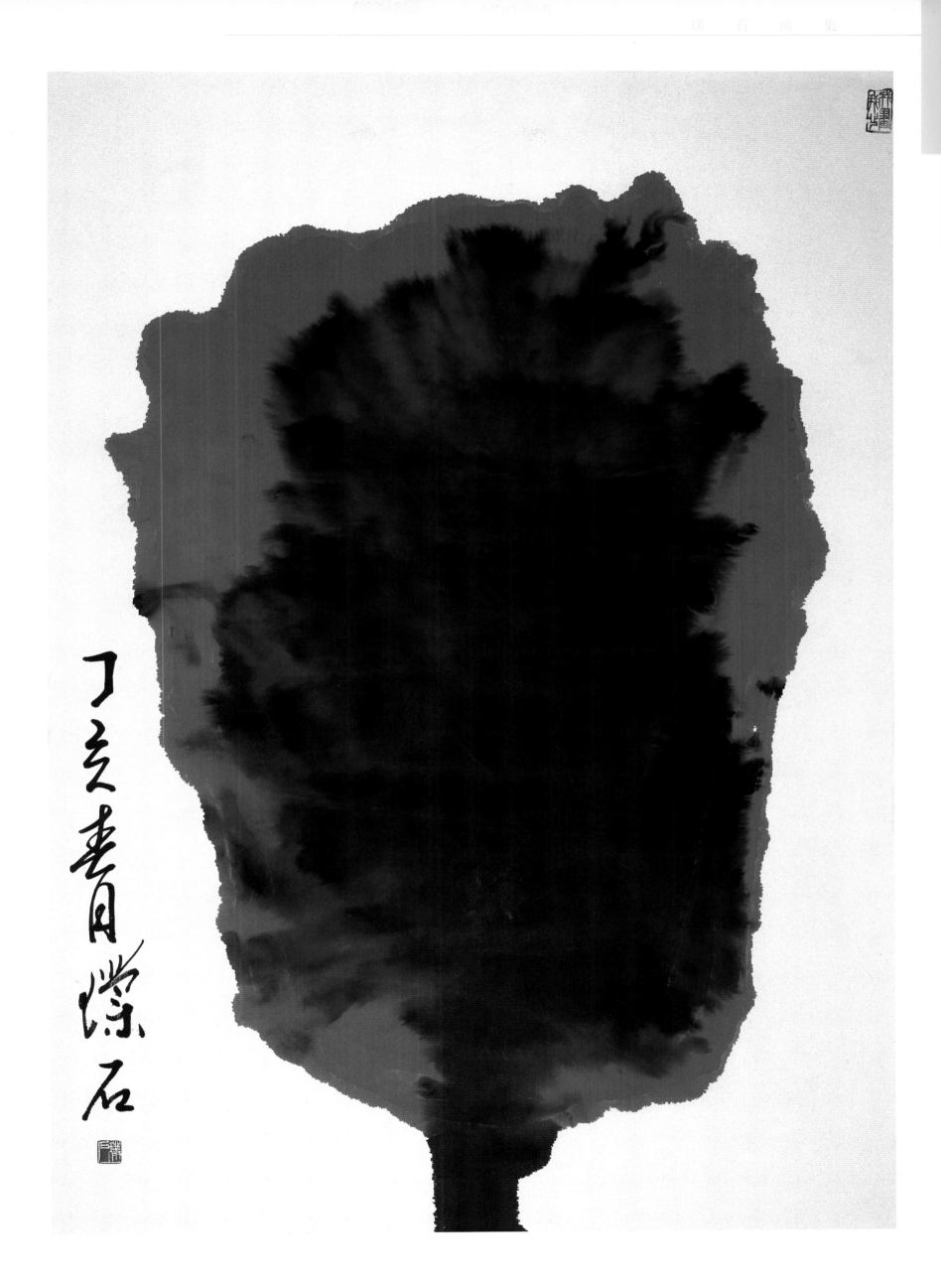

丁亥春日璞石

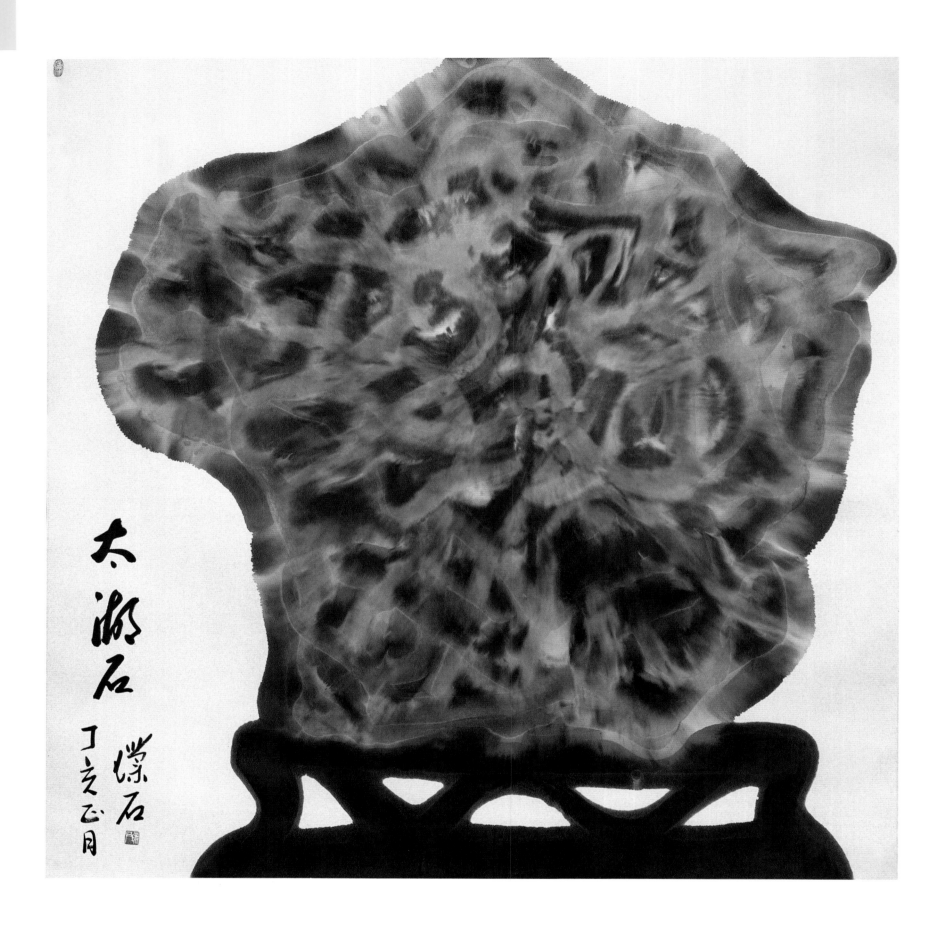

太湖石

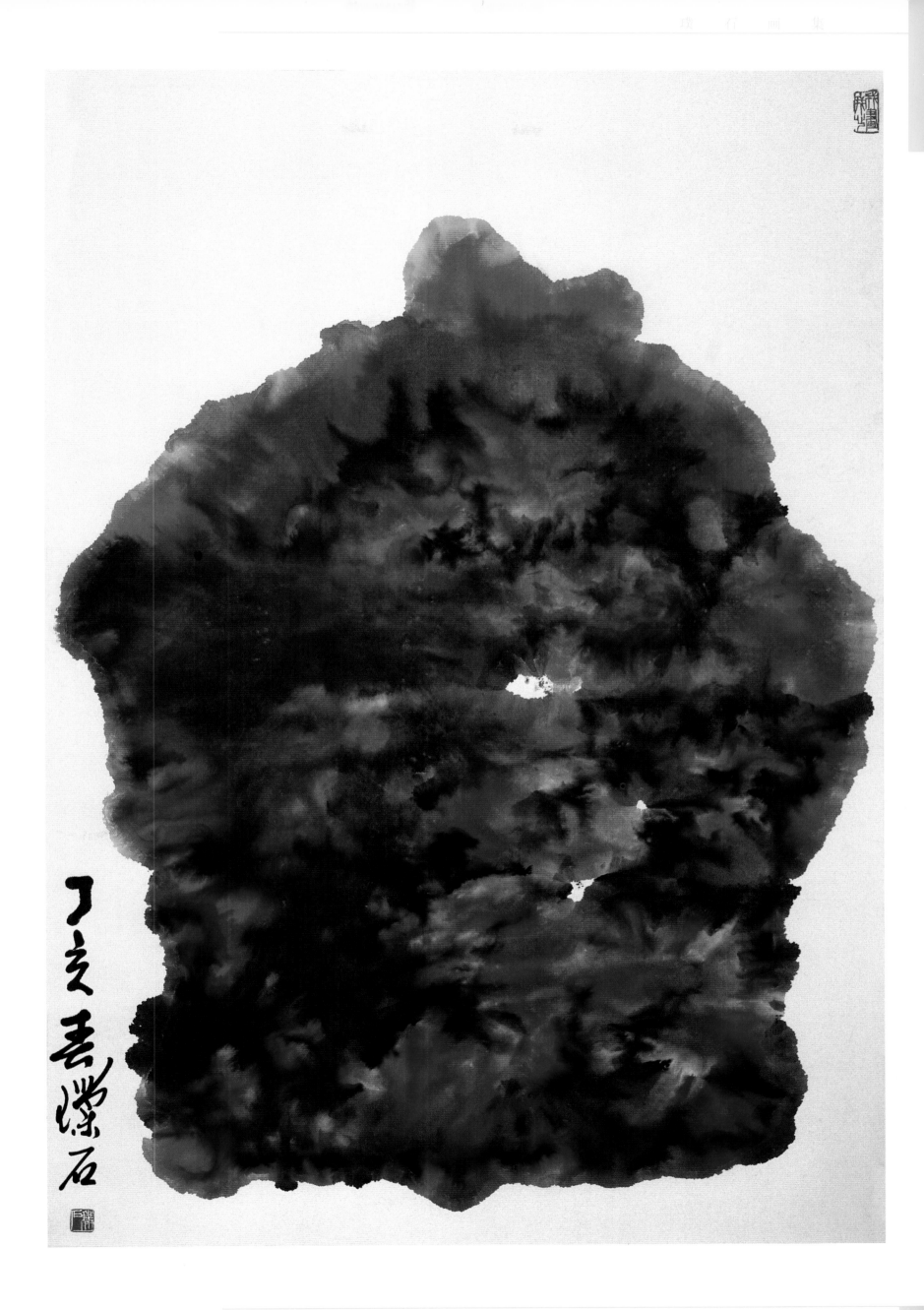

丁亥吾瀑石

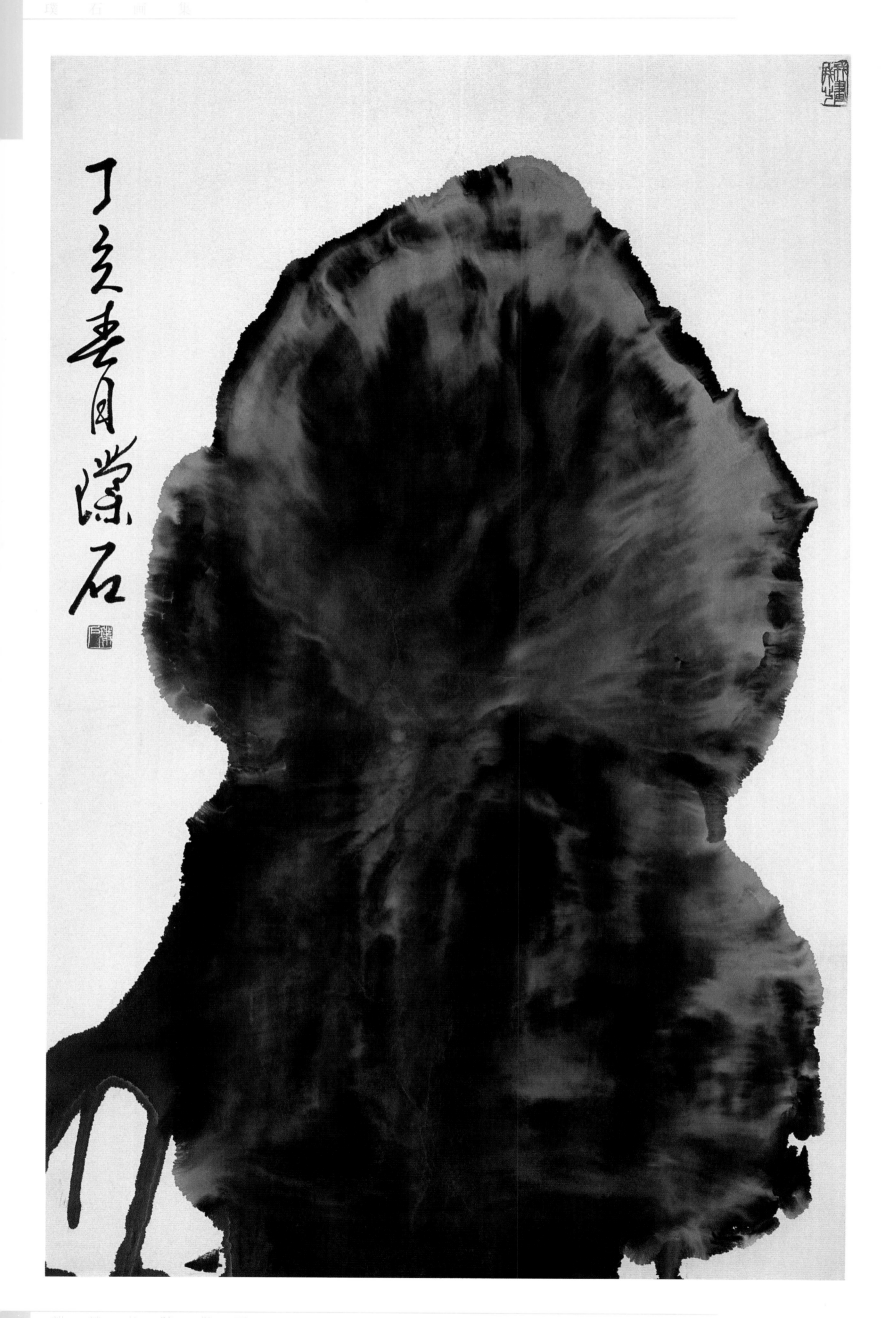

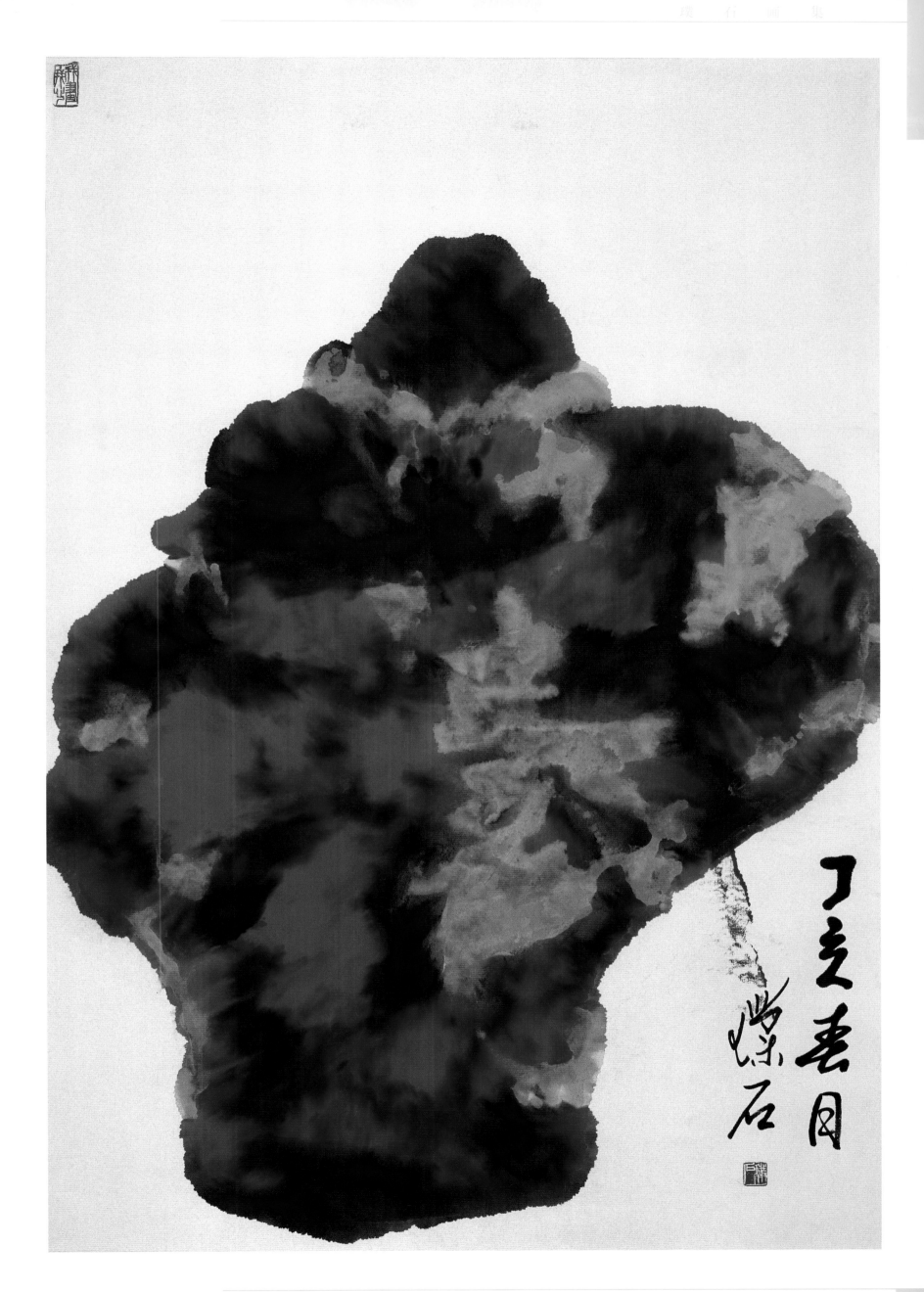

丁亥春月 燥石

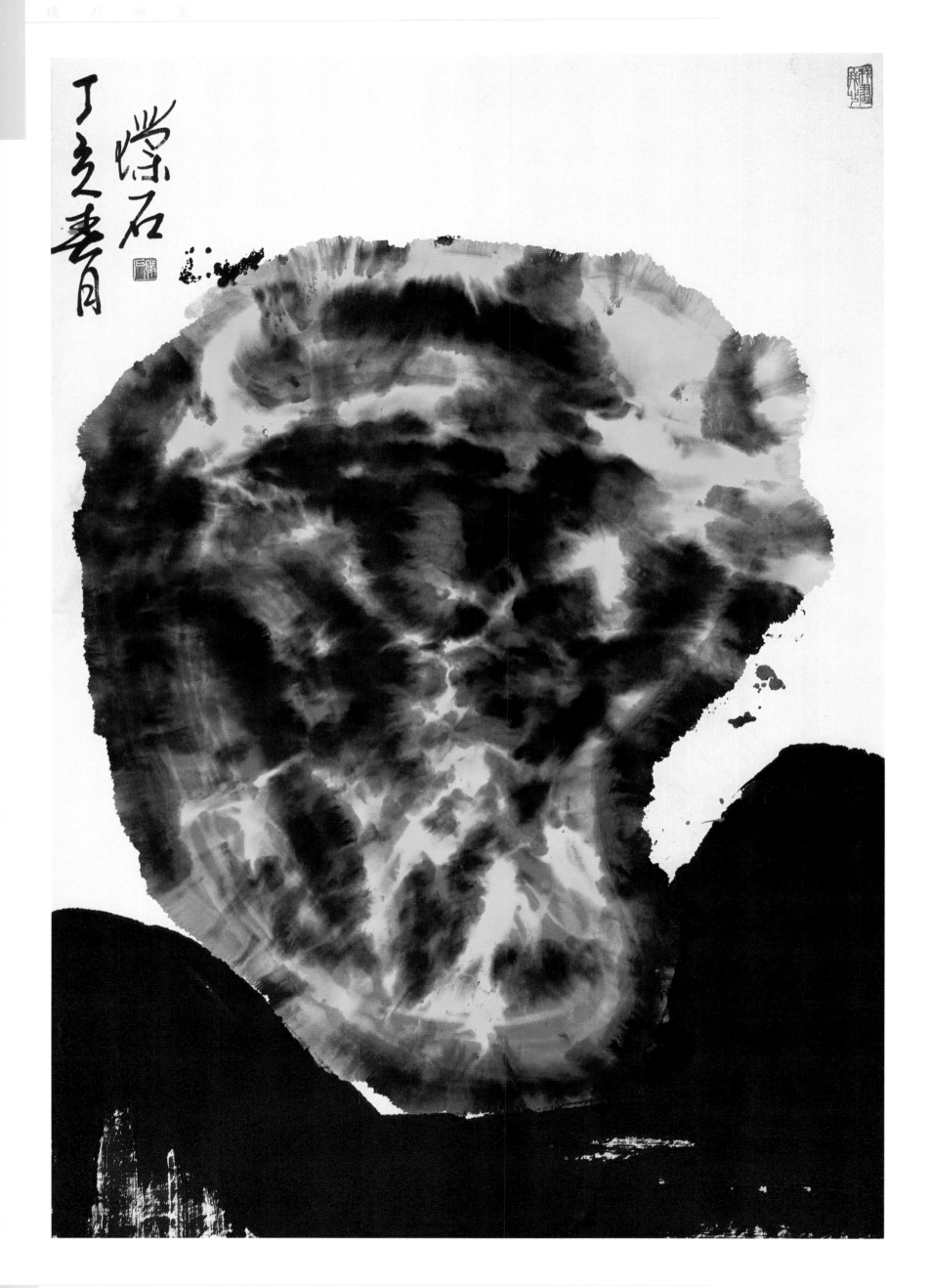

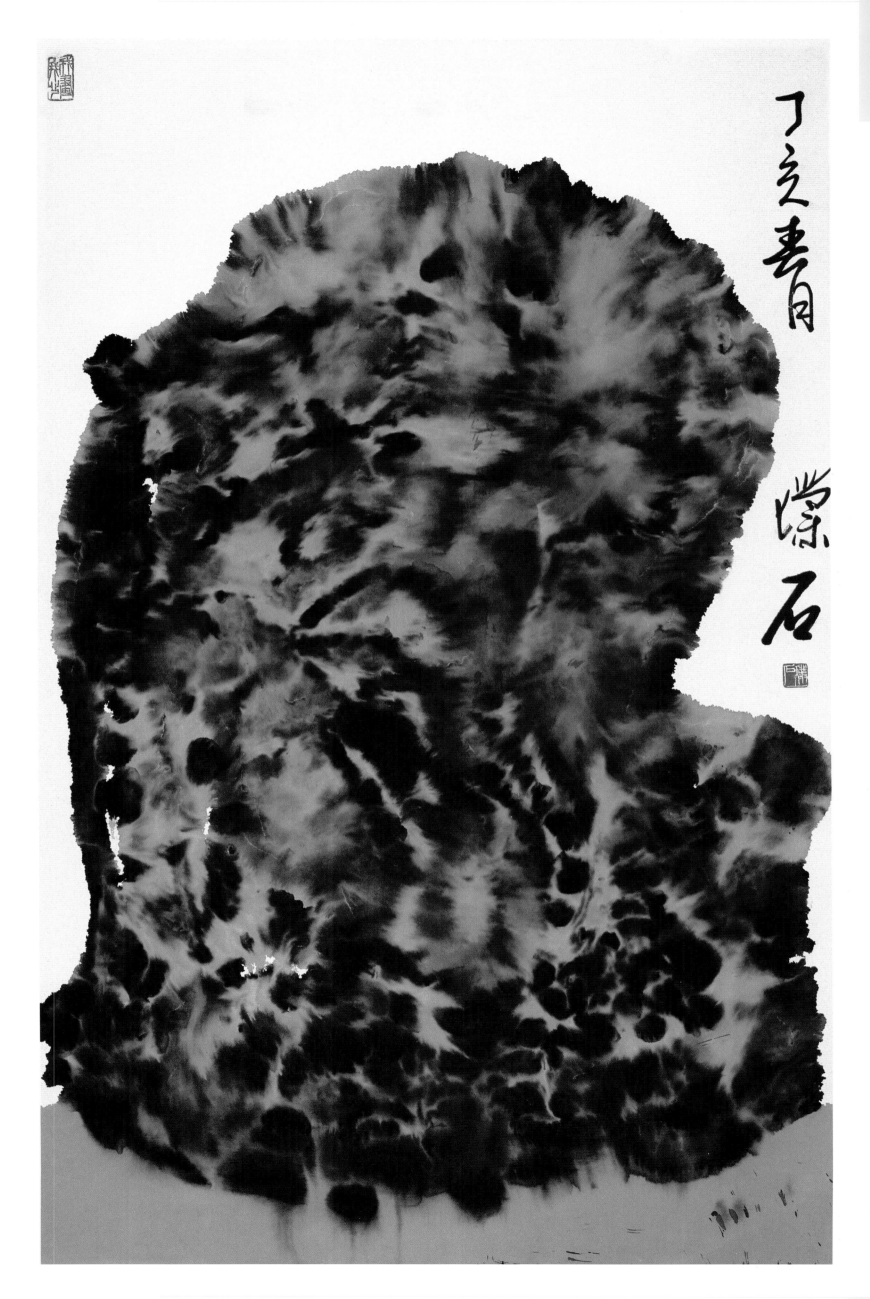

丁之春自

漾石

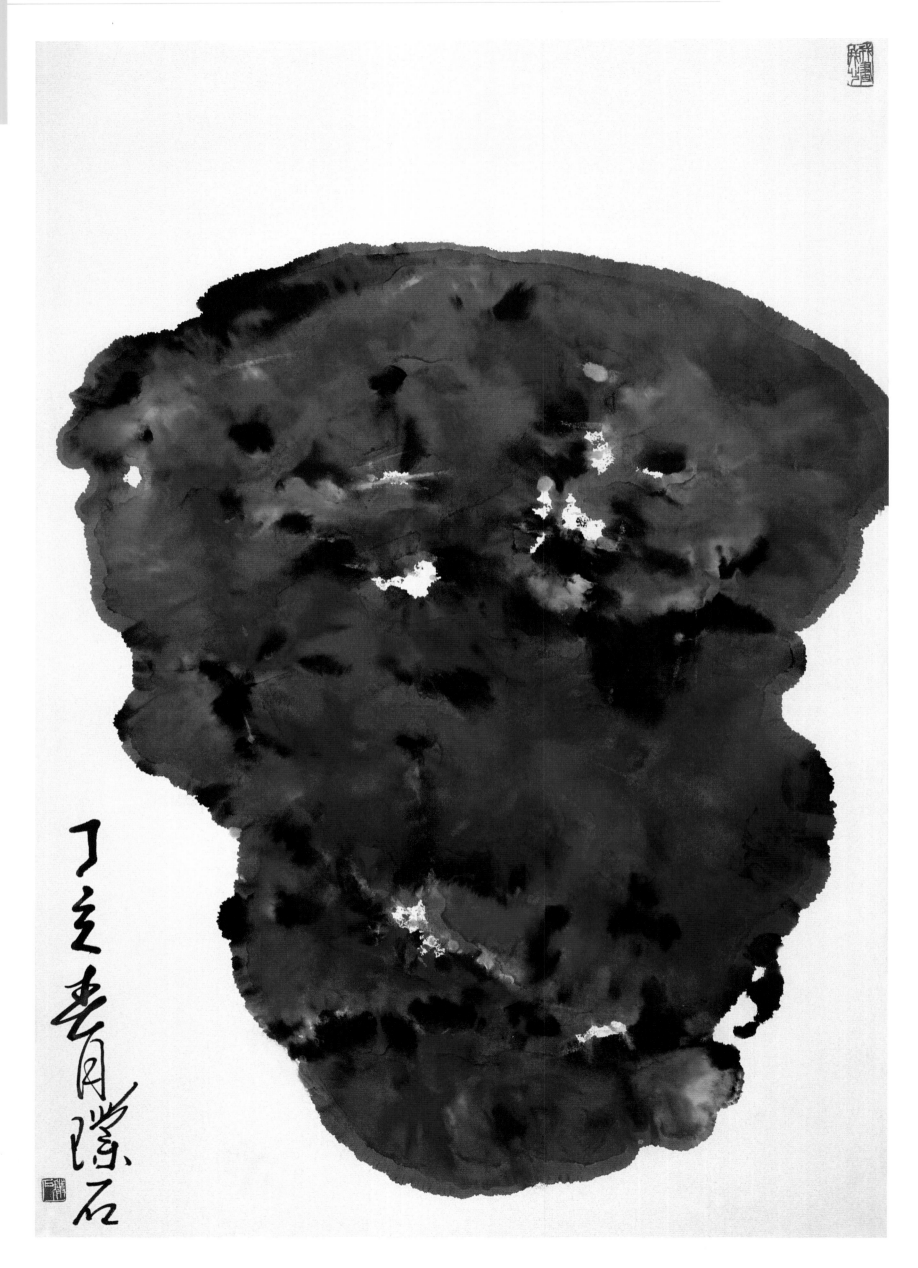

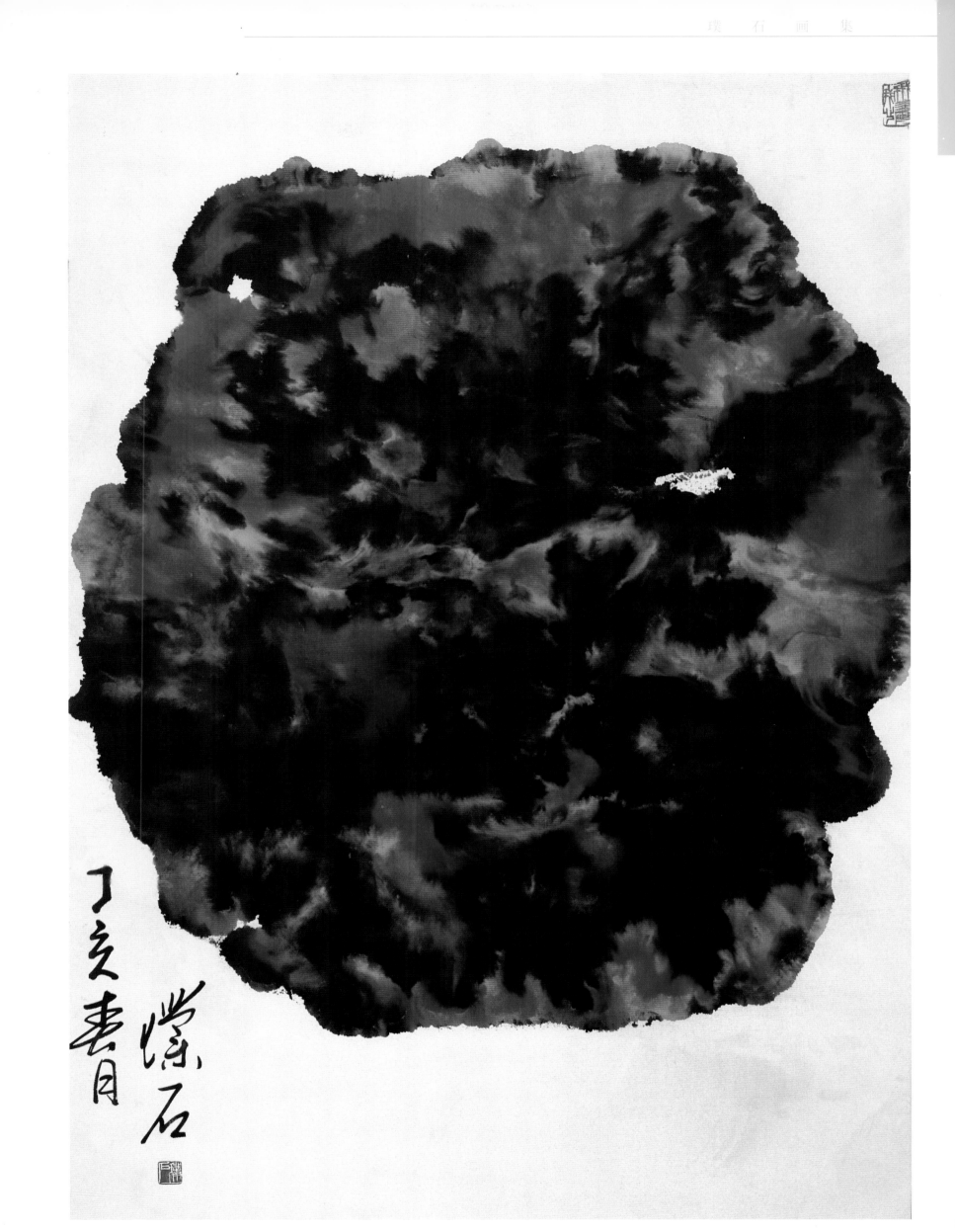

动物　ANIMAL

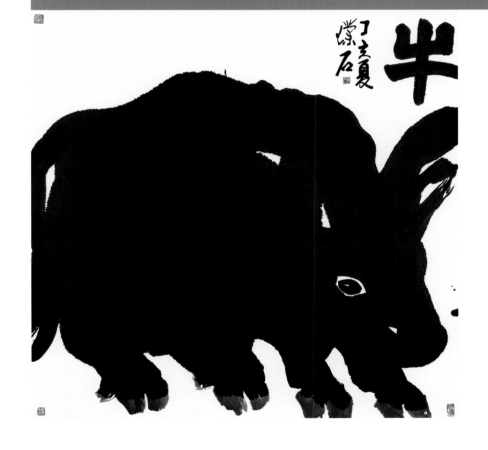

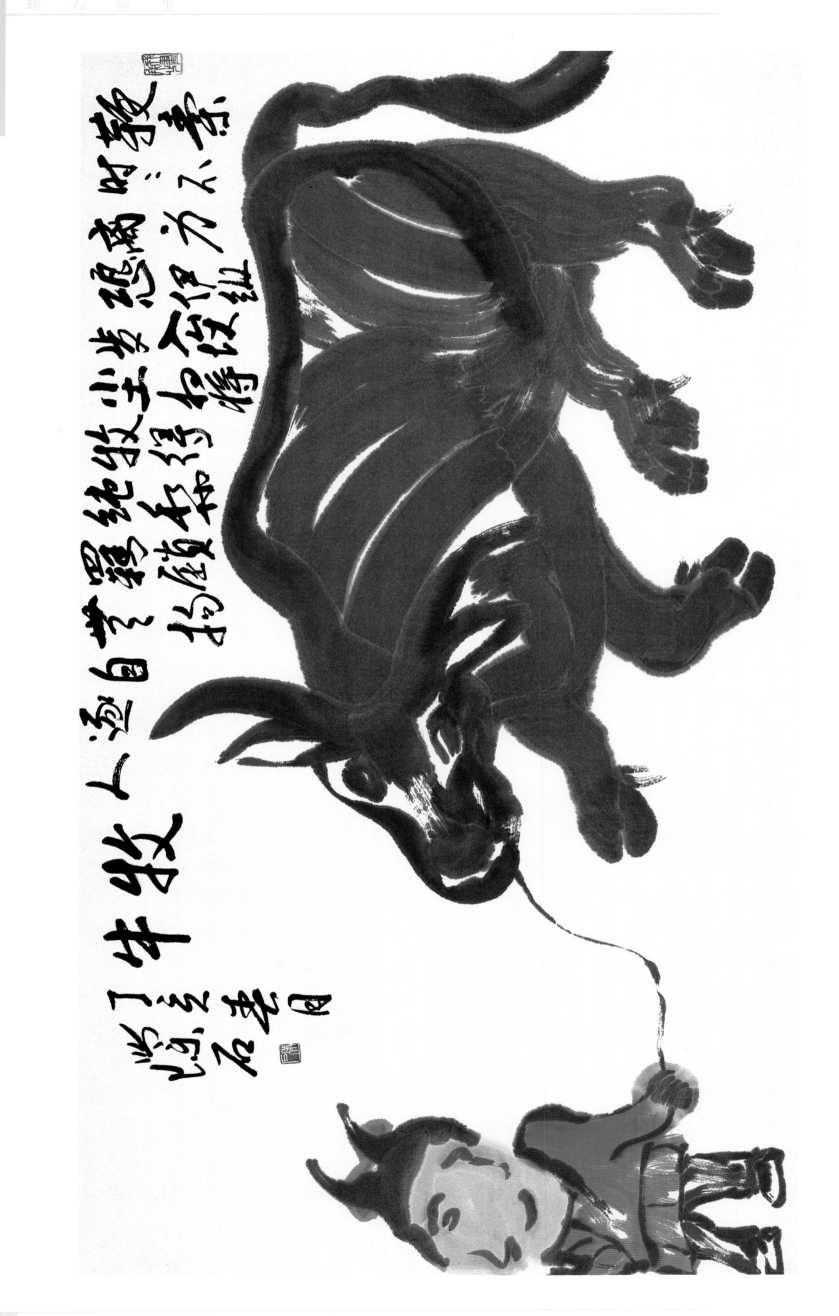

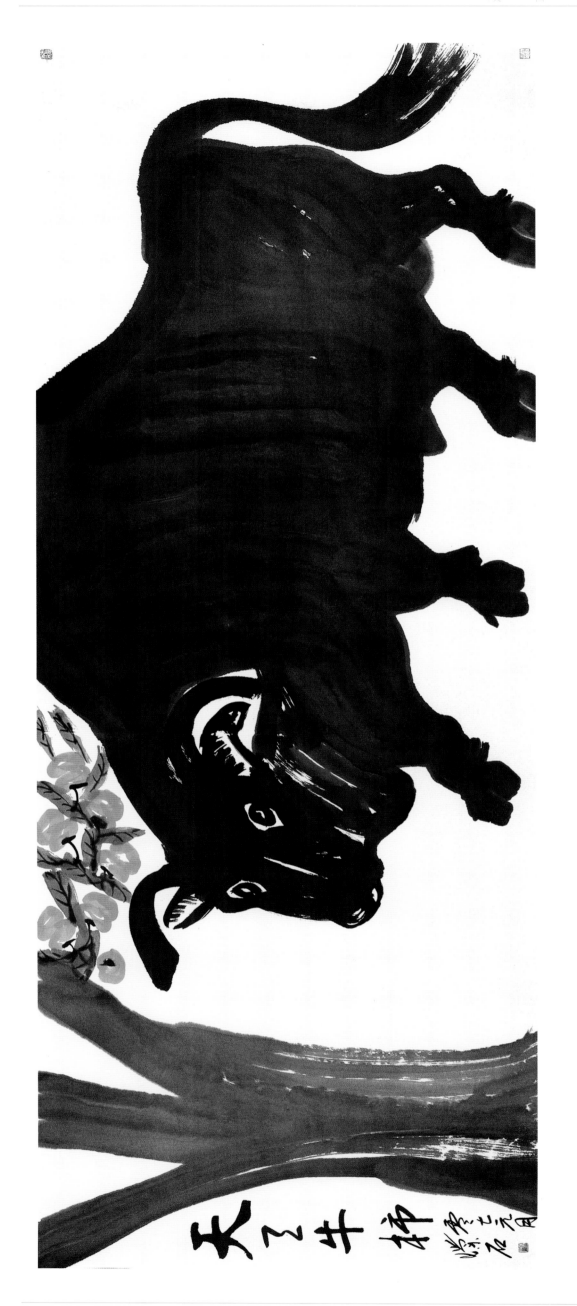

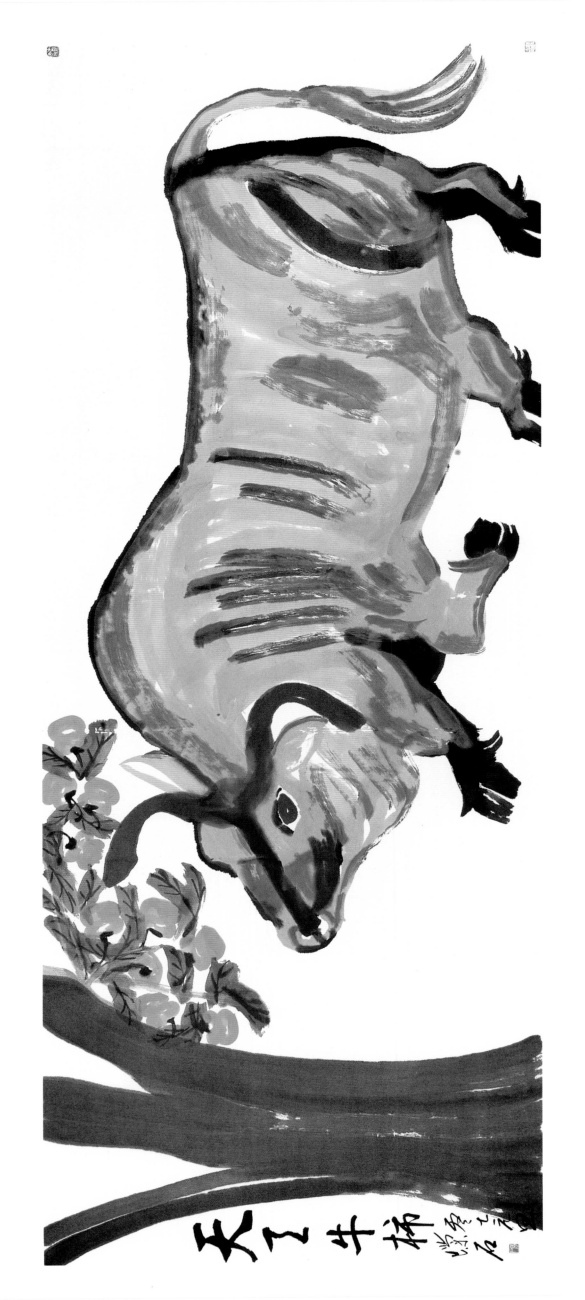

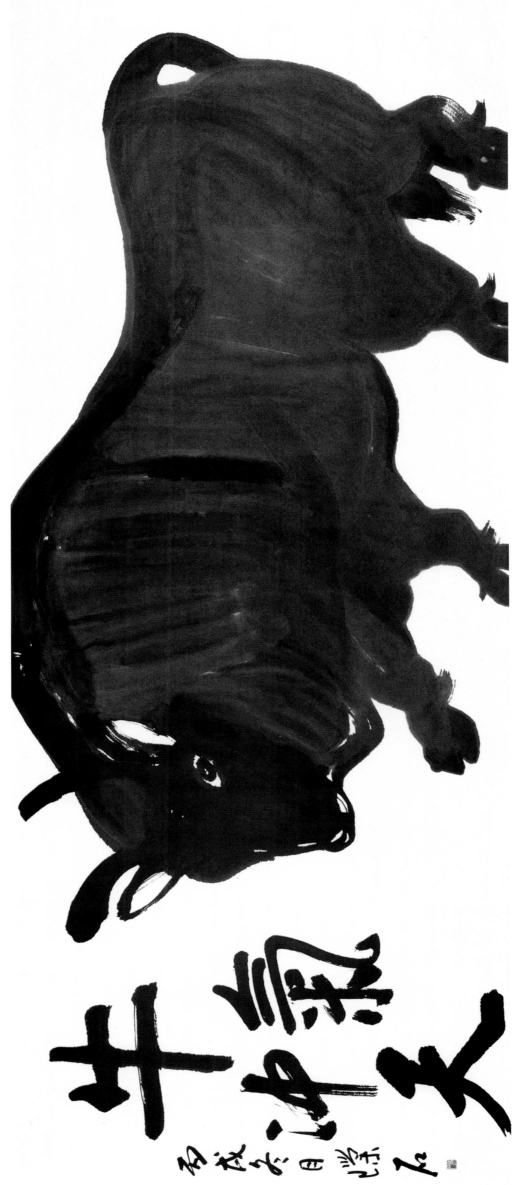

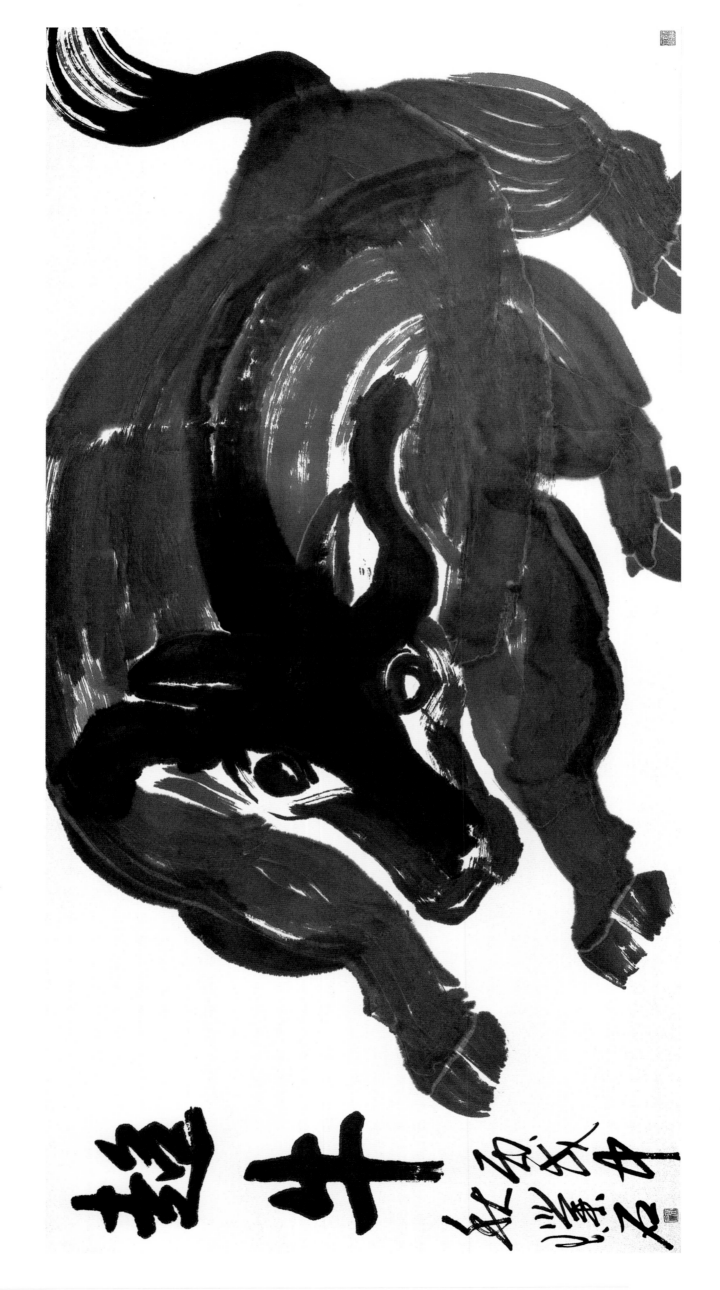

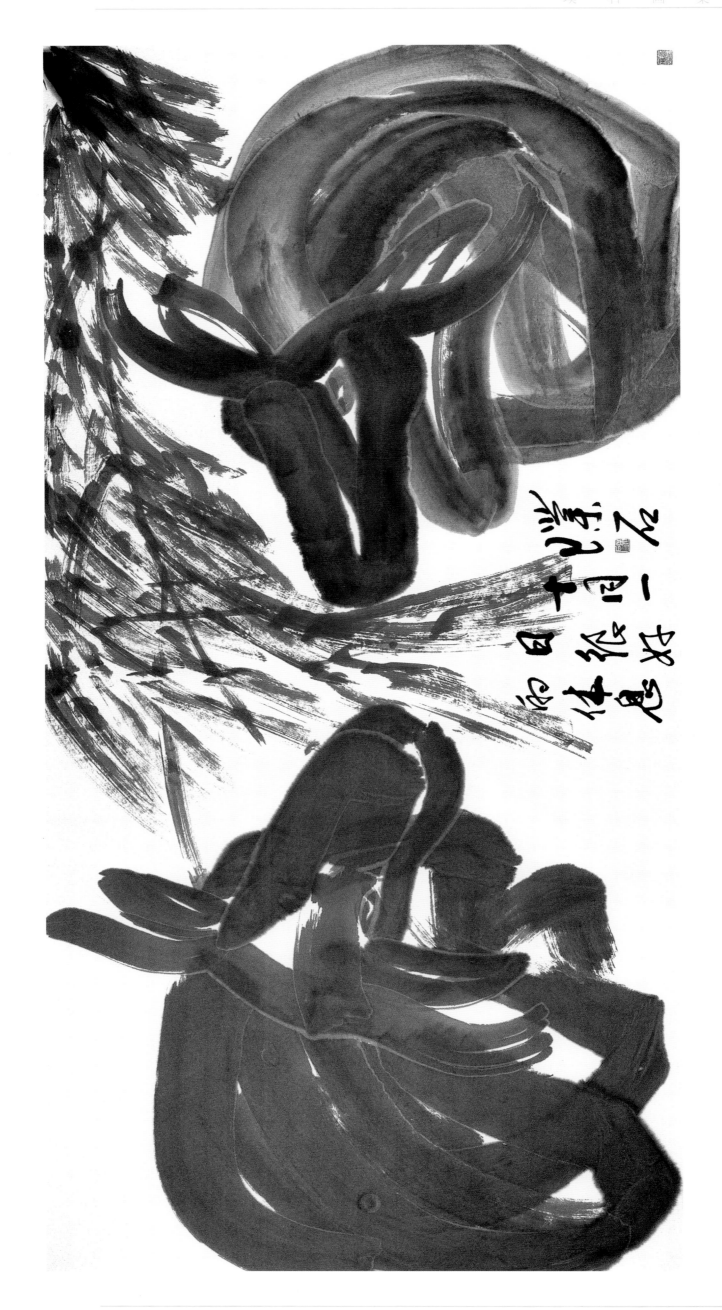

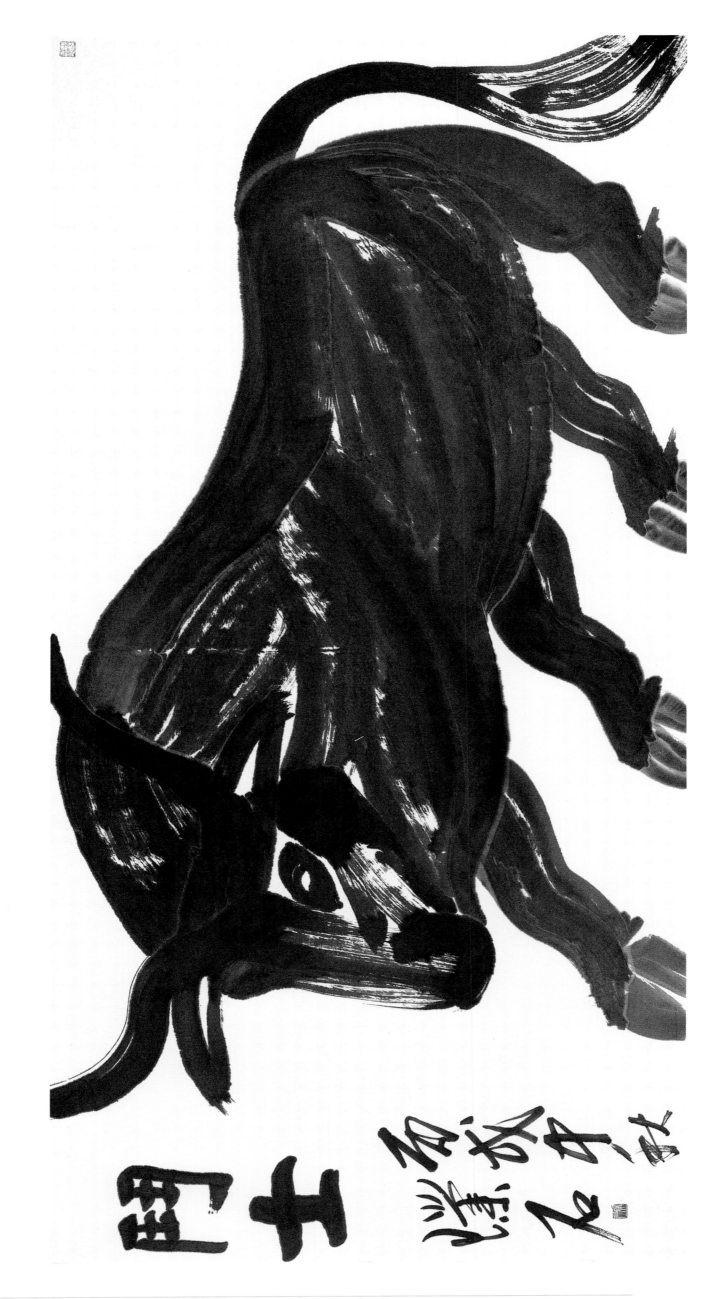

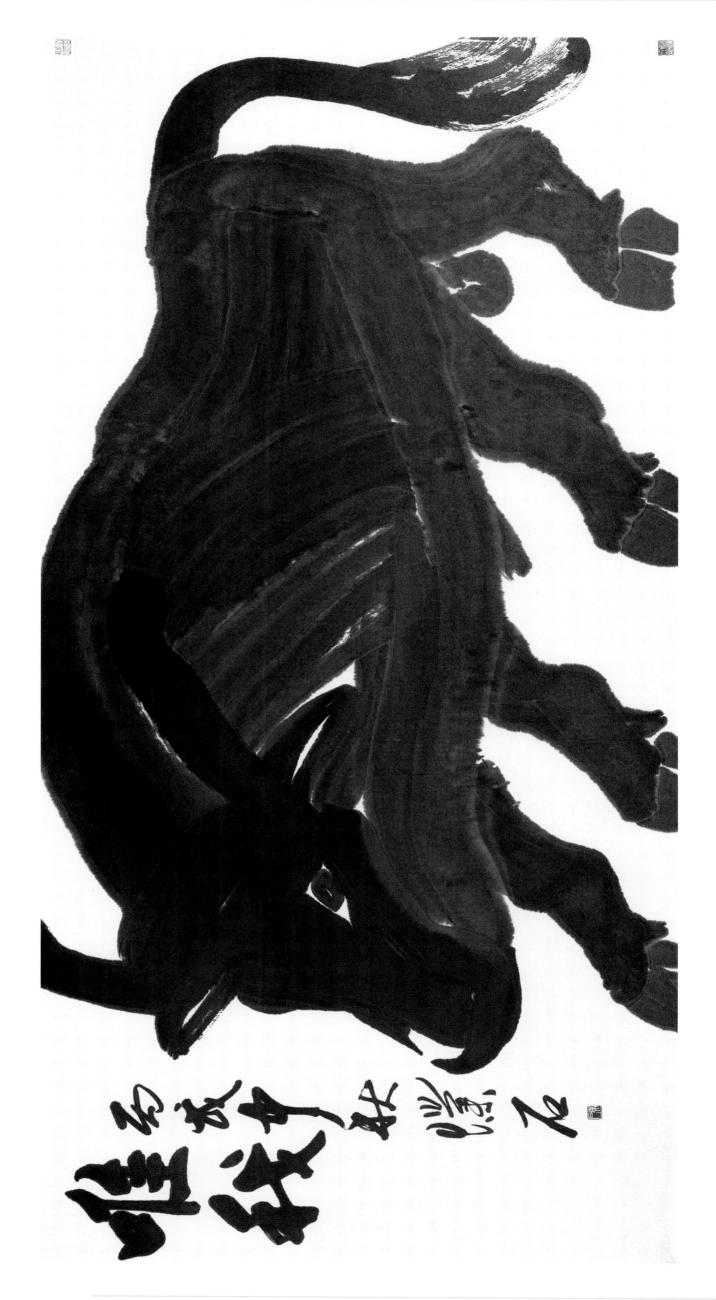

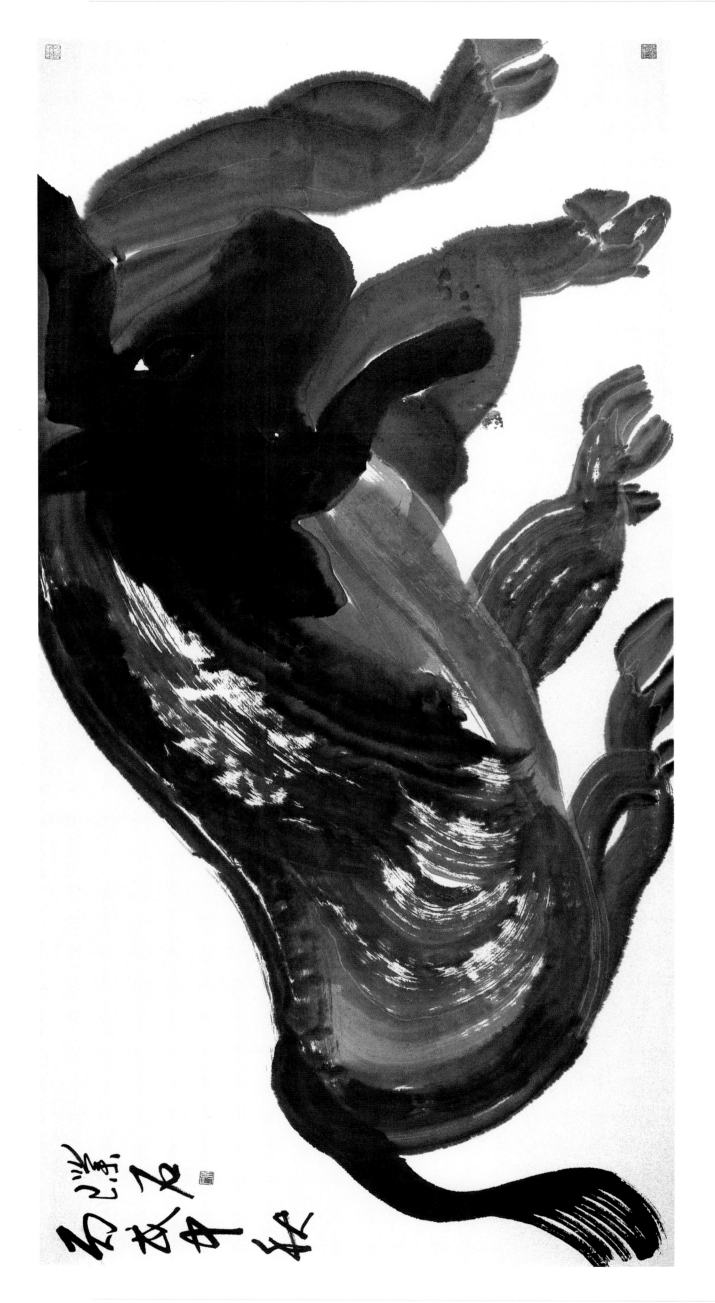

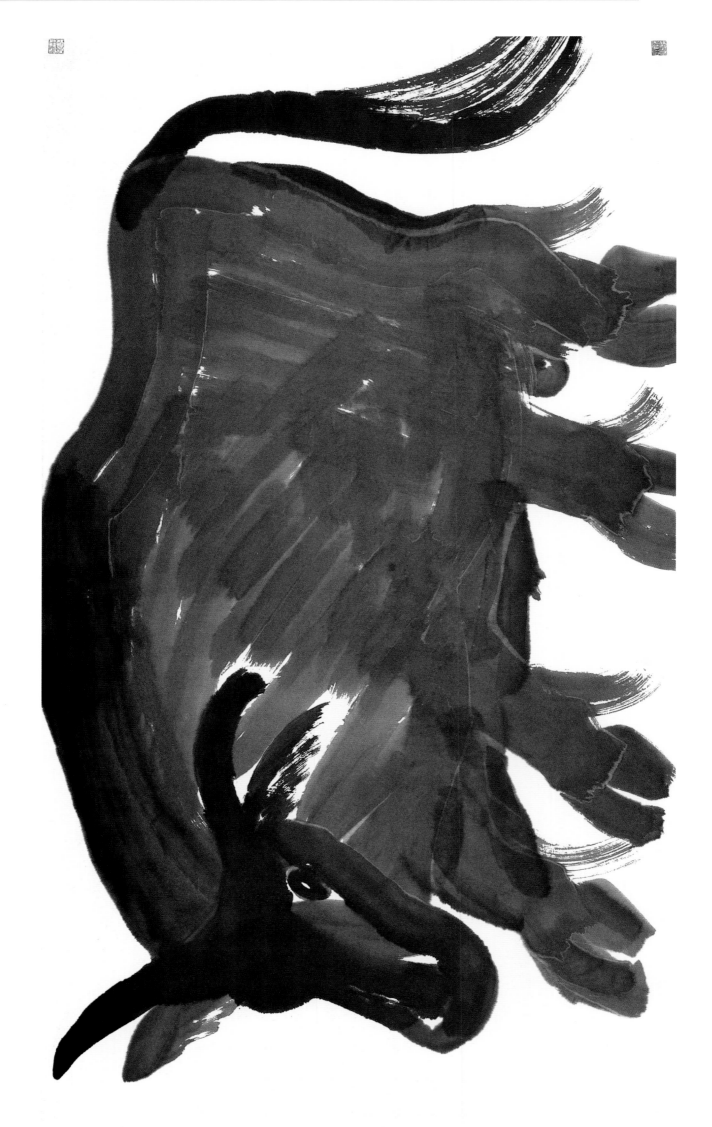

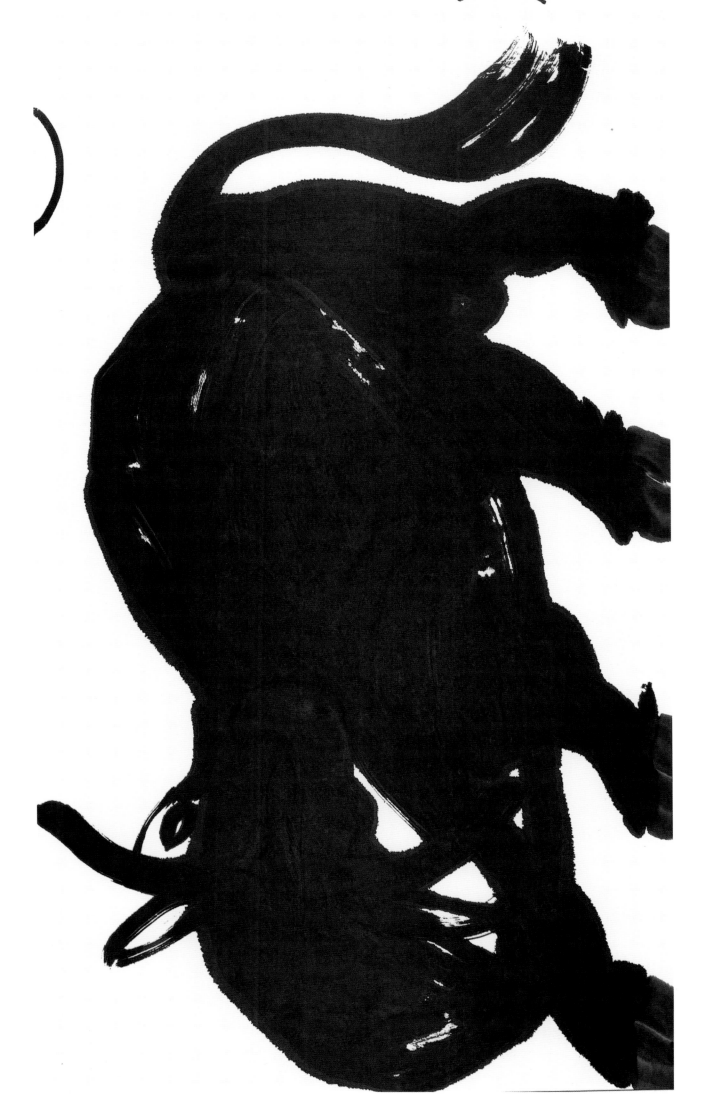

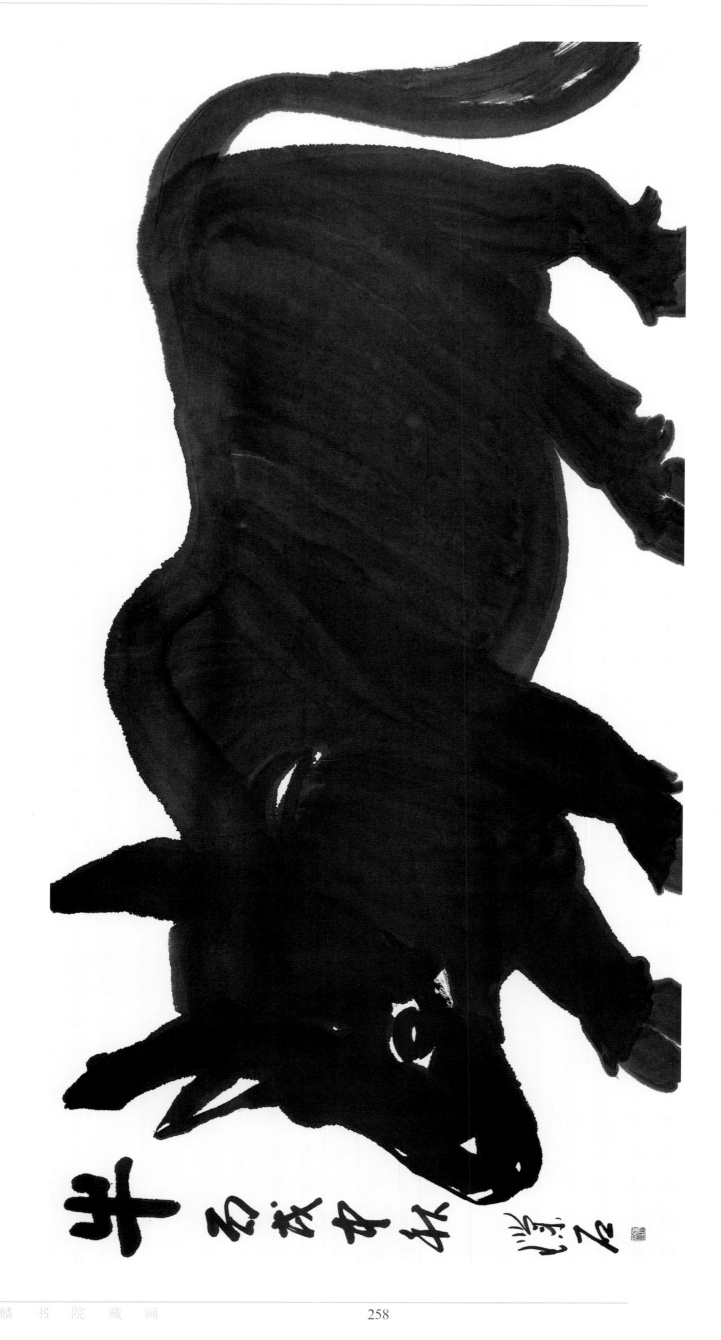

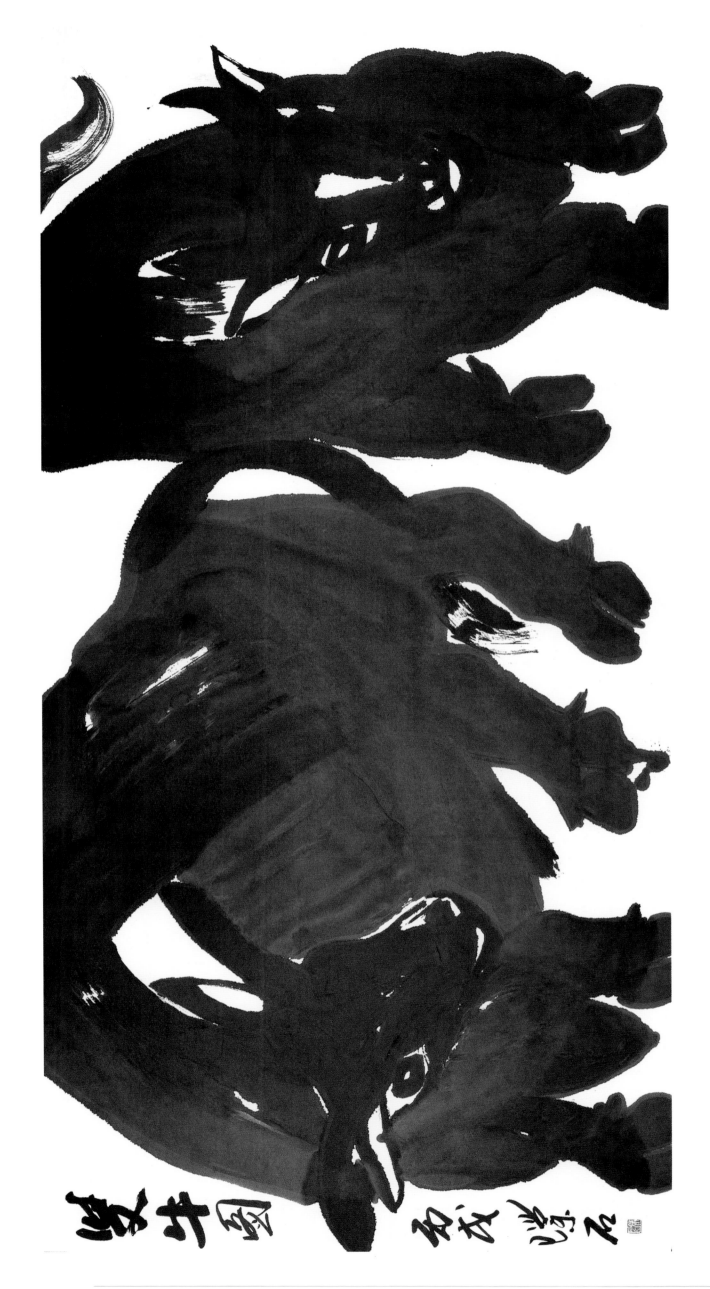

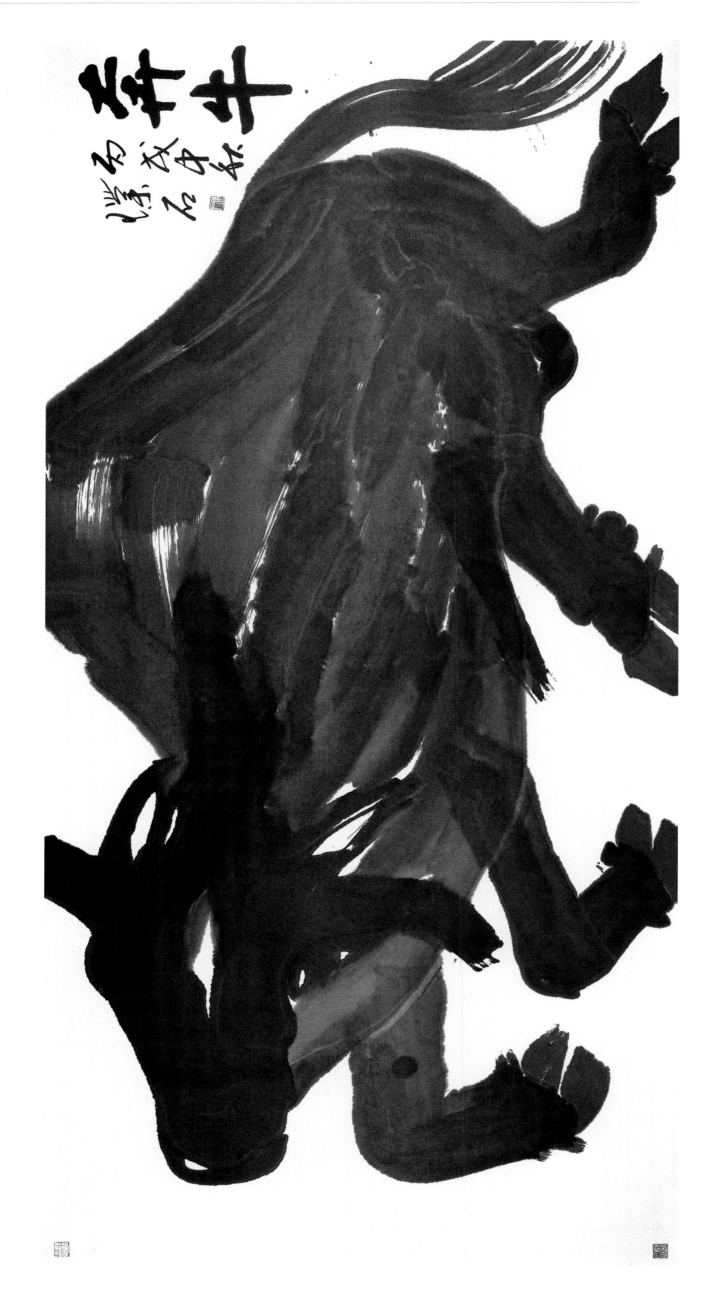

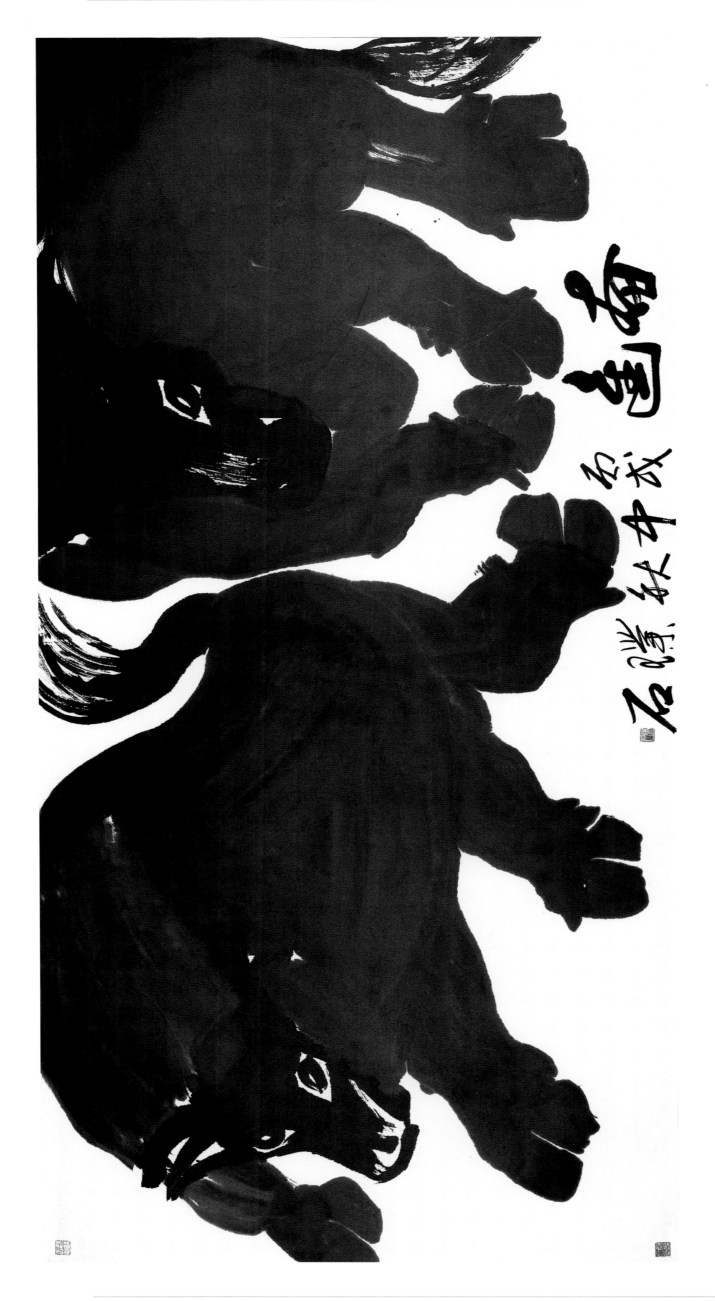

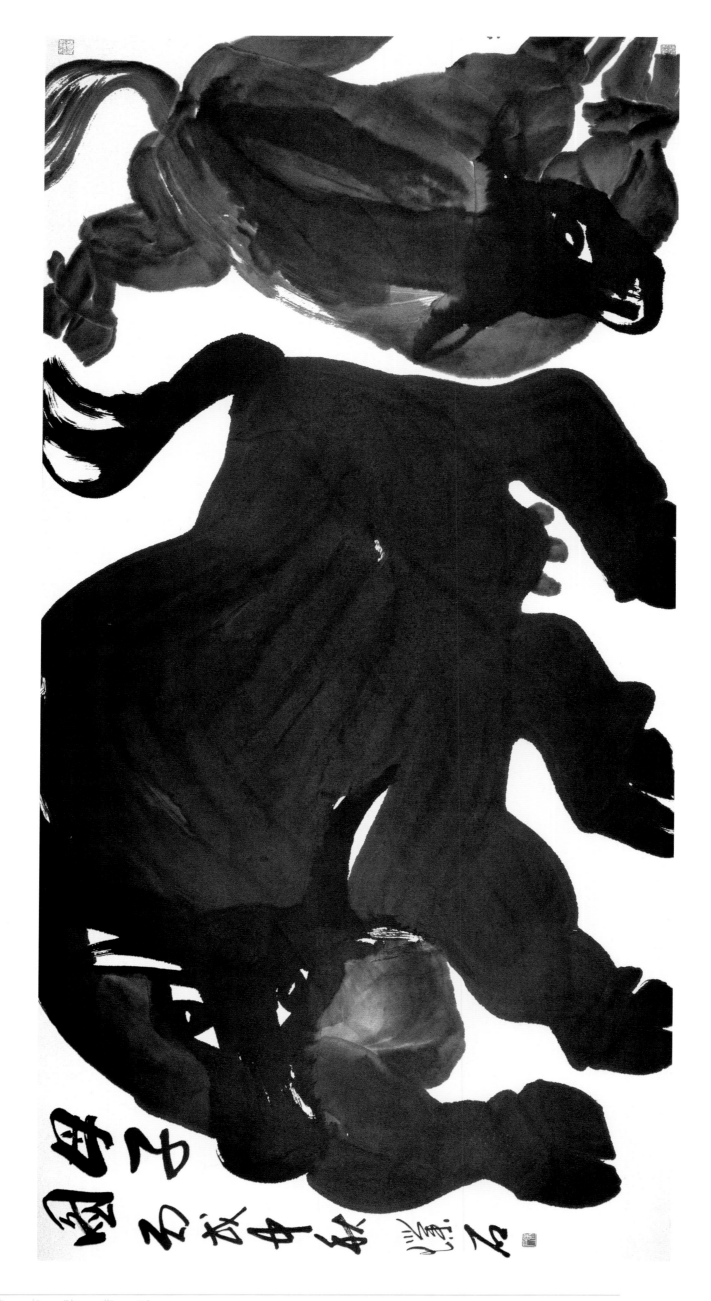

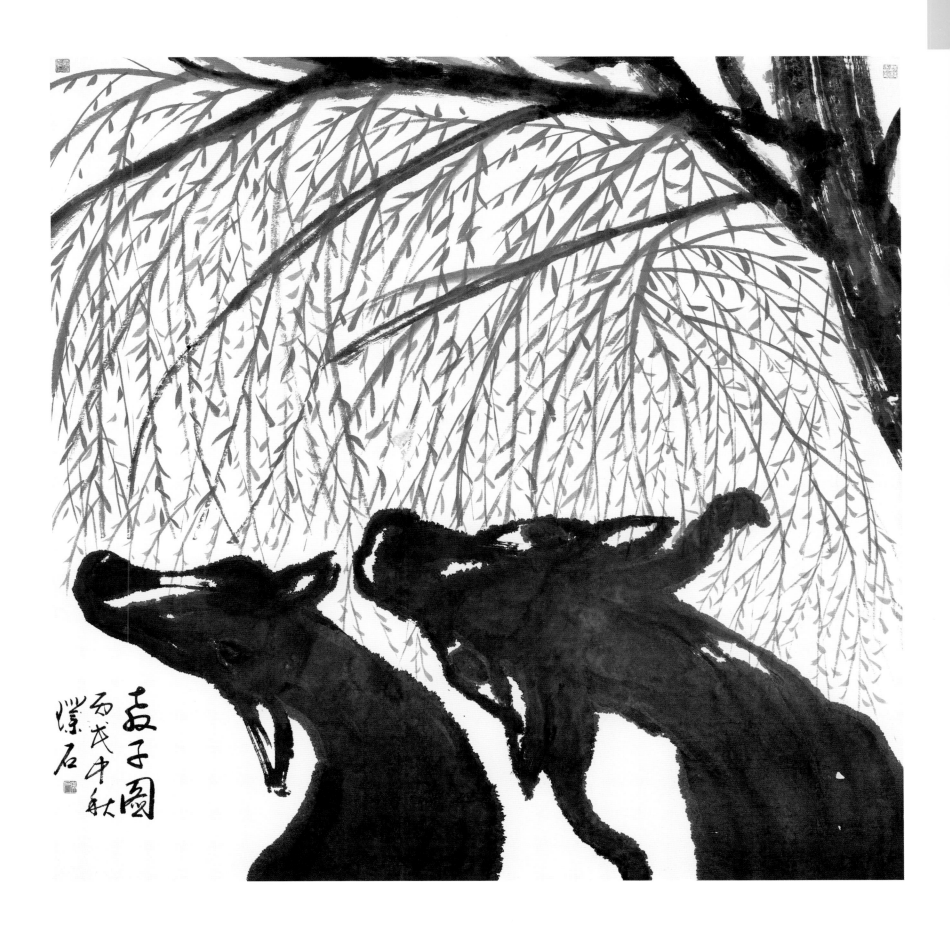

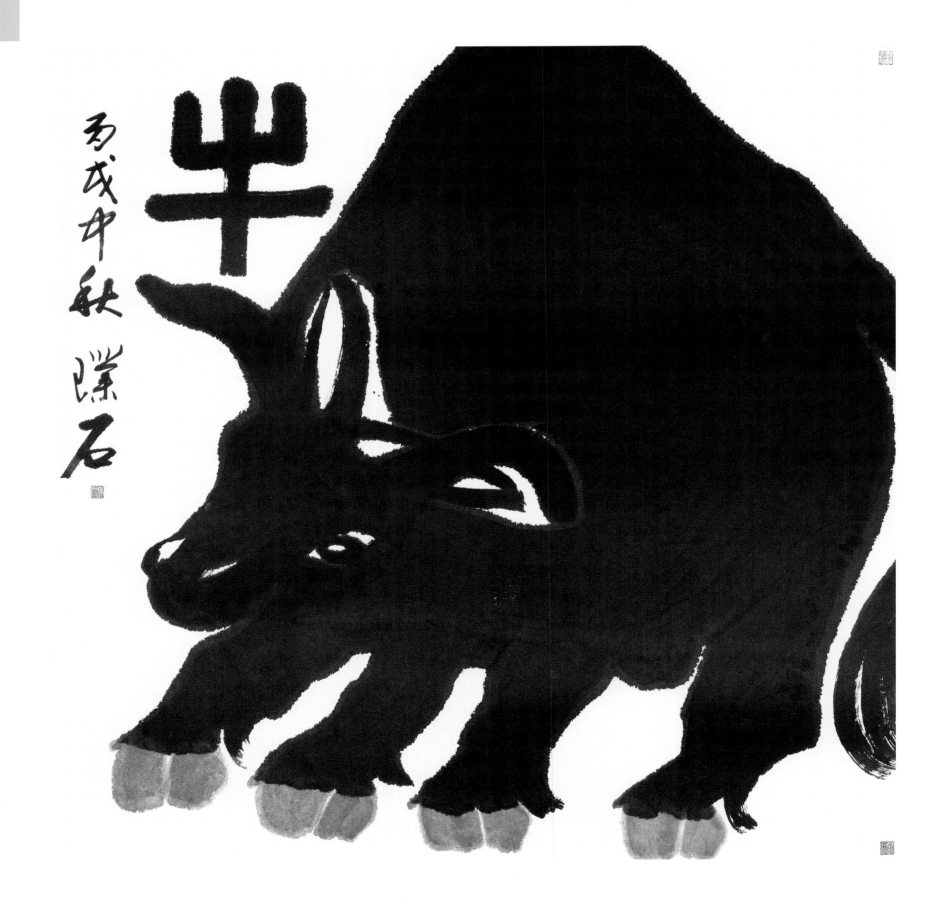

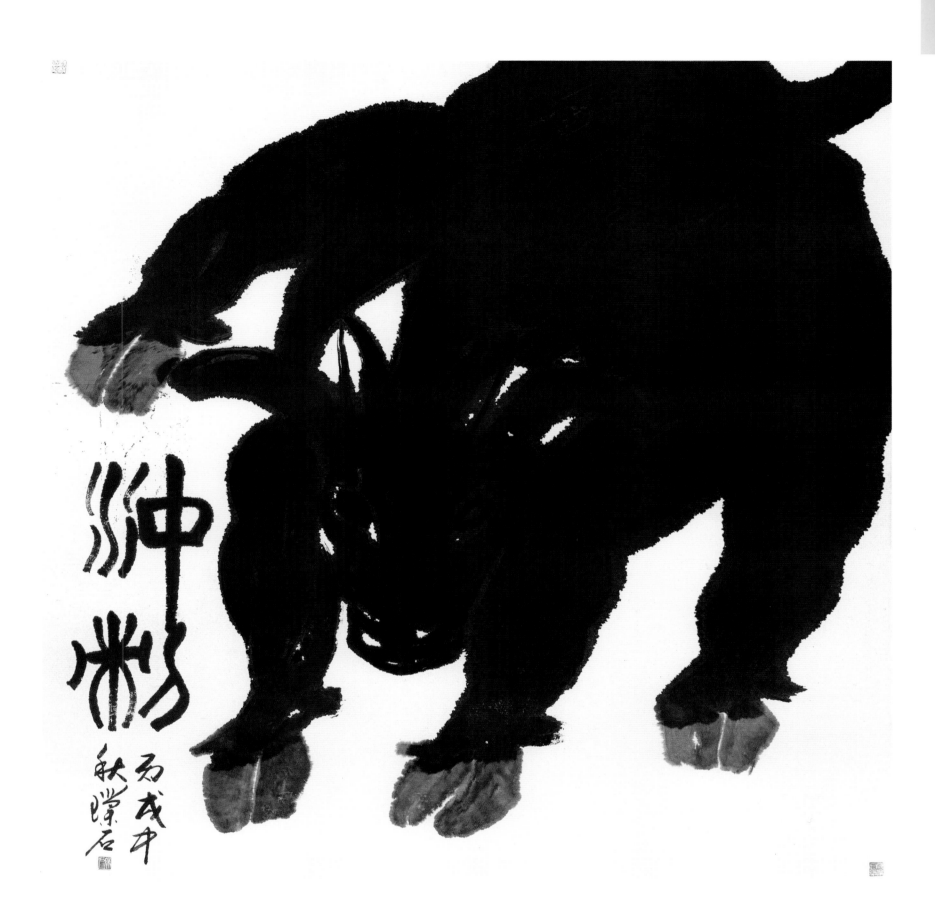

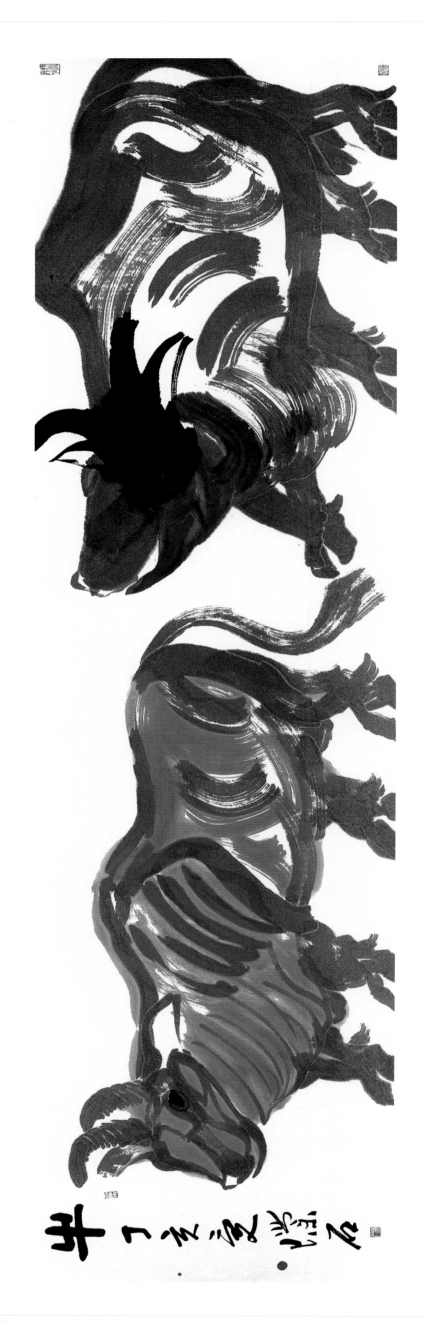

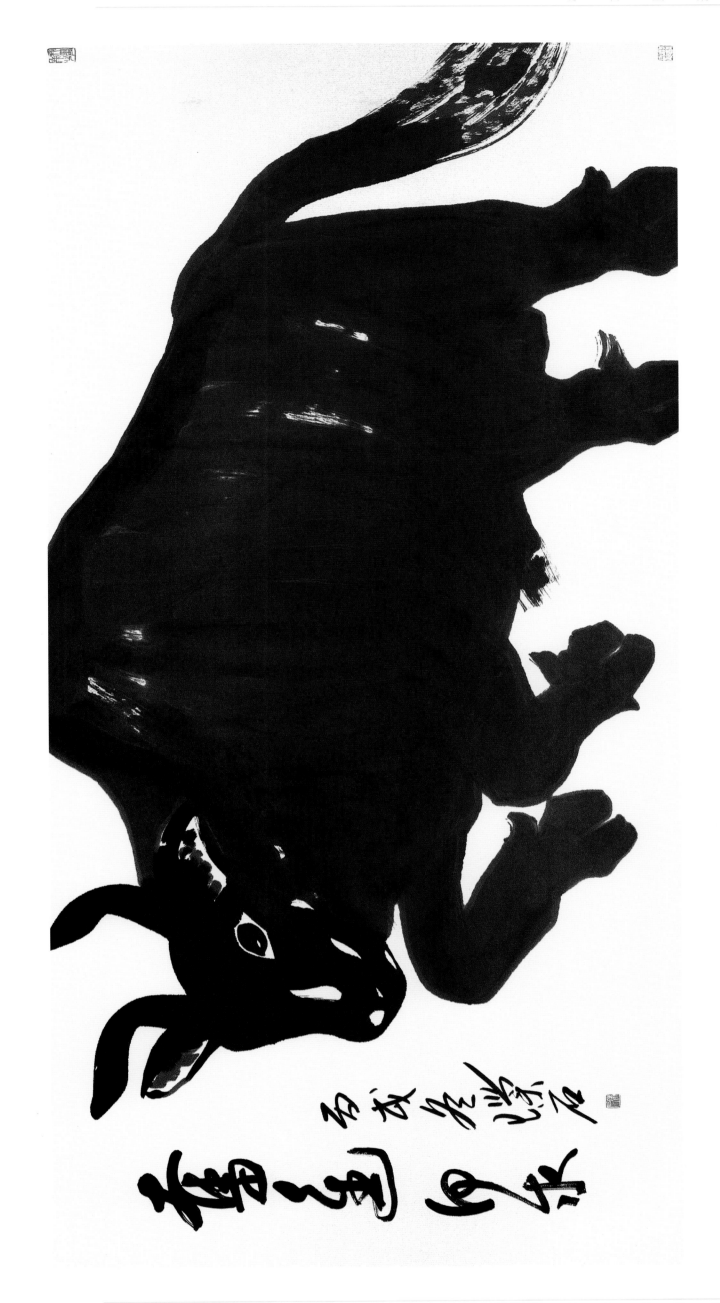

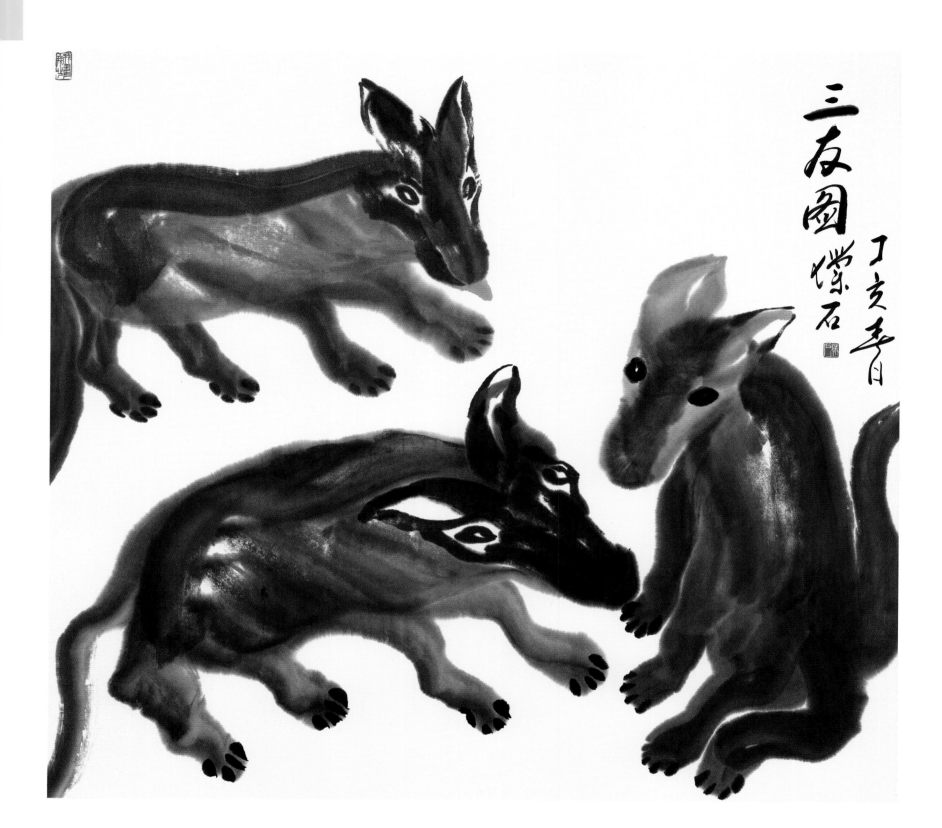

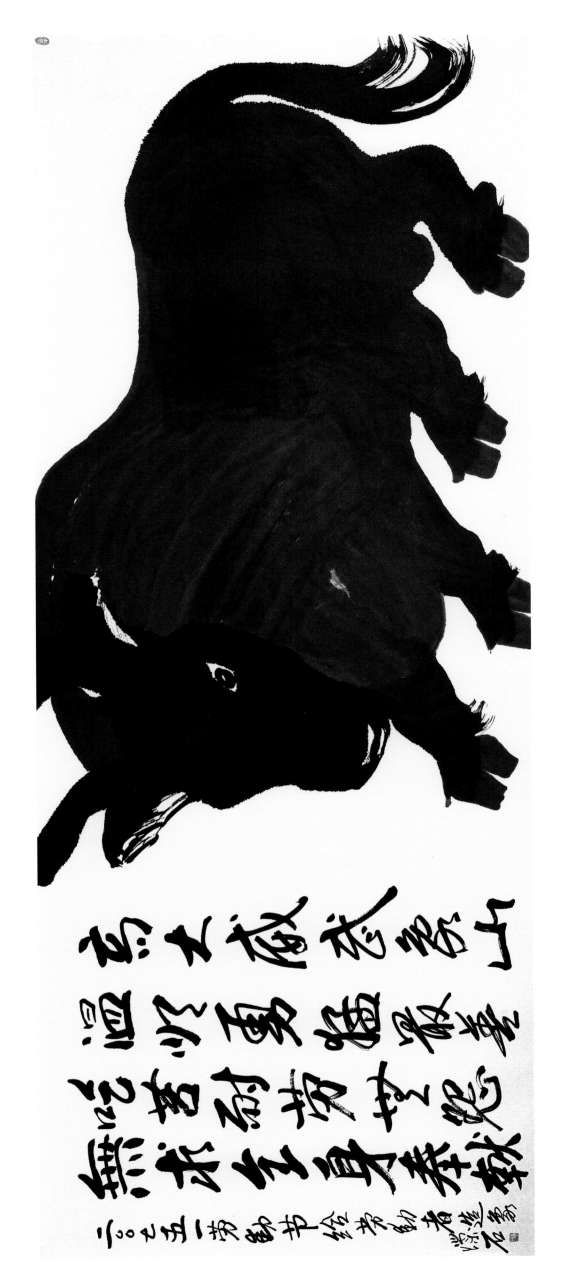

玄体圖 二人天地寬

樹明

柏英

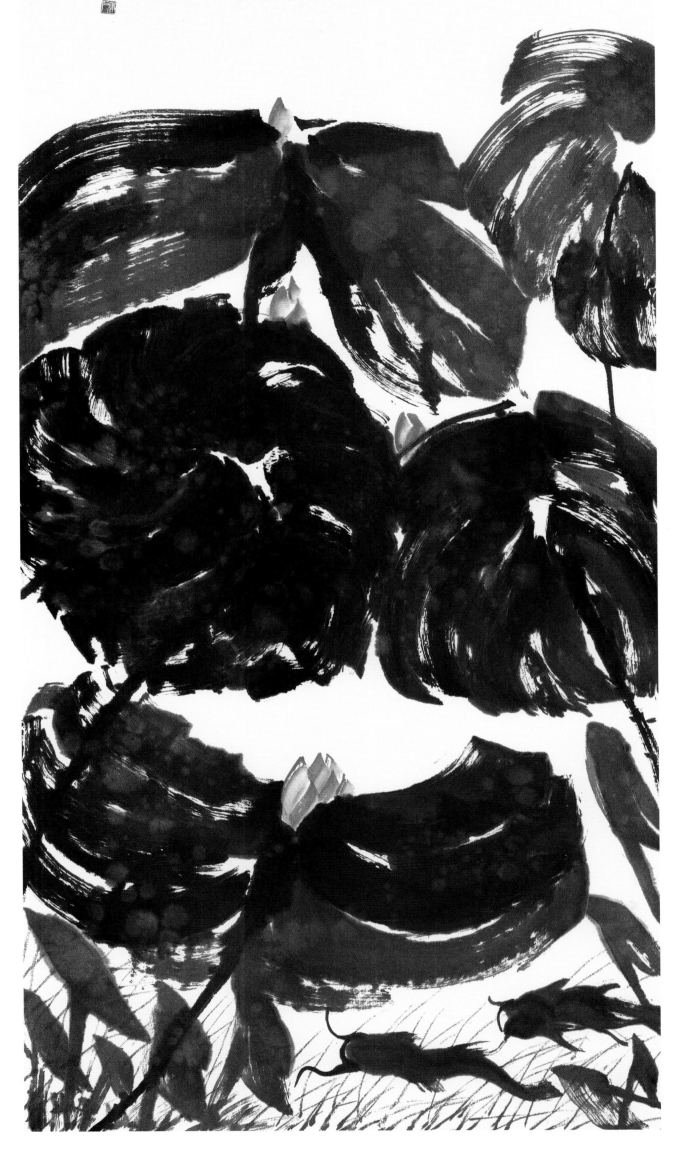

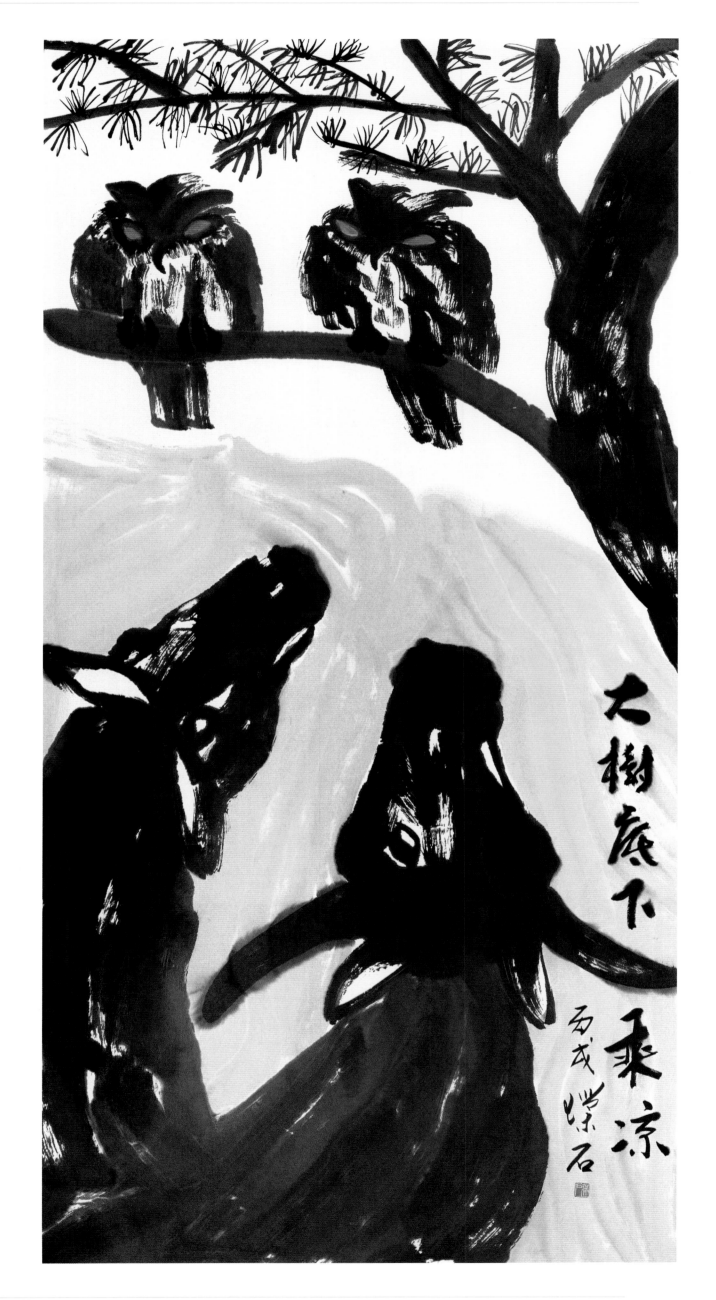

大樹蔭下乘涼 丙戌 璞石

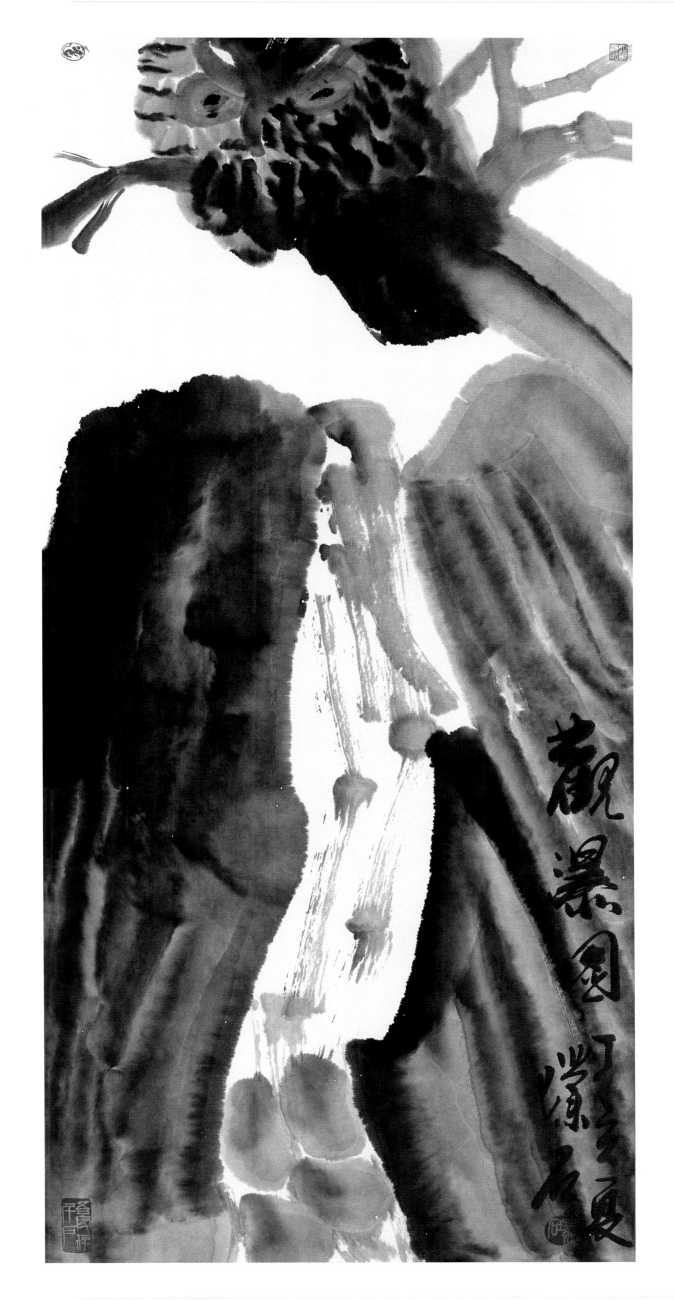

小憩　今天端午节

传说是纪念

屈原能达

到永远活

在人民心才如可

是功德圆满

丁亥夏　漾石

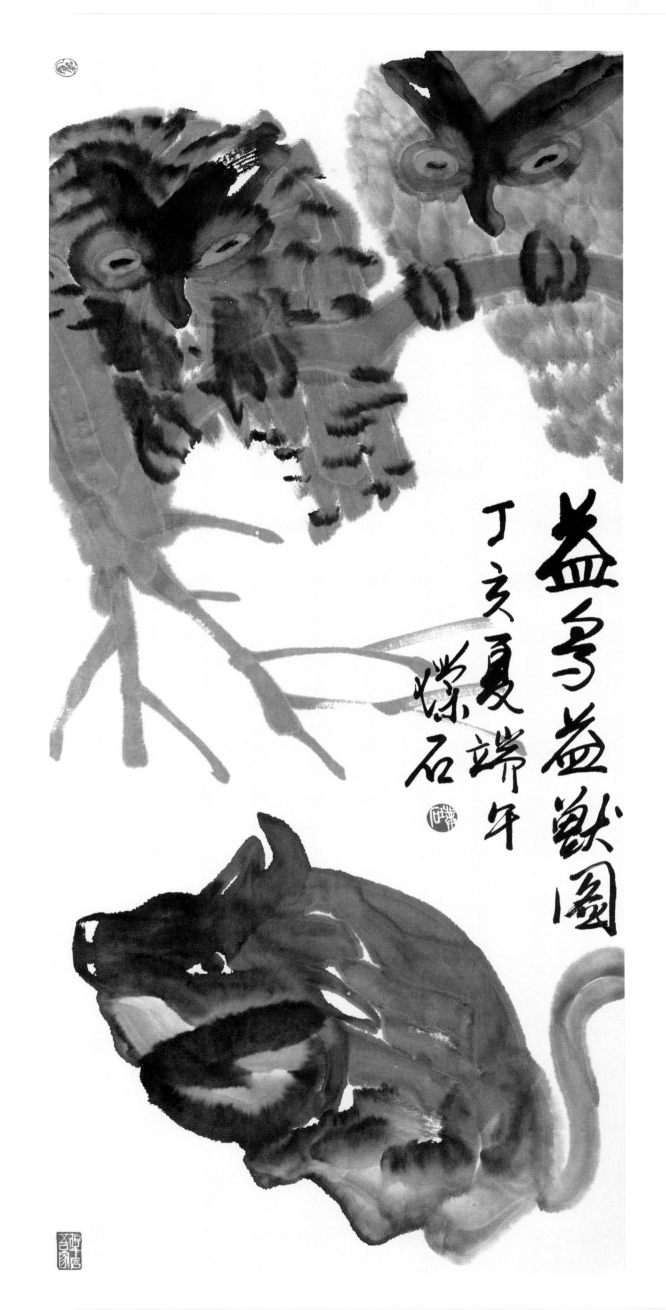

益多益善獸圖
丁亥夏端午
燦石

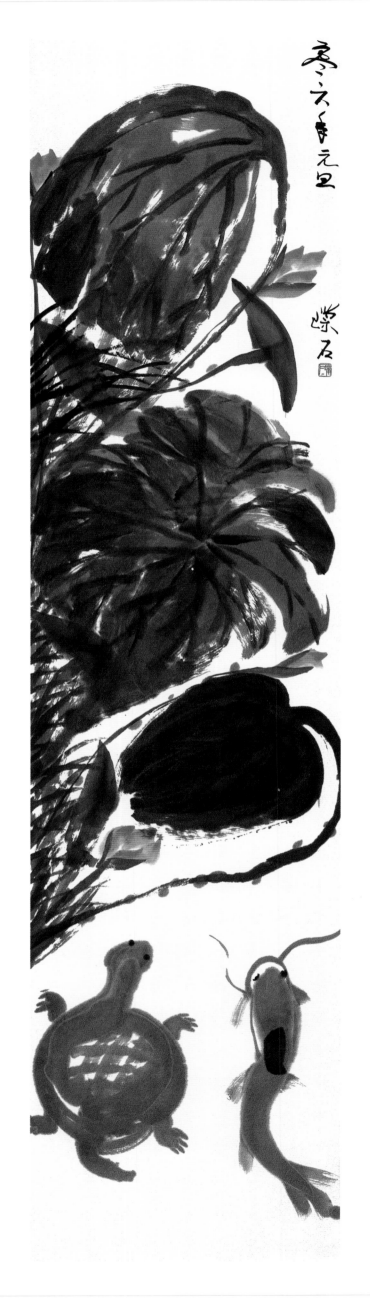

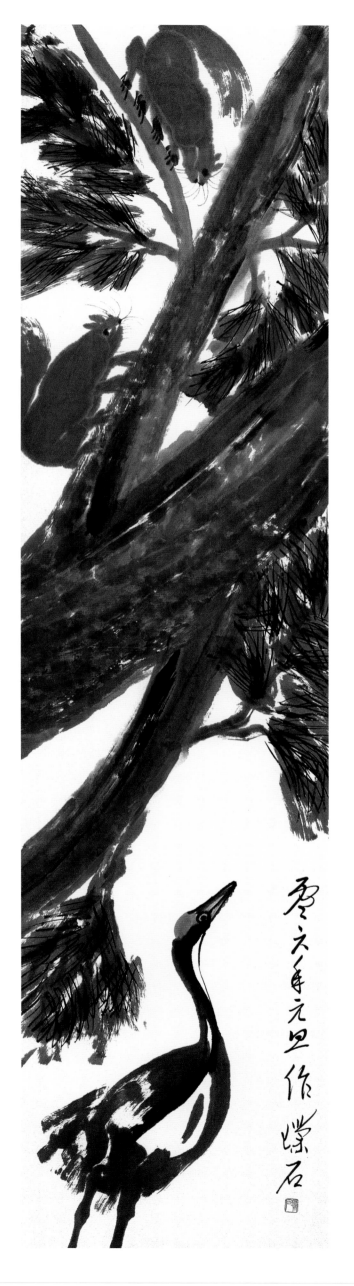

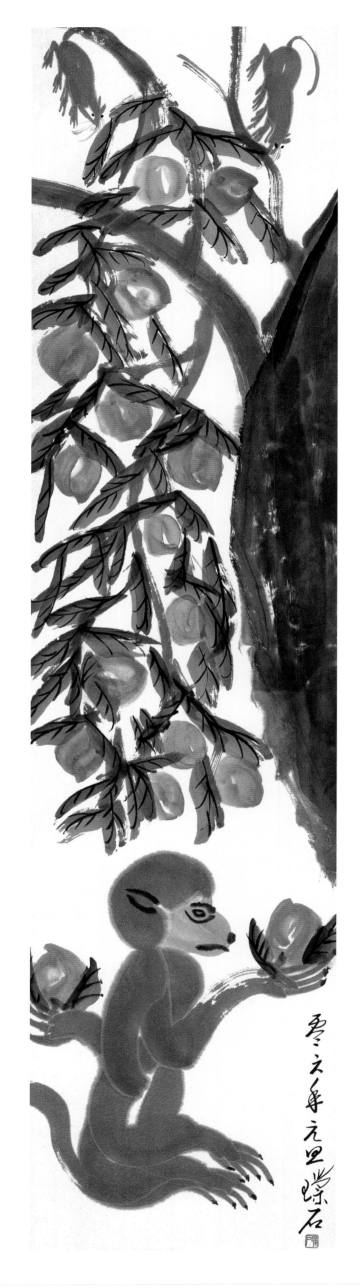

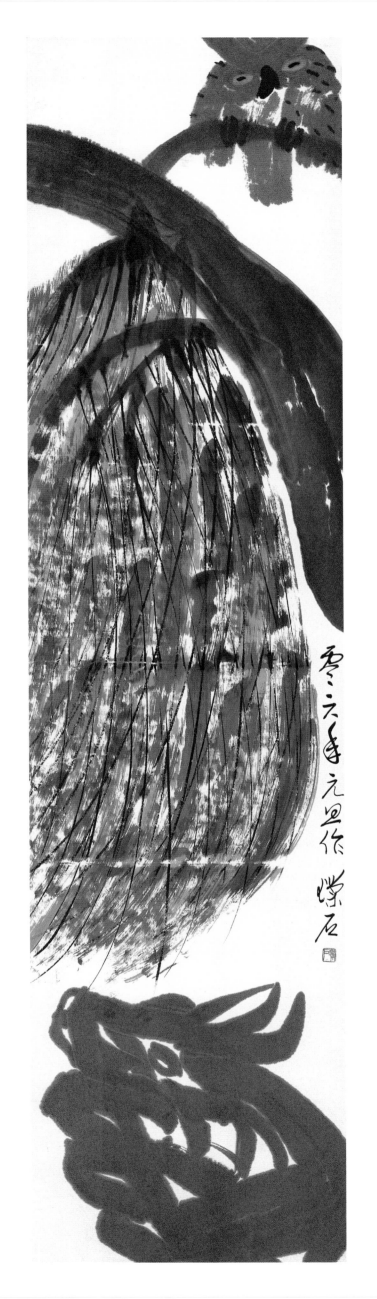

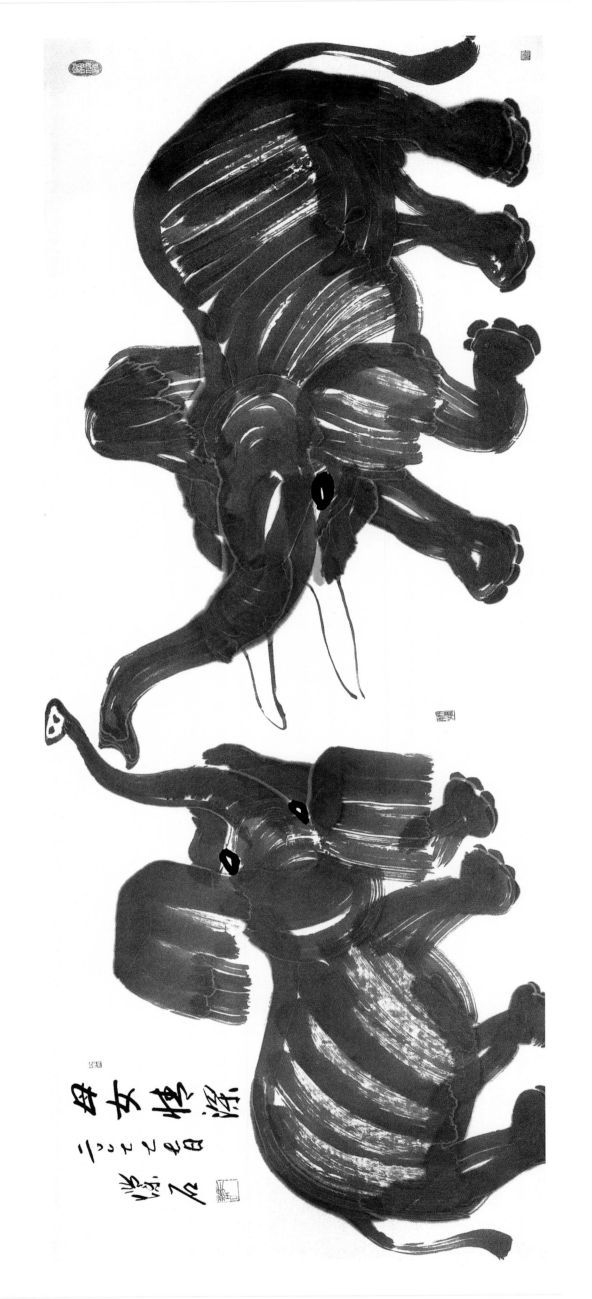

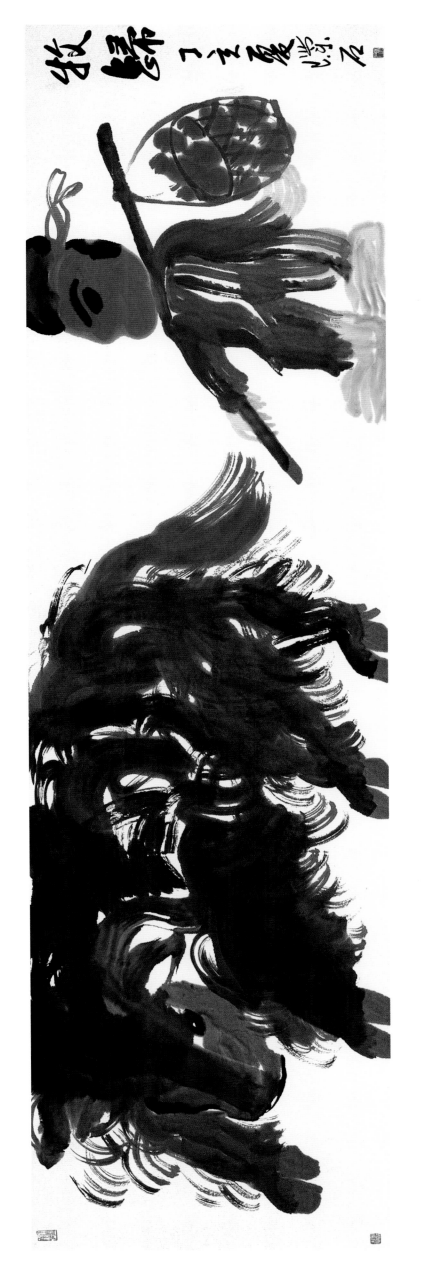

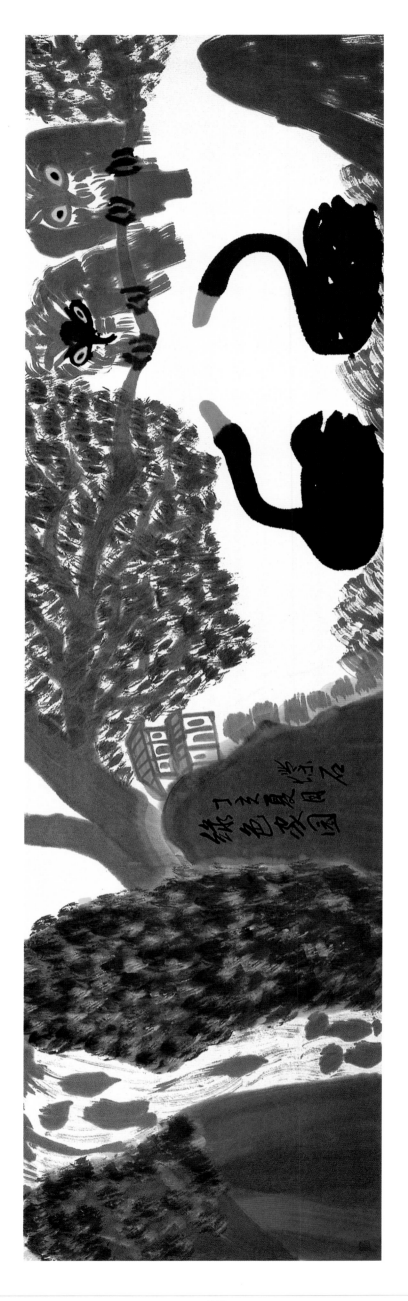

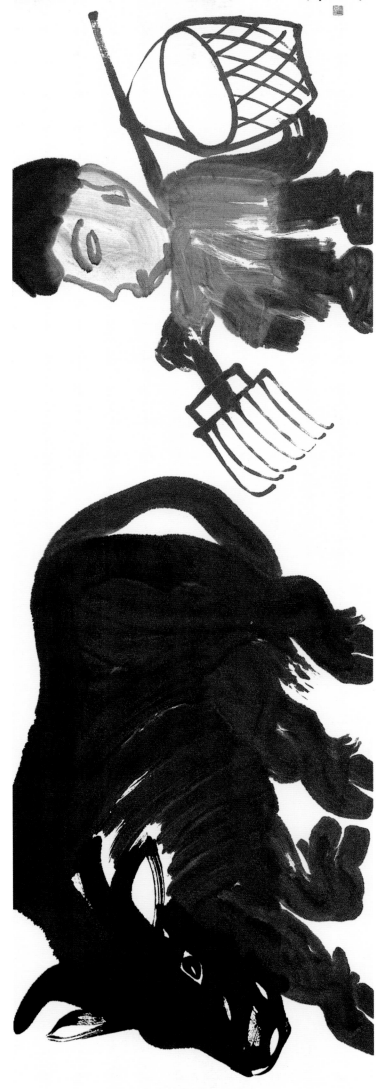

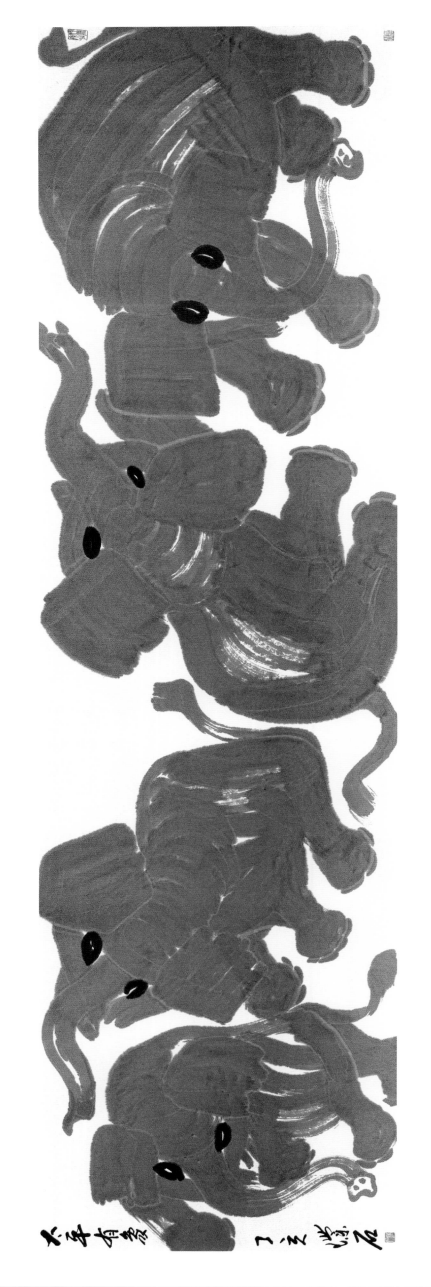

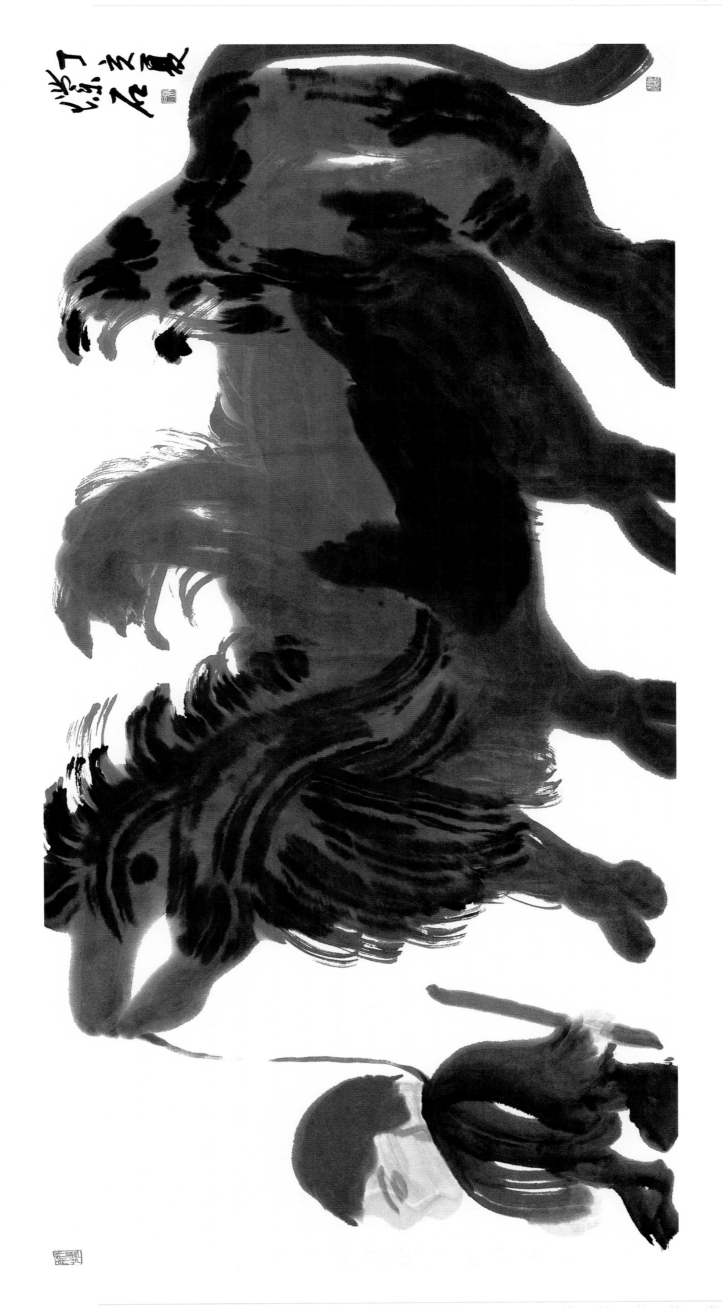

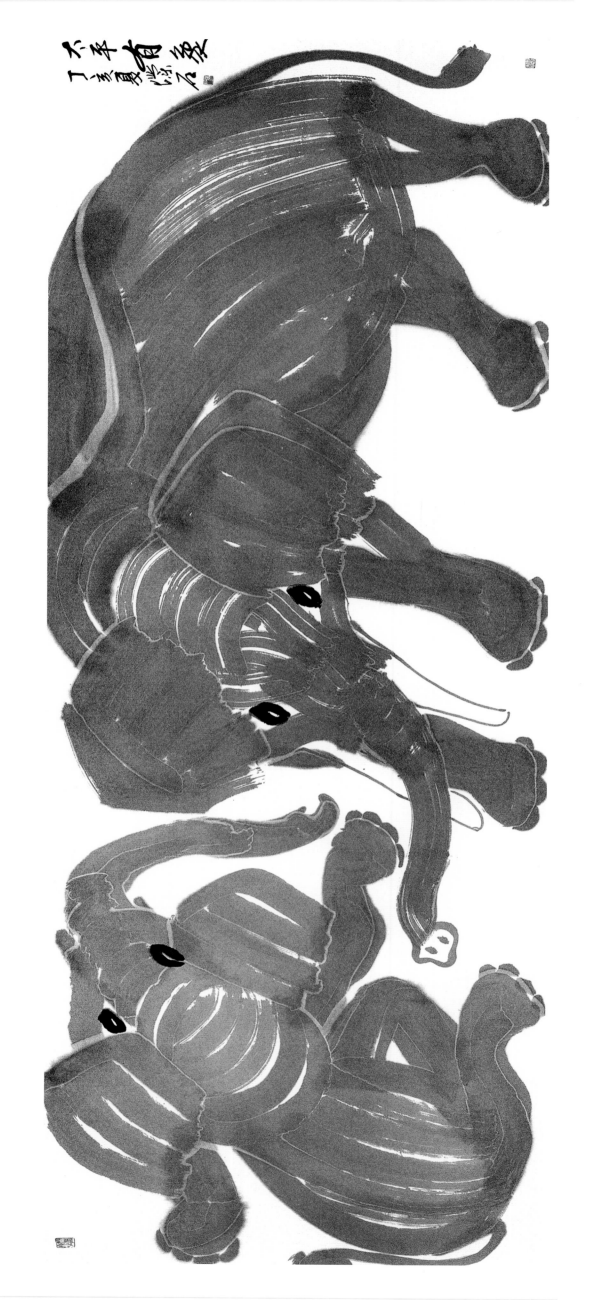

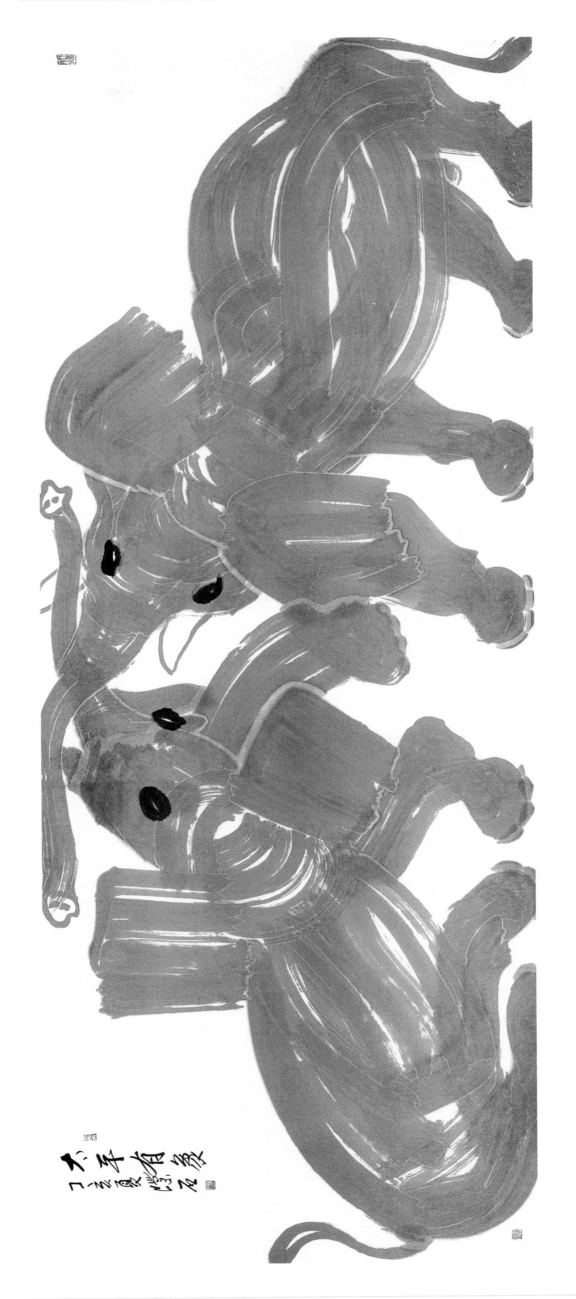

璞石画集

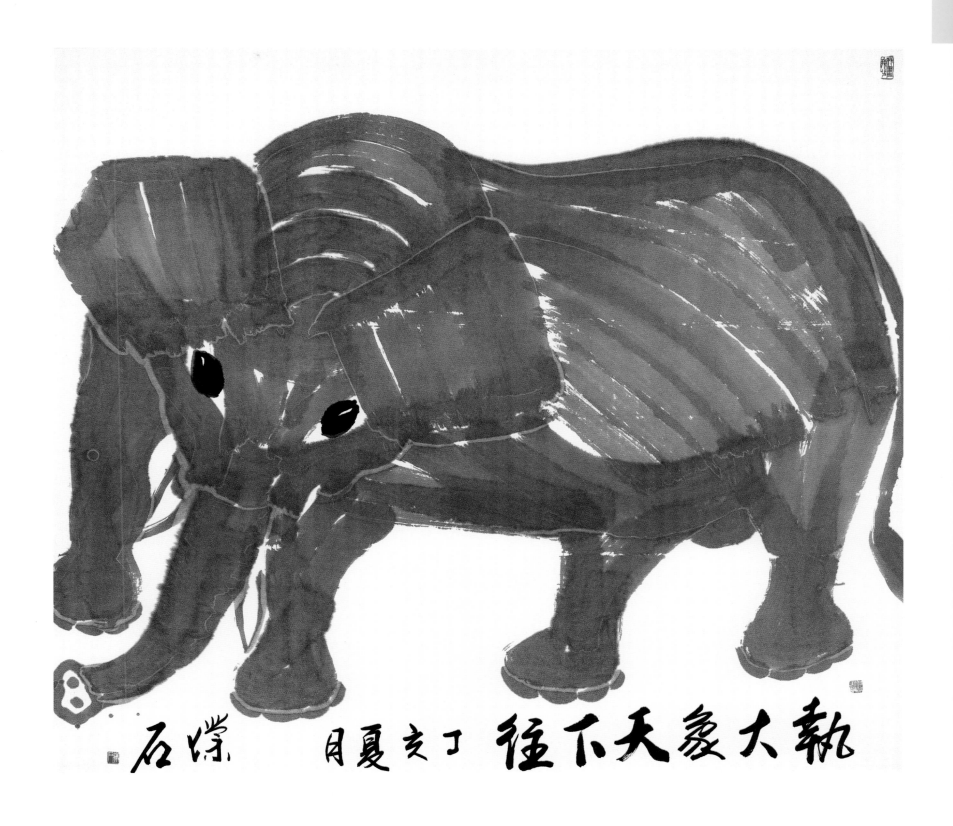

執大象天下往 丁亥夏月 璞石

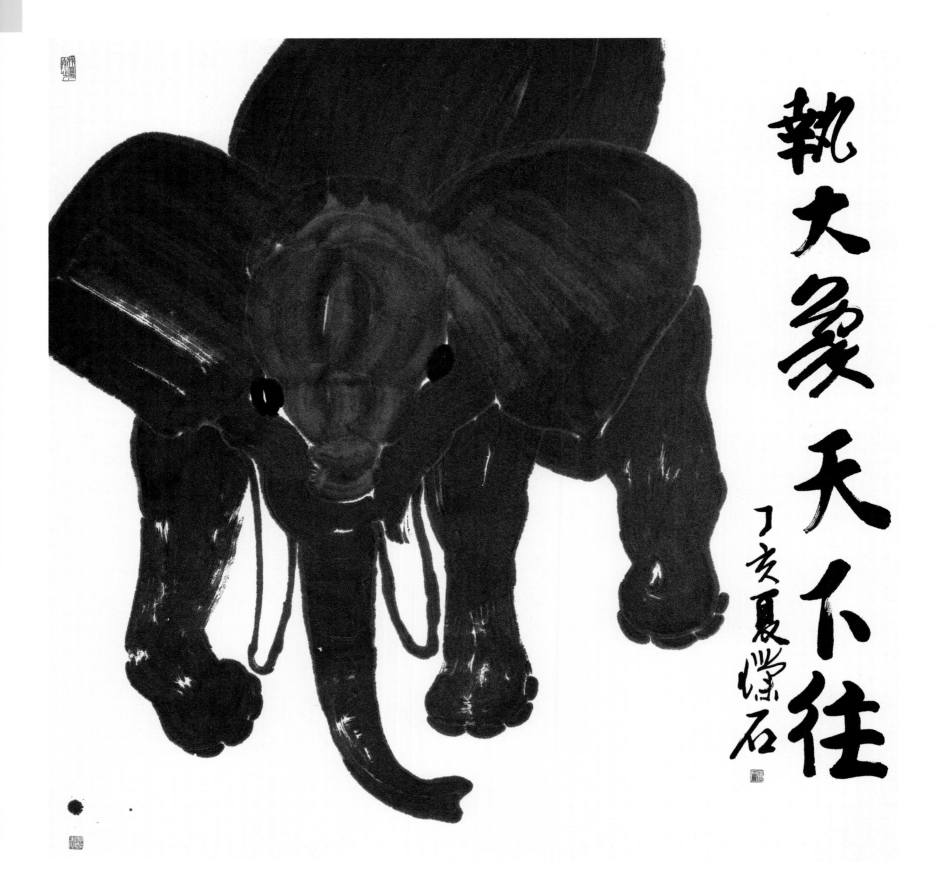

执大象 天下往

丁亥夏璞石

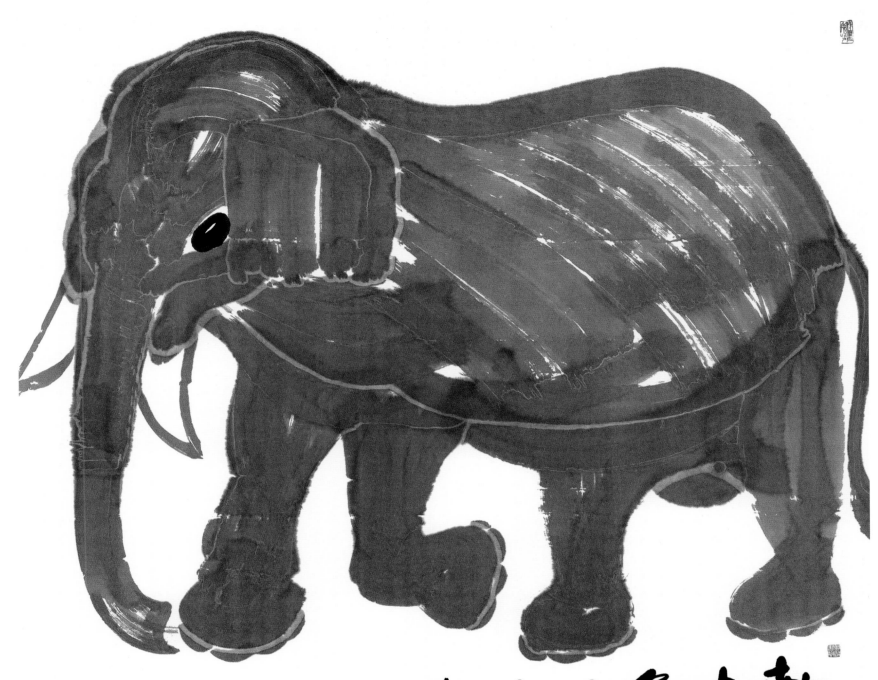

執大象天下往 丁亥夏璞石

人物　　PEOPEL

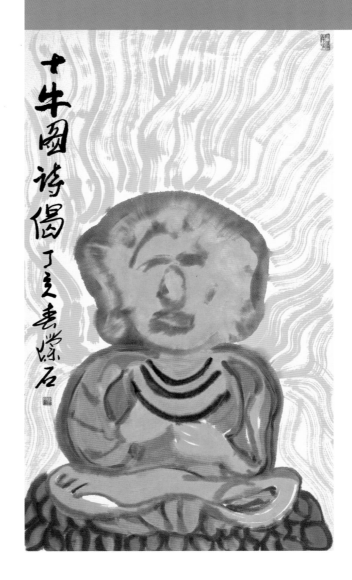

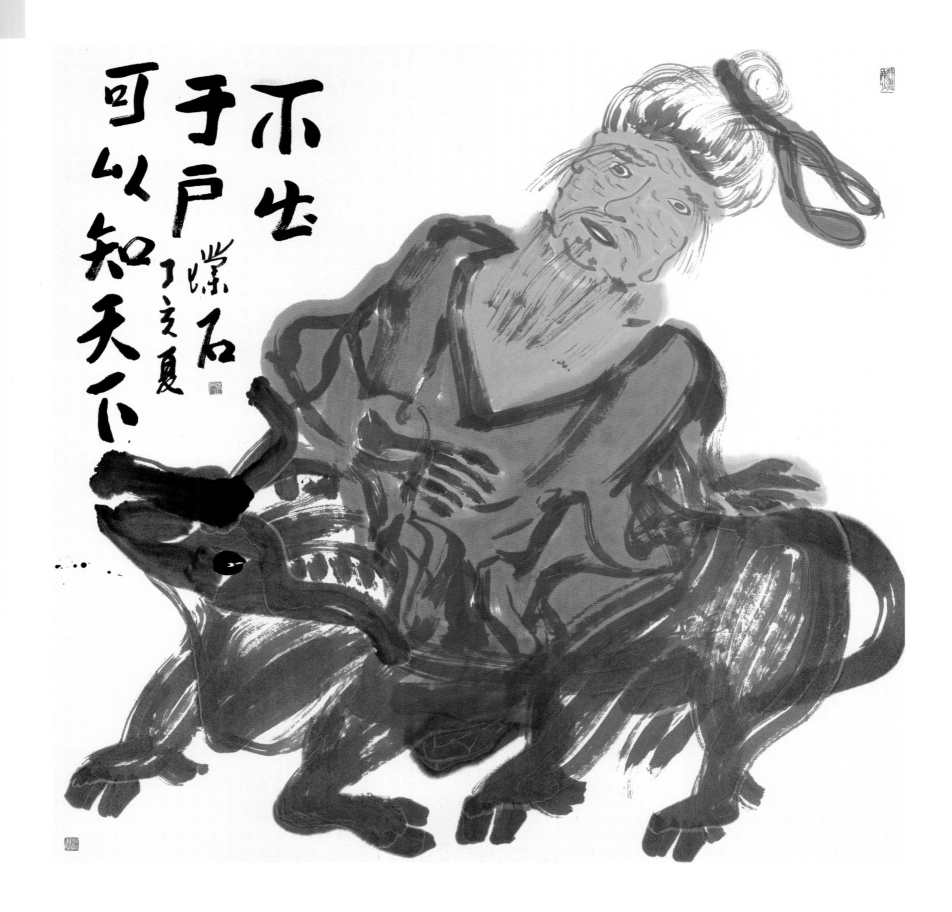

不出
于户燥石
可以知天下
丁亥夏

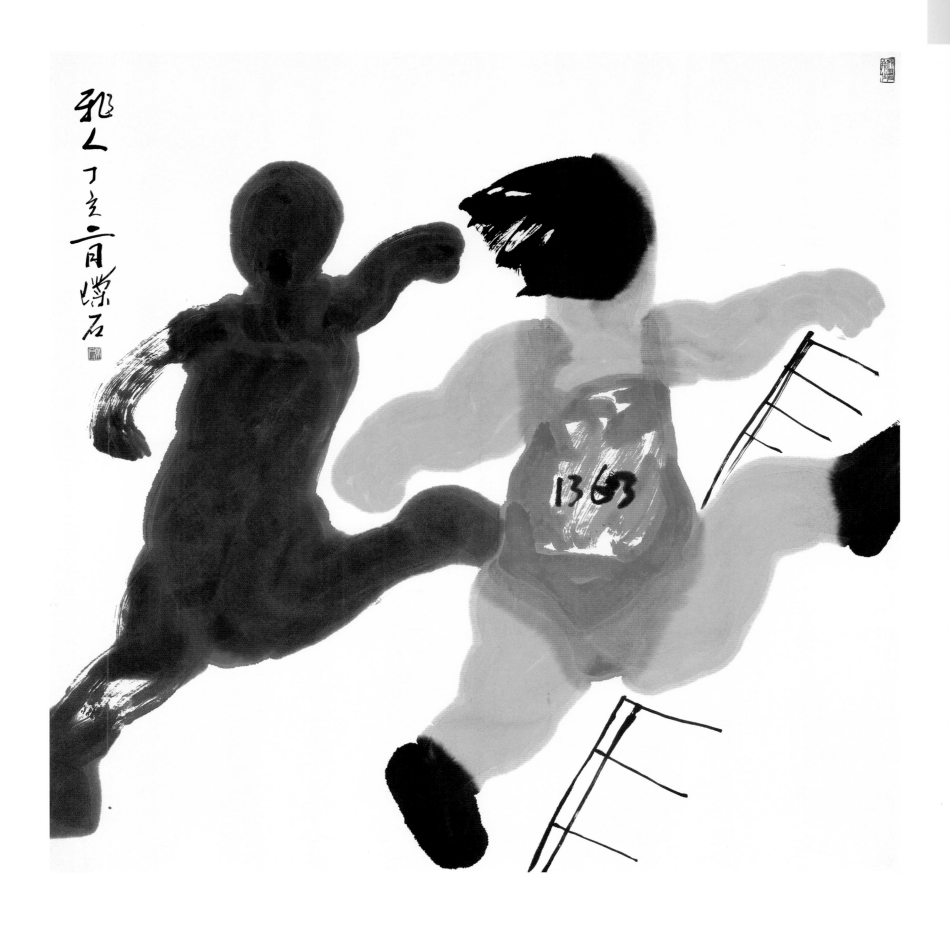

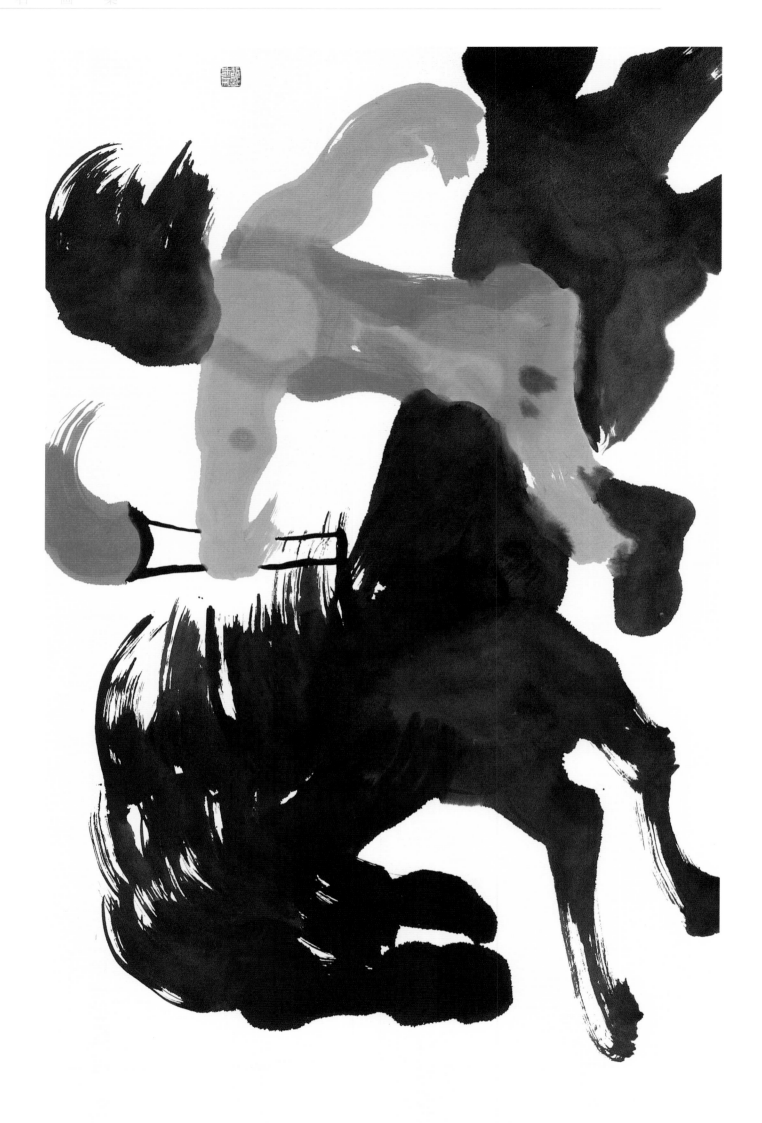

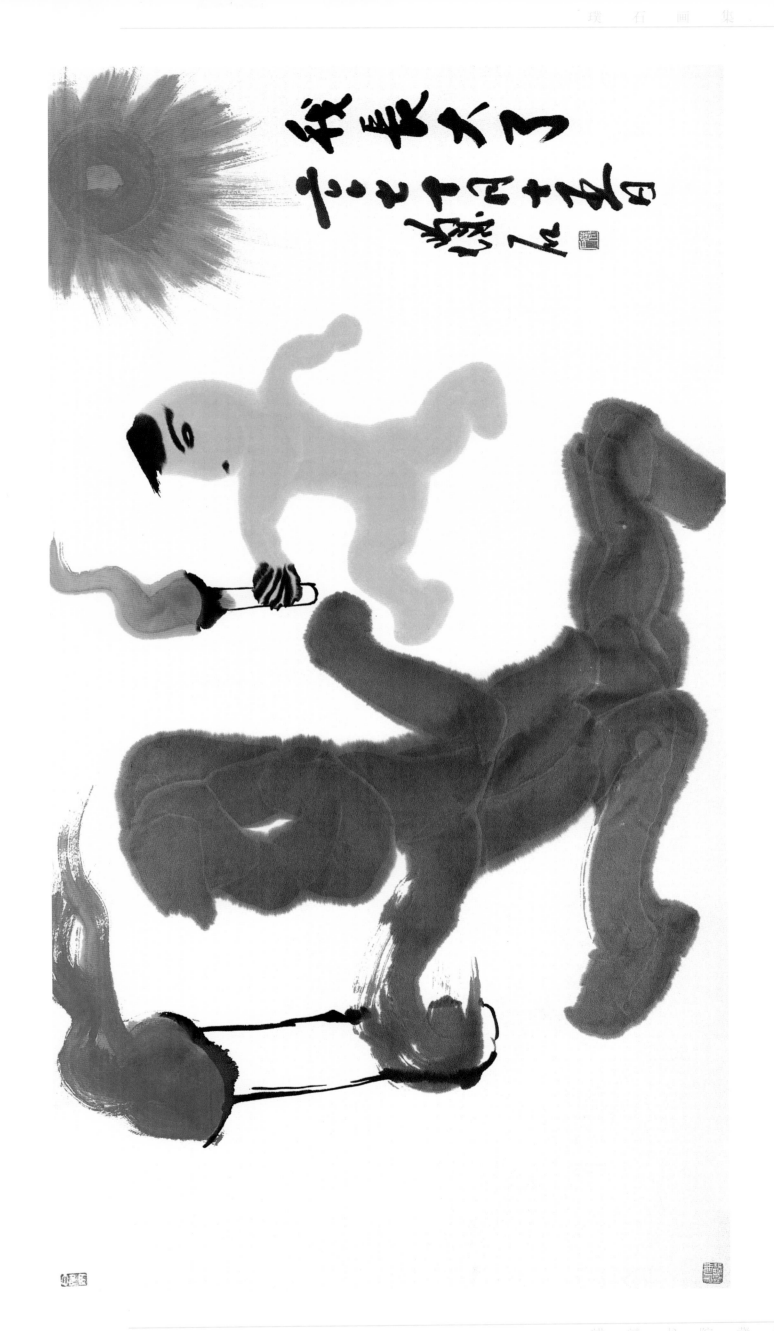

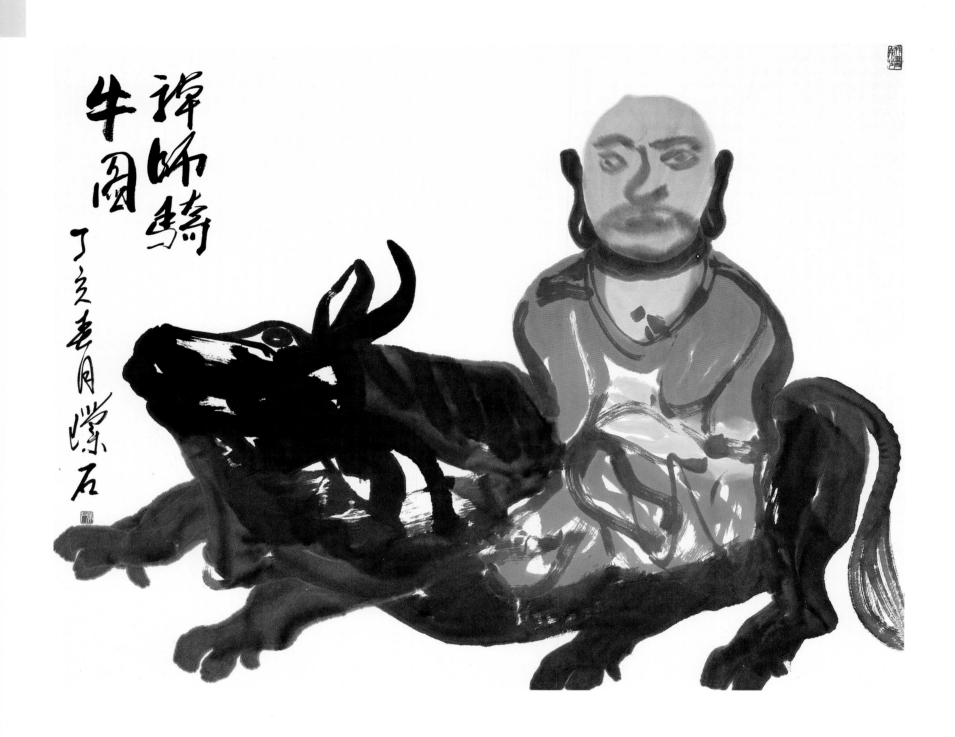

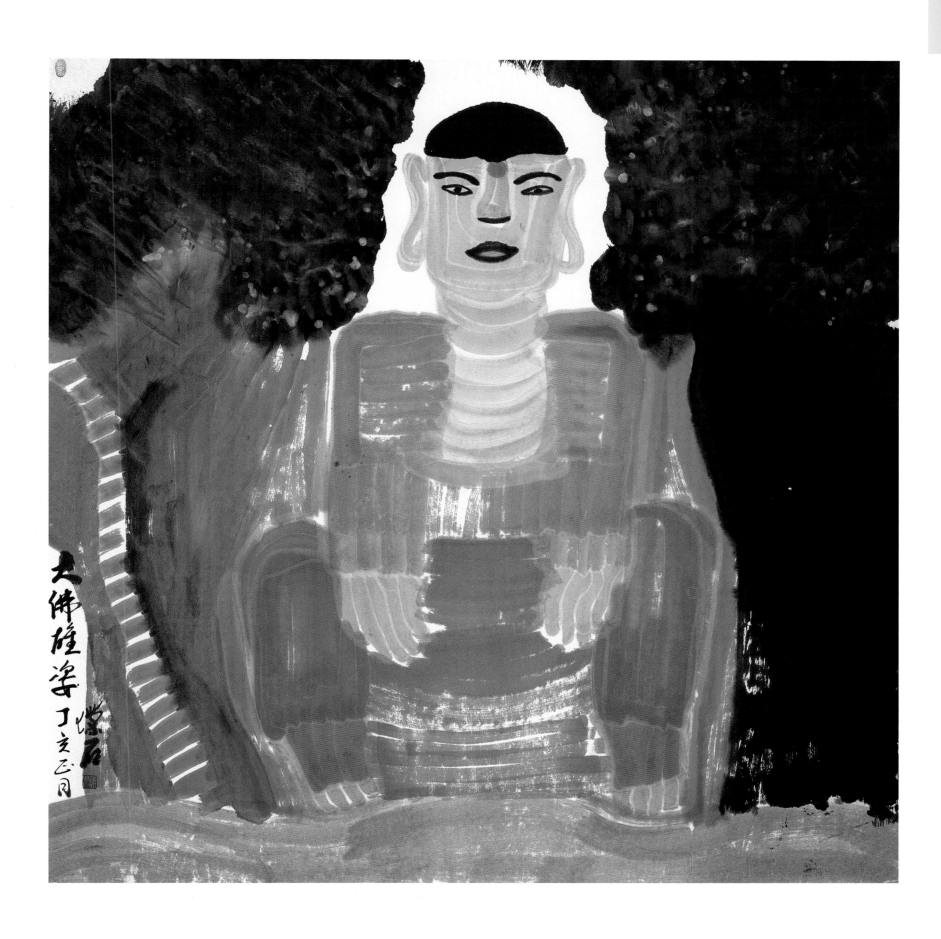

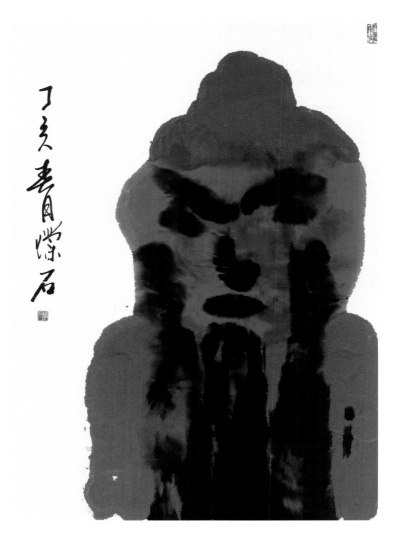

图书在版编目（ＣＩＰ）数据

璞石画集/秦树明绘.—天津：天津人民美术出版社，
2008.3
　ISBN 978-7-5305-3630-8

　Ⅰ．璞… Ⅱ.秦… Ⅲ.中国画-作品集-中国-现代
Ⅳ. J222.7

　中国版本图书馆CIP数据核字（2008）第028235号

璞石画集

出 版 人：刘子瑞
策 划 人：孟德荣
责任编辑：魏志刚　袁金荣
技术编辑：李宝生
装帧设计：陈栋玲　刘艳磊
出版发行：天津人民美术出版社
社　　址：天津市和平区马场道150号
网　　址：http://www.tjrm.cn
邮　　编：300050
电　　话：(022) 23283867
经　　销：全国新华书店
印　　刷：天津市豪迈印务有限公司
印　　张：37.5
印　　数：1-5000
开　　本：787毫米×1092毫米 1/8
版　　次：2008年3月第1版
印　　次：2008年3月第1次印刷
定　　价：380.00元